Japanese Cinema Encyclopedia:
Horror, Fantasy and Science Fiction Films

books by
Thomas Weisser
(available from Vital Books except where indicated)

Asian Cult Cinema
(published by Berkley/Boulevard Books)

Asian Trash Cinema: The Book

Asian Trash Cinema: The Book 2

Japanese Cinema:
The Essential Handbook
by Thomas Weisser and Yuko Mihara Weisser

Japanese Cinema Encyclopedia:
The Horror, Fantasy & SciFi Films
by Thomas Weisser and Yuko Mihara Weisser

Japanese Cinema Encyclopedia:
The Sex Films (volume 1)
The Sex Films (volume 2)
by Thomas Weisser and Yuko Mihara Weisser

Spaghetti Westerns:
The Good, The Bad And The Violent
(published by McFarland & Company)

and
Violets Of Dawn
a terror novel
with an introduction by Herschell Gordon Lewis

Japanese Cinema Encyclopedia:
The Horror, Fantasy and SciFi Films

The First Volume in a Series of Film Reference Books

by
Thomas Weisser
and
Yuko Mihara Weisser

with an introduction by
Oliver Stone

Vital Books
Vital Group Inc.
Asian Cult Cinema Publications
Miami, Florida USA

JAPANESE CINEMA ENCYCLOPEDIA:
HORROR, FANTASY AND SCIENCE FICTION FILMS
By Thomas Weisser and Yuko Mihara Weisser

Text Copyright © 1997 by Thomas Weisser
Cover photo Japanese Copyright © Shochiku/Kadokawa 1982
 From the motion picture
 In Celebration Of Her Seventh Birthday
 (Konoko No Nanatsu No Oiwai Ni)
Back cover photo Japanese Copyright © JHV 1988
 From motion picture *Evil Dead Trap* (Shiryo No Wana)
Color and B&W illustrations and photographs
 by various institutes, organizations and companies.
Grateful acknowledgment is made to the following companies,
whose properties illustrate this book in the spirit of publicity:
 Cinema Purasetto, Daiei, Dreamy Express Zone,
 Japan Art Theater Guild, Gento-sha, [JHV] Japan Home Video,
 Kadokawa Eiga, Kadokawa Studios, Katsu Promotions,
 Mifune Productions, Nikkatsu, Oshima Productions, Shintoho,
 Toei, Toho, Tohokushinsha, Tsuburaya Productions, and Shochiku

Book design by Francine Dali

Published by Vital Books (Vital Sounds Inc) and
ACC Publications P.O. Box 16-1919, Miami Florida 33116
Printed in the United States of America by Colonial Press, Miami
Asian Cult Cinema® is a registered trademark
 of Thomas Weisser and Vital Books Inc

ISBN 1-889288-51-9
FIRST EDITION: September 1997
10 9 8 7 6 5 4 3 2 1

This book is dedicated to
Mary and Steve Getz

our dear friends

Japanese Cinema Encyclopedia:
The Horror, Fantasy and Science Fiction Films

by Thomas Weisser
and Yuko Mihara Weisser

Contents

Introduction
by Oliver Stone

Horror, fantasy and science fiction films are often described as "guilty pleasures," but those of us who are fans don't feel guilty at all for our pleasure.

Throughout the years, several otherwise *serious* American filmmakers experimented with horror and science fiction films during their careers (*e.g.*, **Robert Wise** with **The Curse Of The Cat People** and **The Day The Earth Stood Still**. *Francis Ford Coppola* with **Dementia 13** and **Dracula**, *Brian DePalma* with **Dressed To Kill** and **Carrie**, *John Carpenter* with **Halloween** and his version of **The Thing**, *James Cameron* with **The Terminator**, *Ridley Scott* with **Alien**, *David Fincher* with **Alien 3** and **Seven**, and of course *Stanley Kubrick* with **The Shining**). Some fine directors — think **Hitchcock** and **Polanski** — never made any apologies in the first place for directing horror films.

After two mixed efforts, **Seizure** (1974) and **The Hand** (1981), I long ago decided that I did not have their capabilities of, let's say, driving the nail into the audience's third eye.

And so, it was refreshing for me to discover that in Asia, such movies hold a somewhat more exalted place — certainly in the vibrant, action-packed cinema of Hong Kong, in which ghosts routinely do battle with mortal foes and swordsmen typically fly through the air in supernatural acrobatics — and also in the generally more stately cinema of Japan. Whether they're high gloss, big-budget, name-director epics, "B" action/exploitation flicks, or "Z" porno *pinku eiga*, the unearthly has infiltrated the history of Japanese film as much as it did the earlier visual art of *ukiyo-e*, those populist woodblock paintings created for a mass market and now considered one of the highest expressions of the country's aesthetic.

Looking back at the '50s and '60s, during which time I was falling in love with movies, it's astonishing to realize how many Japanese science fiction, fantasy and horror films were able to be seen in American movie theaters. There were (and still are) the innumerable *kaiju eiga* (giant monster films) strongly influenced by such American antecedents as *Eugene Lourie*'s 1953 **Beast From 20,000 Fathoms** which stands as one of the stop-motion animation maestro *Ray Harryhausen*'s most sublime efforts. This movie really knocked me out as a seven-year-old.

But the Japanese, as always, starting with *Ishiro Honda*'s surprisingly (in retrospect) grim and apocalyptic original **Godzilla** movie in 1954 and its immediate successor **Rodan**, the Japanese nightmarishly relived the trauma of Hiroshima and Nagasaki by conjuring up mindless reptilian beasts to destroy Nippon over and over again, as if losing the war and millions of its citizens wasn't enough. Finally, in the early '60s, these films settled into a childlike cartoonishness, taking the edge off their original intent, which was probably a blessing for the post-war generation of Japan.

But there were also spectacularly frightening period horror films exhibited on American theatre screens in the late 1950s and early 60s from the highest ranks of Japan's filmmakers, including *Akira Kurosawa*'s **Throne Of Blood**, the terrifying Samurai riff of **Macbeth**; *Kaneto Shindo*'s bloodcurdling **Onibaba** and **Kuroneko**; and *Masaki Kobayashi*'s eerie, surrealistic and influential **Kwaidan**. What a pity that with so few Japanese films being theatrically distributed today in the States, we're denied such recent *guilty pleasures* as *Kinji Fukasaku*'s **Chushingura Gaiden Yotsuya Kaidan** (internationally titled **Crest Of Betrayal**), an insanely florid and frenetic merging of two classic legends: the Yotsuya ghost story and the timeless story of the forty-seven loyal ronin.

I first became enamored of Asian cinema by way of Hong Kong action films in the early 1970s in New York at the four movie palaces of Chinatown, although as a schoolteacher in Saigon in 1965, I used to go to several of the sword-n-sorcery, carpet-flying Vietnamese films then being prodigiously made in South Vietnam. They had the most colossal and eye popping posters I had ever seen, and we later tried to re-create some of them for a brief scene in **Heaven And Earth**. During the mid 70s, I also managed to see — in such late, lamented theaters as the Kokusai on Crenshaw Boulevard — lot of sexy, ultra-violent Japanese films *(I couldn't believe these were being made, let alone shown!)*

Japanese cinema tends to be more serious than that of Hong Kong. These films are slower moving, but they're also more perverse. Not even the weirdest Chinese movies have ever approached the no-holds-barred outrageousness of pure Japanese exploitation movies. If you don't believe it, just look at the first title listed in the volume you're now holding— **Abnormal Reaction: Ecstasy**, director *Giichi Nishihara*'s followup to the even more colorfully titled **Grotesque Perverted Slaughter**. Or check out *Toshiharu Ikeda*'s **Evil Dead Trap** (1988), a daring and grim thriller that spawned two sequels, although the first is still the best (*Brian De Palma*'s notorious driller scene in **Body Double** would have been a *starting* point for the **Evil Dead Trap** epics).

These "exploitation films" reveal, as much as any serious sociological work on the subject, Japan's twisted sexual soul. It seems to the foreign observer that in Japan, primness and repression have always lived side-by-

side with an unleashed eroticism that stretches the bounds of imagination (the famed "floating world" of Tokyo's Yoshiwara zone existed until 1957, and its spirit lives on in such current pleasure districts of that metropolis as the determinedly decadent Kabukicho). The artists of Japan have always merged the erotic with the horrific — just take a look at a sampling of the famed *ukiyo-e* by the great 19th century artist Yoshitoshi and you'll understand. Many Japanese filmmakers, from pink-film slezoids like the aforementioned **Nishihara**, to the more respectable **Fukasaku**, have continued in this tradition.

On the other hand, Japanese action/exploitation/horror films — like their Hong Kong counterparts — often feature incredibly strong female leads, the likes of which I have never seen in Western cinema. And unlike the often ragtag, off-the-cuff, post-synced quality of Hong Kong movies —- which in some ways are like the American action movies we watched in drive-in theatres in the early '70s — Japanese films, including those in category "B" and downward, are almost always beautifully crafted. They're like high-grade Hollywood movies, but with politically incorrect themes.

With the exception of scholarly works by the likes of **Donald Richie** and **Audie Bock** on mainstream Japanese films, there is preciously little available in English on the great range of movies that the nation has produced over the last few decades. **Thomas Weisser** and **Yuko Mihara Weisser**'s previous volume, **Japanese Cinema: The Essential Handbook** was an incredibly informative and very important re-opening of this door to the East; and now they've really outdone themselves with their **Japanese Cinema Encyclopedia: The Horror, Fantasy And Science Fiction Films** which features lively reviews and credits for hundreds of movies that would otherwise remain completely undiscovered by the *gaijin* readership.

The very existence of their books serves to validate, in our culture, the otherness of Japanese films, which often brilliantly mirror their own complex, disturbing, always ever-fascinating society and traditions.

Summer 1997

Oliver Stone is a world renowned filmmaker,
director of such reputable motion pictures as
*Natural Born Killers, JFK, The Doors, Salvador, Heaven And Earth,
Wall Street, Talk Radio, Nixon, Born On The 4th Of July, Platoon*.
He is the winner of many
prestigious motion picture awards for excellence
including three oscars.

Foreword
by Thomas Weisser

This is the first volume in what will become a life-long project for Yuko and myself. Over time, we hope to write a series of books, collectively called **Japanese Cinema Encyclopedia**, which will assemble the vast number of contemporary Japanese films, chronicling them by genre.

For this particular volume, we initially had planned to include every Nippon *horror, fantasy and science fiction* film released theatrically in Japan since 1955. But after conducting the research our original goal expanded. Due to the high number of independent productions in the '80s and '90s — as well as the growing popularity of "direct-to-video" releases and experimental "film festival" projects — we decided to include many specialized films in addition to the mainstream theatrical features. As a result, this volume offers the largest, most complete listing of Nihon *horror, fantasy and science fiction* films ever accumulated in a western text.

In the introduction for our previous book, **Japanese Cinema: The Essential Handbook**, I wrote: "Without the help of my wife, **Yuko Mihara Weisser**, this book could not have been written." Those words are unequivocal today. Many writers make comments like that. It's almost a cliche. But, in this case, Yuko's knowledge of Japanese cinema, coupled with a proficiency for both the Japanese and English language, makes her an *invaluable* partner. Yuko's passion for these cult movies makes her a *perfect* partner.

Over the years, many books and magazines have been written on "World Cinema." But, aside from information on the obvious international hits and **Toho** rubber-monster movies, preciously little is known about Japanese genre pictures; only a handful of reference books have seen publication in the West. And many of those suffer from mistakes and inaccuracies. These errors range from minor translation problems (*i.e.,* the actor's name is **Tetsuro Tanba** not **Tamba**; the director of **Godzilla** [1954] is **Ishiro Honda** not **Inoshiro Honda**) to mistakes of somewhat larger proportions. For example, a well-known British "horror encyclopedia" listed **Yoshihiro Ishikawa**'s movie **Ghost Cat of Otama Pond** as **Kaibyo Otamage-ike** instead of **Otama-ga-ike**. This may not seem like a major discrepancy, but in Japanese *Otamage* means "hairy testicles," while *Otama-ga-ike* is "Otama Pond."

We have attempted to transcribe this text with as much accuracy as possible. Yet this book is not perfect. No reference book is. But, I believe it's more accurate and more complete than any previously published chronicle on Japanese Horror, Fantasy and Science Fiction movies. Yuko and I have personally watched a high percentage of the films reviewed in this text and the essays are based accordingly. However, in some instances we have relied on documentation from various Japanese books and periodicals including *Kinema Jumpo, Peer Cinema Club Annual, Eigageijutsu,* and *Kinejun Film Yearbook*. Each review contains a *star* rating system, from [****] the best to [*] the worst. This rating is based on the merits of film *within its intended market* and not necessarily on *artistic quality* when compared to other genres. All Japanese names are treated in Western style, with the surname following the given name. This is how the people of Japan prefer to write their names when transcribing them into English, so we followed their lead.

Often we had a difficult time deciding whether certain titles should be included in this volume or an alternative one. For example, thriller-styled S&M *pinku eiga* presented the biggest dilemma. Eventually we opted to save most of the "sado fare" for the volume on **Sex Films**. But in some instances we decided to include certain "crossover" titles in multiple volumes. And lastly, even though we have attempted to review every genre film, some elusive titles were — most likely — missed. We encourage our readers to contact us regarding any exclusions. Comments and information is appreciated. You can reach us through the Asian Cult Cinema offices c/o Vital Books, PO Box 16-1919, Miami FL 33116 or by E-Mail: *AsCuCinema@aol.com*

Acknowledgements

In addition to those listed previously, Yuko and I wish to thank the following people for their help:

The **Asian Cult Cinema Magazine** writers including **Gerard Alexander**, **Harlan Ellison**, **Eric J Hughes**, **Richard Kadrey**, **Jack Ketchum**, **Graham Lewis**, **Patrick Macias**, **Ric Meyers**, **Steve Puchalski**, **August Ragone**, **Ray Ranaletta**, **Pete Tombs** and **Tony Williams**. Plus a special mention to our computer technician, **Mike Ruiz**.

Maki Hamamoto, who did the extensive research work in Japan; and Naoto Okamura for providing many of the photographs. And also a special thanks to **George Patino**, **Oliver Stone**, **Tim** and **Donna Lucas**, **Michael Weldon**, **Max Allan Collins** and our attorneys **Robert Van Der Wall** and **Stephen Baker**.

But mostly, to our daughter **Jessica Weisser** who did the cross referencing and pain-staking detail work.

The Films:
An Alphabetical Listing and Critique

**ABNORMAL REACTION:
ECSTACY** (1967)
[Ijo Na Hanno: Monzetsu]
director: **Giichi Nishihara**
Tamaki Katori • **Mari Azusa**
Teruko Amano • **Yasushi Matsura**
*

A somewhat restrained, early project from **Giichi Nishihara**, the director who made a career of sleazy *pinku eiga* in the '70s {see *Japanese Cinema Encyclopedia: The Sex Films* for complete overview}. He's probably the trashiest filmmaker of them all, the *Jess Franco* of Japan (also see his **Ghost Story Of Sex** in this volume). Rumor has it that Nishihara cranked out an untold number of kinky movies for a *"front"* film studio owned by the Osaka yakuza.

This is a low-budget erotic thriller about a grieving widow (**Mari Azusa**) who discovers that— perhaps— her husband is really alive. Obviously, he is. And he's got a pretty little thing on the side. The betrayed wife concocts a unique revenge which impales the lovers on a stake in their bed.

Gutter cinema with little to offer. The violence is fleeting. Even the sex scenes are stilted when compared to Nishihara later efforts.

ACRI (1996)
[Acri]
director: **Tatsuya Ishii**
Tatsuya Fuji • **Tadanobu Asano**
Yosuke Eguchi • **Kimika Yoshino**
*½

Director **Tatsuya Ishii** (the former lead singer for the Japanese pop group called the *Come-Come Club)* follows his 1994 debut, *Kappa* — the bittersweet story of an ET alien living in a lake— with this tale of a mermaid named Acri and a team of scientists dedicated to documenting her existence.

A professor (**Tatsuya Fuji**, who also had a co-starring role in *Kappa* but is best known for *In The Realm Of Senses*) sets out to prove his theories about the authenticity of mermaids. When he can't garner support from the Japanese academia, he moves his opera-

Kimika Yoshino (L) with Tadanobu Asano
in Tatsuya Ishii's *Acri*

tion to Australia. He's accompanied by a student named Hisoka (**Tadanobu Asano**) who tells a tale of being rescued by mermaids during a shipwreck. A journalist (**Yosuke Eguchi**) also joins the exhibition. Soon, the two older men begin to suspect that student Hisoka had been sexually active with one of the mermaids. Eventually they learn he is actually an offspring of a *married* mermaid couple.

Although it might sound like a fun romp, this is no *Splash*. Filmmaker **Ishii** is deadly serious. Stiflingly so. His heavy-handed filmmaking techniques, while fresh and breathtaking in **Kappa**, are simply ponderous here.

ADVENTURE IN THE PARALLEL WORLD (1986)
[Hoshizora No Mukou No Kuni]
director: **Kazuya Konaka**
Yumi Arimori • **Yuji Kanda**
**

A boy (**Yuji Kanda**) vows to find a cure for his terminally ill girlfriend. He needs to secure an antidote which — theoretically — should be readily available in a world that mirrors reality, a Parallel Earth. The boy jumps into this strange new universe, but soon — after getting the potion — becomes lost and is unable to find his way back to the girlfriend. But, there's no need to worry, a happy ending squeezes through.

This debut film by 22 year old director **Konaka** was very successful in attracting an audience from Japan's youth. Small movie, but a major hit. Much more optimistic than his later *darker* projects like **Lady Poison** (1994).

ADVENTURES OF THE ELECTRIC ROD BOY (1995)
[Denchu Kozo No Boken]
director: **Shinya Tsukamoto**
Nariaki Senba • **Tomoroh Taguchi Kei**

Fujiwara • **Shinya Tsukamoto**

This was the lower half of a double feature, released theatrically with **Tokyo Fist** (1995), from the same director {see separate listing}. In a story vaguely reminiscent of *Tim Burton*'s **Edward Scissorhand** (1990), there's a boy who has an electric rod growing out of his back (shades of **Tetsuo**, for sure). He's the butt of jokes, a lonely kid with no friends. One day he enters a time slip and finds himself in a world where a vampire (**Tomoroh Taguchi**) has gained control of all the humans.

An immensely enjoyable short film (clocking in at 50 minutes) that could stand on its own if it were just a bit longer.

ADVENTURES OF KOSUKE KINDAICHI
see **KINDAICHI series**

AGI: FURY OF THE EVIL GOD (1984)
[Agi Kijin No Ikari]
director: **Hikari Hayakawa**
Toru Masuoka • **Kumi Nakamura**
**

Based on a story from the ancient *Konjaku* tales called **Devil Of Agi Bridge**, this film is the debut project by 23 year old director 23 **Hikari Hayakawa**, who also handled the script, music, special effects and cinematography. Today he's best known as the director for **Umezu's Terror Zone** {see separate listing}.

The special effects, especially the transformation from human to *devil face*, are among the best efforts in genre work, especially remarkable for such a low budget *indie* production. But the story of a bumbling samurai terrorized by Devil Agi is seriously dated and fails to generate much interest.

The bridge conflict, easily the best segment in the movie, is also used as introduction footage for *Masayoshi Sukida*'s 1990 film **Tastiest Flesh**, a much more successful venture.

Suzunosuke AKADO series
[movies based on a character created by Tsunayoshi Takeuchi / (1957-1958)

Originally designed as a children's version of the popular **Musashi Miyamoto** series (directly influenced by **Hiroshi Inagaki**'s *Samurai Trilogy* [1954-1956]), this collection of nine entries follows the exploits of a young swordsman as he fights evil in Japan during the Edo Period. The first four entries adhere to the typical *chambara* action formula. But with **#5**, monsters and supernatural happenings are added to the mix.

Initially based on a manga penned by **Tsunayoshi Takeuchi** in the 1930s, the *Suzunosuke Akado* legend became a successful radio drama in the 40s. After a theatrical run in the mid 1950s, the series surfaced on television as a weekly animated kid's program.

The movies tell the story of an orphan, Suzunosuke Akado (played by **Shoji Umewaka** {*#1-7*}, and then by **Taro Momoyama** {*#8 & 9*}). Akado is the son of a brave samurai who dreams of following in dad's footsteps. In **#1**, Akado is being raised by grandpa, a conservative old man who tries to persuade the boy to "turn the other cheek" when threatened by an unsavory bully named Rainoshin Tatsumaki (a reoccurring arch rival played throughout by **Naritoshi Hayashi**).

Grandpa is murdered in the second installment. And Akado is forced to grow up overnight. After his guardian's death, the swordsman seeks guidance from a master samurai, Shusaku Chiba (**Yataro Kurokawa**). Chiba puts Akado through a rigorous training and then the two men wage war on the gang responsible for the old man's death.

Episodes **#3** and **4** continue the *chambara* machismo, made palatable for the intended juvenile audience with an abundance of spectacular action sequences. Surprisingly, many Japanese critics began to write favorably about the series and soon it attracted an enthusiastic adult following.

The fifth entry, **Devil In The New Moon Tower**, was startlingly atmospheric, with appreciated horrific leanings. *Peer Cinema Quarterly* wrote: "the sets and art design is way too good for a kid's movie. This series, like its leading character, is growing up."

The two best films in the series are **#6** (**Majin With One Leg**) and **#7** (**Chimera With Three Eyes**). Both feature full scale monsters coupled with impressive special effects. In **#6**, director **Kimiyoshi Yasuda** tells the story of a creature with one leg and black wings who steals the village treasure. When people try to retrieve it, the monster melts them. Among the artifacts stolen by the winged creature is a sacred sword which had belonged to Master Chiba. Akado defeats Majin and returns the sword to his teacher.

Interestingly, almost ten years later, the director **Yasuda** would helm **Majin: Monster Of Terror** for *Daiei Studios*. Obviously, he was strongly influenced by his involvement in this now-obscure movie. And equally ironic, **Kazuo (Issei) Mori**, the director of the next *Akado* episode, made the third entry in the **Majin** series, **Majin Strikes Again**, in 1966.

Mori's film, **Chimera With Three Eyes**, is about a birdman creature who kidnaps children born under the sign of the Dog. Samurai Akado invades a ghost mansion believed to be the hideout for the Chimera. There he fights the monster and rescues the kids.

This is a listing of all the films in the Suzunosuke Akado series:

▶ **Suzunosuke Akado #1** (1957)
 director: Bin Kato

▶ **Monster In The Moonlight** (1957)
 [Akado Suzunosuke: Tsukiyo No Kaijin]
 director: Bin Kato

▶ **Beating the Devil Mask Gang** (1957)
 [Kimen-to Taiji]
 director: Kimiyoshi Yasuda

▶ **Hicho Style: Vacum Slice** (1957)
 [Hicho-Ryu Shinku-giri]
 director: Kimiyoshi Yasuda

▶ **Devil In New Moon Tower** (1957)
 [Shigetsu-to No Youki]
 director: Bin Kato

▶ **Majin With One Leg** (1957)
 [Ipponashi No Majin]
 director: Kimiyoshi Yasuda

▶ **Chimera With Three Eyes** (1958)
 [Mitsume No Chojin]
 director: Kazuo (sometimes Isseu) Mori

▶ **Thunderman In Valley**
 of Black Clouds (1958)
 [Kurokumo-dani No Raijin]

▶ **Fighting Skeletons** (1958)
 [Dokuro-dan Taiji]

ALICE'S SANCTUARY (1995)
 [Alice Sanctuary]
 director: Takaaki Watanabe
 Enami Sakai • Kazuki Sakai
 **

Here's another movie obviously inspired by the success of the **All Night Long** series {see separate listing}. It's an ugly mean-spirited slice-of-life tale, shocking in it's anti-social attitude toward humanity in general.

The film begins on an odd, apparently supernatural, note. Before the credits role, an undertaker is seen busily reconstructing the corpse of a dead girl, applying makeup and fluffing her hair. As he exhales gently into her face, she begins breathing once again. This scene appears out of sync within the context of the movie, that is, until the ending.

Although twins, two 17 year olds, Akiko and Keiko, are leading completely dissimilar lives. Akiko, an outgoing girl, actively concentrates on her studies, while sister Keiko, a deaf mute, stays at home. Akiko is also preoccupied with dating and she gets involved with Takeshi, a handsome young tough and his dissident friends. She starts hanging out at boyfriend Takeshi's place, leaving her sister home wallowing in her loneliness. Keiko is envious of Akiko's lifestyle; she secretly dreams of a wilder life and boyfriend to match.

When Takeshi has an argument with his buddies, the boys rape sister Keiko for revenge. This causes her to drift even further into her dreamlike existence. Meanwhile, Akiko decides to move in with Takeshi. This really pisses off the rest of the gang and they destroy their place, killing Akiko in the process. After the boys take off, Takeshi is alone with the dead body. As it turns out though, Akiko's not dead afterall; she is desperately clinging to life. So Takeshi strangles her. She dreams of swimming in a pool of blood, and whispers to her boyfriend that she will be reborn to haunt him.

Presumably, based on the opening sequence, she gets her wish. The title, **Alice's Sanctuary**, however remains somewhat of a mystery, especially since there is no character named *Alice* in the movie. Perhaps, director **Watanabe** is trying to make a contemporary parody of *Lewis Carroll*'s **Alice In Wonderland** (a well-known book, legendary status, in Japan) but, if so, its a muddled attempt. At best.

▶ **ALL NIGHT LONG** (1992)
 [Ooru Naito Rongu]
 director: Katsuya Matsumura
 Eisuke Kadota • Ryosuke Suzuki

▶ ALL NIGHT LONG 2:
 ATROCITY (1994)
 [Ooru Naito Rongu: Sanji]
 aka ATROCITY
director: Katsuya Matsumura
Masa Endo • Kanori Kadomatsu

❖

▶ ALL NIGHT LONG 3:
 ATROCITIES (1996)
 [Ooru Naito Rongu 3: Sanji]
 aka ALL NIGHT LONG 3:
 FINAL ATROCITY
 aka ALL NIGHT LONG: THE END
director: Katsuya Matsumura
Yuji Kitagawa • Kanori Kadomatsu
 and Tomoroh Taguchi
***½

These are three highly controversial films dealing with "dove style violence" (based on a dark canon associated with certain species of birds; when a flock member is *different* or weaker, the others peck at it dispassionately until it's dead). In these movies, this unsavory psychological principle is applied to the world of high school students. Director **Matsumura** stacks-the-deck in favor of his vicious treatise by populating his films with a collection of very unlikeable characters who do unforgivably anti-social things. But the nihilism never seems forced nor unrealistic. This is probably due to Matsumura's own expertise as a documentary filmmaker before entering into the experimental horror genre.

In #1, three teenage boys happen to witness a brutal stabbing in a Tokyo sidestreet. The unusual nature of their experience creates a cryptic bond among them. Originally strangers, these boys are suddenly unified by the savage experience. Meanwhile, a female friend is raped by a gang of delinquents. The three boys react by hunting down the wildboys and massacring them.

Director **Katsuya Matsumura** makes some conceptual changes for #2. As distasteful as the first film may be, the sequel is even more disturbing. In fact, this may be the most offensive *mainstream* movie in Japan's history. When the film was completed, it was denied theatrical release. Even after certain cuts were made, Eirin (the industry "watchdog" rating board) refused approval, describing the film's entire tone as "unacceptable." The movie was released directly to the home-video market amid protests from schools and parental groups.It tells the story of nerdy Shinichi (**Masa Endo**), out of school for summer break, being bullied by a vicious gang of homosexuals. The gay leader is a rich-boy-next-door type who specializes in very anti-social behavior (*e.g.*, kills his boyfriend by pouring glue in his ear while sleeping; captures and brutalizes a girl, hooking her on heroin, raping her, and then yanking off her fingernails). Eventually this mild-mannered psycho and young Shinichi face-off against each other but not before the house is filled with a pile of butchered, dead bodies.

#3 is the best of the trilogy. But it's also the most difficult to watch, relentless in its cruelty. While the plot is similar to the previous entries, the major difference lies in the characterizations. This one has no *good guys*, there's not a trace of humanity anywhere. The *hero* — once again a high school nerd — is loony from the get-go. During the process of film he passes from being simply *withdrawn* to becoming a kill-crazy psychopath.

At one point in #3, co-star **Tomoroh Taguchi** delivers the line which sums up the entire series: "Man is born an incomplete dead body, and it takes a lifetime to become fully dead. Humans," he says, "are living garbage."

Yuko Fujimori is the leader of the *Amazons In White*

Of course, a warning is in order. Not everyone will be able to handle any of these three movies. They are dark and undeniably ugly. But for the dauntless, they're thought-provoking essays on brutality.

AMAZONS IN WHITE (1995)
[Hakui No Amazonesu]
director: Mitsunori Hattori
Yuko Fujimori • Nodoka Kawai
Manami Mizutani • Asami Katsuragi

Yuko Fujimori (foxy lead singer of the *CC Girls*) is Saeko, chief physician and director of the highly unorthodox Karura Clinic. *"An Honest Practice"* is their motto, but something fishy's going on behind the scenes. Karura Clinic is really a front for Dr Saeko's black market *Inquisition Company*. Conceptually similar to **High Heeled Punishers** (1994) {see separate listing}, Saeko and her girls are hired by mistreated and/or abused women to inflict punishment on male ruffians. These *amazons in white* get their men. And they get 'em twice. First they beat up the bastards, then, after these guys are admitted to Kaura Clinic, they're destroyed financially with an inflated medical bill.

Most likely, the producers anticipate the birth of a new series here. This film is constructed accordingly. Filmmaker **Hattori** establishes the concept of the *Amazon Inquisition Gang* and then quickly develops a non-related story within the "wrap-around." This is a tried-n-true method deeply rooted in the traditional television sitcom; it has guaranteed longevity for many a series over the years.

In this entry, a pharmaceutical company, M.E.D.I.C., tries to market a new product called *No Pain*, which relieves all forms of physical discomfort. M.E.D.I.C recruits Karura Clinic for testing, but this drug goes against Doctor Saeko's philosophy of "no pain, no gain." She turns down the offer.

Then Saeko becomes leery of M.E.D.I.C. motives after the death of a young Filipino girl in the conglomerate's big-time hospital. She sends Nurse Jun (**Nodoka Kawai**) on a spy mission to find out what really happened. Sure enough, there are ghastly experiments in progress, including chemical testing on humans and the refinement of a drug which can turn people into mindless killing machines. Jun is captured by the officials and held for ransom.

Ransom for what? Well, this *killing machine* drug isn't working out so well. In an unexpected turn of events, it seems the serum was originally developed by Saeko's own father during WW2. Apparently the formula had been tattooed on her breast (who knows how or why, but it's a great excuse for *CC Girl* **Fujimori** to show off her impressive chest; any complaints?). So, M.E.D.I.C. wants the breast-protected data in exchange for Jun's life. Dr Saeko and her amazon nurses respond by attacking the hospital. She discovers that her mother is part of the M.E.D.I.C. organization. The Amazons win the fight, but both her mom and Nurse Jun are killed in the process.

A visually exciting film, another hi-tech brainchild of SciFi director **Mitsunori Hattori** {also see his **Hunting Ash** [1992]}. But, unlike his previous projects, this one benefits from a more likable cast and a very sly, campy script.

AMBITIOUS STUDENT (1991)
[Ohinaru Gakusei]
director: Takashi Koike
Ryo Iwamatsu ♦ Mariko Aso
*

This directorial debut for cinematographer **Takashi Koike** is *SciFi* by definition only simply because this "slice-of-life" story takes place within the parameters of a futuristic society. However, it could've just as easily been set in current-day Japan.

Komori (**Ryo Iwamatsu**) — an illiterate young man with a kindergarten education — attends a funeral of a childhood chum. There he sees intellectual Ueda (**Mariko Aso**) and the two rekindle their prior friendship. Ueda is a quiet, unassuming guy who quickly falls under Komori's survivalist lifestyle. The movie quickly degenerates into a parade of "comic" vignettes designed to convince the audience that it's better to be stupid than conservative.

ANGEL:
MY SONG IS YOUR SONG (1992)
[Angel: Boku No Uta
 Wa Kimi No Uta]
director: Takayoshi Watanabe
Yuji Oda ● Emi Wakui
**

Tatsuo and Kaori (**Yuji Oda** and **Emi Wakui**) have just broken up. Dejected, Tatsuo is walking down the street when he bumps into a beautiful woman who is carrying a bag full of photos. She has pictures of politicians, TV stars, musicians, and other celebrities. Plus she's got lots of *regular people* photos too. In fact, Tatsuo even sees his girlfriend's picture among them. This gives him an uncomfortable feeling because he suddenly realizes the pictures are of people who have recently died. Does this mean his girlfriend will be next?

The beautiful woman turns out to be an angel, perhaps the Japanese rendition of the grim reaper. She tells him that Kaori is scheduled to die in one week on July 7 at 7 PM. But when the angel sees how upset Tatsuo is, she makes a deal with him: if he and Kaori agree to give up all memories of their past life, the girl will be allowed to live.

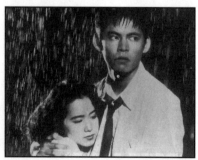

Angel: My Song Is Your Song

He accepts the proposition.

With their memories erased, they don't know each other at all. But seemingly their relationship is part of destiny's plan. A month later, they meet and fall in love. Meanwhile, the angel has been admonished by God for making such a deal in the first place and she's forced to live back on Earth as a human.

If there's a message in all the contrivance, it's completely lost in this overblown motion picture. Director **Watanabe** is such a meticulous craftsman that he makes the entire project seems hopelessly sterile. A heartless production masquerading as a love story. Features the *Elton John* hit **My Song** as the theme.

Angel Dust

ANGEL DUST (1994)
[Enjeru Dasuto]
director: Toshihiro (Sogo) Ishii
Kaho Minami • Takeshi Wakamatsu
**½

Toshihiro Ishii (sometimes called by his nick-name *Sogo* Ishii) began making successful theatrical films while he was still in college {**High School Big Panic** [1978]}. He later got involved in music video production and made a concert/documentary film for the German band *Einsturzende Neubauten* {see **Half Human** [1986]}.

Angel Dust is his first feature film in ten years, since the international success of **Crazy Family** in '84. And despite the serial-killer plot, this is a surprisingly low-keyed production, miles away from **Ishii**'s earlier more exploitive fair {*i.e.*, **Crazy Thunder Road** [1980] and **Burst City** [1981]}. Obviously, the director has aged over the years and his new filmmaking style reflects a less ostentatious flare. But unfortunately, this production could benefit from some of his early editing practices. Segments often drag. They seem even more tedious due to **Ishii**'s new stationary camerawork, a perplexingly out-of-character technique for the filmmaker. The script is also filled with pretentious psycho-babble and the ending is anti-climactic, to say the very least. However, this film remains an enigma. Regardless of the forementioned problems, it truly is haunting. And it does manage to create a real and frightening sense of despair, uncommon in even the best of movies.

The plot has to do with a serial killer who strikes every Monday at 6 o'clock, in the middle of rush hour. This freak, armed with a poison hypodermic, is murdering women on a crowded Tokyo subway train. The police, led by criminal psychologist Setsuko Suma (**Kaho Minami**), try to understand the killer's "mindset" to figure out how to catch him before he strikes again. And again.

ANGEL OF DARKNESS
see **SEX BEAST TEACHER**

ANGEL'S SHARE (1994)
[Tenshi No Wakemae]
director: Toshinari Tsuji
Kaho Minami • Kiminobu Okumura
Tomoroh Taguchi • Renji Ishibashi
**½

Minko and Hiroto (**Kaho Minami** and **Kiminobu Okumura**) are a young couple with far too much social consciousness. These two believe they are angels

put on earth to help people. But every time they perform *God's good works*, something inside them dies. Altruism is taking a toll on their relationship.

The film concentrates on their affable activities one Christmas day. They help a poet who lost his memory, a female novelist suffering the pangs of a failed relationship, a frustrated artist (**Tomoroh Taguchi**) who is ready to take a machine-gun into a crowded subway, and a crazy man (**Renji Ishibashi**) living with the body of his dead wife.

At the end of the day, Minko and Hiroto have changed for the worse. Another sliver, just a fraction, of their *goodness* has disintegrated as they lift the bad karma from the shoulders of their *flock* and allow it to contaminate themselves. One can only guess what will happen if this continues for any length of time. An interesting premise, frighteningly misanthropic while masquerading as the very essence of the Good Samaritan legend.

APOCALYPSE CHRISTMAS (1996)
[Kurisumasu Mokushi-roku]
director: Keoni Waxman
Yuki Amami • Lori Petty
Jason London • Kaoru Hatsuse
**½

In Seattle, on Christmas eve, a terrorist (**Jason London**) informs the authorities that he's prepared to detonate a bomb in a populated Japanese neighborhood. It's all part of a personal genocide program against the Asian race. Meanwhile, there's a female Japanese cop named Yoko Sugimura (**Yuki Amami**) who is in the United States investigating a missing girl case. Her sleuthing uncovers a link between the disappearance of the girl (**Kaoru Hatsuse**) and the mad bomber; apparently she's his girlfriend. Yoko teams up with an FBI agent (**Lori Petty**) to catch the terrorist and save the Nippon

Apocalypse Christmas

population of Seattle. After the usual flurry of chases and close-calls, Yoko succeeds.

The film was financed by the Japanese *Overseas Film Group* and shot entirely on location in Seattle — over a two month period — by American director **Keoni Waxman** {also responsible for *I Shot A Man In Vegas* [1995]}. All dialogue is in English, forcing a release in Japan with subtitles.

Yuki Amami comes to the production with impressive qualifications. She was an honor student at Takarazuka Music Academy, former top star of that academy's prestigious Performing Arts Theater. **Lori Petty**, who plays FBI agent Sara here, is best remembered for her roles in *Free Willy* (1993) and *Tank Girl* (1995). **Jason London** is a former bit player from *To Wong Foo, Thanks For Everything! Julie Newmar* (1995) and *Blood Ties* (1991).

APRIL HORROR (1988)
[Shigatsu Kaidan]
director: Kazuya Konaka
Tomoko Nakajima • Toshiro Yanagiba
**

Science fiction/fantasy based on story written by female manga author **Yumiko Ohshima** benefiting from a quieter approach to the genre, similar to the fantasies of **Ursula K LeGuin**. The major emphasis is on a "joy of living" paradox within this lyrical yarn. Characterization is primary, overshadowing the thinly constructed plot.

April Horror: Toshirou Yanagiba (L)
with Tomoko Nakajima

After an accident, Hatsuko (**Tomoko Nakajima**) believes she is dead. Her soul has left her body and she is wandering about an alternate dimension, refusing to return for fear that she will be cast into the darkness of an afterlife.

Hatsuko's spirit meets the ghost of a young man. He tries to convince her that she's not really dead (apparently her soul is the wrong shade of white) and it's dangerous for her to be roaming around. When she refuses, the ghost takes her under his wing (figuratively, of course) and teaches Hatsuko the art of survival in the netherworld. Predictably, they fall in love, but even the most ardent fan of the Romance Genre will see the inevitable tragic ending long before it materializes.

Ultimately **April Horror** plays like an amalgamation of *Robert Downey Jr*'s fluffy **Heart And Souls** (1993) with the ultra pretentious **Flatliners** (1990). This film is on a collision course with a bright light at the end of a long tunnel.

ATRAGON (1964)
 [Kaitei Gunkan]
 aka UNDERWATER BATTLEBOAT
 aka ATRAGON THE SUPERSUB
director: Ishiro Honda
Tadao Takashima • Yoko Fujiyama
Hiroshi Koizumi • Jun Tazaki
Ken Uehara • Kenji Sahara
**½

Tadao Takashima plays a renegade admiral in charge of Atragon, an elusive atomic supersubmarine. He's a Japanese nationalist who refused to surrender after the Second World War and, ironically, he finds himself to be the only person capable of saving humanity from the underwater kingdom of Mu and their evil queen (**Yoko Fujiyama**).

Rubber monsters take a backseat to the Atlantis tale. There are some impressive creature sequences but their screen time is limited to brief encounters (similar to the giant squid's appearance in *Richard Fletcher*'s **20,000 Leagues Under The Sea** [1954]). Most likely the monsters are included to keep the kids happy in this otherwise decidedly adult story. The real star is the submarine itself, but by today's standards it's really nothing special.

Atragon

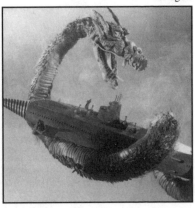

ATROCITY
 see **ALL NIGHT LONG 2**

ATTACK OF THE MONSTERS
 see **GAMERA VS GUIRON**

ATTACK OF THE NEPTUNE MEN
 see **INVASION OF
 THE NEPTUNE MEN**

Attack Of The Mushroom People

ATTACK OF
THE MUSHROOM PEOPLE (1963)
[Mantango]
aka **MATANGO**
aka **FUNGAS OF TERROR**
director: Ishiro Honda
Akira Kubo • Yoshio Tsuchiya
Kenji Sahara • Hiroshi Koizumi
***½

His underlying message may not have been clear in **H-Man** (1958), but this time director **Honda** leaves little doubt of his "anti-drug" stance.

Here six vacationers are shipwrecked on a mysterious island where they are tempted by multicolored mushrooms described as "highly narcotic" by the leader of the group. But it doesn't take long before hungry members of the group begin eating the plants and transform into walking mushrooms. **Akira Kubo** is the only one to resist the temptation (well, maybe not totally), but after being rescued he also transmutes as he tells the authorities about his poor girlfriend and the others who are "still alive but changed."

Of course none of it makes any sense, even in the demented world of horror films. But as a metaphoric fantasy (in the tradition of **Alice In Wonderland** and **Gulliver's Travels**), Ishiro Honda has once again created an atmospheric, dream-like fable far removed from his juvenile mainstream fare like **King Kong Vs Godzilla**, made the same year.

AUGUST IN THE WATER (1995)
[Mizu No Naka No Hachigatsu]
director: Toshihiro (Sogo) Ishii
Reina Komine • Shinsuke Aoki
**

Toshihiro Ishii (a director promoted in the west as *Shogo* **Ishii**) followed his hit, **Angel Dust** (1994), with this psychological SciFi thriller. It tells the story of Izumi (**Reina Komine**), a professional female diver, who almost wins first place at the National Swimming Competition. "Almost" is the keyword in that sentence, because an accident during her last dive sent the girl to the hospital. After drifting between life and death, she miraculously regains consciousness. Izumi is cured, but something in her personality has changed. She becomes obsessively interested in ancient ruins. Soon after being released from the hospital, Izumi is found unconscious at a burial site in the Miko Mountains. Accompanying her, inexplicably, is a wanted felon— a man suspected of stealing a priceless meteor from the Science Institute.

Izumi's boyfriend is worried about her and tries to figure out what she was doing there, in the mountains, with this criminal. He discovers similarities between her behavior and recent news stories about an identical occurrence in India. After piecing together some metaphysical clues, he realizes Izumi has become the reincarnation of a Hindu god sent to Japan to help a community suffering from environmental disasters.

Unfortunately the ending is so extreme, within the rigid confines of **Ishii**'s setup, that it instantly seems absurd. Not quite the reaction he had hoped for. Technically, the film is similar to his post-**Crazy Family** (1984)

productions, purposely slow and low-keyed. It would benefit from tighter editing and a more plausible story.

BAKUFU SLUMP
IN BATTLE HEATER
see **BATTLE HEATER**

BAPTISM (1996)
[Senrei]
director: Kenichi Yoshihara
Rie Imamura ● Risa Akikawa
****½**

Based on horror manga penned by *Kazuo Umezu*, perhaps the best-known thriller author in Japan, this is an excursion into a truly twisted arena. Izumi (**Risa Akikawa**) used to be a famous, big time movie starlet. Now she's old — with a skin disease— hiding away from the public, spending time with no one except her daughter. At first, it seems Izumi is totally dedicated to the little girl. But in reality she is grooming the child for *the* ultimate violation. When daughter Sakura (**Rie Imamura**) turns 13, mom pays an unscrupulous surgeon to conduct a transplant operation, replacing the child's brain with that of her own.

Now, Izumi is living inside the "shell" of her daughter and begins her "new lease on life." She proceeds to seduce her piano teacher, among others. But all is not well. Her estate attor-ney — obviously believing that Izumi is dead — takes advantage of Sakura's underage status and embezzles all the family fortune. So Izumi is left with a new body, but no money. When she develops a cluster of ugly warts on her face, Izumi decides another transplant is in order. She convinces the doctor to put her brain into the body of the attorney's wife. Of course, when Izumi made her decision she had no idea the lawyer kept a mistress and they were planning on killing his wife. . . .

BATTLE GIRL
see **LIVING DEAD**
　　IN TOKYO BAY

BATTLE HEATER (1990)
[Battle Heater: Kotatsu]
aka **BAKUFU SLUMP**
　　in **BATTLE HEATER**
director: Joji Iida
Pappara Kawai ● Sun Plaza Nakano
Akira Emoto ● Yasuko Tomita

Pappara Kawai and **Sun Plaza Nakano** are two leading members of the outrageous Japanese punk band **Bakufu Slump**. They star in this film and that's why in some circles it's known as **Bakufu Slump In Battle Heater**. The movie also features **Akira Emoto**, the founder of the *Tokyo Kandenchi Playhouse* and future lead of **Last Frankenstein** (1992).

A nerdy gnome, Furuike (**Pappara Kawai**), spends his life gathering discarded electrical gadgets from other people's trash. One day he finds an antique *kotatsu* [a portable box heater shaped like a small table] and he takes it home. Inadvertently, Furuike discovers the heater's terrible secret. It's a man-eating *kotatsu*. And it begins a rampage of murder and mayhem in his apartment building. Tongue in cheek terror flick.

Rie Imamura in *Baptism*

BATTLE IN OUTER SPACE (1959)
[Uchu Daisenso]
translation: **Great Space War**
director: **Ishiro Honda**
Ryo Ikebe • **Kyoko Anzai**
Minoru Takada • **Koreya Senda**
Leonard Stanford • **George Whitman**
Harold Conway • **Elise Richter**

The special effects and set designs are quintessential examples of pop art in cinema, an odd combination of the futuristic and the archaic, captured in unnaturally lurid colors. Originally conceived

as a sequel to **Ishiro Honda**'s *Mysterians* (1957), this one far surpasses its predecessor in scope and technique. It features some of **Eiji Tsuburaya**'s best miniature work, especially during the opening segments as the aliens are causing "natural disasters" all over the Earth (*e.g.,* flooding in Venice, burning of New York, and explosions at San Francisco's Golden Gate Bridge).

In retaliation against the unprovoked attack from extraterrestrials, Earth governments stop feuding and join forces against the common foe. They dispatch two space warships to engage in a *Battle In Outer Space*. Initially, the fighting takes place on the moon and then switches to the heavens.

Significantly, this motion picture was the first Nippon production to feature American actors in co-starring roles.[1] However, in this instance, the term *actors* is used loosely. The four western stars (**Leonard Stanford**, **George Whitman** [called **George Whit** in the Japanese credits], **Harold Conway** and **Elise Richter**) are virtually unknown except for this film. Perhaps **Stanford**

and **Whitman** were lucky tourists tapped by **Toho** for their 15 minutes of fame. On the other hand, **Harold Conway** had a brief role in Honda's *Mysterians* two years earlier. And **Elise Richter** found herself in a sleazy women-in-prison film, *White Skin, Yellow Detention (Shiroi Hada To Kiiroi Taicho)* for director **Manao Horiuchi** in 1961.

[1]Prior to this film, American studios would purchase international rights to the film and insert footage of Anglo performers in an attempt to make it more *marketable* (**Raymond Burr**'s non-performance in **Godzilla** being the most notorious example of this practice).

▶ **BEAST CITY** (1995)
[Maju Toshi 9-1]
director: **Shinsuke Inoue**
Mickey Curtis • **Kumi Shiraishi**
Ayane Miura • **Saori Taira**
Yuta Mochizuki • **Rie Hida**

❖

▶ **BEAST CITY 2** (1996)
[Maju Toshi 9-1 II]
director: **Shuji Goto**
Miho Suzuki • **Mickey Curtis**
Mari Nishina • **Miho Nomoto**
**1/2

Mickey Curtis is a werewolf, the divine leader of the Kemono Family. In ancient Japan he is challenged by his rivals, the Ijuin family of female ninjas. Even though the girls succeed in defeating the Death Wolf, the battle is predestined for a rematch in a future lifetime. Mickey and his dark forces materialize in contemporary Tokyo, taking control of the yakuza. They bring the city to its knees. Three perky female ninjas come to the rescue. Lots of computer morphing and low-budget special effects punctuate the campy black humor script. **Mickey Curtis**, fresh from his award-winning supporting role in *Shunji Iwai*'s **Swallowtail Butterfly**, adds an air of dignity to the festivities.

Kumi Shiraishi (L) and Micky Curtis (center) in *Beast City [Nine One]*

The particulars: Mari (**Kumi Shira-ishi**) is a 24 year old office worker living in contemporary Tokyo, completely oblivious to her ninja roots. One evening she and her boyfriend are attacked by a werewolf. Her lover is killed in the assault, but a journalist named Kurozume (**Yuta Mochizuki**) rescues Mari. The next day, Priestess Keiko (**Ayane Miura**) visits her, and arranges a meeting between Mari and two other girls, model Michiyo (**Saori Taira**) and high school student Hiromi (**Rie Hida**). Seemingly, they are each descendants of ancient gang of Female Ninjas. And they have a solemn, *pre-destined* responsibility to band together and eliminate the deadly Demon Wolfman. After Priestess Keiko gets killed by the werewolf, the girls retaliate.

As *#2* opens, the three Ninja Sisters have left their crime-fighting gig. The oldest girl is now working as a masseuse, her sister is a secretary and the youngest still goes to high school.

But when they hear the news about a dead yakuza boss and the graveyard disturbance, they realize there's trouble a'brewing. So they put the costumes back on. Unfortunately, the girls have lost their magical powers — only temporarily, thank God. They can reactivate the ninja magic by having sex with a "strong partner." So, off they go in search of macho men. Meanwhile, the Demon Wolfman Mickey attacks the youngest female ninja, rapes her and tears out her reproductive organs. He plans on using her womb in a Hell Sacrifice to achieve his own immortality. The other two female ninjas are quick to attack the Werewolf for killing their sister. The film ends with everybody dead... but wait, following the credits there's a closeup of Mickey's face and a fleeting shot as his eyes snap open. Obviously, another sequel can't be far away.

As one might expect, the first episode is the best. It has the highest production

values, adequately orchestrated by director **Shinsuke Inoue** son of legendary filmmaker **Akira Inoue**, and benefits from a particular strong cast. Besides **Mickey Curtis**, it also features experienced performers from two different cult hits, *Weather Girl* and *Ring*. Sadly, these ninja girls were replaced by some terrible actresses for **#2**, girls incapable of grasping the nuances of camp humor. There's also an unforgivable problem with the sequel: the ninja stunt-doubles are guys! Brief shots of stuntmen-in-drag spark some unintentional laughs. However, on the plus side, there are lots of cheap thrills and a heavier emphasis on sex and nudity from hack director **Shuji Goto**. Plus **Mickey Curtis** stars in both.

Initially **Mickey Curtis** exploded on the Japanese entertainment scene as a rockabilly singer in the mid 50s, the Nippon Elvis. He then starred in a number of classy films, including **Kon Ichikawa**'s anti-war drama *Fire On The Plains* (1959). In the 60s, Curtis journeyed to the United States where he formed a rock band called *Samurai*. After moderate success he returned to Japan to concentrated on his acting. Today **Curtis** is a Japanese icon.

BEAST TEACHER
see **SEX BEAST TEACHER**

BED OF VIOLENT DESIRES (1967)
[Boyoku No Shikibuton]
director: **Yuzuru Watanabe**
Naomi Tani • **Kiyoshi Kinami**
Yasuko Matsui • **Joji Nagaoka**
**

Hanako (**Yasuko Matsui**) and lover Yamaguchi (**Joji Nagaoka**) decide to kill her wealthy husband. But after they commit the crime and manage convince the police that it was just an accident, daughter Shinko (**Naomi Tani**) plots a gruesome revenge against the two.

Another early sex thriller from **Koei**, a studio which specialized in sleazy fare before **Nikkatsu** made it fashionable in the '70s. Speaking of *Nikkatsu*, actress **Naomi Tani** went on to become their biggest starlet in truckloads of S&M productions over a ten year period (*i.e.*, **Fairy In A Cage** [1982], **Wife To Be Sacrificed** [1974], **Painful Bliss! Final Twist** [1978], *et al*).

BEE FIGHTERS
see **HARD HELMETS**

BEYOND THE GREAT PYRAMID: LEGEND OF THE WHITE LION (1988)
[Piramiddo No Kanata Ni: White Lion Densetsu]
director: **Koichi Nakajima**
Ann Marie McEvoy • **Tracy B Swope**
and **Edwin Mahinda**
**

Maria (**Ann Marie McEvory**, best known for her role in *Children Of The Corn* [1984]) goes into the African jungles in search for her lost mother (**Tracy Brooks Swope**, former **John V Avildsen** alumnus, *i.e.* **Happy New Year** [1987]). The young girl is joined in the safari by guide Moja who leads her into one cliff-hanging adventure after another, including a brush with some perturbed headhunters. But the whole affair culminates with a happy ending, as mom and daughter are reunited and manage to smuggle a rare white lion cub out of Africa, seemingly a perk for all their troubles.

There's nothing very remarkable about this movie. And there's nothing very *Japanese* about it. The cast is Anglo and the film was shot in English (released theatrically in Japan with subtitles). The director, producer and crew are Japanese, but there's little in the production, style or technique which would indicate that. The movie is simi-

lar to many other *Jungle Hell* features produced by Hollywood in the '40s/'50s, and by Italy in the '60s/'70s. No better, no worse.

BIG MONSTER WAR (1968)
[Yokai Daisenso]
aka **BIG GHOST WAR**
director: Yoshiyuki Kuroda
Yoshihiko Aoyama • Akane Kawasaki
Osamu Okawa • Tomoo Uchida

One day the benevolent ruler of Izu is fishing when the Babalonian hell-god, Daimon, flies in and takes possession of him. Two "good" lake ghosts, Kappa and Oil-Licker, try to stop the evil Daimon but they are soundly defeated. Aided by a young soldier (**Yoshihiko Aoyama**), they recruit an army of monsters from all over the countryside to join in battle against Daimon. Eventually they are victorious.

This was an obvious attempt by **Daiei Studios** to compete head-to-head with **Toho** in the *kaiju eiga* market. Since they didn't have a stable of rubber-monsters (*i.e.*, as paraded by Toho in **Destroy All Monsters** [1968]), **Monster Zero** [1965], *et al*), Daiei used special effects wizard **Yoshiyuki Kuroda** and the creatures he developed for the hit **Hundred Monsters** (1968). Popular goblins *Umbrella Man*, *Faceless* and *Long-Neck* are all back for another go-around, joined by a platoon of newly designed monsters. And it's no accident that evil Daimon closely resembles the stone monster *Majin* {afterall **Kuroda** was the special effects director for the **Majin** series}. **Daiei** produced another, less effective, creature bonanza called **Tokaido Road Monsters** (1969) And, of course, the studio continued pounding away at **Toho**'s foundation with their giant turtle, **Gamera**. In 1968, he was busy fighting a squid monster named Viras.

Tetta Sugimoto in *Biriken*

BIRIKEN (1996)
[Biriken]
director: Junji Sakamoto
Tetta Sugimoto • Tomoko Yamaguchi
**½

Biriken is a lesser good-luck god, honored with a statue and shrine in Osaka. When the neighborhood prays to him for help, Biriken comes to life and begins roaming the streets looking for opportunities for good deeds. Biriken's goal is to satisfy as many people as possible, making their every dream come true. Soon this ambitious god becomes completely exhausted and can no longer continue his miraculous pilgrimage. As a result, the people to loose faith in Biriken and they sell his statue to a pawn shop. This causes him to lose his supernatural powers completely. But then, when Biriken helps the community fight against a Yakuza gang, the people rally to support him and rebuy his statue, putting it back in the shrine. Birikin forfeits his human form and returns to heaven. *All's well that ends well.* Basically this is a slice-of-life tale, set in the poorer Shinsekai section of the Osaka, colorful in its zest for life and simplistic charm. This is a rare glimpse at the "real people of Japan" and their attitude toward religion. Many

critics also cited this film as **Tetta Sugimoto**'s *finest hour*; his rendition of the god Biriken won a number of Best Actor awards for him in 1996.

BIRTH OF JAPAN (1959)
[Nihon Tanjo]
director: Hiroshi Inagaki
Toshiro Mifune ● Setsuko Hara
Yoko Tsukasa ● Kyoko Kagawa

The ancestors of the emperor are the divine beings who created the Japanese island in this "biblical" fantasy. It essentially consists of tales about the legendary Japanese gods and goddesses, a film stylistically similar to the Italian-made mythological epics of the '50s and '60s. For example, sun goddess Amaterasu (**Yoko Tsukasa**) goes into hiding after being insulted by her brother. She encloses herself inside a cave causing perpetual darkness to fall all over Japan. After she's chased out of the cave by a giant hydra, daylight returns to the country. Fun in a *Seventh Voyage of Sinbad* sort of way, but overly long at 180 minutes.

BITE IT RIGHT (1995)
[Bite-It-Right]
director: Miyuki Sakaiya
cast: unlisted / unknown
☐ *pick your own rating*
Shot in Vienna Austria by **Miyuki Sakaiya**, a female Japanese director active in European television production. This four-minute movie is registered as a feature film with the Nippon Film Association because it was released theatrically in Japan, co-billed with *Jeff Gillen*'s Deranged[1] upon that movie's re-release in 1995.

One foggy day, a handsome Dracula is looking for a female victim. When the bloodsucker stumbles upon a beauty, he opens his mouth to give her the *bite of love*, and reveals that he's wearing tiny condoms on his fangs. The director has promised to expand on this concept. But aside from the obvious *safe-sex* gag, there seems to be nowhere to go.

[1]**Deranged** is a 1974 American-made horror film based on the life of psycho-killer Ed Gein.

▶ **BLACK JACK** (1995)
[Black Jack]
director: Kazuya Konaka
Daisuke Ryu ● Teruyuki Kagawa

❖
▶ **BLACK JACK 2** (1996)
[Black Jack 2)
director: Kazuya Konaka
Daisuke Ryu ● Honami Tajima

❖
▶ **BLACK JACK 3** (1996)
[Black Jack 3]
director: Kazuya Konaka
Daisuke Ryu ● Masao Kusakari
 and Honami Tajima
**½
In 1977, cult director **Nobunhiko "Obi" Ohbayuashi** made a film based on the multi-volume *Black Jack* gekiga, penned by the god of manga writers *Osamu Tezuka*. It was called **Stranger In Her Eyes** {see separate listing}. Now eighteen years later, new-wave director **Kazuya Konaka** (of *Lady Poison* fame) reacquaints Dr Black Jack to Japanese audiences. This time, frayed **Daisuke Ryu** plays the notorious blackmarket surgeon who takes on projects that the reputable medics won't touch. In episodes *#2* and *#3*, he's joined by a little girl assistant, Pinoko[1] (**Honami Tajima**). And in *#3*, he meets his arch-rival, Dr Kiriko (**Masao Kusakari**, best remembered as the warrior prince in *Masahiro Shinoda*'s fantasy **Himikio** [1974]).

#1 begins with *Dr Jack*'s fall from grace, as he is scolded by the medical society for conducting "ghastly experi-

Daisuke Ryu is *Black Jack*

ments against humanity" after reviving a flatlined youngster. He loses his license but not his medical expertise. This genius surgeon begins a career of helping unfortunate outcasts who have given up on life, people who need "forbidden" medical assistance.

#2 is the most ambitious of these first three episodes, benefiting from an impressive cast which includes **Hiroshi Fujioka** (best known as the original *Kamen Rider*) and filmmaker **Seijun Suzuki**. Little girl, Pinoko, is "born" and she becomes Black Jack's inseparable assistant for his crusade.

The third installment was filmed in Thailand where Black Jack and Pinoko are summoned by a terminally ill patient. Soon, they discover the petition is actually a trap set by arch villain Kiriko, another expelled doctor — a wicked man who has affiliated himself with the underworld and blackmarket crimes.

All three entries were written by **Izo Hashimoto**, the head scripter for *Sukeban Deka* and director of **Evil Dead Trap 2**. Actor **Daisuke Ryu** fits snugly into the role of Dr Black Jack, fairing much better than he has in the past with such embarrassingly awful films as *Shinobu Hashimoto*'s **Lake Of Illusions** (1982) {see separate listing}.

[1]Pinoko is a mysterious character who may or may not be a normal little girl adopted by Dr Jack; there is also evidence indicating that she was created by him, like a Frankenstein monster, from bits and pieces of other children.

BLACK LIZARD (1962)
[Kurotokage]
director: Umeji Inoue
Minoru Ooki • Machiko Kyo
*½

The *Black Lizard* tale was produced twice within six years — with decidedly varying results. The plot for both movies is essentially the same, based on a book by *Edogawa Rampo,* telling the story of a ruthless female gangster as she attempts to steal the precious Star Of Egypt diamond and kidnap the daughter of a wealthy jeweler in the process. Black Lizard is eventually foiled by master sleuth Kogoro Akechi who also falls in love with her.

As a suspense tale, this particular entry directed by the innocuous **Umeji Inoue** loses its momentum due to an exorbitant amount of time spent on the relationship between Detective Akechi and Black Lizard. This film's failure is further punctuated by a sluggish performance from veteran **Machiko Kyo** (internationally known for her stellar role in *Akira Kurosawa*'s **Rashomon** [1950]). But, seemingly, director **Inoue** realized his romantic story was not catching fire; he tried to compensate by bloating the soundtrack with *inspiring* overly-produced music. However, he only succeeded in trivializing the entire production.

In 1968, director **Kinji Fukasaku** took these same grandiloquent elements and delivered his version of *Black Lizard*. He produced it as a campy ultra-hip *objet d'art*, even casting transvestite **Akihiro Maruyama** as the supreme villainess.

BLACK LIZARD (1968)
[Kurotokage]
director: Kinji Fukasaku
Akihiro Maruyama • Isao Kimura
Junya Usami • Yukio Mishima

Delicious. Is there a better way to describe this film? Divinely delicious.

Renowned transvestite **Akihiro Maruyama** is *Black Lizard*, the brilliant female boss to a gang of criminals. She has planned a double-pronged caper: the theft of the 1.2 million dollar diamond Star of Egypt; and the kidnapping of the jeweler's pretty daughter Sanae (**Junya Usami**). But Black Lizard is foiled at every turn by Kogoro Akechi (**Isao Kimura**), an equally brilliant private detective.[1] As adversaries, the two match wits. But soon they become infatuated with the cleverness of one another, and they fall in love.

Black Lizard and her gang eventually pull off the crime. She secures the diamond and captures the girl, taking them both to her island hideaway. In the basement of the mansion, Black Lizard gives Sanae a tour of her *doll* museum, a collection of "beautiful people" she has killed and stuffed. Of course, Sanae is next on the list. Fortunately, detective Akechi shows up in the nick of time and rescues the girl. But not before Black Lizard is killed in a melee

by a bug-eyed zombie. "A true jewel has been taken by death," laments Akechi as the closing credits insist it's The End.

Stylishly bizarre. Exquisitely perverse. Pop-art chic from one of the country's most popular directors, **Kinji Fukasaku** (**Virus** [1980], **Professional Killers** series, **Ghost Story Of Yotsuya: Chushingura Version** [1994] *et al*). Based on a story by Japan's #1 horror novelist **Edogawa Rampo** (a Japanization for Edgar Allan Poe, *read his name out loud*). Adapted for the screen by homosexual exponent/activist **Yukio Mishima**, who tailored the script specifically for its transvestite star and who also agreed to a cameo role as a "doll." The original Japanese version is 93 minutes; many American prints, edited for violence and sex, run 81 minutes.

[1]Detective Kogoro Akechi is a reoccurring *Sherlock Holmes* type-of-character by novelist **Edogawa Rampo**; often described as the writer's alterego, Akechi even makes an appearance in **Rampo** *[Mystery Of Rampo]* (1994), a docu-drama of Edogawa Rampo's life. He is best known for the series **Boy's Detective Team** (1954-1959).

Black Magic War

BLACK MAGIC WARS (1983)
[Iga Ninpou Cho]
aka **IGA MAGIC STORY**
aka **NINJA WAR** (USA title)
director: Mitsumasa Sato
Hiroyuki (Henry) Sanada • Jun Miho
Sonny Chiba • Akira Nakao
Mikio Narita • Noriko Watanabe
**½

Here's another big budget ninja fanta-
sy/action movie (on the heels of the
highly successful **Darkside Reborn**)
from director **Sato** filled with extrava-
gant deceptions and sinister double
crossings, all in the name of power and
romance. The dastardly villain Lord
Donjo (**Akira Nakao**) makes a pact with
a sinister magician named Kashin Koji
(**Mikio Narita**). The lord hopes to usurp
the throne by marrying pretty Kakaribi
(**Noriko Watanabe**), a direct descendant
of the Shoganate. However, her
boyfriend, an energetic warrior named
Jotaro (**Hiroyuki Sanada**), responds
with a vengeance when Koji's ninjas
kidnap his woman. Martial arts favorite
Sonny Chiba plays a righteous ninja
who realizes that he's working for the
wrong guy, and joins Jotaro in the
assault against his former employer.

Black Magic Wars
Hiroyuki Sanada & Noriko Watanabe

The story, especially the edited and
poorly-dubbed American version, is
convoluted to the point of being incom-
prehensible in places. But the multi-mil-
lion dollar budget allows for some sur-
prisingly good special effects especially
in the blood-letting department. The
scenes of decapitation and head trans-
plants are very well done, adding a hor-
rific quality to the production.

Jun Miho plays the villainess *Lady
Hellfire* with complete abandonment
and steals the show, reminiscent of her
days with the **Nikkatsu**'s *Roman
Porno* films (*i.e.,* **Pink Curtain** {see
*Japanese Cinema Encyclopedia: Sex
Films*}). Hiroyuki (Henry) Sanada is
the heart-throb who always draws
younger audiences to the theater. The
weakest link of the film is his female
co-star **Noriko Watanabe**. This was
her debut role after winning a country-
wide talent contest. Perhaps it was a
bad decision to cast her in such a piv-
otal role, especially when the part
demanded that she play three charac-
ters. Her lackluster performance(s)
severely tarnishes the film.

BLACK ROSE (1969)
[Kurobara No Yakata]
aka **Black Rose Mansion**
director: Kinji Fukasaku
Akihiro Maruyama • Eitaro Ozawa
Masakazu Tamura • Kikko Matsuoka
**½

After the tremendous success of
Fukasaku's *Black Lizard* (1968),
Shochiku Studios quickly hired the
director to recreate the magic. Once
again, transvestite **Akihiro Maruyama**
returns to the screen as a strong-willed,
mysterious beauty. But this time his/her
character is not nearly as interesting,
nor as cleverly drawn. In **Black
Lizard**, she soars because of her
provocative relationship with an equally
intelligent rival, the super detective

Kogoro Akechi. But here, her charms are squelched by an awkward relationship with a thickwitted gangster.

After a bankjob is horribly botched, a lower-level yakuza goes on the lam to outrun a death contract issued against him. He takes refuge inside an old *haunted* mansion. There, he meets Madam Black Rose and the two fall in love. There were no more *sequels.*

BLADE OF OEDIPUS (1986)
[Oedipus No Yaiba]
director: Toichiro Narushima
Masato Furoya • Masaki Kyomoto

A lightweight romantic mystery taking place at a traditional family gathering in Shimonoseki. Husband Masato, a man obsessed with sword collecting, is both delighted and perplexed when the legendary Greek sword of Oedipus Rex suddenly turns up on his doorstep. However, the weapon appears to have cast an eerie spell on everyone at the party; at first, there's an erotic edge to the proceedings, but then things turn decidedly ugly. It's not a bad movie, but it would be more suitable as an episode of *Tales From The Crypt.*

BLIND BEAST (1969)
[Moju]
director: Yasuzo Masumura
Eiji Funakoshi • Mako Midori

It's a long trek from **Gamera** (1966) to this film, but actor **Eiji Funakoshi** made the journey. He is convincing as Michio, a blind sculptor, who kidnaps a young girl and eventually turns her into the perfect statue.

Mako Midori is Aki, the unlucky model chosen to be inspiration for Michio's greatest *objet d'art.* She is captured and dumped into his work room, a virtual maze of sculptured body parts. In a standard plot twist, popular-

Eiji Funakoshi (R) and Mako Midori in *Blind Beast*

ized by **William Wyler** for his film **The Collector** (1965), the captured girl soon begins to identify with the mad artist. They discuss politics, religion, and the Arts. She is in awe of him and gladly accepts her role as his slave. They begin S&M games. Biting. Whipping. Domination. She agrees to be more than the "motivation behind the art," but to become the sculpture itself. The blind craftsman, with butcher knife and mallet in hand, accepts the girl's decision and promptly dismembers her. He then kills himself.

Despite the outrageous plot from a book by **Edogawa Rampo**, the film is elegantly produced. As seen in his earlier movies **Tattoo** and **Red Angel** (both 1966), director **Yasuzo Masumura** is more interested in developing characters and exploring ideas than delivering a gore festival. Even the limb-severing is handled with restraint, not a drop of blood is shown. But the underlining tone of the film paved the way for the many S&M features that followed in the mainstream cinema.

BLIND WOMAN'S CURSE (1970)
[Kaidan Nobori Ryu]
translation: Horror Ascending Dragon
aka TATTOOED SWORDSWOMAN
director: Teruo Ishii
Meiko Kaji • Hoki Tokuda
Makoto Sato • Yoko Takagi
****½**

Director **Ishii** makes horror films with a certain ambivalence, almost a distaste for the genre. Yet when he directs straight-out exploitation fare (*e.g.,* his **Joys Of Torture** and **Decadent Edo** series), he includes generous portions of horrific terror. Oddly, these moments are more effective than anything in his actual *horror* films.

Critics have suggested that **Teruo Ishii** is Japan's premiere filmmaking renegade. He was one of the first notable directors to dedicate time and ability to a budding sex-n-sadism market. Seemingly, he enjoyed the freedom represented by the *adult film* arena. And Ishii's best efforts bloomed from his work in these non-restrictive genres, rather than in the well defined structure of the horror film.

Simply, this is a horror film that wants to be something else. The *ghost/curse* elements are confusing at best. For example, Akemi Tachibana's fear of cats (a central theme of the film) is never quite explained, only that it has to do with a cat drinking the blood of her injured opponent and "the animal always attacking" her face while she dreams.

The real story **Ishii** is interested in telling deals with a tattooed swordswoman who becomes hopelessly paranoid (cursed?) after she kills the Aozora Yakuza boss and accidentally blinds his daughter. This plot allows the director to incorporate many excessive scenes of sex and bloodshed (*i.e.,* a demented hunchback who skins women for their tattoos).

In actuality, this film is a supernatural variation of *Ishii*'s **Ascending Dragon: Gambler's Skin** [Nobori Ryu Tekka Hada] from the previous year, which also starred **Meiko Kaji** as the vengeful swordswoman with the rising dragon tattoo.

BLOOD AND ECSTACY (1995)
[Chi To Ekusutasi]
director: Hitoshi Ishikawa
Mamiko Aso • Yuzo Takeda

Excessive. But wildly entertaining.

A young investment banker has been sliced-up and fatally stabbed, his nude body "crucified" on the bedroom wall. He appears to be the victim of a *gyaku-rape* (counter rape) and everything points to his girlfriend. At least, that's how the investigating detectives see it. They visit Niomi (**Mamiko Aso**), a brazen woman who flatly denies any knowledge of the crime. Detective Hideo (**Yuzo Takeda**) isn't convinced; he stakes her out. Before long, his cover is blown and Hideo finds himself sharing the bed with Niomi. It's a bit uncomfortable because he's tied up and she's a bit rough, but ultimately the detective becomes obsessed with her bizarre behavior.

She completely dominates him, bondage and strange sex games are merely the appetizer in this sadistic relationship. The bigger question remains, is this woman a murderer? Hideo discovers the answer too late. She's a genuine serial-killing freak who lives for the orgasm she gets while stabbing her partner to death.

Director **Ishikawa** started in the business as a member of the trio who made movies under the pseudonym *Go Ijuin* {see **Captured For Sex 2**}.

BLOODSHED (1971)
[Shura]
director: Toshio Matsumoto
Kazuo Nakamura • Yasuko Sanjo
Juro Kara • Masao Imafuku
***½
Funeral Procession Of Roses (1969) is a hard act to follow {see separate review}. But director **Matsumoto** gives

it his best shot and delivers another controversial cult movie, years ahead of it's time.

This is a movie based on one of the least popular Kabuki plays written by **Nanboku Tsuruya**. It tells the story of a samurai forced to raise money through violent means when he vows to avenge his evil lord. For this one, **Matsumoto** takes the tale at face value, vividly reconstructing the atrocities suggested in the original play. {**Roman Polanski** directed a similar project, also in 1971, with his violent rendition of *Shakespeare*'s **MacBeth**}. **Matsumoto** uses stop-motion animation, innovative camerawork, and some highly creative editing techniques to deliver a film that manages to look *fresh* and *new* today. However, the conclusion which graphically depicts the killing of an infant, is excessive even by liberal Japanese standards. The movie was officially banned in the UK and Australia. It never showed commercially in America.

BLOODSUCKING MOTH
see **KINDAICHI** series

BLOODTHIRSTY Trilogy (1970-1975)
[Chi O Suu] Toho's Vampire series

Two of the three films in this series (#2 and #3) were released theatrically in the United States, redubbed and promoted as *Dracula* films to the drive-in circuit.

▶ **BLOOD THIRSTY DOLL** (1970)
[Chi O Suu Ningyo]
aka **NIGHT OF THE VAMPIRE**
director: **Michio Yamamoto**
Kayo Matsuo • Akira Nakao
Yukiko Kobayashi • Yoko Minakaze
**

A concerned woman named Keiko (**Kayo Matsuo**) is searching for her missing brother. The investigation takes her to his fiancee's home, a mysterious mansion where Keiko learns that her brother is dead and girlfriend Yuko (**Yukiko Kobayashi**) has left. But she is suspicious. Keiko and her boyfriend decide to stay the night.

It's a typical night cloned from every other cliched horror film, filled with strange noises, dimwitted servants, creaky stairs, a mysterious doctor, howling wind, and — girlfriend Yuko wandering in the garden. She's a vampire, the victim of an odd survival pact between her mother and the devil. Through the magic of flashback, her sad story is revealed. But Yuko is still a killer who slaughtered Keiko's brother and when she attempts to chow down on Keiko's boyfriend, the bloodsucker is destroyed by the ghost of her father.

Humdrum camerawork by **Kazutami Hara**; lifeless direction by **Michio Yamamoto**. Obviously inspired by Western horror mythology, but the soul is missing.

❖

▶ **BLOOD THIRSTY EYES** (1971)
[Chi O Suu Me]
aka **LAKE OF DRACULA**
director: **Michio Yamamoto**
Shin Kishida • Midori Fujita
Osahide Takahashi • Sanae Emi
***½

The second film in **Toho**'s vampire trilogy fares much better than the other two. Veteran cinematographer **Rokuro Nishigaki**'s unique sense of design and symmetry elevate this movie beyond the derivative storyline. The opening sequence — an angry expansive ocean contrasted against the red sky — paints an eerie, yet melancholy, tone which succeeds in establishing its inconsistent psychology. In fact, **Nishigaki**'s camerawork is so good, one wonders why director **Yamamoto** went back to **Kazutami Hara**'s lazy eye for the third entry, **Blood Thirsty Rose**, in 1975.

A coffin arrives by truck and is dropped off at a country station. Soon

various locals are acting peculiarly, and
vampirism is suspected. Meanwhile,
Akiko (**Midori Fujita**) is having recurrent dreams of a childhood incident
involving an old castle with a vampire
living inside. She discovers the castle
isn't far from her own house, and she
goes to investigate (a similar theme was
used by French director **Jean Rollin** for
his *Lips of Blood [Levres De Sang]* in
1975).

The ending [the vampire impales himself on a wooden post after falling from
a balcony] has been criticized for its
close resemblance to **Terence Fisher**'s
conclusion in **Horror of Dracula** (1958).
But the entire structure of the feature so
closely resembles a **Hammer** film that it
more accurately should be considered
an *homage*.

When this film was dubbed for the
American market, the vampire's name
was changed to Dracula for obvious
commercial reasons. The running time
was trimmed by three minutes, eliminating most of the bloodsucker's
impalement scene and his subsequent
meltdown.

❖

▶ BLOOD THIRSTY ROSE (1975)
[Chi O Suu Bara]
aka **EVIL OF DRACULA**
director: Michio Yamamoto
Toshio Kurosawa • Mariko Mochizuki
Shin Kishida • Kunie Tanaka
*½

Yamamoto's previous **Blood Thirsty
Eyes** may have been an homage to
Hammer films, but **Blood Thirsty Rose**
is just a ripoff. **Lust For A Vampire**
(1970) is the all-too-obvious source
material for the final installment in
Toho's Vampire Trilogy.

The principal of a rural girls-school
and his wife are descendants in a long
line of vampires. The school is their
hunting ground. However they aren't
gluttonous bloodsuckers; but rather,

Michio Yamamoto's *Bloodthirsty Rose*

they are careful to only consume one or
two girls a year. Yet things get uncomfortable when a new teacher arrives and
becomes suspicious of their behavior.

Besides lackluster cinematography by
Kazutami Hara (also responsible for the
flat look of **#1**), this one also suffers
from a horrendous script by **Ei Ogawa**.
In an embarrassing flashback sequence
recounting the "birth" of the vampire
elder, it is alleged that granddaddy was
originally a Christian priest forced to
choose between divinity and cannibalism after being shipwrecked.
Obviously, he chose the latter, thus
turning into a vampire.

**BLOOD FRAGMENTS ON
A WHITE WALL** (1989)
[Shiroi Kabe No Kekkon]
aka **LUCKY STAR DIAMOND**
aka **LSD**
director: Izo Hashimoto
Naoko Amihama • Shiro Sano
and Reiko Nakamura
** *(or *** for the gorehounds)*
Poor Yoko (**Naoko Amihama**). She
woke up to find herself locked in a hospital room. And terrible things are happening to her. She's bleeding from the
vagina. In fact, something looking a lot
like intestines just plopped out. Then
she was raped by her doctor who followed with some unorthodox brain
surgery. While recuperating the nurse
tried to seduce her, but then was
stabbed and mutilated for her efforts.

The doctor, wearing nothing but a large cardboard box, is crawling through the blood and gore, attacking poor Yoko with a butcher knife. She loses a portion of her skull in the fracas and brain matter is spilling everywhere.

What the hell? Is any of this really happening. Or what? The film concludes with a grim disclaimer: "Yoko Shirako died at a private clinic in Shinjuku from self-inflicted knife wounds during treatment for drug abuse." A brilliant conclusion to an over-the-top gory mess, from the future director of **Evil Dead Trap 2** (1991) **Izo Hashimoto**. After watching this, it's easy to see his thought process for the ultra-bloody denouement of that entry. **Hashimoto** was the head writer for the **Sukeban Deka** TV series (1983-88) and spin-off theatrical pics. He also penned the animated hit **Akira** (1988).

Actor **Shiro Sano**, who plays the doctor here, also stars in the **Evil Dead Trap** series and a variety of other films including **Lady Battle Cop** (1991); and **Reiko Nakamura** is a **Nikkatsu** *pinku eiga* starlet, seen in such movies as **Banned: Woman's Secret Pictures** [1983] and **Zoom Up: Graduating Photos** [1984]).

BLUE CHRISTMAS (1978)
[Blue Christmas]
director: Kihachi Okamoto
Hiroshi Katsuno • **Keiko Takeshita**
Tatsuya Nakadai • **Eiji Okada**
* or ***

The advertising campaign insists: *"It's the Era of Horror and Love"* (whatever that means). But judging from this entry, it's really the era of cheaply-made political science fiction thrillers.

Throughout the world, people are seeing UFOs. However, this empyrean experience contaminates their body, turning their blood from red to blue. Ostensibly, this metamorphosis has a calming effect on the brain which causes a person to become non-aggressive. For some reason, the world government sees this as a negative situation, rationalizing that people without nationalistic hostilities are bad citizens. And so, an organization known as the *World Elimination Force* is formed. Their mis-

Blue Christmas with Hiroshi Katsuno (L) and Keiko Tateshita

sion is to round up the mutants and exterminate them. Oki (**Hiroshi Katsuno**) is a jingoistic agent for *WEF*, but he changes his hawkish philosophy when girlfriend **Keiko Tateshita** sees a saucer. They try to escape the political net in this *1984/Logan's Run* hybrid.

There are so many obvious similarities between this film and **X-Files** that one can't help but wonder if it's merely a coincidence. But the movie never addresses the real problem, that is, the premise of governments being potentially scarier than any threat from UFOs. In actuality, the whole thing is an updated version of **Time Of Madness**, an earlier Okamoto film lensed in 1967.

Interestingly, the budget for director Okamoto's SciFi projects never seems to equal that of his *chambara* films (*e.g.*, **Samurai** [1965], **Red Lion** [1969], **Zatoichi meets Yojimbo** [1970], *et al*). Even though his peers do incredible things with special effects (*Kinji Fukasaku*'s extravagant **Message From Space** made the same year, for example), Okamoto is forced to use bargain basement FX (*i.e.*, blue lights instead of UFOs). As a result, his SciFi films are never taken seriously by the critics or audiences.

BODY HAMMER
 see **TETSUO 2**

BODY POISON
 see **LADY POISON**

BODYSNATCHER FROM HELL
 see **GOKE**

THE BOTTOM
 OF THE SWAMP (1995)
 [Numa Nite]
director: Makoto Tezuka
Kumiko Tanaka • Harue Miyamoto
 and Shigenori Kanbayashi
**

This Japanese interpretation of an obscure European folk tale looses a great deal in the transformation. Originally part of the *Grimm Fairy Tale* collection, this story now plays more like *Akira Kurosawa*'s **Lower Depths** (1957).

Danielle and Miranda are sisters who live on the bottom of a swamp. Danielle (**Harue Miyamoto**) is ultra religious and − perhaps not-so-coincidently − mentally handicapped. On the other hand, Miranda (**Kumiko Tanaka**) is outgoing, even hedonistic. Handsome Jorjo (**Shigenori Kan-bayashi**) shares the cavern with the two girls. He's in love with both of them, but initially prefers Miranda because of her breezy disposition. However, soon, Danielle's darkly brooding personality begins to affect Jorjo and he starts thinking she's the one of his dreams. Jorjo tells her so and admits that he would like to make love with her. Danielle reacts with rattle-brained confusion, eventually praying to God for an answer. God replies by saying if she consummates their love, she will lose her sister. If she doesn't accept his love, the three of them can live happily together. So Danielle obviously decides not to play hide the sausage. Then, in a state of depression, she commits suicide. Miranda grieves over the death of her sister. She prays to God for advice. God tells Miranda that if she or Jorjo commits suicide, then Danielle would come back to life. Miranda agrees to kill herself. Jorjo is scared and he tries to run away, slipping and falling to his death. His *suicide* allows Danielle to return from the dead. The two sisters live happily ever-after at the bottom of the swamp.

There's so much wrong with this film that the lush photography can't save it. The performances are uneven, often laughable in their exaggeration (especially when "Danielle" goes into her

witless religious trances). The biggest problem, however, lies in director **Tezuka**'s inability to concentrate on his story long enough to allow the characters to interact with one another. His previous effort, **Monster Heaven** (1990) had similar troubles but not as noticeable due to that film's omnibus format.

BOUQUET FOR
SPINSTER YAMADA (1990)
[Yamada Babaa Ni Hanataba O]
director: Toshio Ohi
Kuniko Yamada • Hikaru Nishida
**

Perhaps **John Woo** was influenced by this movie for his more serious *Face/Off* (1997), and just maybe this film was initially inspired by Disney's *Freaky Friday* (1977). But officially it's based on a novel by **Aiko Hanai**.

At a strict girl's high school, a young spinster teacher named Miss Yamada (**Kuniko Yamada**) is in charge of Conduct and School Code. Her nemeses, Runa (**Hikaru Nishida**), is a wild and popular student. In this film, after an accident, their souls get switched. Suddenly the *bad* girl is living inside the body of the stuffy teacher, and vice versa. At first they are confused and disoriented by the unfamiliar lifestyles, but soon they begin to understand each other's feelings. Beneath the flurry of cheap laughs, that's the real message.

BOY'S DETECTIVE TEAM (1954-59)
[Shonen Tantei-dan] 10 episodes

Initially *Boy's Detective Team* existed as a *Shochiku* theatrical serial, a series of interrelated short films based on stories by **Edogawa Rampo** chronicling the adventures of Detective Kogoro Akechi and his gang of kid sleuths. In 1954, *Shochiku* stitched together three episodes {**Human Or Devil**, **Giant Vs Phantom** and **Mysterious Master**

Thief} into something resembling a feature film. The result, as expected, is a disjointed feature telling the rambling story of a youth detective group and their subsequent investigation of crimes committed by the *Phantom with 20 Faces.*

Rampo's famous detective, Kogoro Akechi (**Eiji Wakasugi**), is on hand to supervise the junior investigators as they track down clues. It all revolves around the father of one of the kids, Doctor Hashiba, who has developed a nuclear generator only to have the plans stolen by the Phantom. Of course, the biggest problem with the plot is the same one that plagues most youth-detective tales: if Top Secret nuclear bomb secrets truly were stolen, retrieval would most likely *not* be in the hands of a neighborhood kid's gang.

The film (and/or serials) spawned a highly successful children-oriented *Shochiku* television series (1955-1960) which also starred **Eiji Wakasugi** as Kogoro Akechi and **Hitoshi Numao** as the kid leader. However the company transferred the motion picture rights to *Toei Studios*, allowing that studio to produce nine theatrical sequels between 1956-1959. **Eiji Wakasugi** was replaced by **Eiji Okada** as the big-screen *Kogoro Akechi* in the first four sequels. Then Okada was usurped by **Susumu Namishima** for the next four. And, **Tatsuo Umemiya** played the famous detective in the final installment.

The films marked with [■] are considered the best in the series:

□ **PHANTOM WITH 20 FACES** (1954)
[Kaijin Niju-menso]
director: Susumu Yumizuri
Eiji Wakasugi as Detective Akechi
■ **BOYS DETECTIVE TEAM:**
PHANTOM SCIENTIST (1956)
[Shonen Tantei-dan: Yokai Hakase]
director: Tsuneo Kobayashi
Eiji Okada plays Detective Akechi

■ BOYS DETECTIVE TEAM:
 DEVILISH PHANTOM
 20 FACES (1956)
[Shonen Tantei-dan:
 Nijumenso No Akuma]
Eiji Okada plays Detective Akechi
□ BOYS DETECTIVE TEAM:
 MYSTERY OF THE BEETLE (1957)
[Shonen Tantei-dan:
 Kabutomushi No Youki]
Eiji Okada plays Detective Akechi
■ BOYS DETECTIVE TEAM:
 PHANTOM OF IRON TOWER (1957)
[Shonen Tantei-dan: Tetto No Kaijin]
Eiji Okada plays Detective Akechi
□ BOYS DETECTIVE TEAM: RETURN
 OF PHANTOM 20 FACES (1957)
[Shonen Tantei-dan:
 Nijumenso No Fukushu]
Susumu Namishima plays Detective Akechi
□ BOYS DETECTIVE TEAM:
 PHANTOM'S NIGHT LIGHT (1957)
[Shonen Tantei-dan: Yako No Majin]
Susumu Namishima plays Detective Akechi
■ BOYS DETECTIVE TEAM:
 INVISIBLE PHANTOM (1958)
[Shonen Tantei-dan: Tomei Kaijin]
Susumu Namishima plays Detective Akechi
□ BOYS DETECTIVE TEAM:
 MAN WITHOUT A HEAD (1958)
[Shonen Tantei-dan: Kubinashi-otoko]
Susumu Namishima plays Detective Akechi
□ BOYS DETECTIVE TEAM:
 THE ENEMY IS A
 NUCLEAR SUBMARINE (1959)
[Shonen Tantei-dan:
 Teki Wa Genshisenkoutei]
Tatsuo Umemiya plays Detective Akechi

BRIDE FROM HELL (1968)
 [Kaidan Botandoro]
 translation:
 Ghost Story Of Peony Lanterns
director: **Kojiro Hongo** • Miyoko Akaza
Kojiro Hongo • Miyoko Akaza
Michiko Otsuka • **Takashi Shimura**
**

If someone were to mix a ghost story
with a Hallmark greeting card, the
result would be this film. It's a sugary
sweet rendition of a traditional Japanese
legend about a man who meets a

woman during the O-Bon Festival (a
time similar to the west's Halloween).
Despite warnings from everyone,
including the woman herself, he falls in
love. After a spectacular night of love-
making, his dead body is recovered by
the townspeople. Of course, he is still
holding his lover's skeleton in his arms.

Star **Kojiro Hongo** was better known
for his role in the **Gamera** films which
he made from 1966 thru 1968. **Takashi
Shimura**, who plays a concerned priest
here, is the veteran of many Toho mon-
ster pics (from **Mysterians** [1957] to
Frankenstein Conquers The World
[1965])

BRIDE FROM HELL 1990 (1990)
 [1990: Botandoro]
director: **Kazumichi Isomura**
Tetta Sugimoto • **Chikako Aoyama**
**

 It's the same plot as *Satsuo
Yamamoto's* Bride From Hell (1968),
except this version transfers everything
to a modern setting. There's a man
obsessed by a beautiful ghost woman.
His name is Hagiwara (**Tetta
Sugimoto**). He's the manager of a rock-
n-roll group, B-Goode (played by
Kabuki Rocks).
 Unlike the original story, this *Bride
from Hell* is clad in a very kinky,
leather outfit. And once their affair
begins, Hagiwara's business sense starts
falling apart. When he becomes
obsessed with uncovering the woman's
background, the rock group leaves him.
Hagiwara realizes that she reminds him
of a one-night-stand from years before.
He returns to the small town where the
love affair took place, and discovers...
surprise! She is dead, killed in a motor-
cycle accident. Within moments, he
finds himself in a similar situation and
also dies.
 Actor **Tetta Sugimoto** is a former pop
star who brings a certain knowingness

Toshihiro Ishii's *Burst City*

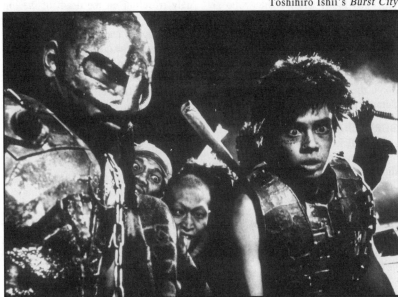

to the role. But the modern setting, the leather-clad ghost, and rock and roll is a poor substitute for the initial atmospheric, romantic horror tale. Perhaps the elements are good, but they'd be better served with an equally modern script. Besides, the original wasn't that good to start with.

BROKEN LOVE KILLER
see **EVIL DEAD TRAP 3**

BURST CITY (1982)
[Bakuretsu Toshi]
director: Toshihiro Ishii
Takanori Jinnai • Shigeru Izumiya

The setting is the near future, a *Death Race* has just begun {obviously director **Ishii** is borrowing heavily from two American films **Death Race 2000** (1975) and it's sequel **Death Sport** (1978)}. Psychos in custom cars are zooming across Japan. Meanwhile, activists in a small rural city are protesting the construction of a nuclear

power plant. Tempers begin to flare; tension is in the air. The Death Wheelers, looking for fun, decide to crash the protest rally and flatten some bodies. Of course, all hell breaks loose.

Wild (for some critics, senseless) and unbridled action from the director who would also make the international hit **Crazy Family** in 1984 and many more refined features in the '90s.

BURUBA (1955)
[Buruba]
director: Jukichi Suzuki
Yoshihiro Hamaguchi • Yuko Hashio
**

The Japanese Tarzan. Shot in the United States at Samuel Goldwyn Mayer studios, this big budget production is essentially the bastard stepson *Edgar Rice Burroughs* never knew he spawned.

A Japanese kid is raised by lions after a plane crash-lands in the African jungle. But the story pertains mostly to the adult Buruba as he comes to the aid of

an Asian father and daughter who get lost during a diamond expedition.

Like icons **Johnny Weissmuller** and **Buster Crabbe**, this apeman (lionman?) was also an Olympic medal-winning swimmer. **Yoshihiro Hamaguchi** took home the gold from the Helsinki 1952 Summer Games.

BURUSERA[1] SHOP OF HORRORS (1996)
[Burusera-shop of Horrors]
director: Takeshi Miyasaka
Junko Asamiya
**

[1] A *burusera-shop* is a perverse retail phenomenon limited almost exclusively to Japan, at least , as of this writing. Here is a store — appealing to male fetishes — wherein a customer may purchase dirty underwear which is guaranteed to have been worn by nubile high school girl.

Three HS girls, tired of living off their allowances *("We don't even have money for an extra hamburger!")*, decide to sell their underwear to a seedy burusera-shop in inner-city Tokyo. They are lured by the promise of "Your panties are worth 10 times more to us than other shops." But instead of the lucrative offer, they find themselves face-to-face with bloody horror. Apparently the newest fetish craze is "blood-stained clothes." Conceptually similar to *Herschell Gordon Lewis'* wig-shop gore-fest **Gruesome Twosome** (1966) but with lots more nudity. Starlet **Junko Asamiya** can also be googled in **Sex Beast On Campus**.

CAB (1996)
[Cab]
director: Akio Murahashi
Takanori Jinnai ● Miki Ozawa
**

Ryosuke (**Takanori Jinnai**) is a taxi driver. He's an honest and considerate man, but one night when he picks up an obnoxious yukuza chief, his patience is pushed to the limit. Ryosuke suddenly finds himself in a squabble which turns ugly, resulting in the death of the big boss.

Even though the cabbie is found innocent in court (he claims self defense) his life has become enveloped in a constant veil of dread; Ryosuke lives in fear of retaliation from the gangster family. Then, one day, everything changes after Mariko (**Miki Ozawa**) enters his life. She teaches him to relish the anxiety and trepidation, to enjoy the thrill of killing. They become lovers and killers, attacking the rest of the mob and a number of innocent civilians in the process. Probably influenced by the success of *Oliver Stone*'s **Natural Born Killers** (1994) although it's a pale imitation.

▶ CAPITOL STORY (1988)
[Teito Monogatari]
director: Akio Jissoji
Kyusaku Shimada ● Mieko Harada
Shintaro Katsu ● Mikijiro Hira

❖

▶ CAPITOL GREAT WAR (1989)
[Teito Taisen]
aka **DICTATOR OF THE CITY**
director: Takashige Ichinose
Masaya Kato ● Kaho Minami
Tetsuro Tanba ● Kyusaku Shimada

❖

▶ CAPITOL STORY: SECRET REPORT (1995)
[Teito Monogatari Gaiden]
director: Izo Hashimoto
Kazuhiko Nishimura ● Sawa Suzuki
Kazuko Shirakawa ● Hatsuo Yamane

Based on a long-running adult *gekiga* (comic book) called **Teito[1] Monogatari** by **Hiroshi Aramata**, this incredible SciFi extravaganza is directed by **Akio Jissoji**, the man who helmed the **Return Of Ultraman** TV series (1971-1974) for *Eiji Tsuburaya Productions*

and also developed the subsequent **Ultra Seven** programs. But, this time, he leaves the kid's stuff behind and creates a darkly sinister adult fantasy. Japan's leading cinema publication, *Peer*, called it *the best Japanese science fiction production of all-time*. That may be an exaggeration, but the set design alone (especially the destroyed Tokyo Ginza district) by **Itsuo Kimura**, *Seijun Suzuki*'s long-time collaborator and art director, puts this film in a class by itself. The special FX and miniatures by the *Tsuburaya* staff are equally spectacular, with their climactic earth-quake taking the grand prize. A terrific cast, including a strong supporting role by *Mr Zatoichi* **Shintaro Katsu**, adds to the fun.

A gluttonous power-hungry demon named Yasunori Kato tries his damnedest to destroy Tokyo and enslave the inhabitants. A small group of activists discover of his plot and try to stop him. **#2** is taken mostly from episode 11 of the manga dealing with Kato and the Great Psychic War. The demon challenges two holy seers who are determined to save the Earth no matter what the cost. **Screaming Mad George** provides the ultra-gory special effects.

#3 begins 50 years after the Great Psychic War and the subsequent fall of Yasunori Kato. Saijo Hospital is filled with people who were mentally disabled in the War. Their paranoia ignites the second coming of the Demon God. The psycho/suspense formula (and its preoccupation with necrophilia in a sideplot) makes this entry considerably different from the previous two. But all in all, it's a workable terror tale from the director of **Evil Dead Trap 2** (1991).

[1]*Teito* is an ancient word which means *Capitol City*, or more correctly, *Battle City*. The word infers "center of a military community."

CAPTURED FOR SEX 2 (1986)
[Kankin Sei No Dorei: Ikenie 2]
aka **Sacrifice: Captured For Sex 2**
director: Go Ijuin
Shiko Shima • **Souji Kanehako**
Kei Sano • **Aiko Matsuoka**

Capitol Story: Secret Report

Three enterprising film-school graduates created **Yu Productions**, a company which would specialize in *Ero-Gro* (Japanization term meaning *Erotic Grotesque*) films. They picked up distribution rights for some classic S&M titles and also made a few of their own. The three partners [**Genji Nakamura, Ryuichi Hiroki** and **Hitoshi Ishikawa**] produced and directed movies together, signing the projects with the single pseudonym **Go Ijuin**. They dissolved the partnership in 1992; today, they direct films separately {see **Blood And Ecstacy** [*Hitoshi Ishikawa*], **Lots Of Killing** [*Genji Nakamura*], and **Dream Devil** [*Ryuichi Hiroki*] listed separately in this volume}.

Captured For Sex 2 is generally considered the best of their in-house productions (**Captured For Sex 1** [1987], while an interesting film, cannot be considered a horror story; it is actually part of *Tetsuji Takechi*'s **Daydream** series {refer to *Japanese Cinema Encyclopedia: The Sex Films* for complete background information}). On the other hand, #2 tells the story of a young couple, Shingo and Miki, who experience car problems in the middle of a dark woods. A local man (**Shiko Shima** *aka* **Kazuyuki Watanabe**), offering a helping hand, takes them back to his modest home. Before they know what's happening, the two are hog-tied and sexually abused by the good samaritan. However, Shingo is impressed by the man's brutal treatment of Miki, and he asks to become his apprentice. The two men then capture other girls and take them back to the house for torturous sex games.

Despite the high production standards and convincing performances, this is rough *entertainment* featuring one indignity after another, a virtual parade misogynous behavior. Although it may be too much for the casual viewer, this film is a quintessential example of the sadistic horror genre.

CAPTURED STARLET
see **MANIAC 2**

CASTLE OF ILLUSION
see **SAMURAI SPY**

CATASTROPHE 1999
see **LAST DAYS**
 OF PLANET EARTH

Checkers In Raccoon Fever

CHECKERS IN
RACCOON FEVER (1985)
[Checkers in Tan Tan Tanuki]
director: **Toru Kawashima**
Checkers ● Yumiko Endo
*½

Another "idol" movie, this time obviously inspired by the frenetic style-n-story of *Richard Lester*'s Beatle movie **Help** (1965). Members of the famous Japanese pop group *The Checkers* play themselves in a story about singers who discover they have special *raccoon* psychic powers. An international criminal organization tries to kidnap the boys and use their sacred ESP abilities for evil purposes.

The man-to-raccoon transformation scenes are surprisingly good. On the

other hand, the songs are less than memorable and the acting falls considerably below the basic minimum requirements.

CHIMERA WITH THREE EYES
see **AKADOM Suzunosuke** Series

COMPUTER-AGE GHOST (1988)
[Youjo Densetsu '88]
director: Noboru Tanaka
Naomi Oki • Kouji Saito

Director **Noboru Tanaka** was one of *Nikkatsu*'s primary filmmakers, making a wagonload of sex movies for that studio's famed *pinku eiga* line (*e.g.,* **Female Teacher: Private Life** [1973], **She Beast Market** [1974], **Walker In The Attic** [1976], *et al*). After *Nikkatsu* temporarily closed its doors in the early '80s, **Tanaka** became a freelance director, with **Cursed Village** (1983) being his most popular effort. He drifted to television where he made a few action-oriented movies, with little

recognition. This film marks his return to the big screen. Visually it's competent, and stylistically reminiscent of his work in **Angel Guts: Nami** (1980). Newcomer **Naomi Oki** is beautiful, once removed. Her detached persona adds a quirkiness to this modern *kaidan*.

A young man (**Kouji Saito**) begins a computer relationship with an enchanting girl, flirting and chatting over the Internet. He becomes obsessed with her, especially after finding out how attractive she is. But he also discovers that she's very dead and her signal is coming from the darkside.

COSMIC MAN
APPEARS IN TOKYO (1956)
[Uchujin Tokyo Ni Arawaru]
aka **MYSTERIOUS SATELLITE**
aka **STARFISH MONSTERS**
aka **WARNING FROM SPACE**
director: Koji Shima
Toyomi Karita • Keizo Kawasaki
Isao Yamagata • Shozo Nanbu
**

Cosmic Man Appears In Tokyo

Generally dismissed as a Japanese clone of **Robert Wise**'s **Day The Earth Stood Still** (1951), but it's actually based on a prestigious SciFi novel by **Gentaro Nakajima**. However, the theme of friendly aliens coming to warn Earthlings about the dangers of nuclear weapons is indeed familiar. This time the aliens are actually giant starfish creatures (with an eyeball protruding from the middle of their body) who transform into human shape to keep from scaring people.

This is the first color SciFi film from **Daiei**. The overall budget was considerably more than customary for this type of fare, as the studio made a conscious effort to compete with **Toho**'s runaway hit **Godzilla** (1954). They even hired **Taro Okamoto**, the famous surrealistic avant garde artist, to design the starfish aliens. The result at the box-office was, however, less than stellar.

CRANE (1988)
[Tsuru]
director: Kon Ichikawa
Sayuri Yoshinaga • Hideki Noda
Bunta Sugawara • Kyoko Kishida
**

Kon Ichikawa is a square director, sorely out of step with contemporary Japanese cinema. Yet, he is widely respected for his major artistic contributions of the '50s {especially his sprawling anti-war epics, *i.e.*, **Harp Of Burma** [1956], and **Fires On The Plains** [1959]}, and thus he's still exalted by the film purists today.

This one, however, is another bloated fantasy (similar to his equally ostentatious **Story Of The Bamboo Hunter** [1987]). It tells a bittersweet love story based on a traditional Japanese folk legend, *Tsuru No Ongaeshi [Gratitude of the Crane]*. Here, a hunter finds an injured crane, and after nursing it back to health, releases the creature to the wild. Then the bird, transformed into a beautiful young woman, returns to show gratitude. The hunter falls in love with the *crane-girl* and they marry. The bride begins weaving beautiful garments for her husband, but warns him to never watch her as she works in the sewing room. He promises; however the man can't resist the temptation of seeing his beautiful wife at work on the spinning wheel. One day he spies on her and discovers that she's really the crane, using her own magic feathers and beak to weave the clothes. (Can this be a surprising denouement for anyone in the audience?) The woman becomes upset when she realizes that her husband can't be trusted. And so, she leaves him.

Sayuri Yoshinaga was 43 years old when she made this movie. She's a distinguished actress who managed to maintain her popularity over the years, while many of her peers fell by the wayside. She was not a stranger to **Kon Ichikawa** nor his work, starring in his 1983 *comeback* film **Makioka Sisters** and the less successful **Ohan** (1984). The *Crane* project was especially chosen by Ms Yoshinaga to celebrate her 100th film. Unfortunately for her, the critics were not kind.

CRAZY FAMILY (1984)
[Gyaku Funsha Kazoku]
translation: **Back-firing Family**
director: Toshihiro (Sogo) Ishii
Katsuya Kobayashi • Mitsuko Baisho
Hitoshi Ueki • Yuki Kudo

A unique *violence-at-home* drama.

Daddy is obsessed with having "the perfect home," representing the best in family ideals and professional success. Mom is the *typical* traditional mother who's secretly getting sick of the goody-goody role. Their daughter is completely obsessed with the Pop

Culture and lives only to hear the newest hit song. And her brother is a nerdy book-worm type, hopelessly at war with his own pubescence. In short, these four individuals are broad caricatures of the contemporary, suburban Japanese family. They are the Nippon *everyman*.

On the surface everything appears normal, but— when cantankerous grandpa comes to live with them, coupled with daddy finding termites in the house, this space-age family starts going berserk. The whole thing ends in a blood-drenched free-for-all.

Toshihiro Ishii, who started his career while still in college {**High School Big Panic** [1978]}, went on to make music videos and a concert film for the German metal-rock band *Einsturzende Neubauten* {see **Half Human** [1986]}. He also directed a classy serial-killer movie, **Angel Dust**, in 1994.

CRAZY THUNDER ROAD (1980)
[Kuruizaki Sanda Rodo]
director: Toshihiro (Sogo) Ishii
Tatsuo Yamada • Masamitsu Ohike
Toshiji Kobayashi • Koji Nanjo
***½

Hold on tight. This is one hell of a ride. It's the best bike-gang movie of them all, arguably the best in the world. In the Town Of Illusions somewhere down the long stretch of Japanese highway known as Thunder Road, a young hero takes on a gang of ultra-right wing bikers, the O-Mankos, after they beat up and kill his best friend.

It was both praised and damned by the Japanese critics for its nihilistic characterizations, which includes junkies, homosexuals, and various other society *misfits* and *radicals*. The conservative industry rating board, *Eirin*, chastised the film's inherent message (*i.e.*, the use of excessive violence in dealing

Crazy Thunder Road

with violence) as an unacceptable criteria for general audiences. However, the film has survived the test of time, oddly becoming more contemporary with each passing year.

Originally, this incredible movie was **Toshihiro Ishii**'s graduation project at prestigious Japan University in Tokyo. *Toei* bought the rights and restruck it from 16mm to 35mm for a theatrical release. He followed this feature with **Burst City** (1981).

CREST OF BETRAYAL
see **GHOST STORY OF YOTSUYA: CHUSHINGURA VERSION**

CRISIS 2050 (1990)
 [Crisis 2050]
 aka **Solar Crisis**
director: Alan Smithee[1]
 [Richard Sarafian]
Tim Matheson • Charlton Heston
Peter Boyle • Annabel Schofield
Jack Palance • Tetsuya Bessho
*½

It's based on a science fiction novel by **Takeshi Kawata**, produced by **Takehito Sadamura**, and financed by NHK [*Nihon Hoso Kyokai:* the Japan National Broadcasting Group, a government owned public television network], however everything about this project screams *United States*. It's helmed by an American director, with a predominately Anglo crew, and **Maurice Jarre** writes and conducts the music. *Blade Runner* art stylist, **Syd Mead**, acts as the Futuristic Designer here. But his humdrum sets only seem to prove that the creative design-work in *Blade Runner* was more the brain-child of **Ridley Scott** and FX specialist **David Dryer** than those of Mr Mead.

The Earth's atmosphere is being ravished by solar disturbances. Scientists are predicting a Mega Flare in the very near future; this will result in the elimination of life on Earth. At considerable expense, even in the face of financial disaster, the nations of the world unite to fund an expedition to the sun. The Freedom Team's mission is to divert the flare away from Earth and save humanity. They plan to perform this feat by detonating a super bomb (5 tons of anti-matter) on the far side of the sun, thus prematurely activating the Mega Flare in a safe direction. Pilot Ken Minami (**Tetsuya Bessho**, the only Japanese actor in the entire cast) volunteers for the Kamikaze mission. But then he's later replaced by feminist super pilot Alexandria (**Annabel Schofield**).

The SciFi stuff borrows liberally from **Star Wars**, but it also owes a big debt to **2001: A Space Odyssey** (including the same trippy psychedelic conclusion when the probeship penetrates the sun, not to mention a know-it-all soft-spoken computer named Freddy, which might have easily been called Hal).

Yet the real story isn't about the rocket, the crew, or even the Solar Mega Flare. That's merely window-dressing for **Richard Sarafian**'s smaller adventure yarn, a pretentious tale of a cadet, Steve Ketso (**Tim Matheson**), and his attempt to reach the space station before his father is whirled away on the Sun Probe Mission. Young Steve's trek is populated with colorful (albeit ostentatious) characters, remarkably similar to those found in the director's existential car-chase movie, **Vanishing Point** (1971). Enroute, Steve's conservative philosophies are challenged by the crazed rantings of vagabond Travis (**Jack Palance**, in a very hammy role).

Meanwhile, it starts to look like the Earth might not be in any danger after all; the whole project could be a scam concocted by a secret network of international businessmen headed by an evil megalomaniac (played by **Peter Boyle**, who rivals **Jack Palance** for garish flamboyancy.)

Reportedly, Sarafian was immensely displeased with the project. When the movie was set for release in the United States, he had his name removed from the credits, replacing it with the industry goofus pseudonym *Alan Smithee*. However Sarafian's name still appears on the Japanese version of the film.

[1]As reported in Michael Singer's book **Film Directors: A Complete Guide** [Lone Eagle Press], *Alan Smithee* (sometimes spelled *Allen Smithee*) is the official pseudonym developed by the Director's Guild Of America for those members who wish to have their name removed from the on-screen credits and advertising credits of a particular film. This is usually the result of studio interference or loss of creative control.

Cruel Ghost Legend

CRUEL GHOST LEGEND (1968)
 [Kaidan Zankoku Monogatari]
 translation: Ghost Story Of Cruelty
director: Kazuo Hase
Sae Kawaguchi • Yusuke Kawazu
Masakazu Tamura • Hiroko Sakurai
*½

A complicated tale of intrigue and incest is set into motion when a samurai kills an unsympathetic banker. The dead man's ghost plagues the warrior and his family, cursing everyone for generations to come.

Director **Hase** is more concerned with creating an intricate plot than giving chills to the audience. Regardless of the obvious exploitation elements, his story is needlessly confusing and hopelessly talky. The original Japanese version is 126 minutes; the International edit is considerably shorter at 88 minutes.

CURSE OF THE NIGHT
 see **GHOST STORY OF YOTSUYA**

CURSED LUGER P08 (1995)
 [Kyouju Luger P08]

director: Takeshi Watanabe
Hiroshi Abe • Hiromi Nakajima
**½

A young businessman is approached by a homeless man one evening. The beggar offers to give him a gun in exchange for a "spot of cash." As it turns out, the pistol had been used by a high-ranking Nazi during the war and, as such, it was responsible for hundreds of deaths. Once the junior executive takes possession of the luger, everything changes in his life. He starts by having weird, antisocial dreams about

Cursed Luger P08

death and "ultimate power through bloodshed." The gun is a magnet; he can't let go. In the middle of the night, he wakes up clutching it. His body becomes dependent on the gun. And the young man turns into a vicious serial killer, revitalizing his psyche every time he pulls the trigger.

CURSED VILLAGE (1983)
[Ushimitsu No Mura]
director: Noboru Tanaka
Masato Furouya ♦ Shino Ikenami

This true story, based on a 1938 massacre in the rural mountains of Okayama, plays more like a backwoods version of **Crazy Thunder Road** (1980). The similarities are probably intentional.

Tsuguo (**Masato Furouya**) is a popular boy among the villagers. He's a polite teen always ready to extend a helping hand. But their attitude towards him changes when he can't pass the army physical due to a tuberculosis diagnosis. The city turns its back on Tsuguo; the townspeople shun and ignore him. He becomes a social outcast. Soon, his loneliness turns to

Masato Furouya in *Cursed Village*

despair and Tsuguo begins to hate the community with a fiery passion. Isolationism has driven Tsuguo to the point of insanity. He arms himself and goes on a killing spree, murdering 30 villagers and wounding countless more.

Director **Noboru Tanaka** cut his teeth on a steady diet of *Nikkatsu* sex movies throughout the '70s (*e.g.*, **Female Teacher: Private Life** [1973], **She Beast Market** [1974], **Walker In The Attic** [1976], **Angel Guts: Nami** [1980], *et al*). When the studio reduced production in the early '80s, Tanaka drifted to television as a freelance director. He made a number of action-oriented movies, but received little notoriety. From time to time, he returned to the big screen, with **Computer-Age Ghost** (1988) being his most successful *post-Nikkatsu* venture.

CURSED VILLAGE
IN YUDONO MOUNTAIN (1984)
[Yudono Sanroku Noroimura]
director: Toshiharu Ikeda
Toshiyuki Nagashima • Eiko Nagashima
****½**

Here's a novelty in Japanese horror: a "*mummy* ghost" movie, and conceptually it's very similar to **Hammer**'s **Curse Of The Mummy's Tomb** (1964). A university historian (**Toshi-yuki Nagashima**) goes to the Yudono Mountains to research an ancient cult of Buddhist monks. He stumbles upon a underground temple and "suicide graves" known as *sokushin jobutsu*.[1] Of course, the professor ignores the inscription which promises terrible calamities to the entire village if anyone should violate the tomb. And as a result, the monk's ghost slaughters as many people as it can.

As always with **Toshiharu Ikeda**'s movies, his cinematography is exceptional, capturing both the sinister atmosphere and the exquisite beauty of

the mountain community. He continues to be one of Japan's best horror directors {see **Evil Dead Trap** [1988], **Mermaid Story** [1984], **XX: Beautiful Prey** [1996] *et al*}.

[1]*sokushin jobutsu*: a priest buries himself in a casket without food or water; to show his endurance, he continuously rings a bell connected to the surface by a string. When the bell no longer rings, the community celebrates, knowing that his death will bring fertility to the land.

CURSE OF OIWA
see **GHOST STORY OF YOTSUYA**

CURSED BEAUTIES
see **GHOST OF EVIL SPIRITS**

▶ **CUTIE KNIGHT IN COSTUME** (1995)
[Kpsupure Senshi Cutie Knight]
director:
Miho Yabe • **Sara Shimada**
**½

▶ **CUTIE KNIGHT IN COSTUME 2** (1996)
[Kosupure Senshi Cutie Knight]
director: **Noriaki Yuasa**
Akane Kanazawa • **Sumina Morishita**
**

Two girls, Mai and Rei (**Miho Yabe** and **Sara Shimada** respectively), are female freedom fighters in contemporary Tokyo. Their days are filled with battles against monsters and lecherous sex-maniacs. These two girls are cute and they shed their clothes without much coaxing. The *gimmick* behind this series is both girls have an extensive wardrobe of superhero costumes. The whole thing plays like a high-camp fashion show. The original two girls are replaced for *#2*. **Akane Kanazawa** and **Sumina Morishita** take over the starring roles, but their looks are so similar to the first girls (and usually camouflaged behind a costume) most audiences never noticed a difference.

ad mat for *Daigoro Vs Goriasu*

DAIGORO VS GORIASU:
GIANT MONSTER CONFLICT (1972)
[Kaiju Daifunsen: Daigoro Tai Goriasu]
director: **Toshihiro Iijima**
Hiroshi Inuzuka • **Shinsuke Minami**
**½

Alright. There's this big monster (which looks a lot like an orange *Barny the Dinosaur*) and somebody has to take care of him. The poor guy is an orphan, so the government leaders decide *Daigoro* should be a "ward of the state" and, as such, must be fed from the national budget.

But very soon, the Finance Manager realizes Japan will deplete its gold reserve if the monster continues growing and demanding more food. A national poll is taken. The people vote against a proposed Daigoro tax. The children of Japan are devastated and they rebel, clogging the streets with "Save Daigoro" rallies. They chant and beg for public support.

Meanwhile, there's yet another monster, a vicious brute from Outer Space named Goriasu (insert Godzilla here).

Will Daigoro be able to save the day? Can enough money be raised to feed him and nurse him back to health so he can protect the Earth? Will he even want to? These, plus many more questions are answered in this parody of the **Baby Cart** and **Godzilla** films. A *lost* gem from *Toho* studios, produced by the legendary *Tsuburaya Company* to celebrate their 10th anniversary.

However, there's a twofold problem with this motion picture. Seemingly director **Iijima** is reluctant to pursue the parody aspect to its fruition. Too quickly he abandons the clever satire in favor of some very tired slapstick and overwrought juvenile antics. This leads to the second obvious problem: while this film was intended as a parody against *kaiju eiga* (the studio is specifically jabbing at the **Gamera** movies here), it's ultimately ineffective against a genre which has become a joke unto itself. For example, while *Toho* produced this movie, they were also making **Godzilla Vs Megalon**, a supposedly *dignified* entry in their ongoing series. But, remember, that's the one which features Big G fighting an enormous chicken.

DANGEROUS TALES:
THREE DREAM STORIES (1989)
[Abunai Hanashi: Mugen Monogatari]
director: **Kazuyuki Izutsu** with
 Kiyoshi Kurosawa & Tomoaki Takahashi
Naoto Takenaka • Shiro Sano
Hideo Murota • Renji Ishibashi
**½

An omnibus film, featuring three tales which skirt the horror genre without really embracing the formula. More correctly, these are *dream stories* directed by a trio of *New Wave* Nippon filmmakers, emphasizing what happens when an "everyman" is faced with a life-threatening situation.

Story **#1**, deals with a man who accidentally stumbles into a yakuza hang-

from the second story in *Dangerous Tales*

out; and **#3** features a young couple preoccupied with committing the perfect crime.

The second story, directed by **Kiyoshi Kurosawa** (of **Sweet Home** fame), is the best of the three. It's an atmospheric thriller about a man, attacked and pursued by two strangers in samurai garb, who are unduly maniacal about capturing him.

Veteran actor **Kazuhiko Hasegawa** was initially signed to direct an additional episode but he backed out before production began. Despite persistent rumors claiming his segment was completed and suppressed by the studio, there is no concrete evidence to prove the accusation.

DARKSIDE REBORN (1981)
[Makai Tensho]
aka **SAMURAI REINCARNATION**
director: **Kinji Fukasaku**
Kenji Sawada • Akiko Kana
Ken Ogata • Hiroyuki Sanada
Shinichi Sonny Chiba • Mikio Narita
***½

Another big-budget, epic production by **Kinji Fukasaku**, on the heels of his highly successful **Virus** (1980) {see separate review}. This one is based on a fantasy novel by *Kazetaro Yamada*

(author of many female ninja and/or black magic thrillers). In it, Yamada takes certain liberties with historic facts and legendary heroes, twisting stale myths into a new tale of bravado.

The central character is Shiro Amakusa (**Kenji Sawada**), a Christian rebel who had fought against the government and lost his life in the fracas. However, his soul never found peace in the afterworld. And he finally decides to return to heathen Japan for revenge. In an obvious parody of **Kurosawa**'s **Seven Samurai** (1954), Amakusa travels around Purgatory trying to convince other super-warriors to join him in the battle.

His *right-hand man* is a *woman* named Hosokawa (**Akiko Kana**). She's also a Christian martyr with an ax to grind. Hosokawa uses her body to seduce the enemy and then her religious magic to finish 'em off. This is no Mother Theresa.

Eventually Amakusa recruits his entire Darkside Army. Besides Hosokawa, it includes notorious swordsman Musashi Miyamoto (**Ken Ogata**), legendary ninja Goemon Ishikawa (**Hiroyuki "Henry" Sanada**) and an array of other colorful Japanese folk heroes. The evil government officials don't stand a chance against this ghost squad.

The film was such a success that *Toei* tried to continue the charisma with a similar tale, **Black Magic Wars** in 1983, also penned by Yamada. Too bad they didn't hire filmmaker Fukasaku again for that project.

The **DARKSIDE REBORN** remake:

DARKSIDE REBORN (1996)
[Makai Tensho]
director: **Masakazu Shirai**
Hiroyuki Watanabe ● Yuko Moriyama
Tomoroh Taguchi ● Hiroshi Miyauchi

❖

DARKSIDE REBORN:
PATH TO HELL (1996)
[Makai Tensho: Mado-hen]
director: **Masakazu Shirai**
Hiroyuki Watanabe ● Yuko Moriyama
Tomoroh Taguchi ● Hitomi Shimizu
****½**

Here's a double-dose of **Kazetaro Yamada**'s epic fantasy novel. Director **Masakazu Shirai** restructures the same story from the 1981 hit {see previous listing for details} for this remake about seven reincarnated legendary warriors and their war against the the corrupt Yagui family. And just like the original feature, the first entry ends as the ghost army is preparing for the final conflict.

#2, Path To Hell, adds a new character, Shosetsu Yui (**Hitomi Shimizu**)— a reincarnated activist rebel from the Edo period— and delivers the action immediately, culminating with the long-anticipated war. Of course the ghostly warriors are victorious. And that's the biggest problem with these two features: predictability. **Shirai** takes very few chances. He delivers his story in a matter-of-fact fashion with no surprises. No curves. And very little feeling.

DARK STORY OF A
JAPANESE RAPIST (1967)
[Nihon Boko Ankokushi Bogyakuma]
director: **Koji Wakamatsu**
Miki Hayashi ● Osamu Yamashita
Kazue Sakamoto ● Mikiko Okawa
****½**

After the unmitigated success of his **Violated Angels** (which was based on the 1967 case of the American *Richard Speck* who slaughtered a houseful of nurses in Chicago), director **Wakamatsu** decided to recreate story of **Yoshio Kodaira**, a rapist who stalked the streets of Tokyo just after the Second World War.

Interestingly, Wakamatsu chose not to identify the character as *Yoshio*

Kodaira, but rather as *Marquis De Sadao*. The film also takes a number of exploitive liberties. The rapist (played with calculating sternness by **Osamu Yamashita**) is a killer who enjoys whipping and mutilating his victims while having sex.

However, on the artistic level, Wakamatsu's eye for detail is exquisite. And his recreation of post-war Japan challenges the art direction of major studios, especially considering his minuscule budget. As with the previous **Violated Angels** {see separate review}, there are also some heavy-handed segments which suggest that aberrant behavior in Japan is caused by the emergence of capitalism.

DEATH HOUSE
 ON HOSPITAL HILL
 see **KINDAICHI** series

DEATH POWDER (1986)
 [Desu Pawuda]
director: Shigeru Izumiya
Shigeru Izumiya • Takichi Inukai
Rikako Murakami • Mari Natsuki

Death Powder

Here's yet another example of how a creative filmmaker can overcome the obstacles of a limited budget. Director **Izumiysa** intercuts black-and-white footage with his stock film, multi-layering it with computer generated video images. The result is cyberpunk gut-punch in the same arena as **Tetsuo** (1990) and **Pinnochio 964** (1992). But there's one big distinction: The plot is secondary to the strange and frightening images streaking across the screen. It's been described as the ultimate acid trip.

Three mercenaries steal a top secret cyborg. They are unaware that the *Guernica* is capable of polluting their minds with a psychedelic kill-drug known as Death Powder. Infected, these unfortunates become slaves, living in an alternate universe under the domination of the Scar People, but in reality their bodies are mutating into one enormous amoeba.

This movie drifts in and out of various hallucinogenic worlds with little regard for the germ of a plot. Even the characters within the story are confused, when one of them wanders around in a daze, he is told: "Just pretend like you understand what's going on. This, like life, makes no sense."

In the early '70s, **Shigeru Izumiya** was considered the *God of Protest Music* ("the Japanese Bob Dylan") by his legions of fans. By 1978, his musical career had evaporated and he gravitated to television. There **Izumiya** became a popular villain, playing a psycho-killer on many TV action shows. In 1982, he starred as a wacko bad guy in a theatrical feature, **Beast Detective** [Yaju Deka] for which he won the Nihon Academy Award for best supporting actor. He made two "experimental films" (**Profession Hitman** and **Harlem Valentine Day** before tackling *Death Powder*.

Miho Sugano (l) with Toshirou Yanagiba in *Defender*

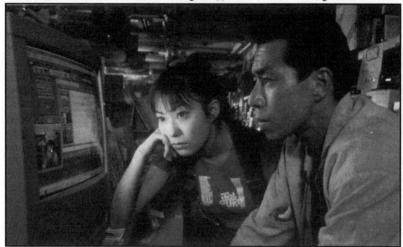

DEFENDER (1997)
 [Defender]
director: Kazuya Konaka
Toshiro Yanagiba ● Miho Sugano
Tomoroh Taguchi ● Shiro Sano

Obviously inspired by *Shinya Tsukamoto*'s 1990 cyberpunk anthem **Tetsuo**, new-wave director **Konaka** delivers a clever counter-take on the *Ironman* concept. Here, computer engineer Takashi (**Toshirou Yanagiba**) notices that a microchip is protruding from his head. He contacts a notorious hacker (**Tomoroh Taguchi**, the original star of *Tetsuo*) for help. Meanwhile, Takashi's world is turning upside down. He's robbed at knifepoint and then chased through the crowded Tokyo streets by a giant. Or maybe not. Perhaps the microchip is only making him *think* these things are happening.

Soon he realizes there's a connection between all the bizarre traumas and a girl named Masami (**Miho Sugano**). Seemingly, all his troubles started when she visited his repair shop and asked him to fix her CD Rom unit. Eventually Takashi finds himself psychically linked

to the girl. As it turns out, they are secret government-made humanoids, programmed to live undetected within society and then – when the need should arise – they are activated as professional fighters. The action of the movie itself plays like the *Defender* arcade game.

Director **Konaka** fares well with computer oriented stories. His perverse Internet Horror tale, **Lady Poison : Beasts Of The Underground** (1994) made him popular among the Nippon cult film fans {see separate listing}.

DEMON POND (1979)
 [Yashaga Ike]
director: Masahiro Shinoda
Tamasaburo Bando ● Go Kato
Tsutomu Yamazaki ● Koji Nanbara
**

In 1913, there's a remote village near a lake. The lake is haunted with demons. The demons can be controlled by the ringing of a magic bell. Accidentally, the bell is destroyed and the spirits cause a tidal wave which drowns the entire village. In typical **Shinoda** fashion, it's picturesque but excessively

slow. Based on a story by **Kyouka Izumi**, the director (probably with input from his leading male *actress* **Tamasaburo Bando**) has chosen to shoot this film in ancient *Kabuki* fashion. All parts, both male and female, are played by men. Kabuki actor **Bando** plays at least three different roles.

DESTROY ALL MONSTERS (1968)
 [Kaiju Soshingeki]
 translation:
 Monsters Fighting Together
director: Ishiro Honda
Akira Kubo • Jun Tazaki
Yoshi Tsuchiya • Kyoko Ai
Yukihiko Kobayashi • Ito Sisters
** (or nostalgia rating ***)

For some reason, most genre enthusiasts fondly remember this film. Perhaps it's because **Destroy All Monsters** was one of the few that received a widespread release in the United States, playing mostly to the Drive-In circuit during the prime '68/69 years.

Plus, if you like monsters, lots of monsters, this one is unbeatable. All the *Toho* creatures (the great ones and the near great) are living together on Monster Island, an artificial community designed to give these beasts a comfortable existence without endangering the rest of mankind. Sort of like a giant monster zoo. Of course, there's Godzilla, the king of monsters (incidentally, starring in his 8th film)— plus Rodan, Mothra, Varan, and Baby Godzilla plus obscure one-shot wonders like Wenda (from **Atragon**) and Baragon (from **Frankenstein Conquered The World**). If the invisible man from **Human Vapor** is there, he wasn't vocal about it.

The story deals with evil aliens who gain control of the monsters and release them from captivity, sending each one on a rampaging mission against every major capitol of the world. Eventually, Ghidra [Ghidorah] is deployed and all the monsters fight it out atop of Mt Fuji while Baby Godzilla cheers them on. Regardless of the nostalgia vote, this movie is a far cry from director **Honda**'s original **Godzilla** masterpiece in 1954.

DESTROY ALL PLANETS
 see **GAMERA VS VIRAS**

Destroy All Monsters

DEVIL GARDEN (1967)
[Akuma No Niwa]
aka **REVENGE OF DR X** (USA)
aka **VENUS FLY TRAP**
director: Kenneth Crane
James Craig • Miyoshi Umeki
and James Yagi
****½**

Rocket scientist Bragan (**James Craig**, doing his best *Clark Gable* imitation), is on the verge on a mental breakdown caused by the stress of his job. But then, after a successful rocket launch (a segment which includes a lot of obvious NASA stock footage), a colleague (**James Yagi**) convinces Dr Bragan to enjoy a relaxing vacation in Japan. Inexplicably, Bragan takes the long way to an airport — up the United States coastline, from Cape Kennedy to Wilmington, North Carolina — before catching the plane to Tokyo. During this sojourn into the wilderness, his car breaks down. While it's being repaired, Dr Bragan roams around the swampland and finds a venus fly trap. He stuffs the plant inside a paper bag and takes it with him to Japan (it's still a mystery how he ever got through customs with the thing).

In Tokyo, Dr Bragan is met by Noriko (**Miyoshi Umeki**), his guide and female assistant. Together they drive to her father's abandoned resort-house near a sleepy fishing village. Bragan is obsessed with his plant and he's anxious to conduct some new "wondrous experiments" with it. He and Noriko convince a group of female swimmers (topless, yet) to make a dive and retrieve some rare underwater seaweed — a distant relative to the American venus fly trap — for the scientific research. Dr Bragan combines the cells of the two plants and creates "the most powerful creature in the universe," a monster (*i.e.*, another man in a rubber suit) with a long tail and fly-trap hands and feet! Against the wishes of Noriko, Dr Bragan feeds the creature an assortment of mice, a puppy and blood from a pregnant woman (which he has stolen from the village clinic). Eventually the fly-trap monster escapes from the lab and Bragan tries to lure it back with a baby goat. The movie ends when master and monster fall into a volcano. The goat, however, survives.

> Notice: this film is shrouded in mystery, The authors of this book have attempted to piece together as much information as possible regarding the production credits. Some details are still open to speculation.

The video boom of the early 80s produced a girth of titles which had previously been deemed unreleasable. Many films, cluttering the dusty warehouse shelves, suddenly got a new lease on life, camouflaged with bright artwork and promoted as a "lost treasure." Sometimes, in those early days — for a variety of reasons — a movie was released to video under a phony title. A Distributing Company did this 1) to make the film seem more contemporary; 2) to hide the fact that it was a well-known dud; or 3) to distract attention from dubious ownership or copyright entanglements.

Regardless of the reason, in 1984 *Regal Home Video* (now defunct) released this movie to the American market under the bogus title **Revenge Of Dr X** (a computer-generated title-card is sloppily edited onto the beginning of the tape replacing all original credit information). Even more oddly, the video-box artwork makes no mention of the "**Revenge Of Dr X**" title instead this movie is identified as *Eddie Romero*'s 1968 Filipino horror film **Mad Doctor Of Blood Island**. The motion picture enclosed in the package is definitely not *Mad Doctor Of Blood*

Island. Nor is it something called *Revenge Of Dr X.*

Rumors persisted among film historians that the movie was, in fact, a lost **Ed Wood** feature based on his own script. It has since been proven that Wood never directed this movie, but the motion picture is most likely based on his screenplay. According to **Michael J Weldon** in **Psychotronic Video Guide** (St Martin's Press, 1996): "Ed Wood wrote a script called *Venus Fly Trap*, which ended up being filmed in Japan by *Toei.*" In a private interview, Weldon commented further: "I'm convinced the story came from Ed Wood, but I'm not as certain about the *Toei* connection." A representative at *Toei* in Japan told the authors of this book that there is no record of the company making this film. In fact, none of the major Nippon studios lay claim to this movie. And there is no mention of it in any of the Japanese language movie-guide books.

After much investigative research (which even included contacting the manager of the Kowakien Hotel in Hakone, the site of various recognizable interior scenes) some information has been gleaned regarding this film's elusive parentage. It's an American/Japanese co-production, directed by **Kenneth Crane** who helmed a similar project in 1959 called **The Manster** {see separate listing} and a number of other paste-n-patch features including *Ishiro Honda*'s **Half Human** (1955) and his own **Monster From Green Hell** (1957) for which he liberally borrowed stock footage from **Stanley And Livingston** (1939).

The movie was never released theatrically anywhere in the world, but the working title was **Devil Garden** [Akuma No Niwa]. That's how lead-actress *Miyoshi Umeki* (former bit

player in **Girl Named Tomiko** [1962] and **Flower Drum Song** [1961]) identifies it in her filmography. The other two major stars, **James Craig** and **James Yagi** (both deceased), never acknowledged the movie at all.

The date of the production is approximated at 1967. This is based on two observations: In the opening segment, Dr Bragen (**James Craig**) is seen driving a 1966 Chrysler, thus the film could not have been made before '66. And due to the vehicle's slightly used appearance, it was probably '67. Secondly, **James Craig**'s heavy acting schedule in '68 and '69 would've kept him from shooting a movie on location in Japan (during that time he starred in a variety of American-made westerns including **Hostile Guns**, **Arizona Bushwhackers**, **Fort Utah** plus the blaxploitaton feature **If He Hollers, Let Him Go**). By comparison, his filmography lists nothing for 1967.

The other production credits will most likely remain a mystery.

**DEVIL COMES DOWN
AND BLOWS THE FLUTE**
see **KINDAICHI** series

DEVIL IN NEW MOON TOWER
see **AKADO, Suzunosuke** series

Die Hard Angels

DICTATOR OF THE CITY
see CAPITOL GREAT WAR

▶ DIE HARD ANGELS (1992)
[Dai Hado Enjerusu]
director: Arthur Mitsuga Sawada
Naomi Akimoto • Mizkou
Aki Mukai • Yuko Hoshi
*½

❖

▶ DIE HARD ANGELS: PROJECT
ZOMBIE ANNIHILATION (1993)
[Dai Hado Enjerusu:
Kiken Ni Dakareta Onnatachi]
director: Arthur Mitsuga Sawada
Naomi Akimoto • Saeko Komiyama
Naoko Iijima • Rui Sakuragi
*

Bad (bad) adj. n. l. unpleasant. 2. inferior, of
poor quality, worthless, incorrect, defective,
faulty. 3. decayed, spoiled. 4. That which is
bad or unfortunate. 5. Die Hard Angels.
— revised from Oxford American Dictionary

Don't be fooled by the promise of
seven girls kicking zombie butt. Yes, it
is the story of a crack team of cuties,
each with their own skill, brought
together to stop an subversive organiza-
tion rejuvenating dead bodies for fun
and profit. But the movie is terrible.

The seven angels investigate the resur-
rection of two evil criminals known as
Zombie Man and Zombie Woman
(clever, eh?). If it weren't for the fact
that they walk very slowly, nobody
would know they're zombies at all.
Direc-tor Sawada's idea of special
effects is a blue light, and sometimes
when things get tense, he uses red. This
is a no-budget embarrassment. Share it
with somebody you hate.

DISCARNATES
see SUMMER WITH GHOSTS

DISMEMBERED GHOST
see GHOST STORY OF
THE BARABARA PHANTOM

DIVA IN
THE NETHERWORLD (1980)
[Utahime Makai O Yuku]
director: Takafumi Nagamine
Yoko Kurita • Kiyose Fujiwara

Micki (Yoko Kurita) is the most tal-
ented and most famous classical singer
of modern times. At least, that's the
premise here. She and her stage part-
ner, Donald (Kiyose Fujiwara), become
lost in the netherworld of the undead, a
land where they encounter a cannibal-
witch and hordes of gigantic prehistori-
cal monsters. But these two unlikely
warriors are also decedents of a vam-
pire and wolfman, respectively, and
they must bring honor to their families.
In this netherworld, superstar Micki
learns the high price-tag for her earthly
success.

Sort of like an adult version of Never
Ending Story. Lots of breakneck action
and high-spirited fighting set in a pre-
dominately dreamlike terrain. The char-
acterization is purposely broad, accent-
ed by the highly kitsch and very gaudy
art design. This movie could have easi-
ly inspired Robert Rodriguez's Dusk To
Dawn (1995), and in similar fashion
both films were not accepted by general
audiences at their time of release, but
today are considered cult masterpieces.

DOGORA THE
SPACE MONSTER (1965)
[Uchu Dai Kaiju: Dogora]
director: Ishiro Honda
Yosuke Natsuki • Hiroshi Koizumi
Akiko Wakabayashi • Yoko Fujiyama
**½

Dogora the Space Monster, or rather
Monsters, are one-shot creatures creat-
ed by Toho's special effects wizard Eiji
Tsuburaya. They were the last original
monsters designed by Eiji before he left
the studio to form his own company,
Tsuburaya Productions, in 1966.

Dogora The Space Monster

Probably due to ownership/ copyright disagreements, these odd monsters never starred in another *Kaiju Eiga* (although Tsuburaya used many variations in his **Ultraman** television series). The creatures themselves were highly unusual for *Toho*, their translucent bodies made them impossible candidates for the traditional *man-in-a-rubber-suit* concept. Instead, they are computer animated monsters.

The Dogora were gluttonous octopus-like creatures who lived in the skies above Japan. Initially, they devoured precious gems and raw materials (especially carbon which they absorbed through their tentacles). But after discovering tasty human flesh during an encounter with some hapless thieves, the Dogora switched their attention to cars, trains, boats, etc. Eventually they were stopped by a scientist who discovered they had an allergic reaction to wasp venom. Grudgingly entertaining, but considered a lesser film from director **Honda**.

DOGURA MAGURA (1988)
[Dogura Magura]
director: Toshio Matsumoto
Shijaku Katsura • Yoji Matsuda
**½

This fantasy/horror film is based on the novel written by **Kyusaku Yumeno**, a book often called "impossible to film." Perhaps that's what initially drew director **Matsumoto** to the project. After such avant-garde films as **Funeral Procession Of Roses** (1969) and **Bloodshed** (1971), he was no stranger to difficult jobs.

A young Chinese man is confined to a mental clinic after he tries to kill his fiancee. Two enthusiastic doctors attempt to relate his problems to an Oriental philosophy which teaches that the brain has innate defects passed from generation to generation {a similar theme is explored in **Star Of Dave: Beauty Hunting** [1979]}. Via an extended flashback to feudal times, a distant relative kills his wife to demonstrate a point to his lord as he attempts

to show the emptiness of lust against the importance of love. To further explain his premise, the man begins a task of sketching his wife as she slowly decays.

Ultimately, this movie doesn't translate well to the screen. The gore effects are interesting and the camera-work is superb. But it remains a confusing tale of unquenched desire, ultimately leading to complete insanity, with little explanation along the way except "that's destiny." The whole thing is constructed more like a maze than a movie.

▶ **DON MATSUGORO'S LIFE** (1986)
[Don-matsugoro No Seikatsu]
director: **Shinichi Nakata**
Tomomi Nishimura ● **Gin Maeda**

❖

▶ **DON MATSUGORO'S
GREAT ADVENTURE** (1988)
[Don-matsugoro No Daiboken]
director: **Shuji Goto**
Risa Tachibana Ken Ishiguro
*

Here's the equivalent to a Japanese *live-action* **Disney** movie. A genius dog named Don Matsugoro uses a word processor and types the sentence: "All dogs understand human language." This leads to instant panic among the humans in the cast, causing them to do a rash of uncharacteristically stupid things. Don unites his fellow dogs and comes to the rescue after a group of would-be dog-nappers cause a fire.

In **#2**, Don Matsugoro and his son Don Jr fight against a disgustingly rich family who tries to take over a kid's playground called Children Land. One of the film's *high points* features Don and son on air-gliders barking their instructions to other furballs.

The same director went on to make **Beast City** (1996). However, Don Matsugoro didn't survive this lame sequel.

DONOR (1996)
[Donor]
director: **Masato Sasaki**
Aya Sugimoto ● **Shinobu Nakayama**
 and **Takanori Kikuchi**
******½

This is an absurdly wonderful medical/horror film dealing with the tribulations of a brilliant doctor who wants an offspring "to continue the family's great tradition." Apparently he's not impressed with the conventional methods of reproduction, so he begins experiments in DNA cloning. The outcome is disastrous, resulting in mounds of body parts and goo, but soon he succeeds in creating a living clone. The problem is his *twin* matures at an accelerated speed and must be kept in check with a constant diet of blood and other bodily juices. In the meantime, the *brilliant* doctor decides to undergo a sex change (at least that will bring him a couple steps closer to *normal* procreation). Then— and this is a first— he marries his clone!

After this revolutionary solution to "creating one's own likeness," female patients in the hospital start getting attacked and butchered, their genitalia removed. Seemingly, the doctor is trying to piece together the perfect womb and uterus for insertion into his/her own body.

Shinobu Nakayama in *Donor*

Singer **Aya Sugimoto** is the doctor (post sex-change, of course) and **Shinobu Nakayama** (from Hong Kong's **Fist Of Legend** with *Jet Li* [1995] and **Gamera Guardian Of The Universe** [1995]) plays the new nurse who notices a lot of strange things going on. **Takanori Kikuchi** is the doctor's retarded brother who lives in the basement of the hospital and helps with the messier dismemberments.

Despite the outrageous plotline, director **Sasaki** constructs his film in typical horror fashion, with all the usual trappings. There are far too many scenes of inquisitive nurses creeping down long dimly lit corridors. And, on the ludicrous level, what are the chances of a finely orchestrated thunder storm popping up everytime something scary is about to happen?

DON'T WORRY,
 MY FRIEND (1983)
 [Daijobu, My Friend]
director: Ryu Murakami
Peter Fonda • Reona Hirota
****½**

Peter Fonda is an alien from another galaxy in this quirky musical fantasy, filmed long after after the *Easy Rider* phenom and 15 years before his *Ullie's Gold* comeback. In this one, Peter does what he did best during the lean years— he appears bewildered.

Peter Fonda in *Don't Worry, My Friend*

The movie commences in the United States where Peter has a quasi-religious following. His disciples whisper about "miracles" and his ability to "cure the soul." The media calls him *the savior.* Now, time has come for Peter to return to his home planet. But sadly, he has lost his ability to fly. And even sadder, Peter doesn't realize it until he's already airbound. The *bewildered* alien crash-lands in a swimming pool near Tokyo. Three kids are amazed by his splashy entrance and they decide to take care of him (think **ET** here). Their altruistic assistance gives Peter the strength he needs to regenerate his super powers. Eventually, after a neighborhood talent show and a bicycle race (keep thinking **ET**), he flies into space.

Besides making this goodhearted *clone* of **Steven Spielberg**'s box office champ, **ET** (1982), Fonda also made a facsimile of **Close Encounters Of The Third Kind** (1977), an Italian produced film called **Sound** (aka *Close Encounter*) in 1984 for director **Biagio Proietti**. Neither movie has found a release in the United States.

▶ **DOOR** (1988)
 [Doa]
director: Tomoaki Takahashi
Keiko Takahashi • Daijiro Tsutsumi

❖

▶ **DOOR 2:** (1991)
 [Doa 2]
 aka **DOOR 2: TOKYO DIARY**
director: Tomoaki Takahashi
Chikako Aoyama • Jo Yamanaka

❖

▶ **DOOR 3** (1996)
 [Doa 3]
director: Kiyoshi Kurosawa
Minako Tanaka • Akiyasu Nakazawa
Tomoko Mayumi • Ryo Amamiya
****½**

A young housewife (**Keiko Takahashi**) is not having a good day. Her husband is *never* home, the rent is late, her kid has caught flu, and now— someone's at the door. It's a salesman, trying to pawn off some stupid thing or other. There's no time to deal with it. Just tell him to go to hell, to peddle his goods someplace else. And then, when he doesn't listen, she slams the door in his face. Or more accurately, on his hand. And this guy is pissed. The psycho salesman decides to teach her a lesson. He starts making phone threats. Soon the sick bastard has mustered up enough guts to break into her apartment. He savagely torments mommy and child until the woman finally turns the tables and kills him.

#2 is a sequel in name only. This one is about a callgirl named Ai (**Chikako Aoyama**). She likes her job, both for the freedom it provides and its unique sense of danger. She also likes the sex. Lately, Ai has been seeking out kinky clients, and soon she gets one who pushes her *danger* quota to the edge. Then beyond.

The sequel is the more ambitious of the first two films, but it suffers from depending on a lead character who is too "off-center" to garner a sympathetic reaction. Unlike **Takahashi**'s conventional mom in *#1*, there is little affinity between Ai and the audience in *#2*. The character's motivation is never clear. Accordingly, her problems seem to be the consequence of her own corrupt lifestyle.

On the other hand, the more familiar it-could-happen-to-you intrigue of the first film delivers a frightening sucker punch to the belly. Former *Nikkatsu* starlet **Keiko Takahashi** is very convincing as the beleaguered heroine, nicely orchestrated by her director/ husband **Tomoaki Takahashi**. Before mar-

Door

riage, Keiko acted under the name *Keiko Sekine* {best known for **Love Letters** [1981]}.

As expected, *#3* is not related to either of the first two entries. Director **Kiyoshi Kurosawa** (the talented filmmaker from *Juzo Itami*'s Productions, responsible for the stylish horror film **Sweet Home** [see separate listing]) has created a scary tale owing more to *David Cronenberg*'s **They Came From Within** than the *Door* series. Here, Kyo (**Minako Tanaka**) is a door-to-door insurance saleswoman who meets a very charming man, Mitsuru (**Akiyasu Nakazawa**) during her solicitations. Although he's handsome and refined, she finds herself drawn to something else, a "wild impulse" which he seems to emit. Kyo begins dating Mitsuru, and soon finds herself involved in strange — even sadistic — sexual games which would normally be out-of-character for her. Apparently Kyo is the victim of an an aphrodisiac parasite which feeds on female hormones, a parasite developed by Mitsuru himself for the purpose of "controlling women."

Dragon Blue

DRAGON BLUE (1996)
[Dragon Blue]
director: Takuya Wada
Hiroko Tanaka • Keiji Muto
Tomoroh Taguchi • Ryo Hayami
**½

Mayuko (**Hiroko Tanaka**) is a scientist who visits Miyajima Island for her oceanographic research. There, she learns about the legend of the "Dragon God and the Sea Devil." The woman also discovers that she is, in fact, a descendant of the Dragon God.

In typical fashion, it's not long before a few native girls are missing, and the villagers become convinced it's the work of the dreaded Sea Devil. Then, adding credence to the island hysteria, Mayuko makes an unnerving discovery during an underwater dive. She finds that a sacred chain, which had protected the island from evil spirits, is broken. At this point, there's no question about it; undoubtedly the Sea Devil is back and he's chowing down on island beauties. Mayuko lends her help to a detective (**Keiji Muto**) who is searching for the missing girls. Eventually the two become trapped by the giant sea monster in his underwater lair. Mayuko becomes possessed by the spirit of her ancestral Dragon God and she transforms into the good creature to soundly destroy the gluttonous Sea Devil.

This one works on the "old-time" chiller level, similar to the Filipino *Beast Of Blood* films (1969-1972). The special effects are above average and and quite gory. The monster, created by FX maestro **Steve Wang** (of **Relic**, **Beetlejuice**, and **Predator** fame), is far beyond the *man-in-a-rubber-suit* variety.

DRACULA'S LEGENDARY AFTERNOON
see **EMOTION**

DREAM DEVIL (1995)
[Muma]
director: Ryuichi Hiroki
Tomoko Mayumi • Tomoroh Taguchi

An award-winning *Nikkatsu* film from director **Hiroki**, one member of the trio that made movies under the pseudonym *Go Ijuin* {see **Captured For Sex 2**}. This film, called "the virtual reality sex movie" by *Eiga-geijustsu Weekly*, is the very essence of avant-garde cinema. The story constantly takes unusual twists, suckering the viewer into unexpected territory, then snapping him back with a dose of reality. After a while, one can't help but wonder if any of it is really happening.

A bus driver suffers from an erotic childhood trauma. He remembers being bullied by a gang of school kids. A prostitute rescues him and then applies

Tomoko Mayumi in *Dream Devil*

ointment to his bruises. In turn, he puts the medication on her breasts which were apparently burnt by some cigarette-smoking freak during a rough S&M session.

Meanwhile, there's an office lady who makes money on the side as a hooker. Or maybe not. It's also possible that she's only fantasizing about turning tricks. But one thing is certain, she does have nightmares about a john burning her chest with a cigarette. Soon, the bus driver and the office lady meet and they become hopelessly entwined in their shared dreams. He envisions himself raping and killing her. Or perhaps he really does. She has the scars to prove it. But then, if that were true, wouldn't she be dead? And so it goes.

Akira Kurosawa's *Dreams*

Akira Kurosawa's *Dreams*

collection of eight vignettes, at least three too many, with varying degrees of success. Only one dream, with mountain climbers trapped in a ravishing blizzard, reflects the grand style of **Kurosawa**. Other sketches (*e.g,* American director **Martin Scorsese** as a malcontent Van Gogh) are, at best, unfinished miscellany.

Another dream, **Tunnel**, portrays a military officer haunted by ghosts of soldiers who died on the battlefield because of his carelessness. Regardless of the **Kurosawa** imposed moniker, this is actually based on a script written by cult/**Godzilla** filmmaker **Ishiro Honda**. Insiders insist this segment, and maybe others, were directed by Honda not Kurosawa; for the record, **Honda** is credited as the Assistant Director.

DREAMS (1990)
[Yume]
aka **KUROSAWA'S DREAMS**
director: **Akira Kurosawa**
Akira Terao • Martin Scorsese
Mitsuko Baisho • Mieko Harada
** (or **½)

This is pale filmmaking, a fraction of the scope and pageantry which made **Akira Kurosawa** the most renowned Japanese director in the world. But the movie, like the filmmaker himself, is *tired* and *old*.

It's supposed to be the visual re-enactment of 80 year old **Kurosawa**'s most poignant dreams. And as such, this is a

DRIFTING CLASSROOM (1991)
[Hyoryu Kyoshitsu]
director: **Nobuhiko "Obi" Ohbayashi**
Yoshiko Mita • Yashufumi Hayashi
Aiko Asano • Troy Donahue
**

This film can only be called a missed opportunity. Based on an extremely popular *manga* (comic book) by **Kazuo Umezu** about a Middle-School getting swallowed up in a "time slip" was greatly anticipated by its legions of fans. But here's a prime example of the

production not matching the scope of the project.

It's a paradox. There are many good things about the film. For example, the opening sequence, including the devastating time-shift which catapults the school into an alternate universe, is immensely effective. But then, this segment is followed by long murky scenes, *intentionally* too dark. For example, when giant insects invade the building, the visuals become so amorphous it's impossible to tell what's going on. This fuzzy footage is mixed with quick close-ups of kids screaming, supposedly a technique designed to give the audience a chance to use it's imagination. But, in reality, this is old trick from B-directors who didn't have a special effects budget.

However, here's the puzzle. Big dollars *were* spent. The sets are amazing, the mat-work is among the best seen in any SciFi adventure. And some of the incidental creatures are FX masterpieces. Yet there's no consistency.

Brilliant scenes follow ludicrous one like some kind of weird Mardi Gras parade. And, to make matter worse, they don't follow each other very well. The film has an annoying episodic quality, with far too much time spent on incidentals and not enough thought given to a centralized theme.

Troy Donahue in *Drifting Classroom*

Yet, all of these things could be forgivable in the grander scope of things. The biggest problem with the movie is the English speaking actors. Here is a collection of embarrassing performances, including a really bad one from former-heart-throb-*cum*-cult-actor **Troy Donahue**. One wonders why the producers found it necessary to make this an "international English-speaking school" in the first place since the original one in the comic book was an "average Japanese middle school." Perhaps they were hoping for an International release.

Director **Ohbayashi** had much better results with **House** (1982) and **Summer With Ghosts** (1989).

EAST MEETS WEST (1995)
[East Meets West]
director: **Kihachi Okamoto**
Hiroyuki Sanada • Ittoku Kishibe
Naoto Takenaka • Tatsuya Nakadai
ENGLISH SPEAKING ACTORS:
Angelica Rome • Jay Carr
Scott Bachita • Richard Mason
**½

A fantasy rooted in history, but ironically this is a cockeyed interpretation of *American* history, presumably more inspired by *John Wayne* movies than facts. In 1860, a band of ninjas led by Tamajiro (**Hiroyuki "Henry" Sanada**) are dispersed on an assassination mission to the United States (where most of the motion picture was filmed). Their job is to find and kill an ambassador who stole money earmarked for struggling Japanese families in San Francisco.

The film follows the adventures of these ninjas as they try to slip into the American culture. There are gunfights, robberies, and all the usual trappings found in every typical American Western. Eventually these magic warriors befriend a tribe of Indians. Tamajiro

marries the chief's daughter (**Angelica Rome**) and the ninjas infiltrate the tribe. Under Tamajiro's guiding hand (he becomes the chief and lives to the age of 144), these indians create their own sovereign state, prospering in harmony with the American settlers.

The English-speaking cast-members are virtually unknown entities in the States. The only one with *any* acting experience is **Richard Mason** who also starred in various *Andy Milligan* features, including **Torture Dungeon** (1970) and **The Rats Are Coming... The Werewolves Are Here!** (1972).

EDA (1976)
[Futari No Iida]
director: Zenzo Matsuyama
Kenichi Ueya • Yuko Haraguchi
**

A brother and sister, Naoki (**Kenichi Ueya**) and Yuko (**Yuko Haraguchi**), move to Hiroshima with their magazine editor mom. One day, while exploring the forest behind their new home, the children meet a talking chair. Seemingly, the chair has been waiting decades for the return of a girl, Eda, who died in the WW2 Atomic Bomb explosion. Believing that Yuko is the reincarnated spirit of the dead girl, the chair proceeds to tell her of the horrors and devastation caused by the deadly war.

The story based on a famous anti-war poem written by *Miyoko Matsutani* which focuses on the tragedy of the Hiroshima bombing. Too bad this great humanistic litany has to be told through a talking chair.

EIGHT SAMURAI
see **LEGEND OF THE EIGHT SAMURAI**

EIGHT TOMBSTONE VILLAGE
see **KINDAICHI** series

Elementary School Ghost Story

ELEMENTARY SCHOOL GHOST STORY (1995)
[Gakko No Kaidan]
director: Hideyuki Hirayama
Hironobu Nomura • Masumi Toyama

❖

ELEMENTARY SCHOOL GHOST STORY 2 (1996)
[Gakko No Kaidan 2)
director: Hideyuki Hirayama
Hironobu Nomura • Naomi Nishida
**½

Based on the bestselling book series, *School Ghost Stories*, scary ghost stories written by grade-school students. The tales deal with *true* legends from schools all over Japan {also see **Hanaka In The Restroom** [1995], a similar film based on the same collection of books}.

In **#1**, a girl uses the restroom in the dilapidated building next to the school. When she doesn't return, her sister (**Masumi Toyama**) goes searching for her. Inside, she meets other students who are also wandering around. Soon everyone realizes they're locked inside. As night falls, they are terrorized by a wide variety of ghosts, skeletons and goblins. Worried parents contact a teacher (**Hironobu Nomura**) and he breaks into the old building. It doesn't take long for him to get caught up in the darkside bloodbath. Eventually, the

surviving members of the cast escape through a black hole which transports them into the school swimming pool.

#2 finds a bunch of urban kids visiting a school in the countryside. The locals play "chicken" games with the students from the city, daring them to run through the school during the haunted 4:44 time. There's a legend in the community which prophecies that every April 4th at 4:44 PM, "something supernatural" will happen inside the school. And sure enough — at least this year — it does. The doors all lock, the windows bolt themselves shut, and the city-slickers get trapped inside. Ghosts and goblins show up, apparently slipping in from the temple next door.

These two films have been described as a trip through an amusement park funhouse. Many critics praised them as a conceptual return to the classic goblin films of the late '60s (*e.g.*, **Hundred Monsters** [1968], **Big Monster War** [1968], **Tokaido Road Monsters** [1969]). Although initially conceived as children movies, in the capable hands of **Hideyuki Hirayama**, they became much more. This is the same director who thrilled audiences with **Maria's Stomach** {see separate listing}. Cult fans should take note of his name.

Elementary School Ghost Story 2

EMBRYO
see **WHEN EMBRYO GOES POACHING**

EMOTION: DRACULA'S LEGENDARY AFTERNOON (1966)
[Emotion: Densetsu No Gogo=Itsukamita Dracula]
aka **MY NAME IS DRACULA**
director: Nobuhiko *Obi* Ohbayashi
Jinichi Ishizaki • Mitsu Mori
Keiko Machida • Jusin Kitamura
**

With dreams of becoming a feature film director, **Nobuhiko Ohbayashi** raised the money for this experimental short movie (40 minutes) while he was working on television commercials for Calpis Soft Drink. Obi admits that this film is an homage to his favorite movie, *Roger Vadim*'s **Blood And Roses** (1961). "May these two spirits join," the director says during the prologue.

Emi, a girl from a small sea village, visits the big city. There she meets Sari. The two girls become instantaneous friends, and possibly lovers (as suggested by *Sheridan Le Fanu*'s **Carmilla**, the original source material for both **Blood And Roses** and this film). Sari's parents are a sensuous couple, perhaps vampires, who want to have a sexual liaison with the girls. It all ends in a "spaghetti western" influenced showdown, afterwhich Emi is savagely assaulted in a surrealistic crimson-colored rape sequence.

The production is purposely disjointed, made even more fragmented by a parade of quick edits and jarring stop-motion photography. Seemingly, Obi was strongly influenced by the fads of the mid-60s, creating an odd mixture of surreal nihilism, or better yet, *psychedelic noir*. Fortunately, over the next few years, he managed to retain his quirky sense of amalgamation but he also learned the necessity of cohesive story-telling. He went on to write and direct some of Japan's best fantasy and horror films (*e.g.*, **House** [1982], **Summer With Ghosts** [1989], *et al*).

ENTRAILS OF A BEAUTIFUL WOMAN (1986)
[Bijo No Harawata]
aka GUTS OF A BEAUTY
director: Gaira (Kazuo Komizu)
Megumi Ozawa • Kazuhiko Goda
**½

An early entry in **Gaira**'s splatter-eros trilogy which also includes **Entrails Of A Virgin** [1988] and **Female Inquisitor** [1987] {see separate listings}. These films are odd hybrids, essentially horrific porno movies.

A female psychologist (**Megumi Ozawa**) fights back when one of her patients commits suicide after being raped by a yakuza toughguy. However, the lady doctor is tricked by the same man; she is trapped, raped and killed. Megumi gets buried with the dismembered body of a gangster from a rival gang. As one might expect, her vengeance can't be stopped by the grave, but apparently it can be *transmutated*. Megumi emerges as a hermaphrodite[1] zombie-creature who proceeds to take a savage revenge on the Yakuza enemy.

Although it's much more mean-spirited and degrading, this film is conceptually similar to the American slasher films of the '80s (**Friday The 13th** [1980], *et al*). The preoccupation is on the *carnage*, with particular emphasis on unique methods of killing. For example, the yakuza Big Boss has a nymphomaniac wife. This woman is forced to perform fellatio on the monster's penis. During the act, she is suffocated by the creature's vagina. Some of the other murders are exceptionally gory, with lots of dismembered limbs and spurting blood. **Gaira** is obviously influenced by the popularity of the **Herschell Gordon Lewis** films (even in Japan, Herschell is recognized as the Godfather of Gore).

[1] an hermaphrodite is an organism with both male and female genitals; arguably this is the first, and perhaps only, hermaphrodite monster in the annals of world horror cinema.

ENTRAILS OF A VIRGIN (1986)
[Shojo No Harawata]
aka GUTS OF A VIRGIN
aka ENTRAILS OF A WHORE
director: (Gaira) Kazuo Komizu
Saeko Kizuki • Naomi Hagio
Kazuhiko Goda • Taiju Kato
**½

Models and their professional crew, returning from a rural photo-shoot, take refuge in an old house after the highway is closed by dense fog. After an evening of abusive sex games, they are systematically murdered by a creature who rises from a nearby swamp. Many unlikable characters are graphically slaughtered; the females get raped before being killed. One girl goes bonkers from the bloody carnage and starts masturbating with her boyfriend's severed arm. There's only one survivor, a girl impregnated by the swamp thing. The movie closes with her pondering over the type of baby she will have.

Director **Kazuo Komizu** signs most of his movies with the *Gaira* pseudonym, probably inspired by the name of the evil green monster in **War Of The Gargantuas** (1966). To date, his most financially successful film has been **Living Dead In Tokyo Bay** (1992). But he is best remembered for his series of *splatter-eros* films (which includes **Entrails Of A Beautiful Woman** [1986] and **Female Inquisitor** [1987] {see separate listings}), and this movie.

ESCAPE OF MECHAGODZILLA
see TERROR OF MECHAGODZILLA

ESP SPY (1974)
[Esupai]
director: Jun Fukuda
Hiroshi Fujioka • Kaoru Yumi
Masao Kusakari • Tomisaburo Wakayama
*

As typical of most Fukuda films[1], this one plays like it's half finished, with a directionless plot that does little more than embarrass an otherwise competent cast. Loosely based on novel written by **Sakyo Komatsu** (pop SciFi writer, best known for his self directed **Sayonara Jupiter** in 1985), this one is a *psychic* actioner about a bad ESP syndicate planning to kill world leaders through mental telepathy. The good guys are a top secret group called *ESPY* (a cutesy Japanazation combining ESP and SPY) and they're in charge of stopping the killer psychics.

Hiroshi Fujioka, one of the original *Kamen Riders*, does everything he can to save the movie, but it's not enough. Veteran actor **Tomisaburo Wakayama** looks like he'd rather be visiting the dentist. And **Kaoru Yumi**, a former professional classical dancer, has a chance to strut her stuff in an erotic dance sequence — wildly out of place in this film.

[1]**Jun Fukuda,** is often called a *poor man's Ishiro Honda,* as he directed five of the second wave **Godzilla** films starting with the truly awful **Godzilla Vs the Sea Monster** (1966) continuing through the equally rancid **Godzilla vs Megalon** in 1973 (featuring big G fighting a mutant chicken named Borodan).

EVENING CALM BATTLE LINE: **AUGUST EDITION** (1994)
[Yunagi-sensen 8-Gatsu-go]
director: **Ohji Suzuki**
with **Takashi Hayashi**
*

Directed by manga writer **Ohji Suzuki**, this 50 minute short film was released as the bottom part of a double bill with **Twilight** {see separate listing}.

One summer evening, a boy playing baseball goes after a ball lost in the brush. There, in the thicket, he meets a middle aged man reading a magazine called *Evening Calm Battle Line*. The boy returns to the ballgame but he can't stop thinking about the man in the bush with the magazine. Another foul ball gives the youngster the opportunity to check things out again, but the man and magazine are gone.

Is there something symbolic going on here? Perhaps a hidden metaphor or something?anything?

▶ **EVIL DEAD TRAP** (1988)
[Shiryo No Wana]
translation: Trap of the Dead Ghost
director: **Toshiharu Ikeda**
Miyuki Ono • **Fumi Katsuragi**
Hitomi Kobayashi • **Eriko Nakagawa**

❖

▶ **EVIL DEAD TRAP 2:**
 HIDEKI (1991)
[Shiryo No Wana 2: Hideki]
director: **Izo Hashimoto**
Shoko Nakajima • **Rie Kondo**
Shiro Sano • **Shino Ikenami**

❖

▶ **EVIL DEAD TRAP 3:**
 BROKEN LOVE KILLER (1993)
[Shiryo No Wana:
 Chigireta Ai No Satsujin]
director: **Toshiharu Ikeda**
Shiro Sano • **Megumi Yokoyama**
***½

#1 is similar to American slasher flicks, but the real story drifts into uncharted territory. After all, not many movies end with a man giving birth to his split personality.

The whole thing starts with late-night talk show hostess Nami (**Miyuki Ono**) receiving a mysterious tape in the mail. It's a snuff video. She watches in disbelief as a girl is mercilessly killed (the blade-into-an-eyeball sequence is *the* most graphic you'll ever see). Nami and her crew decide to play detective and get the scoop behind the video. They follow clues and end up at an abandoned factory in the middle of

nowhere. Each member of the group is murdered in the most hideous ways imaginable until the film climaxes into a confrontation between Nami and the demented killer.

#2 tells the story of Aki (**Shoko Nakajima**), an overweight unattractive girl who "lives a hermit existence" as a projectionist in a neighborhood theater. She passes time by killing prostitutes, butchering them and cutting out their stomachs. Eventually, Aki becomes involved in a deadly love/hate relationship with her beautiful friend Ami (**Rie Kondo**). The conflict between the two girls is heightened by the sexual aggressions of a mutual boyfriend (**Shiro Sano**). In short, he beds them both. Ami gets pregnant; Aki gets jealous. This is the catalysis for the film's blood-bath finale.

#3 deals with a policewoman, Nami (not the same *Nami* as in **#1** [every screenplay written by **Takashi Ishii** has a character named *Nami*; it's his signature], this is a new character played by **Megumi Yokoyama**, *Princess Saki* from **Renegade Robo Ninja**). She is investigating the supposed suicide death of a university student. Clues lead to a professor (**Shiro Sano**) who may — or may not — have been sexually involved with the girl. Nami stakes out the teacher's house, and ends up shadowing his wife to a lesbian bar, a particularly creepy scene which ends in shocking axe assault. After the dust settles, the policewoman discovers the mutilated body of a dead woman. But the professor and his wife aren't around for interrogation, it appears they've left the city for their resort home near the beach. When yet another headless/limbless corpse is discovered on the seashore, Nami realizes she's dealing with a serial killer. But nothing could prepare her for the real truth.

Arguably, these three entries are best of the contemporary Japanese horror films. While each is distinctly different in plot *and* execution, #1 and #3 were written by **Takashi** *[Gonin]* **Ishii** (see *Angel Guts* in *Japanese Cinema: Essential Handbook* for overview of

Toshiharu Ikeda's *Evil Dead Trap 1*

Ishii's work) and two were directed by the same man, **Toshiharu Ikeda** {see **Mermaid Legend** [1984] and **XX: Beautiful Prey** [1996] *et al*}. The second installment was written and directed by **Izu Hashimoto** who also made **Bloody Fragments On White Walls** (1990). He is a highly successful scriptwriter responsible for the animated **Akira** (1988), **Drifting Classroom** (1991) and **Sukeban Deka**— both the TV series and the feature films (1983-1988). Actor **Shiro Sano**, who stars in **#2** and **#3**, can be seen in many other films including **Scared People** (1994). He started his career in Tokyo's leading Experimental Theater called *Jokyo Gekijo*.

#1 is obviously inspired by the European thrillers, especially the films of **Dario Argento**. Even **Tomohiko Kira**'s music is remarkably similar to **Claudio Simonetti**'s score for **Deep Red** (1975). On the other hand, **#2** is told as a first-person narrative, a technique virtually unused in cinema art. While the two films differ considerably in treatment, they are very similar in composition. Both of them dive deeply into excessive blood-n-gore for their climax, with little regard for continuity. **#3** is different yet again from the first

two. In many ways, it is a better written movie, relying more on character development and a complex story-line than mindless splatter. If the influence for **#1** was *Argento*, **#2** and **#3** had to be motivated by *David Lynch* and *Alfred Hitchcock* respectively.

EVIL OF DRACULA
 see **BLOOD THIRSTY ROSE**

EVIL WOMAN (1976)
 [Youba]
 aka **EVIL OLD WOMAN**
 director: Tadashi Imai
 Machiko Kyo • Rentaro Mikuni
 **

Made during the boom of "foreign" thrillers (supposedly inspired by the huge box-office hits **Exorcist** [1973], **Omen** [1976], and **Suspiria** [1976]), this film was promoted as the Japanese equivalent to "the imported psychological terror pictures." But unfortunately it failed to deliver on the promise. Instead *Evil Old Woman* is little more than a bloated *human-interest drama*.

Veteran actress **Machiko Kyo** (the star who initially found fame in *Kurosawa*'s **Rashomon** (1950) and continued helming major projects for more than 30 years, *e.g.*, **Gates Of**

montage of scenes from *Evil Dead Trap 2*

Evil Woman (Evil Old Woman)

Hell [1953], **Street Of Shame** [1957], **Black Lizard** [1962], *et al*) plays the lead here, a part that demands a range from teenager to elderly woman. And her performance is impressive. However, the "ghosts" promised by the advertising campaign turn out to be "personal ghosts" which haunt this jealous woman's life. As strong-willed Machiko struggles with her demons, she is constantly fighting madness until it finally engulfs her in the end.

Although enjoying some critical accolades, including a special Nippon Academy Award, this angry film failed to attract an audience.

▶ **EXORSISTER** (1994)
[Uratsukidoji:[1] Hakui Jigoku-hen]
translation: **White Uniform Hell**
director: Takao Nakano
Kahoru Katagiri ● Waki Taniguchi
 and **Ban Ippongi**
****½**

❖
▶ **EXORSISTER 2** (1994)
[Uratsukidoji: Daiinshin Fukkatsu-hen]
translation: **Rebirth of Great Lust God**
director: Takao Nakano
Yumika Hayashi ● Anri Inoue
 and **Ban Ippongi**

❖
▶ **EXORSISTER 3** (1995)
[Uratsukidoji: Joyou Senmenki-hen]
translation: **Female with 1000 Faces**

director: Takao Nakano
Ban Ippongi ● Yuri Ishihara
****½**

❖
▶ **EXORSISTER 4** (1995)
[Uratsukidoji: Makai Gakuen]
translation: **Hell School**
director: Takao Nakano
Karin Tsuji ● Kaoru Nishida
 and **Ban Ippongi**

[1] **Urotsukidoji** (Wandering Kid) is the title of the first adult animation from Japan, a series which mixes hard-core sex with extremely graphic violence; despite the similar Japanese title here (*Uratsukidoji*), the "Exorsister" films are not officially related to the infamous XXX animated series. Producer Nakano has simply created a bogus word to imply a similarity. "Uratsukidoji" has no meaning in the Japanese language.

This low-budget series (apparently shot on Betacam) offers some creative gross-out special effects and a collection of cute girls who spend a plethoric amount of screen time in the nude. The stories are functional at best, merely providing ample opportunity for the excessiveness.

In **#1**, *White Uniform Hell*, a horny tentacled creature with poisonous jets of jisum attacks nurses. The besieged hospital calls female monster hunter, exorsister Maria Cruel (**Ban Ippongi**) for help.

The second one, *Rebirth Of The Great Lust God*, finds a bevy of conservative female office workers being transformed into sex starved creatures who attack their co-workers. They are being controlled, like puppets, by the almighty Lust God. Once again Maria Cruel — wearing her black cape and cowboy hat — comes to the rescue.

The third, *Female With 1000 Faces*, is set inside a school where a decaying monster needs the blood from virgins to regain his strength. He wastes no time attacking the school girls. As with the previous episodes, cigar-smoking Maria Cruel saves the day.

Exorsister (Uratsukidoji)

And **#4,** *Hell School*, returns to the classroom for its cheap thrills. Once again, young coeds are attacked and raped by the poison-tongued sex beast. Maria Cruel uses her sacred weapons against the slimy tentacled monster.

Ban Ippongi, famed manga illustrator, plays the Exorsister in each of the films. Her tongue-in-cheek performance is endearing. Armed with a six-gun and a razor-edged crucifix, she fights all the nasty creatures from Hell and — never once — gets a run in her fishnet stockings.

Director **Nakano** has accomplished a lot with a very limited budget. But, then cheesiness is an intricate part of the film's charm. It's obvious that he's a fan of the 60s. And *political correctness* is a term that has no meaning in his world of sex beasts and catfighting girls.

FACE OF ANOTHER (1966)
[Tanin No Kao]
director: Hiroshi Teshigahara
Tatsuya Nakadai • Mikijiro Hira
Kyoko Kishida • Eiji Okada

A man's face is disfigured in an industrial accident. When he returns to society, the "faceless" man feels detached. He no longer fits because now he's different from everyone else. When the wounds heal, he is fitted for a mask. Even though it's a life-like disguise— it's still a disguise none-the-less. And so, the man feels even more alienated because he believes everyone knows he's wearing a mask.

Obviously, this movie is most effective as an allegory dealing with man's perception of himself and his communicative abilities within society, especially the encouraged "double face" standards of the Japanese society. Often films of **Hiroshi Teshigahara** dealt with similar themes of alienation, rejection and subservience (*i.e.,* **Woman In The Dunes** [1964] and **Ruined Maps** [1968]). Interestingly, most every **Teshigahara** film is an adaptation of a **Kobo Abe** novel.

This one is highlighted by moody black-and-white photography reminiscent of **James Wong Howe**'s harrowing work in **John Frankenheimer**'s stunning film, **Seconds** (also 1966). The two films have strikingly similar plotlines.

Face Of Another

FEAR FOR THE MUMMY (1958)
[Yami Ni Hikaru Me]
 aka **TERROR OF THE MUMMY**
director: Masakura Tamura
Mako Sanjo • **Rokuro Matsubara**
*½

Several episodes from a Nippon television series edited together for a quick theatrical run. Some of the mummy stuff is quirky (*i.e.*, stealing the coat and hat from a man he just killed, and slipping unnoticed into a neighborhood bar) but most of it is hopelessly dated, with the typical kid-in-peril subtext. **Bob Strickland**, an American '40s bit-actor (*e.g.*, the *June Allyson/Peter Lawford* vehicle **Good News**), also has an extended cameo. Does anyone even remember who he is?

FEMALE BODIES
 ARE DISAPPEARING (1967)
[Jotai Johatsu]
director: Seiichi Fukuda
Yuki Izumi • Michiko Sakyo
Midori Enoki • Hachiro Tsuruoka
**

Here's a sadistic twist on the "mad scientist" tale. Professor Ejiri (**Hachiro Tsuruoka**) is a respected college teacher who secretly captures girls for his unorthodox experiments in pain endurance. He roams the streets of Tokyo searching for naive office girls (**Yuki Izumi** and **Michiko Sakyo** are kidnapped early on and tortured throughout the film). Sometimes he snatches a pretty bar hostess, like **Midori Enoki**. Eventually, Ejiri's ex-wife becomes suspicious and goes to the police.

Michiko Sakyo has also made films under the name **Michiko Sakamoto**, her most famous being *Koji Wakamatsu*'s **Violated Angels** (1967). **Yuki Izumi** became part of sleaze-meister *Giichi Nishihara*'s troupe, starring in such infamous pink films as **Abnormal Passion Case: Razor** (1977) and **Please Rape Me Once More** (1976). Some source books insist that she's married to director Nishihara.

FEMALE DETECTIVE
 see **MURDER FOR PLEASURE**

FEMALE INQUISITOR (1987)
[Goumon Kifujin]
director: Gaira (Kazuo Komizu)
Keiko Asano • Saeko Kizuki
Ayu Kiyokawa • Hitomi Kazama

Hiroko Ichijo (**Keiko Asano**) is a descendent of the royal family; her ancestors were the original judges and executioners of the ancient Nippon Inquisition. Today, in modern Tokyo, Hiroko has an *underground* company called *JII*, Japan Inquisition Inc. Essentially, she and her assistants capture criminals — mostly thieves and embezzlers — and torture them until they reveal the whereabouts of their stolen loot. Hiroko is amassing her fortune in hopes that, one day, she can buy

Seiko Kizuki yanka on a toenail in *Female Inquisitor*

a castle and live in grandeur with her trusted teammates. She is also a lesbian who pleasures herself constantly with a perky assistant played by **Saeko Kizuki**.

Most of the film deals with the gang's attempt to *break* a self-assured bank manager who has snatched a million dollars from his company. The inquisitors torture both him and his girlfriend until he finally surrenders the combination to his safety deposit box.

Director **Gaira** incorporates his affinity for splatter, S&M, black humor, sex and melodrama (this film is considered another entry in his *splatter-eros* series which also includes **Entrails Of A Virgin** (1988) and **Entrails Of A Beautiful Woman** (1986). The biggest difference between this one and all the other **Gaira** movies is his budget. Since this film was backed by powerful *Nikkatsu Studios*, the director had the necessary funds to hire a competent cast, production assistants and special effects wizards. **Female Inquisitor** is one of **Gaira**'s best looking endeavors.

But despite the high production standards, this motion picture is still recommended for only for acquired tastes. Some viewers will be offended by the surprisingly graphic sex scenes. Others will be nauseated by the casual stream of on-screen violence (which includes dismemberment, ripping off toenails,

yanking out teeth, to mention just a few atrocities). However, the campy script does manage to cushion the mean-spirited theme, ever so slightly.

FEMALE NEO NINJAS (1991)
[Kunoichi Senshi Ninja]
director: Masahiro Kasai
Yuka Oonishi • Senako Fujimoto
Akemi Ohshima • Tetsuro Tanba
Shimon Sumii • Hideyo Amamoto
***½

In the vast world of exploitation there are very few movies so anxious, so willing, to simply do their job: entertain the audience. Director **Kasai** understands his assignment well. He is not making **Rashomon** here. This is, afterall, a goddamn movie about three cute ninja girls fighting crime in contemporary Tokyo. And from the very beginning, when the heroines foil the plans of nasty flesh-traffickers, this film promises to be something special.

It's the story of three female ninjas {headed by **Yuka Oonishi**, one of the **Sukeban Deka** side-girls [*Kazama Sisters*] from motion picture *#2* and *#3*}. They are upset because demand for their services has taken a nose dive and lately they've been having trouble making ends meet. Everything changes when the girls investigate the death of a monk and the disappearance of a sacred scroll. The girls fall into the clutches of a sadistic maniac who strives to control the world through an alliance with beings from outer space.

Even though the plot is outlandish and reminiscent of Saturday morning kid's stuff, the treatment is decidedly *adult*. When one of the perky ninjas tries to get information out of the governor, she poses as a hooker. And after a crime-fighting sister is captured by the bad guys, she's stripped, suspended and viciously whipped. This incredible gem has absolutely everything, but it espe-

cially has a sly hipness and a very black sense of humor. Plus it's also got veteran actor **Tesuro Tanba** playing an extraterrestrial. How can it miss?

FEMALE NINJAS:
IN BED WITH THE ENEMY
see **IN BED WITH THE ENEMY**

FEMALE NINJAS: MAGIC
CHRONICLES series (1989-1995)
[Kunoichi Ninpou-cho] 6 Episodes

This collection is a *series* in concept only. Each film deals with the exploits of new female ninjas. Since **Masaru Tsushima** directed all the episodes, the style is similar and the overriding message is the same: *despite their training and dedication, these ninjas can't control their emotions, especially love.* But don't worry, this lofty theme doesn't keep director **Tsushima** from his true mission of entertaining the audience. He does this two ways, by filling the movies with very attractive nubile ninjas who are experts in magical arts; and by having them get naked a lot.

These ninjas are skilled in an impressive array of lethal tricks. For example, they are ready to kill with "vagina bubbles from hell" or a stream of "acid milk rain" squirting from their breasts. The girls realize their greatest weapon is their body. Through magic they are prepared to use its power whenever an occasion should arise. And that's almost all the time.

Female Ninja: Magic Chronicles

In **#1** the girls are protecting their master's unborn baby. They pass the embryo between one another with unique sexual dexterity as they attempt to keep it from the clutches of their enemy. It's a terrific introduction to the world of female ninjas. And despite the abundance of nudity and supernatural tricks, the story is paramount. It's a fresh new approach for fans who have become jaded by the standard *chambara* films.

#2 is about Christian rebels who get a shipment of gold coins from the Vatican, earmarked as seed money to establish the religion in Japan. Lord Matsuhira wants to get his hands on the treasure and wipe out Christianity. Clues to it's whereabouts are written on a collection of tiny bells inserted, for safe keeping, into the genital area of five female ninjas. At one point Matsuhira muses: "What kind of a religion would hide a bell inside a woman's vagina?" Indeed.

In **#3**, the advisors are worried that their emperor will never have a heir due to his inability to maintain an erection. They send the female ninjas to find and secure a sacred book describ-

the girl warriors from *Female Ninja: Magic Chronicles 4*

ing various sexual techniques. Unfortunately, this book is owned by Lord Nakari and he will not share it. The ensuing adventure makes this the best of the series, filled with well-drawn characters and kinky magic tricks (*i.e.*, Wild Sperm, Bouncing Echo, Magic Hair and the ever popular Rain of Milk plus Vagina Bubbles From Hell).

#4, is the weakest. Unlike the first three films, this one is not based on an original story. Rather, here's a variation on a popular Nihon legend [*Chushingura*] dealing with a conquered lord, reinstated by his loyal samurai bodyguards who organize a counterattack against the new ruler. Director **Tsushima** tries to insert his female ninjas into this traditional tale, but they clearly don't belong.

Regardless of the inherent problems in the previous entry, the next one, **#5**, was released theatrically in 1995 with extensive fanfare. Interestingly, this time, the female ninjas are the villains. The Fujido family loses the heir to the throne in a freak accident, leaving only Princess Mari (**Michiyo Nakajima**), a daughter who cannot inherit the throne. The royal parents force her into a marriage to secure the kingdom. It is arranged, Mari weds Ishigoro (**Takanori Kikuchi**) from the wealthy shogu-

nate family. But he's mentally retarded and Mari hates him. Female ninjas are dispatched by a neighboring providence to seduce the imbecile prince and wreck havoc in the kingdom. A masked superhero named Jaraiya shows up and kills all the enemies of the state. The royal family is saved by *White-Mask*. Princess Mari seduces him and discovers that Jaraiya is really her own husband who isn't retarded at all. He's just very cunning.

It's a big budget production, costing twice as much as #4, but the film still misses the mark. Too much time is spent on the incongruous superhero premise (not a bad storyline, but inappropriate in the *Magic Chronicles*), forcing the female ninjas to take a subordinate role to the real action. This same criticism was lodged against the previous episode. But director/writer **Tsushima** finally puts things back on track for the next installment.

In *#6*, benevolent Shogun Yoshimune of the Tokugawa dynasty secretly has many mistresses, some of whom could be political embarrassments for the empire. Kouga Ninjas, the shogun's sworn enemy, tries to expose the emperor's sexual escapades to discredit him and his court. In retaliation, the emperor's advisors employ their band of female ninjas to find and kill Yoshimune's lovers.

This episode is a deliberate "return to the basics" in concept and style to the first three entries, featuring a heady mixture of sex and bizarre magic tricks (*i.e.*, the ever popular vagina bubbles are back). Plus, in a stunning casting coup, **Yuka Ohnishi** (the popular star of *Female Neo Ninjas* and *Sukeban Deka*) plays the head of the government ninja force who challenges the cruel annihilation policy. It's one of the best episodes in this stalwart collection — an appreciated return to form.

There is every reason to believe this hit series will continue for many years. The best entries are indicated with a symbol (■):

■ **Female Ninjas: Magic Chronicles Protecting The Royal Embryo** (1989)
[Kunoichi Ninpou-cho]
director: Masaru Tsushima
Yasuyo Shirashima • Reiko Hayama

■ **Female Ninjas: Magic Chronicles 2 Secret Of The Christian Bells** (1991)
[Kunoichi Ninpou-cho II: Seishoujo No Hihou]
aka **Secret Treasure Of Girl Saints**
director: Masaru Tsushima
Yuki Sumida • Kenji Yamaguchi

■ **Female Ninjas: Magic Chronicles 3 Sacred Book Of Sexual Positions** (1993)
[Kunoichi Ninpou-cho III: Higi Densetsu No Kai]
aka **Mystery Of Secret Positions**
director: Masaru Tsushima
Hase Marino • Miyuki Komatsu

□ **Female Ninjas: Magic Chronicles 4 Rebel Forces At The Threshold** (1994)
[Kunoichi Ninpou-cho IV: Chushingura Hishou]
aka **Secret Story Of Chushingura**
director: Masaru Tsushima
Makiko Ueno • Megumi Sakita

Female Ninja: Magic Chronicles 6

□ Female Ninjas: Magic Chronicles
 Secret of Jaraiya (1995)
[Kunoichi Ninpou-cho:
 Jaraiya Hisho]
director: Masaru Tsushima
Michiyo Nakajima • Takanori Kikuchi
■ Female Ninjas: Magic Chronicles
 Ninja Moon Shadow (1996)
[Kunoichi Ninpou-cho VI:
 Ninja Tsukikage-sho]
director: Masaru Tsushima
Yuka Ohnishi • Tetsuo Kurata
Rina Kitahara • Miho Nomoto

FEMALE SEDUCTRESS (1995)
 [Sasou Onna]
director: Takashi Kodama
Masahiro Imai • Megumi Morisaki
Mai Kitajima • Yuriko Tomoda
**

Here's a suspense thriller about a
woman obsessed with the notion of
being raped by a famous horror writer.
This is an odd cinematic departure for
director **Kodama** whose previous claim
to fame was **Making The Grade**
(1982], a lightweight *coming-of-age*
comedy. **Female Seductress** isn't partic-
ularly good filmmaking, it's just a lot
tougher than his previous teen sex
flicks.

Tomoko (**Megumi Morisaki**) calls the
novelist's home and tells his wife that
she had been attacked and raped by her
husband. She also claims that he's
secretly a serial rapist sought by the
police. But wife Yasuko (**Mai Kit-
ajima**) doesn't take the complaint seri-
ously. She presumes the caller is mere-
ly one of her husband's obsessive fans.
Tomoko is angry over Yasuko's non-
chalant attitude. She continues to make
a nuisance of herself, even to the extent
of planting *evidence* on the writer.

However, in the meantime, the real
serial rapist is arrested. Thus Yasuko
presses charges against Tomoko for
stalking, trespassing and attempted
blackmail. Tomoko is more pissed off
than ever. She attacks the writer, seduc-
ing him, while video taping the whole
thing. Wife Yasuko finally snaps and
retaliates against woman.

So why was Tomoko obsessed with
framing the writer in the first place?
Because she had been raped in a dark
backstreet some years before. And
apparently the horror writer had stum-
bled onto the scene but did nothing to
help her. Instead he had watched and
then used the assault as the basis for his
first novel.

Female Seductress

FEMALE VAMPIRE (1959)
[Onna Kyuketsuki]
aka **VAMPIRE MAN**
director: Nobuo Nakagawa
Yoko Mihara • Shigeru Amachi
Junko Ikeuchi • Keinosuke Wada
**

Fish On A Tree

Director **Nakagawa** mixes traditional Japanese folklore with Christian oriented Western horrors. An vampire (**Sigeru Amachi**) kidnaps Niwako (**Yoko Mihara**) whom he believes is the descendent of his soulmate. He has "infected" her with an non-aging process and is keeping her in a cell. She refuses his advances, even when he transforms her into a wax doll. Eventually, her daughter and boyfriend rescue mom from the bloodsucker's underground castle. But it's difficult to tell which is the mother and which is the daughter. In fact it's difficult to figure much out in this confused, but elegant looking film.

Amachi also starred in **Ghost Story of Yotsuya** the same year. Critics praised him for both features, calling him the new horror actor "bringing nihilism and tradition to the genre."

FIGHTING SKELETONS
see **AKADO, Suzonosuke** series

FISH ON A TREE (1997)
[Ki No Ue No Sougyo]
director: Atsushi Ishikawa
Tadashi Nishikawa • Takami Yoshimoto
Seijun Suzuki • Reiko Kusamura
**

Hiroshi (**Takami Yoshimoto**) is a hermaphodite, born with both male and female sexual organs. And even though his male genitalia isn't working properly, mom (**Reiko Kusamura**) refuses to listen to the doctors who insist that the situation could be fatal if he doesn't undergo an operation which would remove his penis. Wrong! Those doctors don't know anything about Hiroshi's father. If dad found out that he didn't have a "son" afterall— *that* would be fatal! So mother has managed to keep Hiroshi's ambidextrous sexuality a secret.

One day, while dad and son are fishing, schoolmate Waturu (**Tadashi Nishikawa**) accidentally stabs Hiroshi with a knife. When his father tries to bandage the wound, he discovers Hiroshi's secret. The shock is so great that enroute to the hospital, dad has a heart attack and dies. Meanwhile in the midst of all the excitement, the other student, Waturu, is overwrought and becomes sexual impotent.

In the hospital, a doctor (**Seijun Suzuki**— what's he doing in this?) convinces mom to allow an operation on Hiroshi's penis, removing it completely. She figures: With his father dead, what could be the harm? So Hiroshi emerges from the hospital as a girl.

Fast forward eight years. The paths of Hiroshi and Waturu cross once again. Waturu, still suffering from impotency, is suddenly attracted to the *female* Hiroshi. As the two begin a sexual liaison, the plot stumbles badly—

becoming barely more that a turgid melodrama.

"In today's modern world, people are losing gender identities." That's the central point of this film. The movie's not afraid to address the complexities of sexual ambiguity. It's a controversial theme by western standards, but *unthinkable* to the average Japanese, where women are still considered second class citizens.

However, this fresh philosophy can't save the film. The biggest problem is *Hiroshi* herself (himself?). From the beginning — no matter how hard the FX people try — actress **Yoshimoto** never looks like a man. The story would've been more effective, and more honest, if a male actor had played the role. Perhaps, despite all the rhetoric, the producers were afraid of making a "gay" movie.

FIST OF THE NORTH STAR (1995)
[Hokuto No Ken]
director: Tony Randel
Gary Daniels • Isako Washio

Here's a bloody scifi actioner based on the bestselling manga drawn by **Tetsuo Hara**, later converted into a weekly TV series for Nippon Television. But the film is mostly reminiscent of the old *Sonny Chiba* **Streetfighter** (1974) in its brute-force convergence on the genre. These kung fu battles result in major carnage. Organs are ripped from bodies, arms and legs severed, and heads get split wide-open. Not surprisingly, it's all graphically photographed by director **Tony Randel**, British filmmaker responsible for such fare as **Hellraiser II** (1989) and **Ticks** (1993). The excessive bloodletting will probably keep it from being released uncut in the States and Great Britain, but this is "mother's milk" for the Asian audiences who have

Gary Daniels in *Fist Of The North Star*

always enjoyed the roughest edit of any feature film. Reportedly, the Japanese production company specifically demanded the exorbitant carnage from Randel who originally wanted to tame it down.

A martial arts assassin Kenshiro (**Gary Daniels**, from the *Jackie Chan* vehicle *City Hunter* [1993]) strikes his opponents with jabs to the pressure points. Before every kill he unnerves his enemy with the cryptic words: "You are already dead" (which is also the publicity stinger for this widely advertised hit). The story is set in a nightmarish landscape, sometime after the Great Armageddon. Governments have fallen; the world is overrun by anarchy. Only the strong survive. Kenshiro is the solitary chance for decent people in this brave new land.

Filmed mostly in English, this movie played theatrically in Japan with subtitles.

FOREVER WITH YOU (1995)
[Kimi To Itsumademo]
director: Ryichi Hiroki
Tomoroh Taguchi • Yumi Goto
****½**

Another psychological thriller from **Ryuichi Hiroki**, the director who made **Dream Devil** earlier in 1995, which also starred cult actor **Tomoroh Taguchi**. Here, a woman is trapped (or then maybe not) by a mentally disturbed sado freak. Everything is visualized through her eyes, so the viewer only sees what she sees, knows what she knows. The film basks in its distorted glimpses of reality, odd mixtures of fear-induced trauma accentuated by stark horrific brutality mingled with moments of tense calm.

Shizumi meets a guy in an S&M Club. They get drunk together; the next thing she knows is she's tied to a bed in a locked room. For the remainder of the film, the captor tortures Shizumi, physically and mentally. She eventually tells him about the distorted love she has for her brother. And she confesses that, some years ago, her brother showed his love for her by killing their father. The whole thing ends in a face-off with Shizumi, the psycho, and her brother all on top of the S&M club building.

But then, in keeping with the chic ambiguity of the film, everything shifts to Shizumi, as she recuperates in a hospital bed. The obvious question, of course, remains unanswered: Was everything imagined, just the product of an overactive mind? or did the entire sadistic adventure really take place?

FRANKENSTEIN CONQUERS THE WORLD (1965)
[Furankenshutain Tai Baragon]
translation: **Frankenstein Vs Baragon**
director: Ishiro Honda
Nick Adams • Tadao Takashima
Kumi Mizuno • Takashi Shimura

American actor **Nick Adams** (*Johnny Yuma* from TV's western **The Rebel** [1959-61]) went to Japan for the starring role in this **Ishiro Honda** produc-tion. The inclusion of an Anglo, particularity in the headlining position, was a major departure from previous casting practices of Toho Studios (Originally, the Japanese companies were content making films for their own specific market, with little concern for "world sales"). Usually sequences showcasing Anglo performers were spliced into the Japanese footage in an attempt to *Westernize* the production, with Raymond Burr's non-performance in both **Godzilla** (1954) and **Godzilla '85** (1985) as the most notorious examples.

The story is co-written by director **Honda** with **Kaoru Mabuchi**. Critics who recognize the *kaiju eiga* genre as something more substantial than disposable kiddie SciFi often interpreted it as a political allegory. Nazi scientists in Germany send Frankenstein's heart to Hiroshima for closer examination, but just as experimentation begins the United States drops the atomic bomb thus ending the war *and* contaminating the infamous vital organ at the same

Frankenstein Conquers The World

time. Later, hungry boy Sanda finds the heart and eats it, causing him to grow into a 100+ foot giant. The lad is befriended by an American scientist (**Nick Adams**), doing research in the Fuji Mountains.

Trouble erupts when a mutant dinosaur named Baragon shows up and *Sanda Frankenstein* successfully challenges him in a battle for Japan's safety. In the Asian version, there is also a fight between Sanda and a giant octopus (predecessor to **Yog: Monster From Space** [1970]). Although this sequence is missing from the International / American prints, the sequel (**War of the Gargantuas** [1966]) shares some of the same footage.

Nick Adams also stars in Honda's next film **Monster Zero** (1965). However, he did not return for the *Frankenstein* sequel.

FRESHLY SEVERED HEAD (1967)
[Namakubi Jochi Jiken]
director: Kinya Ogawa
Hachiro Tsuruoka • Kozue Hinotori
Junko Kozuki • Yoshi Izumida
*

Despite the exploitive title, here is merely another in a long line of *traditional* Japanese ghost stories. Little distinguishes this one from the many others it's imitating, except it tends to embrace the seedier *Ero-Gro* roots.

Reiko Fujiyama (**Kozue Hinotori**) is dead. She was murdered by three people: her husband, her doctor and a nurse who loves both men. As these kind of movies go, Reiko returns from the grave and she tries to scare the killers to death — this time through the apparition of her dismembered head.

FROM THIS WORLD TO
THE GREAT SPIRIT WORLD
see **TANBA'S GREAT**
SPIRIT WORLD

FULL MOON:
MR MOONLIGHT (1991)
[Mangetsu: Mr Moonlight]
director: Kazuki Ohmori
Saburo Tokito • Chise Harada
**

Koyata (**Saburo Tokito**), victim of a time slip, is a young samurai from the Edo Era who appears in modern-day Sapporo. A love affair develops between the epoch-jumper and Mari (**Chise Harada**), a teacher at the local High School. A Japanese date movie.

FUNERAL PROCESSION
OF ROSES (1969)
[Bara No Soretsu]
director: Toshio Matsumoto
Peter • Yoshio Tsuchiya

Perhaps Japan's most notorious cult movie, absolutely revolutionary filmmaking by director **Toshio Matsumoto**, a motion picture that **must** be discovered by Western audiences. This is a gay version of *Oedipus Rex* (Oedipus The King). It's also one of the *hippest* films in the world.

Peter, homosexual exponent and renown transvestite, plays Eddie. He's the #1 hostess in a popular gay nightclub. Life is grand. He's got a great job and more friends than he can handle. But Eddie's got eyes for the club owner (**Yoshio Tsuchiya**, a bold career choice for the actor who starred in various Toho monster movies including **Attack Of The Mushroom People** [1963] and **Destroy All Monsters** [1968]) and would like to snatch him away from his prissy boyfriend, the Madam. As Eddie starts preparing for his seduction strategy, he begins having restless nights. He's plagued with terrible dreams which, somehow, are interrelated to a past he can't quite remember. His childhood is a blur. There's a faceless father who disappeared when he was

very young, and a mother who— who— did Eddie really kill his mother? how did it happen? was it an accident? He has no recollection. The only memory he has of mom was when she took her cigarette and obliterated the face of his father from a family photo. Eddie still carries that marred faceless snapshot in his wallet. *But the past is the past*, Eddie thinks, *the important thing is the seduction.*

And so Eddie is victorious in stealing the affections of the bar owner, even though it kills the Madame. Then one night, the man sees Eddie's photo and realizes that his young transvestite lover is actually *his* son. In despair, he commits hara-kiri. When Eddie realizes what has happened, he takes the knife and gouges out his eyes.

Description can't possibly do justice to this remarkable film. It fluctuates seamlessly from chic to kitsch, shock to camp, and from grim drama to surrealistic horror. This is a modern masterpiece, followed by **Bloodshed** in 1971.

FUNGAS OF FEAR
see **ATTACK OF THE**
 MUSHROOM PEOPLE

▶ **GAMERA** (1965)
[Daikaiju Gamera]
director: Noriaki Yuasa
Eiji Funakoshi • Harumi Kiritachi
Junichiro Yamashita • Yoshiro Kitahara
AMERICAN VERSION ONLY:
Brian Donlevy • Albert Dekker
Diane Fidlay • John Baragray
**

Spurred by the success of Toho's "good guy" Godzilla (beginning with **Monster Zero** [1965]), Daiei Studios also decided to make a play for the

Gamera

lucrative children/teen market. They created this series featuring a giant flying turtle who befriends children and, between 1965-1995, has protected Japan from a variety of terrible monsters 9 times.

In this one, an atomic bomb awakens Gamera from his sleep of ages. In his frustration, Gamera heads towards Tokyo, clumsily destroying everything in his path. Eventually he is caught and whisked into space aboard a rocket.

However in the USA version, through the magic of splice-n-glue, **Brian Donlevy** and **Albert Dekker**—with a team of American scientists—save the day. The inserted footage is directed by **Sandy Howard**, an unlucky filmmaker who started his career with the disastrous sex farce, **Diary Of A Bachelor** (1964) featuring an early performance by **Dom DeLuise**.

Other films in the **Gamera** series:

▶ GAMERA VS BARUGON (1966)
[Gamera Tai Barugon]
director: **Shigeo Tanaka**
Kojiro Hongo • **Kyoko Enami**
Akira Natsuki • **Koji Fujiyama**
**

A meteor propels Gamera back to Earth after he was banished to Outer Space at the conclusion of Part 1; meanwhile giant dinosaur Barugon is discovered in New Guinea. The two creatures, representing good and evil, fight each other, destroying Tokyo and Osaka in the process.

The most surprising thing about this film is Daiei Studio's blatant disregard for Toho's patented creatures. Besides Barugon's uncomfortable resemblance to Godzilla (the unicorn in his snout doesn't fool anybody), this creature is an obvious clone of Toho's **Baragon**, the monster from **Frankenstein Conquers The World** (1965). Toho never gave Daiei the satisfaction nor the attention of a law suit.

❖

▶ GAMERA VS THE GAOS (1967)
[Gamera Tai Gyaos]
director: **Noriaki Yuasa**
Kojiro Hongo • **Kichijiro Ueda**
Naoyuki Abe • **Reiko Kasahara**

By this third episode, Gamera is fully recognized as a "good" monster and a friend to children everywhere. Likewise, Gaos *[Gyaos]* is a flying pterodactyl who is essentially "bad" and enjoys eating children. The two monsters obviously must clash.

Gaos, generally considered the best of the Gamera foes, returns for the impressive, updated 1995 version.

❖

▶ GAMERA VS VIRAS (1968)
[Gamera Tai Uchu Kaiju Bairasu]
aka **Gamera vs Super Monster Bairasu**
aka **Destroy All Planets**
director: **Noriaki Yuasa**
Kojiro Hongo • **Toru Takatsuka**
Michiko Yaegaki • **Mari Atsumi**
*

The pretense is completely gone. This series is no longer a children's movie masquerading as SciFi, with this entry it becomes nothing more than a kid's flick. Two boyscouts accidentally submerge in a submarine and are captured

by Gamera who has been hypnotize by evil aliens. The two kids manage to break the trance in time for Gamera to fight a squid-like creature named Viras.

❖

▶ **GAMERA VS GUIRON** (1969)
[Gamera Tai Dai Akuju Giron]
aka **Gamera vs Super Monster Giron**
aka **Attack of the Monsters**
director: Noriaki Yuasa
Nobuhiro Kashima • Chris Murphy
Eiji Funakoshi • Yuko Hamada
**½

This one plays like a kid's movie written by Hannibal Lecter. Two boys (one Japanese and one American, a *first* for the series) are kidnapped by alien females who hungerly devour the brains of captured children. They also have a giant pet monster with a hatchet head named Guiron *[Giron]* who guards their planet from snoopers. Of course, flying turtle Gamera rescues the children and saves the day.

❖

▶ **GAMERA VS MONSTER X** (1970)
[Gamera Tai Dai Akuju Jaiga]
aka **Gamera Vs Super Monster Jaiga**
director: Noriaki Yuasa
Tsutomu Takakuwa • Kelly Varis
Katherine Murphy • Kon Omura
**½

The future of the World's Fair [Expo 70] is at stake. Gamera fights a giant lizard named Jaiga who is determined to trash the fair because his sacred resting place was disturbed. While the bad monster is dying, he (she?) plants an egg in an open wound on Gamera's chest. A little Jaiga hatches and proceeds to suck all the blood from the heroic turtle. Two children (again, one Japanese and one America) board a mini-submarine which is shot into Gamera's artery (ala **Fantastic Voyage** [1966]) to find and destroy the troublesome offspring. Of course, they succeed and the fair is a safe place to visit.

Gamera: Guardian Of The Universe

▶ **GAMERA VS ZIGRA** (1971)
[Gamera Tai Shinkai Kaiju Jigura]
director: Noriaki Yuasa
Yatsushi Sakagami • Mikiko Tsubouchi
Ken Utsui • Yusuke Kawazu
*½

Nasty female aliens from Planet Zigra (*Jigura*, in Japanese) come to Earth to take control. Accusing the Earthlings of polluting their environment, these women unleash a monster who promptly kills Gamera and throws his body into the ocean. The children bring their giant buddy back to life by electrifying the water. Gamera retaliates against the Zigarians and their monster.

Despite the ineptitude of this feature, it was the first *kaiju eiga* to introduce "pollution" as a primary enemy. This "environmental issue" worked its way into most every rubber monster flick to follow.

❖

▶ **SPACE MONSTER
 GAMERA** (1980)
[Uchu Kaiju Gamera]
director: Noriaki Yuasa
Mach Fumiake • Yaeko Kojima
*

Gamera: Guardian Of The Universe 2 (Coming Of Legion)

Space pirates from Zanon send monsters to destroy Earth. Luckily, three spacemen from Planet M38 are visiting on a goodwill mission. They call Gamera to come and help.

All the "monster fighting scenes" in this Grade-Z productions are edited from the previous seven entries.

❖

▶ GAMERA, GUARDIAN OF
 THE UNIVERSE (1995)
director: Shusuke Kaneko
Tsuyoshi Ihara • Akira Onodera
Shinobu Nakayama • Ayako Fujitani

After a 15 year recess comes the best Gamera film to date. And ironically, with **Daiei** out of business, this one is released by the *enemy*, **Toho Studios**. Funny how time heals all wounds, and money makes the world go 'round.

This episode doesn't make any more sense than the previous installments, although there is an honest attempt at continuity. But it's still a movie about a giant flying turtle. The FX are state-of-the-arts and it's not so goddamn goofy. Simply— it looks better, thanks to

director **Shusuke Kaneko** (best known for his cult hit **My Soul Is Slashed** [1991]).

Gamera protects the world from attack by deadly prehistoric birds (yes, the Gyaos are back) and Tokyo is once again destroyed in the melee.

❖

▶ GAMERA 2:
 COMING OF LEGION (1996)
 [Gamera 2: Region Shurai]
 aka **ADVENT OF LEGION**
director: Shusuke Kaneko
Miki Mizuno • Toshiyuki Nagashima
Tamotsu Ishibashi • Mitsuru Fukigoshi

Director **Shusuke Kaneko** returns with an arguably better *old-fashion monster* film than the previous one. A meteor storm pummels the Hokkaido community. But when the National Guard investigates the caters, but they find no evidence of meteoric rock. Obviously, there's something fishy going on here. Then fiber cables begin disappearing and a beer factory looses its glass supply. It's the work of a monster called Legion (actually a network

of creatures all living intertwined, conceptually similar to The Destroyer, Godzilla's final nemesis). After Legion attacks people on a subway, the city is in panic. Gamera responds to their cry for help.

出演：ダンカン、ビートたけし、他総勢128名　オールスター・キャスト

GETTING ANY LATELY? (1995)
[Minna Yatteruka?!]
director: Beat Takeshi Kitano
Dankan • Beat Takeshi Kitano
Akio Yokoyama • Moeko Ezawa

Asao (**Dankan**) is obsessed with the idea of having wild and passionate sex in his car. That simplistic premise is the foundation for one of the hippest cult comedies of the year. Asao is a *Walter Mitty* character, drifting casually between reality and fantasy, as he attempts to make his dream come true. First, Asao figures, in order to "have sex in a car" he's gotta have a car. And, it's gotta be the kind of car that would attract the type of girl who would want to "have sex in a car." After a series of mishaps, he decides on a snazzy convertible. But where's he going to get the money to buy the car?

At this point the movie shifts into high gear and never looks back. Asao sells his grandfather's kidneys and liver. He also tries to rob a bank, then steals a Brinks truck, becomes Zatoich, joins the Yakuza. Finally, Asao realizes his "sex in a car" quest may not be realistic, so he gets the idea of becoming an invisible man (he hopes to sneak into a women's Bath House undetected). Asao stumbles onto a scientist (**Beat Takeshi**), the head of **IMEA** {The Invisible Man Experimental Association}, who agrees to help him. But when the boy is inserted into the

Invisible Man capsule, a housefly is accidentally sealed inside with him. And, just like in the movie which it parodies {**The Fly**}, Asoa becomes a human insect. However, in this version, he grows to *Godzilla* proportions. The "G Force" comes to the rescue, dumping tons of shit inside Kawasaki Baseball Stadium, luring the colossal fly-creature into a trap. The Force kills Asao with a king-size flyswatter, smashing him face-down into the mountain of excrement. The closing credits role— but it's not over yet. Afterwards Asao transmutes into The Giant Grasshopper Man. He tries to hop away but only succeeds in impaling himself on the Tokyo Tower steeple.

Not everything works. Cultural humor almost never transcends the country of origin. Some things are uproariously funny in Japan but don't merit a chuckle elsewhere. This comedy is especially demanding on the viewer, as many of the gags require a certain amount of familiarity with Nippon sociology. Some of the humor is topical, relying on a knowledge of current events or, at the very least, some background in Japanese cinema (*i.e.*, audiences who are unfamiliar with blind Zatoich, Ultraman, Yakuza films, Ken Takakura's umbrella, Godzilla [and G-Force], Baby Cart, Jo Shishido *and* The Invisible Man Vs The Flyman will be scratching their heads during many of the jokes).

Beat Takeshi (R) in *Getting Any*

Many Beat Takeshi fans in the west will find this excursion into the *Theatre of the Absurd* out-of-character for the director who became internationally famous with his tough-nosed gangster trilogy {*e.g.*, **Violent Cop** [1989], **Boiling Point** [1990] and **Sonatine** [1993]}. But in reality, this film is closer to Takeshi's roots than those testaments to ultra-violence.

In the early '70s, Takeshi Kitano and partner, **Kiyoshi**, were a *manzai* (a two-man comedy team) know as **2-Beat**. Their counter-culture humor made them regular guests on many TV shows, but the biggest problem facing Beat Takeshi was his partner, Beat Kyoshi, wasn't very funny. By the end of the decade, Takeshi started taking solo jobs. He became the star of a *hip* television series, a parody of super-heroes and rubber monsters called **Super Superman**. Most likely, many of the ideas in **Getting Any Lately** were hatched during those early TV

episodes. **Beat Takeshi** still enjoys active involvement with gun-n-gangster movies (he starred in **Erotic Liaisons** [1992], **Gonin** [1995], *et al*). But since his near-fatal motorcycle accident in 1994, his self-directed films have drifted toward comedy (**Kid's Return** [1996] and this film in 1995).

**GHIDRAH THE THREE
HEADED MONSTER** (1965)
[Sandai Kaiju Chikyu Saidai No Kessen]
translation: **Three Greatest Monsters
In Earth's Biggest Fight**
aka **GODZILLA VS GHIDRAH**
director: Ishiro Honda
Yosuke Natsuki • **Yuriko Hoshi**
Hiroshi Koizumi • **Ito Sisters**
Takashi Shimura • **Eiji Okada**
**½

This is the sequel to **Monster Zero** (also 1965), shot in tandem with that film, but interestingly it includes none of the same cast members. This one benefits from better acting, especially

Ghidrah The Three Headed Monster

from notable heavyweights like **Takashi Shimura** (the bureaucrat who looked for meaning of life in *Akira Kurosawa*'s **Ikiru** [1952]) and **Eiji Okada** (the entomologist captured by the neurotic lady in *Hiroshi Teshigahara*'s **Woman In The Dunes** (1964).

Die-hard Godzilla fans continue to lament the Big Monster's "good guy" role as he joins forces with Mothra and Rodan against evil Ghidorah. Most film historians site 1965 as the beginning of Toho's conscious decision to shift the audience from adult to children. Subsequent films became no more than exaggerated wrestling matches with men in rubber monster suits. Not until 1985, when Godzilla returned as a heinous beast, would Kaiju Eiga films be taken seriously by the cult critics.

GHOST CAT films *[Kaibyo]*

The concept of a *ghost cat* has long been popular in Japanese folklore. Over the years, it's also been the central theme for a number films, the most widely known being **Kaneto Shindo**'s **Kuroneko** (Black Cat) [1968], *Tokuzo Tanaka*'s **Haunted Castle** (1969) and *Teruo Ishii*'s 1970 production, **Blind Woman Curse** {see separate listings for all three}.

In the mid-50s actress **Takako Irie** became the quintessential *Ghost Cat*. In four films she played a lady who could transform into a sleek feline, usually for reasons of revenge

▶ **Horror of Saga Mansion** (1953)
[Kaidan Saga-yashiki]
director: Ryohei Arai
Takako Irie • Yoshitaro Bando
Kikue Mouri • Chieko Naniwa

▶ **Ghost Cat Of Arima Palace** (1953)
[Kaibyo Arima Goten]
director: Ryohei Arai
Takako Irie • Michiko Ai

▶ **Ghost Cat Disturbance In Okazaki** (1954)
[Kaibyo Okazaki Sodo]
director: Bin Kato
Takako Irie • Yoshitaro Bando

▶ **Ghost Cat From Night-Crying Swamp** (1957)
[Kaibyo Yonaki Numa]
director: Katsuhiko Tasaka
Takako Irie • Shintaro Katsu

After the proven success of **Takako Irie**'s *Kaibyo* films, other ghost cat movies began to surface. (The following list is in chronological order.) By the end of the '60s, the craze had run its course.

▶ **Ghost Cat: Cursed Wall** (1958)
[Kaibyo Noroi No Kabe]
director: Kenji Misumi
Shitaro Katsu • Yoko Uraji
**

A rebel family attempts to take over the prefecture. The anarchist leader kidnaps the king's favorite mistress, kills her and seals her body behind a brick wall— along with a black cat. Obviously, more-than-inspired by the *Edgar Allan Poe* tale.

❖

▶ **Ghost Cat: False Ceiling** (1958)
[Kaibyo Karakuri Tenjo]
director: Kinnosuke Fukada
Sumiko Suzuki • Ryunosuke Tsukigata
**½

A notorious chess player is killed by King Nabeshima, a samurai ruler who is envious of the man's talent. The player's fiancee is then kidnapped and forced to become Nabeshima's mistress. The dead man's mother commits suicide and returns as a ghost cat to curse King Nabeshima.

❖

▶ **Ghost Monster Cat Mansion** (1958)
[Borei Kaibyo Yashiki]
director: Nobuo Nakagawa
Toshio Hosokawa • Noriko Kitazawa
*½

After his wife grows ill, a wealthy doctor relocates the clinic to his mate's

hometown, moving into a countryside mansion. Soon their nights are plagued by the ghost of an old witch who transforms into a cat and tries to kill the doctor's wife. According to a local priest, the specter is seeking vengeance for a massacre which took place on those very grounds— a bloodbath which had been orchestrated by the wife's sister. Contrived nonsense.

▶ Ghost Cat Of Otama Pond (1960)
[Kaibyo Otama-ga-ike][1]
director: Yoshihiro Ishikawa
Seizaburo Date • Noriko Kitazawa
Hiroshi Sugi • Fujie Satsuki
*½

An instantly forgettable story about the ghost of a cat who disguises herself as a witch to seek revenge on the decedents of the man who killed her master. Besides having an absurd plot — even within the lenient folklore guidelines — this film suffers from being tediously slow and unnecessarily talky. There's little to recommend, with the lone exception of lovely **Noriko Kitazawa**. But she was much better in **Ghost Story of Yotsuya** the previous year.

[1]Incidentally, some American/British publications have incorrectly listed this film as *Kaibyo Otamage-ike* instead of **Otama-ga**-*ike*. This may not seem like a major discrepancy, but *Otamage* actually means "hairy testicles" in Japanese.

❖

▶ Ghost Cat In
 The Haunted Swamp (1968)
[Kaibyo Noroi Numa]
director: Yoshihiro Ishikawa
Ryohei Uchida • Kotaro Satomi
Kyoko Mikage • Hiroshi Nawa
**

Unfortunately, this one is as goofy as all the rest, with slightly better special effects supplied by *Toei*. The best thing about this tale of a Cat Monster meowing up a storm in a swamp during Japan's Edo period is *Shigedru Akatsuka*'s sets. The atmospheric designs and intricate mat-work compensates for

the less-than-horrific subject matter. Cats simply aren't scary enough to carry an entire film.

GHOST CAT OF NABESHIMA
see **HAUNTED CASTLE**

GHOST CLASSROOM (1996)
[Borei Gakkyu]
director: Norio Tsuruta
Juri Miyazawa • Kei Ishibashi
*½

Loosely based on a manga by *Jiro Tsunoda*, but obviously it owes a greater debt to the success of *Hideyuki Hirayama*'s **Elementary School Ghost Story** (1995). It's no better— nor worse-- than the many other clones that followed. This time, the ghostly action crescendos in a high school at nightime after a gang of students place bets on who will be brave enough last until dawn. The kids sit around telling ghost stories until their tales begin to materialize.

Director **Tsuruta** must be attracted to these kind of sophomoric thrills. He made the similar **Ghost Story Of The Evil Spirit: Cursed Beauties** earlier in the year. Neither film shows much flare for the genre.

GHOST FROM THE POND
see **GHOST STORY OF**
 THE ONE EYED GOD

GHOST JOURNEY
see **SAMURAI COMEDY**

GHOST IN A TAVERN (1994)
[Izakaya Yurei]
director: Takayoshi Watanabe
Kenichi Hagiwara • Shigeru Muroi
Tomoko Yamaguchi • Yuji Miyake
**½

Imagine *Cheers* as a ghost story.
Bar-owner Sotaro (**Kenichi Hagiwara**) makes a death-bed promise {"I'll

Ghost In A Tavern

never remarry"} to his wife Shizuko (**Tomoko Yamaguchi**, who won the Nippon Academy Award for best actress in '94 for this role). But shortly after Shizuko passes away, he does in fact marry a pretty young thing named Satoko (**Shigeru Muroi**). A jealous Shizuko returns from the grave to haunt her husband. But Sotaro's new life is going great; his young wife is beautiful and her personality attracts hordes of customers to the tavern. Business is better than ever.

Soon, Sotaro becomes tired of his ghost-wife's antics. He seeks advice from a priest and receives an "exorcism scroll" which will drive the unwanted spirit away. However the scroll gets stolen when Sotaro takes the train home from the temple. When he arrives at the tavern, everything is in turmoil. A furious ghost possesses her ex-husband's brain, forcing him to violently rape Satoko. The nubile wife flees the bar, running back to an old boyfriend, a local yakuza tough.

After this episode, Sotaro decides that he better start paying more attention to his customers. One of them, Tatsuo (**Yuji Miyake**), is crying in his beer over how much money he's gambled and lost on a series of baseball games.

Sotaro takes pity on this sad sack. He asks his ghost-wife to foretell the score of the big Saturday night game. Shizuko agrees to help, but when she uses her supernatural powers to foretell the future, she is forced to return to the darkside. Since the tavern is no longer haunted, Satoko leaves her boyfriend and returns to husband Sotaro. Just another happy ending.

This film was a surprise boxoffice hit, appealing to the mainstream Japanese audiences. Critics, for the most part, were not so enthusiastic.

❖

GHOST IN A TAVERN 2 (1996)
[Shin Izakaya Yurei]
aka **NEW GHOST IN A TAVERN**
director: Takayoshi Watanabe
Hiroshi Tachi • Kyoka Suzuki
Keiko Matsuzaka • Masahiko Tsugawa
*½

In the first one, director **Watanabe** played his story for laughs, but in the "sequel" he goes for a straight-ahead love story. The set-up is similar: after his wife dies, a tavern-owner remarries a young sexpot causing the ghost of his spurned mate to show up and create chaos. After establishing this analogous framework, the plot changes. For the new story, the owner befriends a struggling waif who reminds him of his former wife. His new wife starts playing footsie with an old boyfriend. And the ghost falls in love with a hapless patron in the tavern.

Ghost In A Tavern 2

Ghost Of An Actress

GHOST OF AN ACTRESS (1996)
[Joyurei]
director: Hideo Nakata
Yurei Yanagi • Yasuyo Shiratori
*½

This horror story wants to be something else; but, seemingly, no one in authority is willing to switch gears. Indecisiveness is the film's biggest problem. It flounders badly from ghostly meanderings to soap-opera hijinks – with no commitment for either genre. Everyone walks through their parts with hesitation; they deliver their lines indecisively, as if the words are supposed to be meaningful on some symbolic level. This failed attempt at camp humor — if in fact it's done on purpose in the first place — only emphasizes the vacuum in the plot itself.

It's a ghost story set inside a movie studio. Strange things start happening when a director, Murai (**Yurei Yanagi**), finds a spool of undeveloped film. He processes it and watches the *lost* movie. Afterwards, the star of that film — seemingly a long-dead, unknown studio starlet — begins to show up during his own production. Her ghost visits the preview room, the sound stage, even the restroom. Murai decides to find out who the actress is. But he runs into a brickwall from the studio executives who would rather keep the identity of the actress a mystery.

GHOST OF CHIDORI-GA-FUCHI SWAMP (1956)
[Kaidan Chidori-ga-fuchi]
director: Eiichi Koishi
Kinnosuke Nakamura • Yoshiko Wakamizu
*

A very standard chambara ghost story, heavy on atmosphere and hammy performances (especially from **Kinnosuke Nakamura**, future star of TV's *Lone Wolf And Child* series), light on thrills and chills. A samurai's wife comes back to haunt him after getting killed in the swamp. Even the brief 66 minute running time is too long.

GHOST OF THE HUNCHBACK (1965)
[Kaidan Semushi Otoko]
aka **HOUSE OF TERRORS**
director: Hajime Sato
Akira Nishimura • Yuko Kusunoki
Yoko Hayama • Masumi Harukawa
**½

This strongly influenced Euro-thriller was a major hit in both Japan *and* Italy.[1] Director **Sato**, mesmerized by Western cinema (as demonstrated again in his subsequent films **Goke: Bodysnatcher From Hell** [1968] and **Terror Beneath The Sea** [1966]), imitates the atmospheric "haunted house" work of **Mario Bava**.

Ghost Of The Hunchback

A doctor and his entourage decide to move into a mansion despite warnings from the hunchback caretaker. Of course, the house is truly haunted and everyone is slaughtered in gruesome ways. When the doctor's niece (**Kusunoki**) is decapitated by specters, the lovesick hunchback kills himself and burns the house to the ground.

[1]This film was released in Italy as **Il Pozzo Di Satana** (*The Pit Of Satan*) with completely bogus credits, including the ludicrous cast: Robert Sark, Susan Parker, Jerry Murphy and Connie Fisher; the director is listed as Richard Goodwin.

GHOST STORY OF THE BARABARA PHANTOM (1968)
[Kaidan Barabara Yurei]
aka **DISMEMBERED GHOST**
director: Kinya Ogawa
Reiko Akikawa • Setsu Shimizu
Miki Hayashi • Kenichiro Masayama
**

The spirit of Tsukagoshi's first wife can't rest now that her husband has remarried. **Setsuo Shimizu** plays the second wife with an air of ambivalence causing young step-child Masako to wonder if her mom really was killed. The Ghost Mother eventually reveals the truth which implicates older sister Sumiko and her boyfriend in the fatal deed. Like so many other B-thrillers, this one is competently made, but remains unimpressive. Chills are replaced with far too many long stretches of atmospheric posturing.

GHOST STORY OF THE BIRD THAT ATE MOSQUITOES (1961)
[Kaidan Kakuidori]
aka **GHOST OF KAUI STREET**
director: Kazuo (Issei) Mori
Eiji Funakoshi • Yasuko Nakata
**½

Based on a novel by **Nobuo Uno**, this one was brought to the screen and promoted as *horror art film*. Three people (an old music teacher, his mistress and a blind masseur) become involved in an ugly dispute over money. It leads to murder and madness, of course.

Eiji Funakoshi, best known for various **Kon Ichikawa** productions (*i.e*, **Fires On The Plain**, **I Am Two**, *et al*) plays both the role of the masseur and the teacher. He received rave notices and the Best Actor Award for his performance.

GHOST STORY OF THE CURSE OF OIWA
see **GHOST STORY OF YOTSUYA**

GHOST STORY OF THE BREAST ELM (1958)
[Kaidan Chibusa Enoki]
director: Goro Katano
Katsuko Wakasugi • Keiko Hasegawa
**

Another ghost chiller, combining supernatural thrills with brooding chambara heroics. The story of two lovers haunted by the ghost of a slain mistress is no better nor worse than many other interchangeable titles from the same period.

Director made number of "B" films for **Shintoho**, including **Ghost Wanderer At Honjo** the previous year.

GHOST STORY OF EVIL SPIRITS: CURSED BEAUTIES (1996)
[Akuryo Kaidan: Norowareta Bijotachi]
director: Norio Tsuruta
Mika Yoshino • Rumi Mochizuki
*½

Nothing new here. During a slumber party, four girls take turns telling scary stories. After all the predictable false scares— after the girls' feigned shrieks— after the lights go out— the tales they told start coming true. Identical plot to director *Tsuruta*'s **Ghost Classroom**.

GHOST STORY OF THE GIRL DIVER (1960)

GHOST STORY OF
THE GIRL DIVER
[Kaidan Ama Yurei]
director: Goro Katano
Juzaburo Akechi ● Shinsuke Mikimoto
*

Add a star to the rating if you have a fetish for "shots of girls underwater." This is another B programmer, created for the bottom of a **Shintoho**'s double bill, directed by **Goro Katano** who specialized in soft-core skin flicks with horrific themes (*e.g.*, **Ghost Wanderer In Honjo** and **Ghost Of The Breast Elm** [both 1959]). This movie, over half of which takes place underwater, tells the story of a girl who is murdered during a dive by her two-timing boyfriend. And, of course, it also shows how she gets revenge as a ghost.

GHOST STORY
OF KAGAMI SWAMP (1959)
[Kaidan Kagami-ga-fuchi]
director: Masaki Mouri
Shozaburo Date ● Noriko Kitazawa
*

Bargain basement horrors, as a businessman and his mistress deceive the rural merchants, killing them in a plot to gain control of the area's lucrative commerce. Finally, there's retaliation from a young couple who inherit a local business. They're aided in the fight against the two charlatans by ghosts from a nearby swamp.

GHOST STORY
OF KASANE SWAMP (1957)
[Kaidan Kasane-ga-fuchi]
director: Nobuo Nakagawa
Katsuko Wakasugi ● Takashi Wada
Tetsuro Tanba ● Noriko Kitazawa

This is the third remake of a classic 19th Century Japanese ghost story (*Encho Sanyutei*'s **Shinkei Kasane-ga-fuchi**). It was originally filmed by

Kenji Mizoguchi in 1926 under the title **Kyoren No Onna Shisho** (**Passion of A Female Teacher**), and then remade in 1937 by **Hachiro Ogura**.

This two-in-one story reiterates the traditional Japanese *sins-of-the-father* philosophy as the film opens with a samurai killing a blind masseur. The dead man's ghost torments the killer until he accidentally slays his wife and then commits suicide by drowning in Kasane Swamp.

In the second part, the samurai's son rejects the attentions of a female teacher (secretly the daughter of the murdered masseur). Instead he prefers whoopee with one of her students. The spurned teacher kills herself and then haunts the young couple until they both take a lover's leap into the same Kasane Swamp.

The film was remade three scant years later by **Kimiyoshi Yasuda**, with decidedly unimpressive results. The same man directed a sexier version again in 1970 under the same title, but internationally it's known as **Horror Of An Ugly Woman** {see separate listing for details}.

the 1960 remake:

▶ GHOST STORY OF
 KASANE SWAMP (1960)
[Jaidan Kasane-ga-fuchi]
director: Kimiyoshi Yasuda
Ganjiro Nakamura ● Yasuko Nakata
Yataro Kitakami ● Yoko Uraji
**

GHOST STORY OF THE NIGHT-CRYING LANTERN (1962)

[Kaidan Yonaki-dourou]
director: Katsuhiko Tasaka
Ganjiro Nakamura • Reiko Fujiwara
Katsuhiko Kobayashi • Hiroshi Nawa
**½

A man is tricked by his boss into getting buried alive. But he manages to dig out of the casket to seek revenge (by disguising himself as a ghost). He shows up in time to see his girlfriend seduced by the deceitful boss, after which the poor sap is killed in a fracas. Now the man becomes a real ghost and he returns to haunt the debaucher, eventually frightening him to death. But it all ends in tragedy as the girlfriend loses her mind and can't stop screaming for sanity.

The motion picture was critically praised by the Japanese press, especially for Tasaka's atmospheric photography and the fine multidimensional performance by young starlet Reiko Fujiwara who had previously been relegated to too many costarring roles in interchangeable chambara features (*i.e.,* Eight Brave Brothers [1959], River Of Fury [1959], Ephemeral Samurai [1961], *et al*). After this movie, she returned to the more lucrative samurai venue, but enjoyed markedly prestigious "A" productions (*e.g.,* Satsuo Yamamoto's Band Of Assassins *[Shinobi No Mono]* in 1963).

GHOST STORY OF THE ONE EYED GOD (1959)

[Kaidan Hitotsume Jizou]
aka GHOST FROM THE POND
director: Kinnosuke Fukada
Tomisaburo Wakayama
and Shinobu Chihara
*½

The beginning was tough for Tomisaburo Wakayama. He didn't waltz into *Toho Studios* one fine day in 1972 and suddenly find himself pushing a baby cart to infamy. Long before he became *Itto Ogami* in the internationally famous Lone Wolf And Child series (1972-1975), Wakayama spent many hard years refining his trade in hundreds of small, insignificant projects. Like this one.

A statue of Jizou, a one-eyed deity who protects children, overlooks a pond in historic Japan. A thief Denzo (Shinobu Chihaha) leaves baby Onami at the statue's feet for safekeeping while he pulls a heist with his friend Jugoro (Tomisaburo Wakayama).

During the robbery, Denzo is discovered and killed by a young child named Kyonosuke. Partner Jugoro, doesn't wait around for the smoke to clear; he takes the money and runs, heading back to the baby and the one-eyed god. In a scene which ironically foreshadows the acclaimed *sword-or-ball* segment from Lone Wolf And Child #1, Jugoro tries to kill young Onami but can't bring himself to do it. He ends up leaving a scar on the baby's cheek.

Fast forward to the future: Onami and Kyonosuke have grown into young adults. They meet for the first time and fall in love without knowing of their cursed past. But eventually Kyonosuke sees her scar and, repulsed by it, he leaves her. So the boy meets thief Jugoro's daughter and falls in love with her. But Onami wants Kyonosuke back; she tries to seduce him. However, the new girlfriend has a brother who kills Onami and dumps her body in the old pond. Yes, the same pond protected by the one-eyed statue. The stone deity, nurtured by the spirit of the hapless victim, comes to life and kills everybody. Was this the inspiration for Majin? or is that too kind?

GHOST STORY OF THE ONE EYED MAN (1965)

GHOST STORY OF
THE ONE-EYED MAN (1965)
[Kaidan Katame No Otoko]
director: **Tsuneo Kobayashi**
Akira Nishimura • **Sanae Nakahara**
****½**

Japanese horror cinema of the '60s was strongly influenced by the Italian thrillers, particularly the atmospheric work of **Mario Bava** and **Riccardo Freda**. Many directors imitated the popular Euro style and structure, often placing a group of *innocent* people in menacing surroundings, especially inside a haunted house.

This feature offers a slight variation on the standard theme. Here, family members gather in a old mansion to kill their patriarch, a wealthy businessman (**Sanae Nakahara**). His ghost returns to slaughter each of them in a gruesome fashion.

GHOST STORY
OF PEONY LANTERNS
see **BRIDE FROM HELL**

GHOST STORY OF THE PIT (1968)
[Kaidan Otoshiana]
director: **Koji Shima**
Mikio Narita • **Eiji Funakoshi**
Mayumi Nagisa • **Mako Sanjo**

Here's a contemporary ghost about a young couple, Fumio and Etsuko

Ghost Story Of The Pit

Nishino (**Eiji Funakoshi** and **Mayumi Nagisa**) who discover the hard way that their new home in Satomi has been built over an entrance to Hell.

Director **Shima** was also responsible for the SciFi thriller **Warning From Space** (*aka* **Cosmic Man Appears In Tokyo**, 1956).

Ghost Story Of Sex

GHOST STORY OF SEX (1972)
[Sei No Kaidan]
director: **Giichi Nishihara**
Maki Kirikawa • **Hiroshi Nishihara**

More gutter cinema from director **Nishihara** who made a career of sleazy *pinku eiga*. He's probably the trashiest filmmaker of them all, with twisted plots delivered in an unnerving matter of fact style. Rumor has it that he cranked out an untold number of kinky sex films for a "front" film studio

Shiho Fujimura in *Ghost Story Of The Snow Girl*

owned by the Osaka yakuza. For this one, a girl kills herself by biting off her tongue during a vicious rape. Her ghost then haunts the rapist as he continues to assault a parade of victims. Eventually, he can no longer take the ghostly aggravation and he jumps to death from the top of an office building.

GHOST STORY OF
THE SNAKE WOMAN (1968)
[Kaidan Hebi-onna]
director: Nobuo Nakagawa
Seizaburo Kawazu • Akemi Negishi
Shingo Yamashiro • Yukie Kagawa
**½

It's the Meiji Era. A poor sharecropper gets run over by the wealthy landowner's buggy. Shortly afterwards, his wife also dies from injuries after being whipped by the plantation boss. Their ghosts are spotted in the main mansion. At the same time, family members start getting knocked off. It turns out that ghost mom has the ability to transform into a snake, killing the offending Sutematsu family in one brutal death scene after another.

Gorier than most *Kaidan* films; Not a terrible film, just a long ways from great.

GHOST STORY
OF THE SNOW GIRL (1968)
[Kaidan Yukijoro]
aka YUKIONNA
director: Tokuzo Tanaka
 and Masaki Kobayashi
Shiho Fujimura • Akira Ishihama
Machiko Hasegawa • Taketoshi Naito
**

In order to capitalize on the success of Kwaidan (1964) in the West {see separate review for background information}, additional footage shot by Tokuzo Tanaka was added to the extracted episode [Yukionna], rounding it out to 80 minutes. The film was then released to the Art Theatre circuit. Unfortunately, this time the response was lukewarm. Seemingly, few people cared about Lafcadio Hearn's tale of snow ghosts who lure travelers to their death in ancient Japan.

Based on the dismal reaction to the original Kwaidan [Kaidan] feature in Japan, this newly edited segment was never released there theatrically.

GHOST STORY OF YOTSUYA
[Yotsuya Kaidan] 11 films (1928-1994)

This is a popular tale in the Japan culture, based on a play originally written

by **Nanboku Tsuruya** in 1894. It tells the story of a rogue samurai, Iemon, who kills a man and marries his daughter. However, he quickly grows tired of the girl and wishes to marry his wealthy mistress instead. Iemon tricks his wife into an adulterous affair at which time he kills both her and the amorous lover. The two return as ghosts and attack Iemon on his wedding night. He goes mad, slaughtering his new bride and her entire family before killing himself.

Most all the movie versions follow the plot with few alterations. However the 1949 film is less a horror film than a samurai drama with emphasis on "personal ghosts" and 1957's **Ghost Story Of Broken Dishes At Bancho: Ghost Of Yotsuya** is a farcical comedy starring **Hibari Misora**, queen of the Nippon Musicals. In a classic example of studio miscommunications, two different versions of *Yotsuya* were released to the theaters in 1959, fighting each other at the box-office until the **Nakagawa** film emerged as the winner. Some versions accentuate the violence (*e.g.*, **Tai Kato**'s 1961 rendering), while others concentrate on the sex (*e.g.*, **Shiro Toyoda**'s version in 1965). But the most unique interpretation must be **Kinji Fukasaku**'s *Ghost Story Of Yotsuya: Chushingura* (1994) wherein he mixes the famous ghost legend with a popular Japanese *chambara* tale.

Misumi's *Ghost Of Yutsuya* (1959)

Here is the list of *Yotsuya* films, including mention of the pre-1955 entries:

▶ **YOTSUYA GHOST STORY** (1928)
[Shinpan Yotsuya Kaidan]
director: Daisuke Ito

❖

▶ **GHOST OF YOTSUYA** (1949)
[Shinshaku Kaidan]
director: Keisuke Konoshita
Kinoyo Tanaka ● **Ken Uehara**

❖

▶ **GHOST STORY OF YOTSUYA** (1956)
[Tokaido Yotsuya Kaidan]
director: Masaki Mouri
Tomisaburo Wakayama
Akami Tsukushi and **Chieko Soma**
**

Similar to the original horror play as written by Nanboku Tsuruya in the late 19th century (unlike the previous 1949 adaption which was more of a psychological drama based on "personal ghosts.") This one is considered a true horror story, with supernatural overtones not to be confused with another version also starring **Tomisaburo Wakayama** in 1961 called *Ghost Story of Yotsuya: The Curse Of Oiwa.*

❖

▶ **GHOST STORY OF BROKEN DISHES AT BANCHO: YOTSUYA GHOST STORY** (1957)
[Kaidan Bancho Sarayashiki: Yotsuya Kaidan]
director: Juichi Kono
Hibari Misora ● **Chiyonosuke Azuma**
**

❖

▶ **GHOST STORY OF YOTSUYA** (1959)
[Tokaido Yotsuya Kaidan]
translation: **Ghost Story Of Yotsuya In Tokaido**
director: Nobuo Nakagawa
Shigeru Amachi ● **Noriko Kitazawa**

Katsuko Wakasugi • Shuntaro Emi

Considered director **Nobuo Nakagawa**'s masterpiece, based jointly on the 1949 film **Shinshaku Yotsuya** (by **Keisuke Kinoshita**) and the 19th Century kabuki play written by **Nanboku Tsuruya**.

Visually, this is a stunning motion picture, one of the first color horror films in Japan. It established **Nobuo Nakagawa** as *the Nippon Hitchcock*. His films, including this one, were enormously successful because they appealed to both the *high* and *low-brow* audiences. **Nakagawa** was never reluctant to use buckets of bloods nor gratuitous sex, but yet his films could also be appreciated as two dimensional psychological dramas. His movies maintained an air of respectability which appealed to critics who usually panned terror pics on general principles.

❖

▶ **GHOST OF YOTSUYA** (1959)
[Yotsuya Kaidan]
director: **Kenji Misumi**
Kazuo Hasegawa • Yasuko Nakada
**

A lesser version of the famous ghost story, completely overshadowed by **Nobuo Nakagawa**'s *Yotsuya* film released the same year. However, director **Misumi** finally reached his moment of fame with the **Lone Wolf And Child** series (1972-1975).

❖

▶ **GHOST STORY OF YOTSUYA:
 GHOST STORY OF THE
 CURSE OF OIWA** (1961)
[Kaidan Oiwa No Borei]
 aka **THE CURSE OF OIWA**
director: **Tai Kato**
Tomisaburo Wakayama
 and **Hiroko Sakuramachi**

Yet another version of the famous Ghost Story of Yotsuya featuring

Nakagawa's *Ghost of Yotsuya* (1959)

Samurai Iemon {see **Ghost Story Of Yotsuya** for plot details}. This time the characterizations are more cynical, with more time spent on the aftermath of Iemon's success and his inevitable decline and agony.

Tomisaburo Wakayama is exceptional as the tormented samurai. But young director **Kato** deserves much of the credit for this film's distinctive style in an already overcrowded sub-genre. He manages to capture the very essence of the turbulent Edo period. The filmmaker is also responsible for the unique, illusionary gore-fest **Requiem For A Massacre** in 1968 {see separate review}. Later the he found success with a variety of *chambara* movies, including **Miyamoto Mushashi: Swords Of Fury 1** and **2** (1973) and the episodes of the **Red Peony** series (1970-1972).

❖

▶ **GHOST STORY
 OF YOTSUYA** (1965)
[Yotsuya Kaidan]
 aka **ILLUSION OF BLOOD**
director: **Shiro Toyoda**
Tatsuya Nakadai • Mariko Okada
Junko Ikeuchi • Mayumi Ozora

This film was somewhat of a risk for director **Toyoda** and **Toei Studios**. The

ShiroToyoda's *Ghost Story Of Yotsuya* (1965)

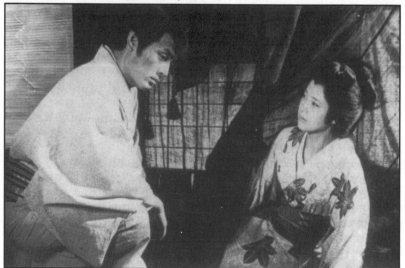

idea of making an expansive, big budget, character-driven ghost story on the heels of **Kwaidan**'s disastrous boxoffice performance must have seemed like a major mistake to the bean counters. But **Toyoda** insured his project by employing a familiar plot. He remade the successful **Ghost Story of Yotsuya in Tokaido** (1959). This new version was different enough, especially in the sex department, that it became a hit.

This time, Samurai Iemon (**Tatsuya Nakadai**) has no "tragic hero" characteristics. He is simply a rogue, driven by greed, who beds and weds a collection of wealthy women. When he kills his wife Oiwa (**Mariko Okada**) to marry another, her ghost torments him until death is the only way out.

The original Japanese print is 190 minutes, while the Western edit (missing much of the violence and almost all of the nudity, released under the prophetically ironic title **Illusion Of Blood**) clocks in at only 107 minutes. Filmmaker **Toyoda**'s most successful film came four years later with his fiery vision of the afterlife in **Hell Screen**.

▶ **GHOST STORY OF YOTSUYA: CURSE OF OIWA** (1969)
[Yotsuya Kaidan: Oiwa No Borei]
aka **CURSE OF THE NIGHT**
director: **Issei Mori**
Kei Sato • Kazuko Inano
Yoshihiko Aoyama • Kyoko Mikage
**

Samurai Iemon is back again in yet another remake of **Nanboku Tsuruya**'s 19th century kabuki play. This time martial artist **Kei Sato** plays the greedy warrior who kills his wife to marry the daughter of a rich merchant. He is then haunted by the dead woman's ghost until his anticipated death in the swamp.

Not much to recommend except **Kazuko Inano**'s performance as Iemon's

Mori's *Yotsuya: Curse of Oiwa* (1969)

wife, Oiwa. The movie was one of many box office disasters for **Daiei Studios** in 1969. Rumors began circulating of a pending bankruptcy. The studio didn't survive another year.

❖

▶ GHOST STORY OF YOTSUYA: HAUNTED SUMMER (1981)
[Masho No Natsu: Yotsuya Kaidan Yori]
director: **Yukio Ninagawa**
Kenichi Hagiwara • Keiko Sekine
Masako Natsume • Renji Ishibashi
****½**

Today she's known as **Keiko Takahashi**, but when she starred in this film she was **Keiko Sekine** (changing her name when she married notorious **Nikkatsu** director **Tomoaki Takahashi**).

This movie is *same-old, same-old*, simply another variation on the **Ghost Story Of Yotsuya** tale {see previous entries for plot synopsis}. There's more emphasis on horrific elements, especially traditional atmospheric effects. The story is recreated in a section of Edo where prostitution is legal, so there's major concentration on sexuality as well as chills. **Yukio Ninagawa** is better known for his stage productions; some critics have complained this film is stilted because of it.

❖

▶ GHOST STORY OF YOTSUYA: CHUSHINGURA VERSION (1994)
[Chushingura Gaiden Yotsuya Kaidan]
aka **CREST OF BETRAYAL**
director: **Kinji Fukasaku**
Koichi Sato • Saki Takaoka
Keiko Oginome • Renji Ishibashi
*****½**

Kinama Quarterly honored this as one of the Top Five motion pictures of 1994. It's an action-packed, big-budget, slick version of the traditional Chushingura Legend {see separate listing for *Chushingura* movies} by one of Japan's most popular filmmakers. **Kinji**

Fukasaku, often called the Nippon *Steven Spielberg*, has been pleasing audiences with highly entertaining movies for 30+ years.

With this one, he combines two different traditional Japanese legends, **Chushingura** and **Ghost Story Of Yotsuya** {see previous series of reviews for plot summary} into one new *chambara* with thriller overtones, as the ghost of Samurai Iemon helps the 47 ronin to avenge their dishonored lord.

Fukasaku's *Yotsuya: Chushingura*

GHOST STORY: SWAMP OF THE CORPSE CANDLE (1963)
[Kaidan: Onibi No Numa]
director: **Bin Kato**
Kenzaburo Jo • Matasaburo Tanba
***½**

Keisuke has been scamming money from his Uncle, a priest. When things get out of hand, the holy man refuses to part with anymore of God's money. So nephew Keisuke decides to kill him. But nobody could accuse Keisuke of being *too* smart. He accidentally kills servant girl Yae (who happens to be sharing the Uncle's bed) instead of killing the Uncle himself.

Then, for no other reason except plot development, Yae's brother comes a'calling. He claims to be worried about his little sister "so young and so

Ghost Story: Swamp Of The Corspe Candle

naive out in the world for the first time in her life." When Hiroko goes looking for sis in the temple, lunatic Keisuke attacks and kills him. But, Brother and Sister ghosts haunt Keisuke, ultimately getting revenge in a particularly anti-climactic climax.

GHOST WANDERER
AT HONJO (1957)
[Kaidan Honjo Nanafushigi]
director: Goro Katano
Juzaburo Akechi • **Shigeru Amachi**
*

Released to theaters as the bottom of a double bill, usually coupled with **Female Vampire** {see separate listing} which also starred **Shigeru Amachi**. The movie is little more than time-filler at 57 minutes, telling a thread-worn tale of a mysterious phantom peeping on geishas in ancient Honjo (Tokyo business district.

Once actor **Amachi** left sleazy *Shintoho* he found the success he so richly deserved with such features as **Ghost Of Yotsuya** (1959) and **Hell** (1960). **Juzaburo Akechi** wasn't so lucky.

GHOSTS OF TWO TRAVELERS
AT TENAMONYA
see SAMURAI COMEDY

GIANT MONSTER CONFLICT
see DAIGORO VS GORIASU

GIGANTIS THE FIRE MONSTER
see GODZILLA
COUNTERATTACKS

GIRL DIVERS
FROM SPOOK MOUNTAIN
see HAUNTED MANSION OF AMA

GIRL WHO TRAVELED BEYOND
THE TIME BARRIER (1983)
[Toki O Kakeru Shoujo]
director: Nobuhiko "Obi" Ohbayashi
Tomoyo Harada • Ryoichi Takayanagi
**½

It's Kaziko's turn to stay behind and clean the classrooms at her high school. While working, she is startled by an explosion in the science lab. Immediately the girl investigates. She discovers a flask had tumbled and smashed against the floor. Some kind of smoke with a lavender odor is leaking from it. Within seconds, Kaziko loses consciousness and collapses. After that, strange things start happening to the girl— memory lapses coupled with eerie blackouts. Eventually Kaziko discovers that she has inherited supernatural powers which enable her to shift through time in out-of-body experiences, particularly triggered when she encounters the lavender smell.

Girl Who Traveled Beyond Time

Obi's story is in the Fantasy genre, but it also boarders on Romance as young Kaziko travels back in time and meets her soulmate, only to lose him forever after an untimely time shift. This film is not one of director **Ohbayashi**'s best, certainly not of the same calibre as his other *Onomichi* films {features shot in his home town of Onomichi in the early '80s, *i.e.* **House, New Student**, *et al*}. But it's harmless fun, a good *date movie*, and – besides – **Tomoyo Harada** is cute.

GIVE ME BACK MY BODY (1996)
[Watashi No Karada O Kaeshite]
director: **Hideyuki Kozuki**
Kazue Ohtake ● Misa Jono
 and **Takashi Hagino**
**

Perhaps it's merely a coincidence, but there are major similarities between this film and **Patrick Schilmann**'s French farce **Gimme Back My Skin** *(Rendez-Moi Ma Peau)* lensed in 1983. In both movies, a man and a woman switch souls after a car accident, leading to a number of gender-bender jokes and obvious sexual identity sight gags.

While the French film is essentially a comedy, the Japanese version takes itself very seriously. The main conflict comes when another woman (**Misa Jono**, star of '95's quirky supernatural drama *Woman Who Needed Sex* {see separate listing}) is attracted to *female* **Kazue Ohtake** and she can't understand these newly realized "lesbian feelings" erupting within her.

GODZILLA (1954)
[Gojira]
 aka **GODZILLA KING OF MONSTERS**
director: **Ishiro Honda**
Takashi Shimura ● Momoko Kochi
Akira Takarada ● Akihiko Hirata
Raymond Burr (American version only)

Godzilla King Of Monsters

Godzilla was not the first dinosaur in motion pictures. A Tyrannasaurus Rex challenged **King Kong** as far back as 1933, **Flash Gordon** successfully fought giant lizards in the early cliff-hangers, and **Cesar Romero** along with **Hugh Beaumont** found a bunch of prehistoric creatures in **The Lost Continent** ('51). Godzilla wasn't even the first dinosaur to invade and destroy a major industrialized city. *Ray Harryhausen*'s creature in **Beast From 20,000 Fathoms** {directed by *Eugene Lourie*} squashed New York and Coney Island in 1953. But Godzilla did manage to capture the fantasy and imagination of the world. Today he's one of the most recognizable characters in all cinema, the star of 22 feature films.

He's a 400 foot dinosaur with distinct Tyrannosaurus features and characteristics {although in **Godzilla Vs Mechagodzilla** [1993] a scientist claims he's from the *Godzillasaurus* family}. Godzilla was "awakened" by an A-Bomb explosion, perhaps the one

dropped on Japan by the Americans in WW2, and he emerges from the sea to wreck havoc. Significantly, Godzilla is not interested in eating humans. Lots of people get crunched, mangled and squashed due to his sheer bulk, but he's really just *a stranger in a strange land* drawn, like a magnet, to electric power sources.

Initially Godzilla destroys a few fishing villages and then on to Tokyo itself. After the military is unable to stop him (God knows, they give it their best shot— pulverizing a goodly part of the country in the process), a scientist uses his newly developed Oxygen-base-destroyer against the monster. It's an amazingly frightful invention, capable of sucking oxygen out of water and disintegrating flesh in the process. The conscientious scientist burns all his paperwork and then kills himself to insure that this doomsday weapon never falls into the wrong hands. Even though director **Honda** includes a shot of Godzilla's bones at the bottom of Tokyo Bay, the creature is back for more in **Godzilla Counterattacks** (*Gojira No Gyakushu*) aka **Gigantis the Fire Monster** (1955) in America.

Initially, in the United States, producer *Joseph E Levine* took the film, sprinkled it with new inserts featuring **Raymond Burr** as foreign news correspondent Steve Martin, usually seen reporting on the carnage from his hotel window. The additional footage was shot by Hollywood B-director **Terry Morse** {best known for his murder mystery **Fog Island** [1945] and the more analogous **Unknown World** [1951]}. The USA version, released amid a huge advertising blitz which totally camouflaged the Japanese roots (presumably because the company wasn't certain a Nippon film would play well in the USA so soon after the War), was a solid box office hit.

The 22 Godzilla films are listed below in chronological order. The best entries are marked with [✦]; see separate reviews for specific information:

✦ **GODZILLA** (1954)
✦ **GODZILLA COUNTERATTACKS** (1955)
 aka **Gigantis The Fire Monster**
◇ **KING KONG VS GODZILLA** (1963)
✦ **GODZILLA VS THE THING** (1964)
 aka **Godzilla vs Mothra**
◇ **MONSTER ZERO** (1965)
✦ **GHIDRAH: 3-HEADED MONSTER** (1965)
◇ **GODZILLA VS SEA MONSTER** (1966)
◇ **SON OF GODZILLA** (1967)
✦ **DESTROY ALL MONSTERS** (1968)
◇ **GODZILLA'S REVENGE** (1969)
◇ **GODZILLA VS SMOG MONSTER** (1971)
✦ **GODZILLA VS GIGAN** (1972)
◇ **GODZILLA VS MEGALON** (1973)
◇ **GODZILLA VS COSMIC MONSTER** (1974)
 aka **Godzilla vs Mechagodzilla**
◇ **TERROR OF MECHAGODZILLA** (1975)
✦ **GODZILLA '85** (1985)
✦ **GODZILLA VS BIOLANTE** (1989)
✦ **GODZILLA VS KING GHIDORAH** (1991)
✦ **GODZILLA VS (QUEEN) MOTHRA** (1992)
✦ **GODZILLA VS MECHAGODZILLA** (1993)
◇ **GODZILLA VS SPACE GODZILLA** (1994)
✦ **GODZILLA VS THE DESTROYER** (1995)

GODZILLA 1985 (1985)
[Gojira 1985]
 aka **RETURN OF GODZILLA**
director: Koji Hasimoto
Ken Tanaka • **Keiju Kobayashi**
Yasuko Sawaguchi • **Shin Takuma**
Raymond Burr (American version only)

This is a sequel. It's not a sequel to Godzilla's previous appearance in 1975

Godzilla Counterattacks (Gigantis The Fire Monster)

it's a sequel to the original 1954 film, **Godzilla, King of Monsters**. Over the past 31 years, audiences have seen Godzilla transformed into a buffoon, into some sort of goofball security guard for the world. Beginning with **Monster Zero** (1965), Big G became a "good" monster protecting mankind from aliens and other creatures (usually Ghidorah). Along with this sorry state of affairs also came poorly written stories and cheap special effects to match. It was an obvious attempt by *Toho* to concentrate on a less-demanding "children's market" for the future success of the series. With this feature, all that changed. Ignore everything that happened inbetween, Godzilla is back and he's a bad-ass monster ready to destroy anything and everything in his path.

FX work by **Nobuyuski Yasumaru** is state-of-the-arts; director **Hosimoto** handles the simplistic story with a nightmarish quality absent since **Ishiro Honda**'s original masterpiece.

Godzilla has been re-awakened from his resting place on the ocean's floor by a Russian submarine. He returns with a vengeance, quickly gaining strength as he follows his instinctive demolition course to Tokyo.

The *Western* version features **Raymond Burr** (TV's **Perry Mason**) as a journalist in some unconvincing inserted footage. The Japanese print is **Burr**-less and runs 13 minutes longer than the 87 minute American version.

❖

GODZILLA COUNTERATTACKS
aka **GIGANTIS: FIRE MONSTER** (1955)
[Gojira No Gyakushu]
director: Motoyoshi Oda
Hiroshi Koizumi • Setsuko Wakayama
**½

As this sequel begins, Godzilla has successfully escaped to a remote island in the Pacific. Apparently, he managed to hightail it from Tokyo Bay before the Oxygen-base-destroyer zapped him dead. After fighting and killing another

"A-Bomb activated" dinosaur named Angurus (squashing a lot of people and temples in the process), Godzilla decides to return to Tokyo to take care of some unfinished business. Enroute, he smashes the hell out of Osaka. But he's buried in a snowy avalanche before he can reach the capitol.

The film was released in the United States by **Warner Brothers**, but they couldn't secure permission to use the Americanized "Godzilla" name from **Joseph E Levine**, the first film's USA producer. Big G's name was changed to *Gigantis* in the dubbing. Extra "insert" footage was also shot by **Hugo Grimaldi**, a B-director who's only other claim to fame is **Human Duplicators** and **Mutiny In Outer Space** (both 1965).

The third *Godzilla* film, **King Kong Vs Godzilla**, would not be made for 8 years.

❖

GODZILLA VS BIOLANTE (1989)
[Gojira Tai Biorante]
director: **Kazuki Ohmori**
Kunihiko Mitamura • Yoshiko Tanaka
**½

The first official sequel in the neo-Godzilla series, essentially a sequel to **Godzilla 1985**. The G-Force team after successfully luring Godzilla into a volcano at the end of that film, now have a new problem.

Some terrorists have broken into Dr Surigama's laboratory. They want to steal his top-secret formula for an oil-producing plant, but in the confusion the thieves grab a test tube containing a Godzilla cell. To make matters worse, they accidentally mix the solutions, resulting in the birth of Biolante.

Eventually, Godzilla returns from his extended tour of the underground to challenge his illegitimate offspring. Once again, Tokyo is destroyed in the ensuing battle. Godzilla returns, with a

Godzilla Vs Biolante

marginally better script in **Godzilla Vs King Ghidorah** (1991). Speaking of the script, this was actually one of 5025 sent to **Toho** by *concerned fans* when the studio announced that they were "out of ideas" for the series. At least, that's the story **Toho** tells.

Director **Omori**, who also holds a medical degree from the University of Tokyo, concentrated on educational films prior to making this Godzilla movie. In 1980, he received the Geijutsu Sensho Award for his film **Hippocratic**, the fictionalized chronicle of overburdened medical students. In the mid '80s he made a series of short horror films "for his own amusement." These creative featurettes (later released on video under the title **Bloody Scary Horror**) helped him secure the contract with **Toho** for the Godzilla projects.

❖

GODZILLA VS THE COSMIC MONSTER (1974)
[Gojira Tai Mekagojira]
translation: **Godzilla vs Mechagodzilla**
aka GODZILLA VS BIONIC MONSTER
director: **Jun Fukuda**
Masaaki Daimon • Kazuya Aoyama
Akihiko Hirata • Reiko Tajima
**

The Good, the Bad, and the Ugly. Just as **Sergio Leone** ended his epic Spaghetti Western (1966) with the now-famous three-way showdown between

Clint Eastwood, Eli Wallach and Lee Van Cleef, director Fukuda concludes this one with Godzilla facing alien-controlled Mechagodzilla and ancient monster-god King Seesar as the soundtrack blares the chords from Ennio Morricone's western opus.

The in-joke is appreciated but the rest of the film is shop-worn. Godzilla forms an apprehensive relationship with an Okinawan god to conquer a cyborg created by nasty space aliens. Mechagodzilla returns in **Terror of Mechagodzilla** (1975).

The two titans will meet yet again— with roles reversed– in 1993 [**Godzilla Vs Mechagodzilla**].

❖

GODZILLA VS THE DESTROYER (1995)
[Gojira Tai Desutoroiya]
director: Takao Ohgawara
Takuro Tatsumi • Yoko Ishino
Yasufumi Hayashi • Emi Kodaka
Sayaka Ohsawa • Saburo Shinoda

Godzilla is back for the 22nd time. And for the second time in his long career, Godzilla does indeed die at the film's conclusion.

This one opens with Godzilla wrecking havoc in Hong Kong. His body has taken on a reddish hue and scientists report to G-Force that he looks like "a furnace ready for an atomic explosion." Not only is Godzilla capable of destroying everything in his path through sheer bulk and brutality, but now his cells are mutating and radiumized (the result of an infection after doing battle with Space Godzilla the year before). Any penetration of his skin could trigger a nuclear explosion which would destroy life on the planet. Thus, orders are issued not to use any kind of military force against Godzilla.

Meanwhile, deep in the murky waters of Tokyo Bay, a new creature is stir-ring, evolved from the residue of the Oxygen-base Enzyme which originally destroyed Godzilla back in 1954. This new monster, called the Destroyer, is a completely alien life-form with a unique anti-oxygen biological chromosome structure, nurtured on the ocean floor without anyone's knowledge. Until now. Despite the protests from bleeding-heart psychic Dr Saegusa (once again played by Emi Kodaka), the scientists at G-Force Headquarters decide to use the Destroyer against Godzilla. Popular TV actor, Takuro Tatsumi, is the rouge agent who discovers the Destroyer's deadly secret too late. And even though Godzilla is dead, now there's a new round of trouble.

Mercifully, director Takao Ohgawara downplays the environmental issues which overpowered the previous installments, however he still has a major continuity problem here. If Destroyer is born from the waste of the weapon which killed Godzilla in 1954, how come Godzilla's alive at all?

The bigger question, of course, is "why does Godzilla die in this one?" In November of 1994, Toho Studios launched an extensive campaign celebrating Big G's 40 birthday, a promotion which included billboards, TV spots, magazine and newspaper ads, plus special video and laser disk collections, not to mention a hit movie Godzilla Vs Space Godzilla. So why did the studio kill off their biggest boxoffice draw a year later?

It most probably has to do with the multi-million dollar deal between Toho and America's Tri-Star Films. Pre-sumably, with Godzilla becoming a stateside actor, his tenure at Toho has ended.

But fear not. Things are not always what they seem. Daddy G may be dead, but his son is growing like hell. And he shares an amazing likeness to his father.

GODZILLA VS GIGAN (1972)
[Gojira Tai Gaigan]
aka GODZILLA ON
 MONSTER ISLAND
director: Jun Fukuda
Hiroshi Ichikawa • Yuriko Hishimi
**

It's better than many of the recent entries, but that's like choosing from rat-bite fever, jungle rot, or tick-borne typhus. They're all pretty bad.

Three perennial themes are whirling about here. First, aliens attempt to take over the Earth; second, their own planet is dying from pollution; and third, the bad spacemen deploy Ghidra [Ghidorah] and Gigan (a new monster with a buzz saw in his belly) to fight Godzilla and his tag team partner Anzilla.

❖

GODZILLA VS
 KING GHIDORAH (1991)
[Gojira Tai Kingu Gidora]
director: Kazuki Ohmori
Anna Nakagawa • Kosuke Toyohara
Megumi Odaka • Kiwako Harada

The action begins three years after Godzilla took a nose dive into the Fuji volcano and was left for dead at the conclusion of Godzilla Vs Biollante (1989). Panic grips Japan as a flying saucer soars through the night and lands in Tokyo. Its crew claims to be from two hundred years in the future, and they wish to save Japan from impending destruction by Godzilla.

They plan to do this by going back to Lagos Island circa 1944 where Godzilla— then just an ordinary dinosaur— was hit by a hydrogen blast and mutated into a monster. By removing him before the mutation occurs, they can eradicate Godzilla from history. But the future people have a secret agenda. They leave three small winged creatures which are in turn bombarded by the radiation and become King Ghidorah, the winged three headed hydra (first introduced in Monster Zero [1965]).

The future people can now control Ghidorah and use him to destroy various Japanese landmarks. A new and improved Godzilla shows up, created by nuclear waste, and stomps Ghi-

the metallic Ghidorah from *Godzilla Vs King Ghidorah*

Godzilla Vs The Sea Monster

dorah. He then turns on Tokyo and begins tearing the city apart. Emi, a sympathetic future girl, returns to the present and revives Ghidorah, turning him into a cyborg, successfully fighting Godzilla again.

As with most films using time-travel as a foundation, this one is riddled with plotholes. But that's really not important, is it? Godzilla kicks ass. The special effects are great. And **Akira Ifukube**'s music has never been better. Life is grand.

❖

GODZILLA VS MECHAGODZILLA (1993)
[Gojira Tai Mekagojira]
director: Takao Ohgawara
Masahiro Takeshima • Emi Kodaka
*****½**

In Japan, this one was promoted as a "non-stop battle movie." And on that level, it's one of the best of the batch. It's not cluttered with the one dimensional environmental lipservice that almost ruined **Godzilla Vs (Queen) Mothra** (1992) and *did* ruin **Godzilla Vs Space Godzilla** (1994). With this film, director **Ohgawara** is concerned

about one thing, and only one thing. Monsters.

Round #1: Godzilla fights Rodan. *Round #2:* Godzilla destroys Osaka and Kyoto while trying to rescue his son. *Round #3:* Mechagodzilla, manned by the megaforce good guys, fights Godzilla and loses. *Round #4:* Rodan destroys the outer islands of Japan. *Round #5:* Godzilla fights Rodan. *Round #6:* Rodan and Godzilla fight the new improved Mechagodzilla. *Round #7:* Godzilla is down for the count. *Round #8:* Rodan fights Mechagodzilla singlehandedly. *Round #9:* Rodan is down for the count, but in tag team fashion, he revives Godzilla. *Round #10:* Godzilla pounds the hell out of Mechagodzilla. *Match over:* Godzilla, the winner by a knock out. And, oh yeah, the **Kenichi Sekiguchi** special effects are great. Plus **Akira Ifukube**'s musical score is unparalleled.

❖

GODZILLA VS MEGALON (1973)
[Gojira Tai Megaro]
director: Jun Fukuda
Katsuhiko Sasaki • Hiroyuki Kawase
***½**

Are the ideas running thin? Underwater aliens deploy two creatures in retaliation against environmental pollution. These monsters, Megalon (a giant cockroach) and Borodan (an enormous chicken) fight Jet Jaguar and Godzilla who is now the friend of mankind.

❖

**GODZILLA VS
THE SEA MONSTER** (1966)
[Gojira Ebira Mosura: Nankai No Daiketto]
translation: **Godzilla, Ebira, Mothra:
 Duel In The South Sea**
director: **Jun Fukuda**
**Akira Takarada • Toru Watanabe
Hideo Sunazuka • Kumi Mizuno**
*

Long time Godzilla director **Ishiro Honda** walks off the set. He is replaced by **Jun Fukuda** who doesn't attempt to keep any semblance of respectability to the proceedings.

It was bad enough when the Big G played *baseball* with King Kong in **King Kong Vs Godzilla** (1963), but this time he plays *football* with sea monster Ebirah. And did we mention that Ebirah is a giant shrimp? See, "Ebi" is "shrimp" in Japanese. What a clever name, huh? But could there be a dumber monster?

The two miniature girls who fly around with Mothra are twins in real life. They have a successful singing career under the name **Ito Sisters**. For the first few *Mothra* films, they were called *The Peanuts*. With this one they became *Pair Bambi*. Later, with **Godzilla vs (Queen) Mothra** (1992) they are called *The Cosmos*.

❖

**GODZILLA VS
THE SMOG MONSTER** (1971)
[Gojira Tai Hedora]
translation: **Godzilla vs Hedora**
director: **Yoshimitsu Banno**
Akira Yamauchi • Hiroyuki Kawase
*½

Godzilla Vs The Smog Monsters

What the hell has happened to Godzilla? He's no longer the ferocious fire-breathing creature introduced in 1954. Now, he's more like a drunk uncle dancing a jig for the kids at a holiday party.

Yoshimitsu Banno's minimalistic direction doesn't help. But, at least, the Big G isn't *talking* anymore (in an embarrassing plot twist, Godzilla had found his voice in **Godzilla's Revenge** [1969]).

Stemming from a concept introduced in **Gamera Vs Zigra** (early 1971), the villain is pollution. A creature is born from the sludge dumped into the rivers. This monster, Hedora, has an insatiable appetite for pollution and he invades Tokyo looking for it. Of course, he finds a ton. Godzilla, aided by special military's generators, attacks and destroys the Smog Monster.

But isn't it logical to assume a monster who lives off raw pollution might not be a bad thing to have around?

❖

**GODZILLA VS
(QUEEN) MOTHRA** (1992)
[Gojira Tai Mosura]
director: **Takao Ohgawara**
**Tetsuya Bessho • Satomi Kobayashi
Emi Kodaka • Akira Takarada**

This is a direct sequel to **Godzilla Vs King Ghidorah** (1991), but essentially it is a remake of **Godzilla Vs The Thing** (1964), with the addition of many embarrassingly simplistic com-ments about environmentalism.

The Cosmos (the last of a dying species of fairies) are kidnapped by an evil businessman. Telepathically, they call to Mothra for help. She destroys most of Japan in her haste to rescue them. But before she can complete her mission, arch enemies Godzilla and Batora (also known as Black Mothra) show up. The three monsters engage in a free-for-all in the streets of downtown Tokyo. As with the other entries in the *new* Godzilla series, the special effects are very impressive, the monster battles are spectacular, and **Akira Ifukube**'s music is superb.

❖

GODZILLA VS SPACE GODZILLA (1994)
[Gojira Tai Supeisugojira]
director: Kensho Yamashita
Jun Hashizume • Emi Kodaka
Towako Yoshikawa • Akira Nakao
*½

This one has a make-it-up-as-you-go quality which is begrudgingly endear-ing. For example, Space Godzilla is a creature zooming towards earth to do battle with Godzilla. Scientist are dis-cussing the *wheres* and *hows*. Where did he come from? And how come he looks so much like Godzilla? With a straight face, a research expert explains: "A cell from Godzilla must have been transferred into space by either Biolante or Mothra and then swallowed into a black hole and back out a white hole as a type of mutation." *Is this for real? Into a black hole and out a white? But wait, there's more*: "And during the incubation, a type of transformation occurred, energized by a crystallization of the stars manifested in the large crystals on his back... the birth of a horrible monster." Now, from an unintentionally funny prospec-tive, this is high camp. But then the film is spoiled with an endless litany of trite environmental sermons, culminat-ing with "If the Earth continues to be contaminated, who knows what kind of creature will be next. This is a warning from God to human beings."

On top of that, there's also Little Godzilla to contend with. This "cud-dly" round-eyed offspring could've stumbled in from some **Walt Disney** opus, except even Disney doesn't do this kind of syrupy sentimentality any-more. And, if that weren't enough, the Big G is back to being a *good guy mon-ster*! He saves mankind by battling Space Godzilla, while the humans cheer for him like they're attending some bizarre sports event.

But perhaps the most irritating thing is the production itself. **Takayuki Hattori**'s soundtrack is gawdawful, a blatant **James Bond** ripoff with none of **Akira Ifukube**'s dynamics. And director **Yamashita** further insults fans of the series by intercutting close-up shots and various "destruction" sequences, *bor-rowed* from other Godzilla movies, thus saving in special effects costs. In fact, the explosive opening credit sequence is lifted directly from **Godzilla Vs (Queen) Mothra** (1992).

Godzilla Vs Space Godzilla

Godzilla vs (Cosmic Monster) Mechagodzilla 1974

GODZILLA VS THE THING (1964)
[Mosura Tai Gojira]
translation: MOTHRA VS GODZILLA
director: Ishiro Honda
Akira Takarada • Yuriko Hoshi
Hiroshi Koizumi • Ito Sisters
**½

Mothra is the *Thing* (in the USA title) for this 4th film in the Godzilla series. The movie opens as a giant egg is washed ashore in Japan and unscrupulous carnival agents steal it. Mothra and her fairy guardians, the Peanuts (**Ito Sisters**), try to retrieve it.

But meanwhile, Godzilla shows up to destroy Tokyo yet again. Mothra, basically a *good* creature, is recruited to do battle against Big G and she accepts, despite the rotten business inflicted by humans on her egg. After Mothra is defeated, the egg hatches and two larva emerge to successfully take revenge against Godzilla.

This film was one of Toho's biggest hits, as it managed to attract both males **and** females to the theatre. Apparently, women liked the idea of a formidable female creature.

GODZILLA'S REVENGE (1969)
[Oru Kaiju Daishingeki!]
translation: **All Monsters Attack!**
director: Ishiro Honda
Kenji Sahara • Tomonori Yazaki
Machiko Naka • Sachio Sakai
*

This is easily the worst **Ishiro Honda** *Godzilla* movie, even more awful than *Jun Fukuda*'s **Godzilla Vs The Sea Monster** (1966).

Apparently, everything is back to normal on Monster Island after the messy fracas earlier in the year (as chronicled in **Destroy All Monsters**). Now, a young boy dreams of visiting Godzilla and Baby Godzilla, playing together and even (yes, it's true) **talking** together. Obviously, *Toho Studios* was being pressured into aiming directly at the children's market based on the unmitigated success of competitor *Daiei*'s **Gamera** series. But *Daiei* never stooped so low as to have Gamera *talk* to the precocious kids.

This is the last film in FX wizard **Eiji Tsuburaya**'s long career. He died from a heart attack in 1970. Director **Honda**

took a six years break from Godzilla movies and became more involved in television production. He returned for Godzilla's 21st birthday celebration, **Terror of Mechagodzilla** (1975).

GOKE: BODYSNATCHER
FROM HELL (1968)

[Kyuketsuki Gokemidoro]
translation: Bloodsucking Vampire Virus
aka BODYSNATCHER FROM HELL
aka GOKE THE VAMPIRE
director: Hajime Sato
Hideo Ko • Teruo Yoshida
Tomomi Sato • Masaya Takahaski

In the previous year, *Shochiku Studios* released **X From Outer Space**, a horror film about space-gunk attaching itself to an interplanetary rocket. And now the studio produces a tale of space-gunk attaching itself to a jumbo jetliner. This time, when the plane belly flops in the desert, the virus infects a passenger, turning him into a bloodsucking vampire. Soon everybody is craving fresh blood. The pilot manages to escape with a stewardess before they both become vampires too.

Reminiscent of countless thrillers from **Don Siegel**'s **Invasion of the Body Snatchers** (1956) to **Lucio Fulci**'s **Zombie [Zombie Flesh Eaters]** (1979) to **Michele Soavi**'s **Dellamorte Dellamore** (1994), the ending finds the survivors discovering the entire world has become hopelessly contaminated during their own traumatic struggle.

GOKUMON ISLAND
see **KINDAICHI** series

GOLDEN BAT (1966)

[Ougon Batto]
director: Hajime Sato
Shinichi Sonny Chiba • Wataru Yamakawa
**

This film is based on a manga serial penned by **Yasuo Nagamatsu** which ran in *Shonen Boken* magazine before the Second World War. Much of the scientific theories are long-outdated and the story is absurdly naive. But as a fantasy, it still holds an unassuming charm.

Arch-villain Phantom Nazo (**Wataru Yamakawa**) wants to shift the orbit of Equuleus, a star in a neighboring galaxy, so that it will crash into Earth. Golden Bat (**Shinichi *Sonny* Chiba**) fights Phantom Nazo and his space warriors to keep the world safe.

The film spawned an animated series on Nippon television which found more success than this original movie.

GOODBYE ARK (1982)

[Saraba Hakobune]
director: Shuji Terayama
Tsutomu Yamazaki • Mayumi Ogawa
**½

This is cult director **Terayama**'s last film before his death in 1983 {see **Glass Labyrinth** for overview}. The story is loosely based on the book *Hundred Years Of Isolation* by European author **Garcia Marquis**, but the movie also owes a debt to the classic **Brigadoon** legend.

There is an imaginary village, hidden deep in the mountains, where customs are strict and the mindset of the community is based on ancient superstitions. One such law forbids cousins to

Goodbye Ark

marry. Tradition warns such a union will produce a child with a pig's tail.

Cousins Sutekichi and Sue (**Tsutomu Yamazaki** and **Mayumi Ogawa**) defy the taboo and get married anyway. The movie is based on their lives within the stoic community. The children they bear are normal; this irritates the town fathers who attempt to demoralize the happy family through black magic.

There were many technical problems during the shoot, mostly due to Terayama's frail condition. He was seriously ill but refused to be hospitalized until the principal filming was completed. The project was shot in Okinawa to take advantage of that prefecture's *surrealistic* topical setting.

GOODBYE JUPITER
see **SAYONARA JUPITER**

GOOD LUCK VENUS (1993)
[Megami Ga Kureta Natsu]
translation:
Summer Bestowed By A Goddess
director: Takeo Imai
Aya Sugimoto • Taro Tsutsumi
Mai Sho • Naomi Serizawa
**½

Kochi (**Taro Tsutsumi**) is the lead guitarist in a band heading for the rocks.

Aya Sugimoto: *Good Luck Venus*

Their lead singer, an obnoxious sod, has miraculously landed a record deal and he is jumping ship. Poor Kochi also has problems at home. His parents are urging him to settle down and marry his mousy girlfriend (**Aya Sugimoto**, in one of her dual roles) but he's not certain that's a good idea. One evening, bummed out and cursing his bad luck, Kochi slips on a stairway and smacks his head. This causes the Good Luck Goddess to appear (again **Aya Sugimoto**, in a role more suitable of her *charms*). Suddenly, everything turns for the better in Kochi's life, thanks to his personal sexy genie. That is, until he falls in love with her.

It's fluff. Probably inspired by **Video Girl Ai** (1991) {see separate listing}. But it's a perfect date movie, quite funny in a sweet way.

Singer **Aya Sugimoto** has the reputation of being "Japan's Bad Girl of Pop" due to her risque CD covers, suggestive songs, and erotic videos. But, she plays this movie with some restraint. The girl definitely knows how to fill out a bikini, however she leaves the nudity for her music clips.

GORATH (1962)
[Yosei Gorasu]
aka **Gorath The Space Monster**
director: Ishiro Honda
Ryo Ikebe • Akihiko Hirata
Yumi Shirakawa • Takashi Shimura
**

A meteor is zooming through space on a collision course with Earth. The World Scientists decide to swerve Earth from its orbit to avoid impact (regardless of the detailed scientific jargon, this seems like a very dangerous solution to the problem, but then it's only a movie).

Everybody is so preoccupied with this orbit shift and the problems relating to it, nobody seems too concerned about a

monster (**Gorath**) generated from hybrid outer space cells. Apparently, Gorath was not a memorable creature for audiences either. He never made another appearance in *Toho* films, not even in the *kaiju eiga* slug-fest reunion, **Destroy All Monsters** (1968).

GRASS LABYRINTH (1979)
[Kusa-meikyu]
director: Shuji Terayama
Takeshi Wakamatsu • Juzo Itami
Hiroshi Mikami • Keiko Niitaka
***½

Originally, *Grass Labyrinth* was produced and released in a French omnibus film, *Private Collection* (1979). But when cult director **Terayama**[1] died in 1983, the Nippon production company extracted this segment from the Euro print and — after rounding it out with a few of Terayama's early experimental films — they arranged for a theatrical release in Japan. Ironically, this eclipsed all previous Terayama films. It became the director's most successful feature, probably due to the extensive advertising campaign on his heels of his dolorous death. Today, however, the movie is considered the "essence of Japanese cinema" by many critics.

Based on story by surrealistic writer **Kyoka Izumi** dealing with a young man, Akira (**Takeshi Wakamatsu**), who is searching for the origin of a children's "bouncing ball" song that his mother used to sing. Under Terayama's deft direction, this bittersweet saga transforms into a supernatural chiller. The lead character stumbles into a time-warp which combines elements from both his adult and juvenile lives. There, in this mirage, he meets a beautiful witch who's hopelessly lost inside the maze of her mansion.

If there's a weakness in the movie, it lies in the narrative structure. The hallucinogenic quality, accompanied by a

Shuji Terayama's *Grass Labyrinth*

tenacious delirium, makes this film difficult to follow— thus demanding quite a bit from the audience. But the project is ultimately made palatable by the breathtaking fantasy effects and eerie horrific atmosphere.

[1] **Shuji Terayama** was a notorious counter- culture playwright/poet from the '50s who became a scriptwriter (mostly for Masahiro Shinoda) in the '60s. His directorial debut came in 1971 with the autobiographical **Throw Away Your Books And Go Out**; Terayama's most notorious film is **Fruits Of Passion: The Story of O** (1981) with Klaus Kinski and Isabelle Illier.

GREAT INSECT WAR (1968)
[Konchu Dai Senso]
aka **GENOCIDE**
aka **WAR OF THE INSECTS**
director: Yoshimizu Nihonmatsu
Keisuke Sonoi • Yusuke Kawazu
Emi Shindo • Reiko Hitomi
Cathy Holman • Rolf Jesser
*½

Okay, here's the real scoop. This movie may be called the *Great Insect War*, but the only *insects* are a swarm of bees. And the *war* consists of a bee attack on a house where one guy gets killed, and then on an airplane where five guys bite it. But then the plane blows up and kills all the bees. So, the war wasn't so *great* after all.

In some corners of the world, the movie is called *Genocide*. That's because the plot's a bit more intricate than it might first appear. There's this Jewish blonde lady (**Cathy Holman**) who lived in Germany during WW2.

Great Insect War

She was imprisoned in a concentration camp and tortured for the the entire length of the war. Now the woman wants revenge. So she's groomed these killer bees in her basement and hopes to use them in a massive *genocide* attack against Germany. Her plan goes haywire when she's assaulted by a Japanese agent who doesn't agree with her antisocial philosophies. She accidentally shoots a hole in the bee cage.

Shochiku latched onto this silly story {probably influenced by the similar *Freddie Francis* movie, **Deadly Bees** [1967]} and produced it in a desperate attempt to revamp their boxoffice image. They had become a big name in TV production, but film revenues were suffering due their conservative reputation. As it turned out, this film wasn't the answer.

GREAT
SENTIMENTAL MASK (1992)
[Daikansho Kamen]
director: Koki Kumagai
Gyu Yonezawa • Kyoko Hashimoto
**½

Mikio Igarasi, a counter-culture manga writer, produced this film based on his comic. It tells the story of a cyborg named Tadokoro (**Gyu Yonezawa**) who transforms into a hardshelled, masked superhero whenever he cries.

Obviously intended for a cult crowd who grew up on *Ultraman* and the *Ultra*-clones, executed accordingly by director **Kumagai**. It's an ultra-hip *kayo-eiga* (pop song film) with a metalman vs yakuza plot.

GREAT SPIRIT WORLD
see TANBA'S GREAT
SPIRIT WORLD

GREEN REQUIEM (1985)
[Green Requiem]
director: Akiyoshi Imazeki
Kahori Torii • Shinobu Sakagami
*

Scifi fantasy about a girl (**Kahori Torii**) who gets nutrition from photosynthesis, similar to a plant. Eventually a scientist (**Shinobu Sakagami**) at the National Botanical Center falls in love with her.

Made for the theatre, but the *Shochiku* sat on it for three years before finally issuing a release in '88. They should've kept it on the shelf.

GREEN SLIME (1968)
[Ganma Sango Uchu Daisakusen]
translation: **Gamma #3: Space Project**
director: Kinji Fukasaku

Great Sentimental Mask

Robert Horton • Richard Jaeckel
Luciana Paluzzi • William Ross
*½

Cheap and goofy thrills from the future director of the **Fight Without Honor** series (1971) and **Virus** (1980). But this production is most notable for being one of the first Japanese/American co-productions, oddly consisting of an all Japanese crew with a team of Anglo performers.

Robert Horton (*Flint McCullough* from TV's **Wagon Train** series [1957-62]) is a space station commander who survives an invasion of vegetable-shaped creatures born from green asteroid slime. Italian actress **Luciana Paluzzi** looks like she'd rather be anywhere else rather than playing a scientist in this silly space opera.

Interestingly, later the same year, director **Fukasaku** made one of his best (and most controversial) films, **Black Lizard**, the brazen pop-art transvestite thriller. The director returned to the SciFi genre ten years later for **Message From Space** (1978) with **Shinichi "Sonny" Chiba** and **Vic Morrow**.

GUINEA PIG series (1988-1993)
[Za Ginipiggu] 8 episodes

Inadvertently, this series received more publicity than it deserved when actor **Charlie Sheen** got involved in a campaign to ban the *Guinea Pig* films in America. As the story goes, he sup-posedly saw a copy of **#3** (**Flowers Of Flesh And Blood**) and, believing it to be a real *snuff* film [actual on-camera-murder footage], he contacted the Motion Picture Association (MPAA). Then, he got involved in a subsequent movement to stop any kind of import distribution for the films. His efforts only resulted in turning an amateurish shot-on-video production into a hot commodity among *fangore* collectors.

Of the six entries, only **#4** (**Mermaid In A Manhole**) has any true cinematic merit. The other installments are viciously cruel vignettes, mildly interesting from a geek-show point of view. They run from a paltry 39 minutes to 77 minutes, depending on the episode. And many of the later ones retread the same footage from the earlier productions.

The series includes:

▶ **GUINEA PIG:**
 DEVIL'S EXPERIMENT (1988)
 [Za Ginipiggu:
 Akuma No Jikken] 43 minutes
producer: Satoru Ogura

Inspired by *Roberta* and *Michael Findlay*'s **Snuff** (1974) {the Argentina/American co-production which allegedly concludes with an on-screen slaughter of an unsuspecting actress} producer **Ogura** presents this Japanese variation. The feature opens with a disclaimer:

> *"The producers received this video. There was no accompanying information. We are researching name, age, and other information about the girl and her three killers."*

In keeping with the *gimmick*, there is no credit information available. But judging from the similarities between this entry and **#3**, it's most probably directed by the same man, infamous manga illustrator **Hideshi Hino**.

A gang of boys kidnap a young girl for some fun and games. But unlike characters in *pinku eiga*, these delinquents aren't interested in sex. They only want to abuse this helpless victim. While the camera lingers, they dispassionately beat her. It's a steady stream of atrocities as these boys use pliers to pull off her fingernails, pour scalding water over her body and then drop maggots into the festering burns, throw animal guts at her, smash her hands with a sledge hammer, stick a needle through her eye. And so forth.

Eventually, the girl dies; they hang her body from a tree.

❖

▶ **GUINEA PIG 2: ANDROID OF NOTRE DAME** (1989)

[Za Ginipiggu 2: Notorudamu No Andoroido] (51 minutes)

director: Kazuhito Kuramoto
Toshihiko Hino • Mio Takaki

At least this entry is an attempt at a cohesive story. A midget mad scientist tries to find a cure for his terminally ill girlfriend. He kidnaps other hapless females, dissects them, and angrily beats them to death when the absurd experimentation fails. The production standards are considerably higher than other entries in the series, but gratuitous gore remains the only attraction. The episode has little else going for it.

❖

▶ **GUINEA PIG 3: FLOWERS OF FLESH AND BLOOD** (1990)

[Za Ginipiggu 3: Chiniku No Hana] (42 minutes)

director: Hideshi Hino
Hiroshi Tamura • Kirara Yugao

A man, dressed in cheesy samurai regalia, kidnaps a girl as she's strolling along a Tokyo backstreet. He takes her to his basement workshop, straps her to a table, and for the next 40 minutes he pokes and dissects, chops and dismembers, eventually decapitating the girl. Then the butcher eats her eyeballs and goes out and to do it all over again.

Directed with sadistic abandonment by **Hideshi Hino**, best known in the States for the book **Panorama Of Hell** [1991]). He also made **#4** (**Mermaid In A Manhole**) and most likely **#1**.

❖

▶ **GUINEA PIG 4: MERMAID IN A MANHOLE** (1991)

[Za Ginipiggu 4: Manhoru No Naka No Ningyo] 63 minutes

director: Hideshi Hino
Shigeru Saiki • Tsuyoshi Toshishige

Manga illustrator **Hideshi Hino** wrote and directed this surprisingly intelligent splatter-punk episode. But unlike all the other entries, this one is *grotesque*, not gross.

Hayashi (**Shigeru Saiki**) is an artist who gets inspiration from the sewer under his street. One day, while snooping around, he stumbles upon a mermaid (**Tsuyoshi Toshishige**) struggling in the sludge. Hoping to paint her, Hayashi takes her home and puts her in his bathtub. The mermaid continues to decay daily, until she begs him "Kill me! Kill me! But first draw my sorrow." He does.

❖

▶ **GUINEA PIG 5: PETER'S DEVIL WOMAN DOCTOR** (1992)

[Za Ginipiggu 5: Peter No Akuma No Joi-san] 52 minutes

director: Hajime Ejiki
Peter • Tamio Kageyama
Naoto Takenaka • Yuji Nakamura

Perhaps the producers were getting too much criticism for the blatant cruelty of this series (cruel, even by liberal Japanese criteria). With this entry the savage tone is dropped in favor of a black humor. An unlikely female doctor (transvestite **Peter** doing her/his best **Cher** impression [perhaps, she's supposed to be **Elvira**]), conducts experiments on a series of odd-ball patients, including males for the first time in the series. The victims are, for the most part, famous and near-famous comedians including **Naoto Takenaka** who later became a serious actor (*i.e.*, **Rampo**, 1994).

❖

▶ **GUINEA PIG 6: SLAUGHTER SPECIAL** (1992)

[Za Ginipiggu 6: Zansatsu Supeshyaru] 77 minutes

director: Satoru Ogura/Hideshi Hino
Hiroshi Tamura • Peter • Kirara Yugao

This is a re-edit and re-release of **#1**

and **#3** with two new *humorous* epilogues. In the first, the guts of the butchered female chases a girl through an underground subway station and into an office building. Then **Peter**, the Devil Woman Doctor, returns and introduces a story about a masochist who starts cutting up his body {this vignette is expanded for **#8**}. The episode concludes with another *funny* bit as an investigative reporter visits a new restaurant featuring a "human body parts buffet."

❖

▶ **MAKING OF GUINEA PIG** (1992)
[Meikingu Obu
Za Ginipiggu] 44 minutes
director: Satoru Ogura

The producers now feel compelled to show how they achieved the gross-out special effects of the previous episodes (excluding **#4**, generally not considered part of the series). This episode was necessary due to mounting controversy that "innocent people were really being slaughtered in these films." The *Guinea Pig* series definitely raises certain concerns, but not necessarily *"Is it real?"* Rather, *"what kind of person would be*

entertained by the mindless misogynist mayhem?"

❖

▶ **GUINEA PIG 8:
HE NEVER DIES** (1992)
[Za Ginipiggu 8: Senritsu!
Shinanai Otoko] 39 minutes
director: Masayuki Hisazumi
Keisuke Araki • Eve • Masahiro Sato

Footage is borrowed from **#3** and the epilogue of **#6**. It's shaped into a new entry with wrap-around scenes of a psychologist droning on about "odd personality types living undetected within society." The main thrust of the episode deals with a masochist who uses himself as a pincushion and then decides to start slicing off various body parts. This brutal footage is intercut with more *humorous* comments from average on-the-street citizens. Last entry in the series.

GUNHED (1989)
[Ganheddo]
director: Masato Harada
Masahiro Takashima • Mickey Curtis
Brenda Bakke • Landy Leyes
James B Thompson • Doll Nguyen
***½

the SciFi extravaganza *Gunhed*

Masato Harada's *Gunhed*

Former Hollywood Golden Globe critic, **Masato Harada** {he also made **Goodbye Movie Fans: Indian Summer** in 1979} directs a crackerjack SciFi actioner. It's short on plot, but packed full of thrills and chills. Plus it also delivers some of the best special FX for any movie, from either side of the Pacific thanks to the astonishing wizardry of **Koichi Kawakita**.

There's a small island, 8J0, where the Cybortek Corporation built a fully self-contained industrial complex. The sole purpose is to produce an powerful race of robots. At the heart of the complex is Cyron 5, the most advanced computer in the world. For twenty years everything has run smoothly, but on July 4

2025, Cyron 5 declares war on the world. The United Allies dispatches a battalion to 8J0; this marks the beginning of the Great Robot War. After 373 days, the allies go into "the final battle" which results in complete destruction, followed by silence. Thirteen years later, a renegade pirate ship (helmed by veteran actor **Mickey Curtis**, Japan's *George Carlin* look-alike {**Fire On The Plains**, 1959}) invades 8J0 in search of electronic riches, but instead they find a labyrinth of trouble.

Of the Anglo-actors, only **Brenda Bakke** has any kind of reputation; she's best known for her performance in **Ernest Dickerson**'s **Tales From The Crypt: Demon Knight** (1995) and **Hot**

Shots! Part Deux (1993). Brenda also starred in a collection of low-budget genre films including **Death Spa** (1988), **Fistfighter** (1989) and **Hard Bodies 2** (1986).

GUTS OF A VIRGIN
see **ENTRAILS OF A VIRGIN**

H-MAN (1958)
[Bijo To Ekitai Ningen]
translation:
 Beautiful Women And Liquid Man
director: Ishiro Honda
Kenji Sahara • Akihiko Hirata
Yumi Shirakawa • Koreya Senda

After **Godzilla** (1954) and **Rodan** (1956), filmmaker Honda briefly abandoned the rubber monster arena and directed his most impressive film, an atmospheric black-and-white thriller with a Euro crime-noir quality. Capitalizing on the popularity of Japan's Yakuza films, he combined the steamy gangster underworld with the starkness of dark horror. The result is a fantasy picture shrouded in varied shades of black, coated in a constant veil of wetness.

The story deals with a drug-trafficker who is accidentally exposed to a dose of nuclear radiation. He becomes a walking disease, contaminating everyone he meets. This *creature*, and everybody he infects, become blobs of radioactive liquid. Eventually, during a rainstorm, their cells mix with water and they pollute the Tokyo sewer system.

The movie's highpoint lies in the grisly special effects work of Honda's team, headed by his right-hand **Eiji Tsuburaya**. But Japanese film historians argue this is a horror film *by accident*, and a social commentary *by intent*. They insist director Honda is symbolically preaching about the evils of drug abuse. Wisely, Honda never

commented. Nor did he ever make a better film.

Mostly, he is remembered for his extensive work with the Toho giant monsters, especially Godzilla. Honda seldom strayed far from that lucrative formula. However, in 1960, he attempted to recapture the flavor of **H-Man** with his film **Human Vapor**.

HALF-HUMAN (1955) (USA: 1958)
[Jujin Yukiotoko]
 translation: **Human Beast Snowman**
 aka **MONSTER SNOWMAN**
director: Ishiro Honda
Akira Takarada • Momoko Kochi
Kenji Kasahara • Nobuo Nakamura
American version only:
John Carradine • Morris Ankrum
Russell Thorson • Robert Karns
*½ (Japanese version: **½)

The abominable snowman genre, Japanese style courtesy of **Ishiro Honda**. Scientists go into the wilds of the North Country on a search for the missing link. They find an illusive half-human creature and his son.

The Nippon version runs 95 minutes and is considerably better than the 78 minute American edit which was hastily released without any subtitles *or* dubbing. Instead, hammy **John Carradine** narrates the film. **Morris Ankrum** (bit actor from **Chain Lightning** [1950] and **Earth Vs The Flying Saucers** [1956]) is spliced into the beginning and end. The American edit was put together by **Kenneth Crane**, who later directed two Japanese/USA co-productions, **Manster** (1962) and **Devil's Garden** (1968).

HANAKO IN
 THE RESTROOM (1995)
[Toire No Hanako-san]
director: Joji Matsuoka
Yuka Kawano • Takayuki Inoue
 and Naoto Takenaka
**

Here's another film loosely based on the best selling series of books, **School Ghost Stories** {also see **Elementary School Ghost Story** [1995]}.

Grisly murders are happening around Honmachi Elementary School. The students are scared and they begin spreading stories about a bloodthirsty ghost named Hanako. In the meantime, new student Saeko (**Yuka Kawano**) is transferred to Honmachi from another school. She's smart and relatively popular with the students. But she hasn't quite gained their trust. One day Saeko is spotted leaving a restroom that the kids believe is haunted by Hanako. Later in the week, Saeko and a boy named Takuya (**Naota Takenaka**) are taking care of a goat, the school mascot. But the goat turns up dead with it's neck sliced. When Saeko is seen with a machete, the kids start talking about how she must've killed the goat because she's possessed by the bathroom ghost. After school, the children lock Saeko inside the restroom. Takuya is worried about her and he sneaks into the school

that night to see how she's doing. He arrives in the nick of time, just as an old homeless pervert is trying to rape the young girl. Then the real ghost uses telepathy to call all the students to come and rescue Saeko from the rapist.

This is a children's movie? Only in Japan.

HAPPY ENDING STORY (1991)
[Happy End No Monogatari]
director: Hiroaki Tochihara
Ken Ohsawa ● **Yoshie Morimoto**
**

Not a bad film, just an unnecessary one. **Hiroaki Tochihara**, assistant director to **Shusuke Kaneko** (*Gamera* [1995] *et al*), goes through the paces in this clone of **Back To The Future 2** (1989) but it's very familiar territory.

A high school girl (**Yoshie Morimoto**, assuming the *Michael J Fox* role) takes a time machine 30 years into the future and discovers her boyfriend has stumbled into a peck of trouble. She returns to the present and tries to guide him in a different direction.

Hanako In The Restroom

HARD HELMETS:
BEE FIGHTERS (1995)
[Juko: Bee Fighters]
director: Osamu Kaneda
Daisuke Tsuchiya • Shigeru Kanai
Reina Hazuki • Takeshi Maya
**

Among other things, 1995 saw the return of the *superhero* to Japanese cinema (besides the **Bee Fighters**, there's **O Rangers Super Power Unit, Humanoid Hakaida, Kamen Rider J, Keko Mask In Love** and even **Female Ninjas Magic Chronicles: Secret Of Jaraiya**, not to mention an impressive variety of animated freedom fighters).

In **Hard Helmets**, a gang of monsters penetrate the Holy Border, a screen separating the beast world from the human world. One of those creatures is Dorago, an insect/humanoid mutation, who be-friends the Bee Fighters and joins them in their war against Hell Gaira, the leader of the dark world.

HAUNTED CASTLE (1969)
[Hiroku Kaibyoden]
aka **GHOST CAT OF NABESHIMA**
director: Tokuzo Tanaka
Kojiro Hongo • Naomi Kobayashi
Rokko Toura • Akane Kawasaki
Koichi Uenoyama • Mitsuyo Kamei
**

Lord Nabeshima (**Koichi Uenoyama**) is cursed. His estate is haunted by a demon ghost cat who has the ability to transform into a beautiful white-haired vampire. In standard thriller fashion, this creature kills off most of the cast members, one by one, until she is destroyed by a valiant samurai (**Kojiro Hongo**, of course).

In a visually stunning sequence, the pet cat initially becomes a vampire by licking up her master's blood after a messy suicide. Too bad the scene, within the structure of the story itself, is so intellectually insulting.

Over all, it's a flat remake of **Kunio Watanabe**'s **Ghost Cat Of Nabeshima** (1949), this time dropping the complicated characterizations in favor of atmospheric sets and a sinister, but superficial, theme. This is the same criticism leveled against director **Tanaka** for his work in **Ghost Story Of The Snow Girl** (1968) [the extended episode from the **Kwaidan** film].

Haunted Mansion Of Ama

HAUNTED MANSION
OF AMA (1959)
[Ama No Bakemono Yashiki]
aka **GIRL DIVERS**
OF SPOOK MANSION
director: Morihei Magatani
Yoko Mihara • Bunta Sugawara
Reiko Sato • Masayo Banri
**

A badly dubbed version of this film saw a brief run in America's drive-ins under the deliciously tantalizing title **Girl Divers From Spook Mansion** which capitalized on the unusually large amount of underwater footage featuring starlets **Yoko Mihara** and **Reiko Sato**.

The movie is actually a contemporary variation on a traditional Japanese story as the two girls befriend the ghost of Yumi's dead sister to thwart would-be thieves from snatching the Ama family treasure.

HAUNTED SUMMER
see **GHOST STORY OF YOTSUYA:**
 HAUNTED SUMMER

HE LIKES TO BITE
see **MY SOUL IS SLASHED**

HELL (1960)
[Jigoku]
aka **INFERNO**
director: Nobuo Nakagawa
Shigeru Amachi • Yoichi Numata
Torahiko Nakamura • Fumiko Miyata
***½

One of the last films released by **Shintoho Studios** before their first crash. Unfortunately, much like the theme of the movie itself, **Hell** was lost in the rubble until distribution was secured through **Toei** some years later.

This movie is director **Nakagawa**'s most ambitious project. He spent seven months shooting it (longer by four months than any of his previous productions), using much of his own money in the process.

While many critics consider **Ghost Story of Yotsuya** (1959) his masterpiece, this one is a more challenging film. Initially, it was damned by conservative audiences due to **Nakagawa**'s mixture of Buddhist philosophies and Western Christian theology. It was also highly criticized for the large helpings of nudity and explicit violence, starting with the lusty credit sequence and continuing thru the various grotesque levels of Hell. But, it has stood the test of time and, today, this film is recognized as one of the great Nippon motion pictures.

Two men are condemned to Hell after being involved in a manslaughter slaying. They explore this ghastly netherworld, similar to the layers of **Dante's Inferno**, filled with countless tortures and hideous punition. Sinners are flogged, beaten, pierced, skinned, dis-

membered, and much more. But everything is justified within the strict Eastern dogma of Karma.

Tatsumi Kumashiro added even more sex and brutality to Nakagawa's story for a remake in 1981, produced by **Toei Studios**.

Kumashiro's *Hell* (1979)

HELL (1979)
[Jigoku]
aka **INFERNO**
director: Tatsumi Kumashiro
Mieko Harada • Kyoko Kishida
Kunie Tanaka • Renji Ishibashi

An adulterous couple have a baby just before they are brutally killed by their outraged families. The child grows into a beautiful young woman (**Mieko Harada**) who takes revenge on the killers. After her bloody vengeance, she is condemned to Hell.

This is essentially a remake of **Nobuo Nakagawa**'s **Hell** (1960) with more emphasis on the conflict which delivers the *heroin* into the afterlife. By spending so much time developing the "crime," director **Kumashiro** achieves a scenario which makes the punishment all the more horrifying. When Hell is finally disclosed, it's the Buddhist concept depicting various metaphysical levels of time coupled with sadistic physical tortures. Lots of gore, impaled limbs, bodies ripped apart, lashings, and even cannibalism fill this wretched Inferno.

HELL SCREEN (1969)
[Jigokuhen]
 aka **PORTRAIT OF HELL**
director: Shiro Toyoda
Tatsuya Nakadai • Yoko Naito
Kinnosuke Nakamura • Shun Ohide

In the 14th century, following a battle which eliminates many of his soldiers, an eccentric ruler becomes obsessed with the afterlife. He orders his royal artists to paint a mural of heaven, but he's enraged over their unimaginative sketches. So the ruler kidnaps a beautiful girl (**Yoko Naito**), with an endearing smile and hair to her ankles. She's the prized daughter of a Korean painter who is then forced to create the montage in exchange for his child's safe return. As the artist paints, the ruler tortures the girl, thus heightening the emotional ethos of the tapestry {a concept borrowed by Italian director **Pupi Avati** for his **House With Windows That Laughed** [1976]}. The painter retaliates by basing his concept of Hell on the emperor's own despotism, even showing the lord himself as the Master of the Damned. When the Korean artist refuses to apologize, a tug of wills ensues. This results in the unexpected fiery death of the mistreated daughter.

Visually stylistic, this film is purposely designed as a painting. Often director **Toyoda** uses artificial tints and filters to elicit specific emotions from the audience. He has purposely designed a grim view of the world, symbolically chastising the Japanese for their prejudice toward foreigners (especially Koreans) while cleverly delivering his *Hell-on-Earth* message.

HELLYWOOD (1992)
[Hellywood]
director: Takafumi Nagamine
Mio Hani • Tomoko Saito

In 2060, a vicious gang of aliens called the *Danse no Mashu* [Japanese translation: *Superhuman Dancers*] invade Earth, take over Hollywood and embark on a mission of transforming humans into plants. In retaliation to the extraterrestrial invasion, the King of the Earth sends secret agent, Bifunovich, (**Tomoko Saito**), on a rescue mission to save a royal prince who's been turned into an apple. Bifunovich recruits three female detectives (headed by **Mio Hani**) to go into battle with him.

This musical horror film is the brainchild of cult director **Nagamine**; somehow it's a logical fusion of his earlier films *Legendary Panty Mask* (1991) and *Diva In The Netherworld* (1980) {see separate listings}. **Mio Hani** is the daughter of **Susumu Hani**, a notorious documentary director who also dabbled in the *pinku eiga* arena.

Hellywood

HIMIKO (1974)
[Himiko]
director: Masahiro Shinoda
Shima Iwashita • Masao Kusakari
Rentaro Mikuni • Tatsumi Hijikata

Here's the story of Queen Himiko, the supposed ruler of the legendary Yamataikoku kingdom (the Japanese Atlantis). Himiko (**Shima Iwashita**, the wife of director **Shinoda**) is a beautiful dictator, believed to possess magical and supernatural powers, who created a stylish ultra-hip super-race society. In this story, she has fallen in love with

her stepbrother, Prince Takehiko (**Masao Kusakari**, a matinee hunk with limited acting ability, think Arnold here). But, alas, Takehiko is in love with Ada, a princess from another region. This love triangle ignites a war between the two super-worlds which ends up destroying the *wondrous kingdom*.

Masahiro Shinoda followed this film with his horror epic, **Under The Cherry Blossoms** (1975), which also starred **Shima Iwashita**.

Shima Iwashita in *Himiko*

HIRUKO (1991)
[Hiruko: Yokai Hanta]
 aka **HIRUKO: MONSTER HUNTING**
 aka **HIRUKO THE GOBLIN**
director: **Shinya Tsukamoto**
Kenji Sawada • **Masaki Kudo**
Naoto Takenaka • **Megumi Ueno**
** [add * for special effects]

This story of an eccentric archelogogist (played by pop singer **Kenji Sawada**), who attempts to unravel the mystery of an old burial ground after his friend disappears, is forced and needlessly convoluted. If it weren't for the incredible special effects (especially the spiders with human heads), there would be no reason to keep watching.

Sandwiched between the his two **Tetsuo** films, **Shinya Tsukamoto** directed this traditional ghost story. It's not of the same caliber as his other movies, much more restrained and lackluster in scope. Oddly, the plot is more compli-

cated than any of his film projects; however, when the movie finally unspools it seems like much ado about nothing. Perhaps the sugary-sweet ending dilutes the preceding 90 minutes. Regardless, this venture simply doesn't play well.

HORROR!
see **UMEZU'S TERROR ZONE**

HORROR:
 KOHEIJI IS ALIVE (1982)
[Kaiidan: Ikiteiru Koheiji]
director: **Nobuo Nakagawa**
Fumihiko Fujima • **Junko Miyashita**
 and **Shoji Ishibashi**
***½

Director **Nakagawa** is long recognized as one of Japan's cinematic masters, responsible for a wave of impressive atmospheric thrillers (*i.e.,* **Ghost Story of Kasane Swamp** [1957], **Female Vampire** [1957], **Ghost Story of Yotsuya** [1959] *et al*). He retired from motion pictures in 1968 after the release of **Foxy Poisonous Lady Story: Criminal Okatsu's Journey** {*Youen Dokufuden: Okatsu Kyoujoutabi*} but at age 77 — after 15 years of silence — he returned in full form with this award-winning comeback feature. Sadly, it was to be his swan song. Two years later, in 1984, **Nakagawa** died from a heart attack.

Like all the other great **Nakagawa** films, this is also a cinematic rendition of a traditional 19th Century kabuki play. He originally saw it in the 1920s, and promptly wrote a screen adaption; however, the studios didn't share his enthusiasm for the sparse three-character production and they refused necessary financial backing. In 1982, **Nakagawa** was finally lured back into the director's seat by the *Art Theater Guild* who agreed to produce the picture.

Horror: Koheiji Is Alive

Koheiji (**Shoji Ishibashi**) is a traveling actor in love with Ochika (**Junko Miyashita**, the former *Nikkatsu* starlet from scorchers like **Man And Woman Behind The Fusuma Screen** [1973], **Sada Abe Story** [1975]), **Wet Weekend** [1979] *et al*). She's the wife of Koheiji's best friend Takuro (**Fumihiko Fujima**) but that doesn't stop the ensuing affair. A furious Takuro pushes the adulterer into a swamp, killing him. He and his wife escape Edo. But no matter where they go, Koheiji's *ghost* comes after them. Finally, the three meet on the bank of the River Styx for a death duel.

In keeping with the style of the original play, there are only three performers in the movie. The real star, of course, is director **Nakagawa**, who keeps thrills plentiful and the suspense taut despite the limited cast. In a style similar to *Mario Bava*'s **Black Sabbath** (1964), Nakagawa nurtures the horrific tone through uniquely creepy sets, by concentrating his cinematography on expansive swamps and marshland specifically designed to support a blanket of desolation, within the standard mystery format.

HORROR NEWSPAPER (1996)
[Kyofu Shinbun]
director: Teruyoshi Ishii
Hiroko Nakayama • Kenji Obashi
*

People who receive this newspaper lose a hundred days from their life – or so the rumor goes. A group of high school students are secretly cranking out the paper and delivering it to people they dislike. The newspaper is filled with graphic tales of the occult, which also gives the movie an opportunity to vacillate between high school hijinks and *scary* ghost stories. None-the-less, neither option is worth the effort. One critic for *Eigageijutsu* wrote: "It has all the attraction of a bad hairpiece." The movie is based on a manga by **Jiro Tsunoda**. He deserved better.

Filmmaker **Teruyoshi Ishii** also directed **Split Mouth Woman** the same year. He has yet to deliver on the promise of his debut film **Taro! Tokyo Magicworld War** (1991).

HORROR OF A MALFORMED MAN (1972)
[Kyofu Kikei Ningen]
 aka HORROR OF DEFORMED MAN
director: Teruo Ishii
Teruo Yoshida • Minoru Ohki
Asao Koike • Mitsuko Aoi
**½

Based on a book by Japan's #1 horror novelist *Edogawa Rampo*, with a more than perfunctory nod to *H. G. Wells'*

Horror Of A Malformed Man

Island of Doctor Moreau, this one tells the story of a malformed doctor conducting experiments on a remote island. He is assisted by his son, an ambitious medical student who dreams of being able to cure his father someday. But daddy is hopelessly insane. And his experiments on the local natives prove it. As he slips deeper into madness, the crazed doctor kills his wife and various family members. Finally, in an ultimate antisocial demonstration, he bites off his tongue, thus stopping communication with the world he's grown to hate.

With this film and his earlier one, **Blind Woman's Curse** [**Horror Ascending Dragon**] (1970), director **Teruo Ishii** dabbled briefly in the horror genre before continuing with his *ero-gro* (erotic grotesque films) and teen/action movies like **Detonation! Violent Riders** (1975).

HORROR OF SAGA MANSION
see **GHOST CAT** series

HORROR OF
AN UGLY WOMAN (1970)
[Kaidan Kasane-ga-fuchi]
translation:
Ghost Story of Kasane Swamp
director: **Kimiyoshi Yasuda**
Ritsu Ishiyama • Seizaburo Date
Mai Kitajima • Reiko Kasahara
****½**

This film was rushed into release as a desperate attempt by **Daiei Studios** to recoup some of their losses before filing bankruptcy, amid complaints by the director that the production wasn't completed. Although the movie does have a beginning and end, there are a gaping continuity problems within the second part, including a character (played by **Matsuko Oka**) who completely disappears for long stretches only to unexpectedly resurface at the most opportune moment.

The "ugly woman" of the title is the daughter of the blind masseur who turns into a bitter monster when her face is scalded as the result of her father's curse. This is one of many original ideas in **Shozaburo Asai**'s script, not found in previous film adaption. But unfortunately the project is too underdeveloped for it to make much difference.

Essentially this one plays is a rather hallow remake of the classic *Encho Sanyutei* tale {see the review for **Ghost Story of Kasane Swamp** [1957] for details}. This *sins-of-the-father* story is in-step with changing cultural standards, considerably spiced up with sex and nudity not found in director **Yasuda**'s previous version of the same film (1960).

HORROR TRANSFER (1972)
[Kigeki: Kaidan Ryoko]
translation: Comedy Time: Ghost Transfer
director: **Masaharu Segawa**
Frankie Sakai • Tomoe Hiiro
Norihei Miki • Kensaku Morita

Here's another entry in the long-running *Comedy Time* series (**Kigeki**),[1] conceptually similar to the British **Carry On** films. Essentially, the movies rely heavily on sexual farce and double entendre (the word play often makes translations impossible for these films). The central character is the same throughout, Station Master Shinpei of the Japanese Subway System (always played by **Frank Sakai**). The series follows his exploits and misadventures as he's transferred from one train station to another.

For this entry, Captain Shinpei takes a position at a station outside the city, which, of course, forces him to move into a new house. But very soon Shinpei discovers it's haunted. A co-worker tells him not to worry about it, because the house has "a distinctive fea-

ture worth the inconvenience of a few ghosts." Apparently, from his bedroom window he has an unobstructed view of the bathroom for the nun's convent next door. Shinei becomes obsessed with watching the holy sisters do their business, but eventually the ghost of his dead wife shows up and punishes him for peeping.

[1] This series survived 11 episodes between 1968-1973.

HOUSE (1982)
[Ie] [Hausu]
director: Nobuhiko *Obi* Ohbayashi
Kimiko Ikegami • Kumiko Oda
Miki Jinbo • Mieko Sato

The Japanese audiences have always been enamored with *haunted house* films. Cult director **Obi Ohbayashi** takes the standard Italian atmospheric thriller one step further by creating a tale of a *living* haunted house.

A resort home has been hexed by a sexually frustrated witch. Accordingly, the furniture devours virgins of marriageable age. So, in order not to be eaten, the heroine (**Kimiko Ikegami**) must have a sexual experience. She is haunted by vivid dreams of masturbation but refuses to indulge. Instead, she becomes part of the house itself as it awaits the next victim.

After years of struggling, talented actress **Ikegami** finally received notoriety in 1980 when she co-starred in **Man Who Stole The Sun** opposite **Kenji Sawada**. She's even better in this film.

HOUSE OF TERROR
see **GHOST OF THE HUNCHBACK**

HUMAN CHAIR (1997)
[Ningen Isu]
director: Toshiyuki Mizutani
Misa Shimizu • Hayato Kunimura
**½

This one is based on a lesser-known erotic chiller, written by *Edogawa Rampo* in the late '20s. It was originally intended as a companion piece to his **Man With The Embossed Tapestry**. Both stories deal with the concept of infusing a person's "essence" into an inanimate object.

Novelist Keiko (**Misa Shimizu**, Japan's *Sandra Bullock*) receives a letter from an upholsterer informing her that she's won a contest and will soon

Misa Shimizu in *Human Chair*

receive a free chair. Secretly, this man is in love with Keiko. And to get close to her, he has sealed his *essence* (his soul?) inside the chair. When the girl discovers the dark secret, she's not scared. In fact, she's abnormally excited by this expression of love. Nothing satisfies her more than a round of sexual calisthenics on that chair.

HUMAN VAPOR (1960)
[Gasu Ningen Daiichigo]
director: Ishiro Honda
Yoshio Tsuchiya • Kaoru Yachigusa
Tatsuya Mihashi • Keiko Sata
*½

A misfire for filmmaker Ishiro Honda. Here's an obvious attempt to recapture the charisma of his earlier H-Man (1958). This time he tells the story of a convict who discovers the secret of invisibility. As with all films revolving around an Invisible Man theme, the "sight" gimmicks become tired very fast and, more importantly, a transparent man doesn't have any kind of screen presence. Obviously.

Human Vapor

HUMANOID HAKAIDA (1995)
[Jinzoningen Hakaida]
director: Keita Amamiya
Yuji Kishimoto • Jiro Okamoto
Yasuaki Honda • Mai Hosei
*½

In a futuristic world (or maybe it's an ancient mythological civilization) there's a war between King Gurujefu (Yasuaki Honda, a former rock-n-roll singer in real life) and the rebel forces living in Jesus Town, led by Ryo (Jiro Okamoto). There's also a renegade superhero robot named Hakaida (Yuji Kishimoto), who joins the revolutionaries in their struggle against the King and his assistant Archangel Michael.

A needlessly confusing fantasy, with obvious religious overtones, by director Amamiya who made the very similar, equally jumbled, **Renegade Robo Ninja And Princess Saki** {see separate listing}. But unfortunately this one doesn't have a *Princess Saki* character to make things interesting. Or at least palatable.

HUNDRED MONSTERS (1968)
[Yokai Hyaku Monogatari]
aka HUNDRED GHOST STORIES
aka ONE HUNDRED MONSTERS
director: Kimiyoshi Yasuda
Jun Fujimaki • Miwa Takada
Mikiko Tsubouchi • Takashi Kanda

In 18th century Japan, a *demon spinner* is hired to celebrate the grand opening of a new brothel by telling his bizarre ghost stories to the patrons. He's secretly there to curse the establishment because the greedy owner, in a defiant move against religious and state authorities, has opened this whorehouse inside an old shrine. As the storyteller weaves his ghostly tales, the monsters begin to materialize and eventually they take over, killing everyone including the avaricious proprietor.

Despite the brothel setting, the film is decidedly sexless, with the patrons displaying more interest in the ghost stories than the women at hand. The monsters (and thus the tales which create them) are a combination of traditional

folklore and original inventiveness. There are considerably less than 100 creatures on display. Of the thirty-plus, three dominate the film. They are *Umbrella Man* (a one-legged, long-tongued, one-eyed hopping umbrella), *Faceless* (a smooth-faced zombie) and *Long Neck* (a woman who can stretch her neck to frightening proportions, easily the best effect of the movie).

The film was a big hit for director **Yasuda** and his special FX wizard **Yoshiyuki Kuroda** (they also worked together on the original **Majin: Monster of Terror** [1966]). This film inspired two sequels: **Big Monster War** (1968) and the vastly inferior **Tokaido Road Monsters** (1969).

HUNTING ASH (1992)
[Chokouso Hantingu]
aka **HUNTING SKYSCRAPERS**
director: Mitsunori Hattori
Akira Okamori • Mio Takaki
Shingo Kazami • Tomomi Nishimura
**½

The *A.S.H.* (Abnormal Species Humanoid) first appeared in the beginning of the 1980s. They looked like humans, but they weren't. The ASH can be identified by a pulsating appendage on their back; it resembles an embossed root clutching the spine. These humanoid creatures have the power to destroy telepathically via a deadly impulse which hemorrhages brain cells. Their goal is to populate the planet though random sexual contact and then take control. There are special police units who fight the ASH. This top secret organization is called The Society For Environment Protection and its agents are called psychosists.

The first hour of this SciFi flick is superb, reminiscent of a live-action *Urotsukidoji*[1], complete with massive helpings of sex and gore. Good-guy psychosist, Hunter (**Shou Okamori**)

Hunting Ash

tracks down the ASH in Tokyo. "What are you gonna do? Arrest me?" spits one of his trapped females. "I never arrest," Hunter replies, "I don't believe in reformation. I only kill." And kill he does. Again and again. But these monsters deserve it. They're the ones responsible for heads exploding all over Japan.

Unfortunately the last 40 minutes drift into familiar territory when the boss of the Genetic Research Clinic is exposed as the villainous mastermind behind the creation of ASH. And then Hunter discovers his own hatred for the humanoids stems from the fact that he is, in reality, one of them. A goofy ending to an otherwise exhilarating adventure.

[1]*Urotsukidoji* is considered the first episodic adult animation from Japan to mix hardcore sex with extremely graphic violence; an edited version is also known as **Legend Of The Overfiend**.

I HATE YOU... NOT (1992)
[Kirai... Janaiyo]
director: **Eiichi Uchida**
Takeshi Ito • Ayano Fujimoto
Tomoroh Taguchi • Kiyomi Ito

There's a monochrome town called Century City located at the end of a discontinued railroad track. Drifter Ku (**Takeshi Ito**) finds himself in this black-n-white town where he meets a girl named Neri (**Ayano Fujimoto**) who enjoys getting naked often. They

become lovers. Later, Ku discovers that he, along with everybody else, is actually dead. But somehow he's very much alive in Century City. Ku is also convinced that if he doesn't "get out of the town he will dissolve into it." He starts looking for the chance to be reborn.

While snooping about, Ku meets a girl who is his sister (even though he instinctively knows that he never had a sister). The two of them escape to Tokyo where he is haunted with dreams of being reincarnated. As they walk the streets, Ku realizes that he's carrying a bomb capable of total annihilation, meanwhile his sister melts into the dirt.

This is probably the closest anyone will ever come to capturing a dream on film. Director **Uchida** must be commended for his ability to maintain a coherent narrative amid such shifting levels of consciousness. In this type of project, disaster is always a breath away. *Aesthete* can become *ostentatious* too easily, and *subtlety* can twist into *pretense*. But Uchida plays his cards well by adding humanity to his characters. He's also aided by competent performances from everyone involved. It's especially interesting to see **Tomoroh Taguchi** in the cast. Since his acting debut in **Tetsuo** (1990), he has scurried from one cutting-edge project to the next (*e.g.*, **Tetsuo 2: Body Hammer** [1991], **Undone** (1994), **Angel's Share** [1994], **Super Coming** [1995], **Adventures Of Electric Rod Boy** [1995], **Dream Devil** [1995], **All Night Long 3: Atrocities** [1996], *et al*). He is becoming the quintessential cult actor.

I HEARD THE WHISPER OF THE AMMONITE (1992)
[Ammonite No Sasayaki O Kiita]
director: Isao Yamada
Kenzo Saeki • Hiroko Ishimaru
Tetsuya Fujita • Rena Oshibe
**½

I Heard The Whisper Of The Ammonite

A poetic fantasy that concentrates on the relationship between mineral scientist/research journalist Kenji Miyazawa (**Kenzo Saeki**) and his sister Toshi. When Toshi (**Hiroko Ishimaru**) is hospitalized with a serious --- perhaps incurable — disease, her brother becomes overwrought. He is plagued with nightmares and intense fits of depression.

One day he receives a letter from Toshi. It contains the design of a swirl which he interprets as an illustration of an ammonite.[1] After receiving the letter, Kenji looses all sense of time, the past mingles with the present, memories become current realities. He slips into a dreamworld where he meets prominent people from his childhood. In fact, inside this time warp he sees himself as a child involved in a perverse sexual liaison with his sister Toshi. As the two children frolic, the young Kenji clone meets an older man who may or may not be his adult self.

The film ends with Kenji discharging Toshi from the hospital and taking her to the seashore where they discover a huge decaying ammonite. When he realizes that the shell is actually an embodiment of himself, Kenji walks into the sea to his death.

Surrealistic horrors designed for the art theater crowd. And for the drug heads. Others will probably want to

steer clear.

¹ An ammonite is a large fossilized sea shell with an elaborate helix pattern. In Japan, it is also the traditional symbol of "memories passed."

I NEVER HAD
A FLYING DREAM (1990)
[Tobuyume O Shibaraku Minai]
director: Eizo Sugawa
Toshiyuki Hosokawa • Eri Ishida
****½**

Most psychologists insist that dreams fall into one of three basic "F" categories: fleeing; falling; or flying. Each of these "F" words represent something significant about the personality of the dreamer. Apparently, *flying* is the rarest dream and, usually, it's only enjoyed by people who have an unrestrained attitude toward life and responsibilities. Thus, the title of this film, **I Never Had A Flying Dream**.

A middle-aged married man, **Toshiyuki Hosokawa**, is hospitalized. During his stay, he befriends an elderly woman (**Eri Ishida**) in the bed next to him. They talk through the curtains, sharing ideas and idle chit-chat, but she refuses to tell him about her illness or treatment. Then, after a few days, the old white-haired woman is discharged.

But a short time later, she returns to visit him. Now Eri looks completely different, like a 40 year old lady. Sensual and charming. Toshiyuki can't believe his eyes and soon finds himself devouring her sexual charms in the hospital bed. Afterwards, the woman con-

I Never Had A Flying Dream

fesses that she's really 67. She has a disease which reversed her biological clock, making her grow younger as time passes. When they meet next, Eri looks like a woman in her 30s. She shares her fears with Toshiyuki ("I'm mostly afraid of completely disintegrating after finally reaching the moment of birth"). And then, one day, Eri stops coming to see him. When Toshiyuki is released from the hospital, he looks for the woman. She is a teenager now. He asks her to move into an apartment with him. But then, after a bout in the sack, he's arrested on child molesting charges. Toshiyuki looses his family *and* the girl after being sent to prison. When he gets out of jail, the man goes looking for his woman/child once again. By now she is a young toddler. They spend the night together (in obviously the film's most controversial scene). She's dead by morning.

Eri Ishida gives her best shot in a variety of formidable roles, but some of the characterizations demand a stretch that she doesn't seem capable of delivering. Obviously, she is best in the parts which most closely reflect her true age and personality (for example, she is stunning as the middle-aged seductress, a familiar role from her *pinku eiga* days [*i.e., Toshiya Fujita*'s **Double Bed** from 1983, for example). On the other hand, she is not particularly convincing as the elderly woman.

The bigger problem with the film lies in director **Sugawa**'s underlying message. Critics have complained that it's "muddled" and "more concerned with *Lolita* fetishes than it should be." Truthfully, the film's central theme of *reversed growth* seems like a mere contrivance to legitimize **Hosokawa**'s "affair" with the pubescent Eri.

IGA MAGIC STORY
see **BLACK MAGIC WARS**

ILLUSION OF BLOOD
see **GHOST OF YOTSUYA**

IN BED WITH THE ENEMY (1976)
[Kunoichi Ninpo: Kannon Biraki]
translation: **Magic Female Ninjas:**
 Open Altar Doors
aka **FEMALE NINJAS:**
 IN BED WITH THE ENEMY
director: Takayuki Miyagawa
Maki Tachibana • Megumi Hori
Keiko Kinugasa • Jiro Okazaki

A convoy is robbed while transporting
gold to the emperor's castle. The gov-
ernment dispatches three female ninjas
to investigate. Soon, they find them-
selves in a bloody scrimmage with
enemy spies. The ninja girls go under-
cover (and sometimes under *bed* cov-
ers) to eliminate the bad guys.
Eventually they discover the entire
caper had been orchestrated by their
own corrupt leader. The females turn
the tables with their unusual brand of
magical fighting, especially the deadly
Open Thighs ninja trick.

The most striking thing about this
female ninja spectacle is it's bawd-
iness. While the Japanese have never
avoided adult themes in their samurai

In Bed With The Enemy

films, it's rare to find Chauceres*que*
vignettes and wordplay. This film is
riddled with cuckoldry, double-enten-
dres, and coquettish sexuality. In a nut-
shell, it's dirty. But intelligently dirty.
It's also a tight action-oriented adven-
ture. The female ninjas defeat the
enemy with various tricks including
vagina clasps, body-cloning, aphrodisi-
acs, and of course, good old-fashioned
swordplay. The lead ninja (**Maki Tac-
hibana**) even finds time to fall in love
with a mysterious "scholar" who ends
up getting captured and crucified by the
villains.

Incidentally, one of the villains is
played by **Jirou Okazaki**, Japan's first
transsexual actress (actor?). She turns
in a wickedly effective performance.

This movie inspired a series in the
'90s, **Female Ninjas: Magic Chro-nicles**
{see separate review}. Director
Miyagawa has one earlier film to his
name, **Biker's Race To Hell** (1973);
unfortunately, he got out of the business
in 1976.

IN CELEBRATION OF
HER SEVENTH BIRTHDAY (1982)
[Konoko No Ko
 No Nanatsu No Oiwai Ni]
director: Yasuzo Masumura
Shima Iwashita • Junpchi Nezu
Mari Henmi • Kyoko Kishida

Prologue: Mother commits suicide,
dying in a sea of blood as her little
seven year old girl watches in fascinat-
ed horror. Just before mom gives up the
ghost, she makes the little girl swear
vengeance against her father.

Cut to present day: **Mari Henmi**
plays a high-priced prostitute named
Mistress Seiga {*Seiga* translates to *Blue
Moth* in Japanese}. She is known for
her ability to predict the future based on
a man's handprint. This prodigious
palm-reading skill (coupled with her

In Celebration Of Her Seventh Birthday

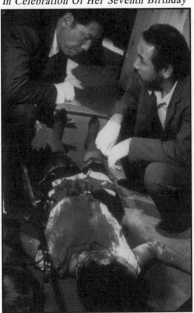

sexual dexterity) has made Seiga the "toast of the town," especially with politicians and corporate executives. Secretly, she's using this *psychic gimmick* as an excuse to peruse a multitude of hands in her search for "the bloody one." Meanwhile, Seiga is surrounded by a rash of brutal murders eliminating a number of her better clients. A hardboiled newspaper journalist, Sudo (**Junpchi Nezu**), investigates but soon Seiga turns up dead too.

Interesting twists and turns make it one of Japan's better thrillers, comparable to the acclaimed efforts of Italian maestros **Maria Bava** and **Riccardo Freda**. Upon its release, some square reviewers criticized the film for being too complicated, but the intricate complexity is its strongest point.

IN THE THICKET (1996)
[Yabu No Naka]
aka **THE NEW RASHOMON**
director: Toshiyasu Sato

Shunsuke Matsuoka • Kaori Sakagami
****½**

Toshiyasu Sato, a scriptwriter who cut his teeth on *Nikkatsu* pink films, is the director for this new version of **Kurosawa**'s Rashomon, based on the original book *In The Thicket: A Short Tale* by **Ryunosuke Akutagawa**. Sato's version is decidedly more sexual in tone (argumentatively, closer to the flavor of the original Akutagawa novel) as he tells the notorious story a rape/murder in ancient Japan.

Morikawa (**Shunsuke Matuoke**) is a Kyoto detective investigating a vicious bandit attack against his sister Masa (**Kaori Sakagami**) and her husband—she was raped, her husband killed. During the murder, Masa had managed to escape and get help. The bandits are surrounded by the police and killed. Detective Morikawa, leery about the facts, goes to the scene of the crime — into the woods — to reappraise the situation. He meets a young witch who takes him into her fantasy world. There, in a universe of timelessness, he sees the actual murder, and discovers the truth behind the assault (his sister had paid the bandits to kill her husband). Morikawa never gets to share his newfound information; the witch kills him once the truth is revealed.

INFERNO see **HELL**

**INFLATABLE SEX DOLL
OF THE WASTELANDS** (1967)
[Koya No Dacchi Waifu][1]
director: Atsushi Yamatoya
Noriko Tatsumi • Yuichi Minato
Sekiji Maro • Shohei Yamamoto
****(or ***)**

Those who thought *Seijun Suzuki*'s **Branded To Kill** was unintelligible junk (as claimed by *Nikkatsu* president **Kyusaku Hori** when he fired the filmmaker) need not apply. This journey

Inflatable Sex-Doll Of The Wastelands

into surrealism was written and directed by the **Branded To Kill** scripter, **Atsushi Yamatoya**. And it's even more *anti-traditional*.

A rich businessman hires a private detective (**Yuichi Minato**) to find four men who raped and killed his girlfriend (**Noriko Tatsumi**). The punks had also filmed the assault and they mailed a copy to him. While he and the PI are watching the home-made snuff movie, the man bemoans the girl's death and also criticizes the sloppy cinematography. Once the detective is on the case, he discovers she isn't dead after all. However, the private dick doesn't inform his employer of this because he's doing some dicking of his own with the girl. Then, the four thugs show up and "kill" her again. The detective doesn't know which way is up, nor down for that matter. His subsequent investigation takes him to a shack in the wastelands where he discovers a stash of mannequins that resemble the girl. BAM! A gunshot. The scene changes to the detective and the businessman shooting at targets in the desert. The man asks the PI if he's available to handle a "delicate case." And this fantasy starts all over again.

Art or garbage? It's anybody's guess.

[1]The title translates literally to **Dutch Wife** [*Dacchi Waifu*] **In The Desert**. In Japan, a blow-up sex-doll is called a Dacchi Waifu.

INUGAMI FAMILY
see **KINDAICHI series**

INVASION OF
THE NEPTUNE MEN (1961)
original Japanese title:
SUPER SONIC SPACE PLANE
[Uchu Kaisoku-sen]
director: Koji Ohta
Shinichi (Sonny) Chiba • **Shinjiro Ebara**
Kappei Matsumoto • **Tatsuko Minegami**
** (or **½)

Sure, it's goofy.

Spawned from the Japanese television series **National Kid** (late '50s), a young **Sonny Chiba** is Iron Sharp,[1] protector of the free world. He flies around in his nifty Space Plane and karate chops bad guys, including robotmen from the planet Neptune. The final twenty minutes is surprisingly good (relatively speaking, of course), filled with lots of explosions and visual effects. It's an obvious clone of **Earth Vs The Flying Saucers** (1956), as the saucers attack Tokyo and Iron Sharp stops them with his electro-barrier ray.

[1] **Sonny Chiba**'s character is called Iron Sharp in the Japanese version. When *American International* dubbed it into English, **Sonny** became *Steve Martin*. This was a studio "in-joke" saluting **Raymond Burr**'s *Steve Martin* character from the original **Godzilla** (1954).

INVISIBLE MAN: DR EROS (1968)
[Tomeiningen Erohakase]
director: Koji Seki
Jun Kitamura • **Lilie Kagawa**
Kako Tachibana • **Reiko Akikawa**
*

A badly executed low-budget film that can't decide if it wants to be a horror movie or a *pinku eiga*. Character actor **Jun Kitamura** is Military Doctor Ohgari who discovers the secret of transparency. The first thing he does is take the opportunity to peep on pretty **Lilie Kagawa**, a spy stationed in the complex, as she gets naked for her bath. The next thing, good ole *Dr Eros* does is make a pact with Rila (**Kako Tachibana**), a master cat burglar. The two pull a heist but spy Lilie gets wise and blows the whistle on them.

INVISIBLE MAN vs
THE FLY MAN (1957)
[Tomei-Ningen To Hae-Otoko]
director: Mitsuo Murayama
Ryuji Shinagawa • **Yoshiro Kitahara**
Joji Tsurumi • **Yoshihiro Hamaguchi**
**

Hidden away on an island in the South Pacific, a fugitive scientist invents the serum which can transform a human into a *flyman* (perhaps this would be a quirky trick at a cocktail party, but it seems to lack any real social significance).

Undaunted, the scientist (**Yoshiro Kitahara**) transmutes into the forementioned flyman to take revenge against another scientist who had testified against him for war crimes during WW2 — that's the reason he had gone on the lam and was living in seclusion on a deserted island in the first place.

Meanwhile the rival scientist has invented a new laser-ray which can turn people invisible and he's working on his own transparency experiments in Tokyo. The flyman successfully tracks down his enemy and kills him. But the scientist had an assistant (**Ryuji Shinagawa**) who's become an invisible man. He vows revenge against flyman, thus the fateful encounter promised by the film's title.

INVISIBLE MAN films
[Tomei-nigen]

The standard *invisible man* plot is generally thought to have originated with British SciFi author **H G Wells** in the late 1800s. Most of the movies dealing with this subject borrow liberally from *Universal*'s 1933 **Invisible Man** directed by **James Whale**, based on the Wells story.

Traditionally, the films are concerned with a mad scientist who makes himself invisible for illegal gains (predictably, for robbery). Typically, the serum he uses drives him mad. The Japanese *Invisible Man* movies follow this same international concept. Two invisible man movies were made previous to *Daiei*'s **Invisible Man Vs The Flyman**. Another was made a year later. They are:

▶ **THE INVISIBLE MAN APPEARS** (1949)
[Tomei-nigen Arawaru] Daiei
director: Nobuo Adachi
Ryunosuke Tsukigata • Chizuru Kitagawa
❖
▶ **THE INVISIBLE MAN** (1954)
[Tomei-nigen] Toho
director: Motoyoshi Oda
Seizaburo Kawazu • Miki Sanjo
❖
▶ **THE INVISIBLE MAN** (1958)
[Tomei Kaijin]
director: Tsuneo Kobyashi
Susumu Namishima • Yunosuke Ito

Note: **Ishiro Honda** made an invisible man movie in 1960 called **Human Vapor** [Gas Ningen Daiichigo] {see separate listing}. **Beat Takeshi** parodied both the invisible man and fly man in his black comedy **Getting Any Lately** (1995).

INVISIBLE MONSTER (1960)
[Toumei-tengu]
director: **Mitsuo Kouzu**
Yutaka Nakamura Mieko Kondo
**

Daiei took their *invisible man* concept (see **Invisible Man vs Fly Man**) and reworked it into a samurai setting, adding a touch of mythology for good measure. The film opens as an innocent man is executed for murder. His son then transforms into an invisible tengu monster (a legendary flying creature with a red face and long nose that lives in the mountains) to take revenge against the real killers.

INVISIBLE SWORDSMAN (1970)
[Toumei-kenshi]
 aka **INVISIBLE SAMURAI**
director: **Yoshiyuki Kuroda**
Osamu Sakai • Yoko Atsuta
**

Samurai Sanshiro's father is killed by a gang of bandits. He knows his honor is at stake — not to mention the honor of his family — but Sanshiro is a wimp. He's a weakling, a coward to the bone. So, a wizard friend concocts a magic potion, turning Sanshiro into an invisible swordsman capable of avenging his father.

Goofy FX comedy starring endearing clown/actor **Osamu Sakai**. Throw-away fun.

IRON MAN see **TETSUO**

IRON RING
 see **WHEEL OF IRON**

ISLAND OF EVIL SPIRITS
 see **KINDAICHI** series

ISLAND OF HORRORS
 see **KINDAICHI** series

JAPANESE GHOST STORY
 see **SUMMER WITH GHOSTS**

JAPANESE GOBLIN STORY:
SATORI (1973)
[Nihon Yokai-den: Satori]
director: **Yoichi Azuma**
Mako Midori • Hatsuo Yamane
**½

Loosely based on a folk tale about a monster named Satori[1], a monkey-like creature who can read minds and who devours the villagers with the most creative thoughts.

The film drifts into lofty territory as, despite some very gory scenes, it attempts to be more than *just a horror movie*. The movie demands much from the viewer; in fact, it is purposely ambiguous to the point of incomprehensible. Characters say and think things which have nothing to do with the ongoing plot (because, don't forget, the creature can read their minds so they purposely act dimwitted). Often there are long passages of dialogue which are diametrically opposed to the otherwise simplistic story. As a result, the film becomes a parable about "closed cultures" and a satire of the Japanese preoccupation with saying one thing and meaning something else.

[1]Satori is a Japanese word that means *"to read someone's mind."*

JAPANESE SEX CRIME:
CONCURRENCE (1967)
[Nihon Seihanzaishi: Torima]
director: **Osamu Yamashita**
Naomi Kaga • Raiko Otsuki
Shohei Yamamoto • Hitomi Isoka
*½

There's a history of rape in Yoshi's family. Her mother was sexually violated near a cliff behind their country home. And, years before, her grandmother was also raped at the same place. Now, a curious Yoshi decides to examine the rocky terrain on her own. As it turns out, she also is violated in the same way by an unknown assailant.

Sometimes there's a message beyond the obvious. And sometimes it's better left buried. Director **Yamashita**'s nasty-edged terror tale is so simplistic, so flagrant in its own excess, that the audience is left with a nagging suspicion that there's more to this story than what meets the eye. Is this some demented *coming of age* film? Or is it a thriller? Could the husband (**Shohei Yamamoto**) be guilty of all three rapes? Perhaps its a rock better left unturned.

On the technical level, this film is brooding and atmospheric – a precursor to the more popular *Nakatsu* films of the '70s, the standard fetish formula.

JUSTICE: FIGHTING THE GOOD FIGHT—
Series: EVERYONE IN PLACE (1975)
[Seigida! Mikatada! Zeninshugo!!]
director: **Masaharu Segawa**
The Drifters • **Rumi Sakakibara**
*

This is the 16th and final entry in a long-running series (**Everyone In Place** from 1967-1975) starring the Japanese comedy team, *The Drifters*. While the former entries concentrated heavily on sight-gags and slapstick, the gang usually kept their feet placed firmly on the ground (becoming chefs in gourmet restaurants or students in a tough military school or detectives on the trail of con-artists) but this time they're *Superheroes*.

These guys are dedicated to helping a community who has run into problems with the local yakuza. The Drifters publish a neighborhood newspaper to expose the Mob's illegal activities. But when that doesn't work, the guys strap on their capes, masks and crime-fight-

The Drifters in *Justice: Fighting The Good Fight*

ing garb. They fight back physically against the yakuza.

A very weak entry in this series. Some funny moments — mostly dealing with each of the Drifters' search for the perfect superhero costume — but obviously everyone in the cast is getting tired of the gig.

KAMEN RIDER
[Kamen Raida] 2 Theatrical Features

Since the mid-60s when **Kamen Rider** zoomed his super-charged bike into Japanese homes courtesy of Nippon television, fourteen actors have played the role. And with each new performer, something about the masked superhero changed (*e.g.*, he went from cape to no cape or switched from a red mask to a black one). But regardless, he always *does* the same thing— Kamen Rider fights monsters. Big monsters. Little monsters. Every kind of monster.

Unlike **Ultraman**, his TV programs have never been re-edited into movies. It wasn't until 1993 that **Kamen Rider** took his routine to the theaters. **Hiroshi Domon** plays the superhero in a pro-

Kamen Rider Z

Kamen Rider J (1995) shades of RoboCop

duction made specifically for the big screen (this relatively short film was released as the top part of a double feature). He fights monster Dorasu, a creature that changes into whatever fits its fancy. Even if Dorasu should be completely destroyed, this thing has the ability to regenerate itself. However, this doesn't stop Kamen Rider **Z**. He challenges the monster and walks away the victor. Of course.

In 1995, Kamen Rider returns for more. Now **Yuta Mochizuki** plays the role; he's Kamen Rider *J*. And this time there's serious trouble brewing. The future of the world is at stake because Fog Mother has come back. She was the one who initially brought the Ice Age to the Earth millions of years ago. Today, she is one human sacrifice away from causing the same havoc all over again. Kamen Rider must stop her before she has a chance to stick the sacred knife into the heart of the little girl she's kidnapped.

Series director **Amamiya** went onto make the equally enjoyable **Zeiram** films.
Kamen Rider Z (1993)
[Kamen Raida Z]
director: Keita Amamiya
Hiroshi Domon • Shohei Shibata
Kamen Rider J (1995)
[Kamen Raida J]
director: Keita Amamiya
Yuta Mochizuki • Yuka Nomura

KAPPA (1994)
[Kappa]
director: Tatsuya Ishii
Takanori Jinnai • Keisuke Funakoshi
Tatsuya Fuji • Ryuji Harada
**

Director **Tatsuya Ishii** is the lead singer for a Japanese pop group called the *Come-Come Club*. His debut film is a beautifully photographed Nippon version of **Steven Spielberg**'s **ET: The Extraterrestrial** (1982). Upon its release, critics were enamored with the stylish "look" of the film, but they were less-than-enthusiastic about the derivative plot.

News photographer Yuta (**Tatsuya Fuji**) reunites with his son after a 15 year separation. The two men bond by swapping stories and Dad decides to reveal a secret he's held since youth. He tells his son about the time he met

waiting for *Kappa*

water imp Kappa, a alien lifeform from space who had taken refuge in a lake. Yuta and his son embark on a journey to the countryside in search of the extraterrestrial.

Initially the movie has a bittersweet quality, enhanced by two fine performances from **Fuji** and **Takonori Jinnai**, but it quickly deteriorates into matinee fodder when the pseudo ET appears. A spark of originality would have insured success for this superbly crafted project. It looks like a gem, but it's only a mirage.

▶ **KEKO MASK: THE BIRTH** (1991)
[Kekko Kamen: Eiga]
director: Yutaka Akiyama
Hajime Tsukumo • Kenji Yanaguchi
Akira Ohizumi • Mayumi Takahashi
**½

❖

▶ **KEKO MASK** (1993)
[Kekko Kamen]
director: Yutaka Akiyama
Hajime Tsukumo • Rei Nakano
Nokko • Risa Kondo
***½

❖

▶ **KEKO MASK IN LOVE** (1995)
[Kekko Kamen Koi: 3]
director: Yutaka Akiyama
Hajime Tsukumo • Asami Katsuragi
Mayumi Yoshioka • Akira Ohizumi

The principal (**Hajime Tsukumo**) of Spartan School is a sadist who believes that discipline is the cornerstone of education. The students are systematically tortured and mistreated by the teachers, but they also have a guardian superhero who rescues them when things get out of hand. That hero is a female crusader named **Keko Mask** *[Kekko Kamen]*, completely naked except for her cape and mask. She eliminates the bad guys by stunning them with a glance at her genitalia before snapping their necks in

Keko Mask (Kekko Kamen)

various ninja leg locks. "The most beautiful vagina I've ever seen," gasps one of the victims before he dies.

The plot for all three centers around Keko's secret identity (the principal believes she is one of the students) and the band of miscreant mercenaries he hires to expose her. Throughout the series new *bounty hunters* arrive and they fumble about trying to discover who the superhero really is. Writer **Go Nagai**[1] even has some of his other characters (*i.e.,* Cutie Honey, Mazinga Z, etc) stop by and join in the hunt, not to mention *The Blues Brothers* (yes, *those* Blues Brothers).

While it's difficult to ignore the vicious attitude of the film, especially its contempt for women, American audiences must remember *political correctness* remains a domestic philosophy not necessarily shared by the Japanese. Director **Akiyama** seems very comfortable thumbing his nose at the concept.

Interestingly, most of the humor stems from "domination" and bullying, with the principal belittling teachers, teachers mistreating students, and students picking on other students. Of course,

it's mean-spirited. But the series is also outrageously hip. With lots of humorous jabs at contemporary Japanese morals, lampooning everything from the political school system to optical censoring of films, this movie is a brazen example of the cliched superhero mystique gone haywire. Ultimately, irreverence is the foundation of satire. And lines of dialogue like: "*Screaming girls and Wagner Music go well together*" are legitimately funny.

Each entry stars **Hajime Tsukumo** as the principal, dressed in a harlequin outfit. His vice-principal is **Akira Ohizumi**, a Russian theater actor who immigrated to Japan in the late '60s. Keko Mask's true identity is never revealed. The credits read: *Keko Mask: Unknown.*

Originally, this was not intended to become series, rather it was planned as a one-shot version of a popular *manga* (comic book). Success begot the sequels. *#1* was designed as a co-feature and is irritatingly short (50 minutes), *#2* has the best production values and is the funniest, and *#3* has the most heart.

[1]Writer **Go Nagai** is the author of many Japanese anime features. He also created another live action film, similar to *Keko Mask*, called **Legendary Panty Mask** {see separate review}.

Detective Kosuke KINDAICHI series *[movies based on character created by Seishi Yokomizo]* (1947-1981)

These films would not be included in this volume if the authors had adhered to the strictest sense of the term "horror." Most of the *Detective Kosuke* movies are atmospheric and creepy. And although they appear to have something supernatural going on (*i.e.,* warrior ghosts in **Yatsuhaka Village** or werewolves in **Bloodthirsty Moth**, *et al*), each time the brilliant detective solves the crime by unveiling decidedly human perpetrators.

Man With Three Fingers (a Kosuke Kindaichi detective thriller from 1975)

Director **Kon Ichikawa** fell into a pile of money when he took *Seishi Yokomizo*'s novel, **The Inugami Family**, and remade it into a feature film. The book had originally been adapted for a 1954 version, **Secret Of Inugami: The Devil Is Dancing** directed by **Kunio Watanabe**. Wisely, **Ichikawa** kept the baffling *Ten Little Indians* mystery, but he also added new complications surrounding the deaths of heirs to an industrialist's fortune. The director also embellished Detective Kosuke Kindaichi (**Koji Ishizaka**) with certain familiar idiosyncrasies. Essentially, Kindaichi is a turn-of-the-century *Columbo*; **Peter Falk** should be flattered.

The Inugami Family (1976) became a surprise hit (it was preceded by less than successful adaptation of **Honjin Satsujin Jiken** in 1975 [a remake of **man With Three Fingers**]); as of this writing, **Inugami Family** still holds the record for being Japan's #1 all-time box-office success. The movie was hastily followed by an inferior sequel also starring **Koji Ishizaka**, **Devil's Bouncing Ball Song** (1977), scripted by **Kon Ichikawa** himself under the pseudonym Kurisutei [*Christie*]. Essentially, this one is also a remake, originally starring **Ken Takakura** as Kindaichi.

More thought was put into the third **Ichikawa** installment, co-scripted by *Christie* and *Seishi Yokomizo*. **Island Of Horror** finds Kindaichi on the trail of a serial killer who leaves clues in the form of haiku poems. Like the other ones, this story was previously adapted for the screen (**Gokumon Island** [1947], directed by **Sadaji Matsuda** starring **Chiezo Kataoka**).

Although **Ichikawa**'s next entry, **Queen Bee**, is based the popular *Yokomizo* novel, little of the original story remains. The tale of a female tycoon who plots the murder of her adversary is replaced by a humdrum mystery about a career-woman targeted by a killer. On the other hand, an earlier 1952 version with **Joji Oka** is very close to the original work.

Island Of Evil Spirits (1981)

With **Death House On Hospital Hill** in 1979, director **Ichikawa** returns to the basics with the essentially same kind of intrigue as his first entry. It's also the only one of his adaptions which is not a remake. While investigating a series of grisly murders, Detective Kindaichi (the last time **Koji Ishizaka** would play the role) discovers a connection between the deaths and a wealthy family living in seclusion on the Pacific Coast. Unfortunately, the plot is too convoluted for its own good.

Mitsumasa Saito remade **Devil Comes Down And Blows The Flute** in 1979 with a stoic **Ken Takakura** in the detective's lead. The original version was produced in 1954 by **Sadaji Matsuda**. One of the best in the series, **Yatsuhaka Village** (aka **Eight Tombstone Village**), is directed by **Yoshitaro Nomura** in 1980. It also is a remake of an earlier and decidedly minor 1951 adaption. The ghosts of samurai warriors seem to be haunting a small countryside community where citizens are turning up dead. It's all linked to ancient curse and Detective Kindaichi (this time played by **Kenichi Hagiwara**) figures it out.

In 1981, legendary director **Masahiro Shinoda** took a stab at the series. He put **Takeshi Kaga** in the lead role and then transported the whole thing to a contemporary setting. This detective is *very* hip. He even solves the case—dealing with a pair of twins charged with murder on a South Seas Island—after studying the lyrics to the **Beatles'** *Get Back* and *Let It Be*.

Bloodthirsty Moth is a singular entry, holding the distinction of not being remade in the *Ichikawa* sweep of the '70s. Nor was it dusted off later to capitalize on Detective Kindaichi's newfound popularity in the early '80s. Perhaps this story of an apple-eating werewolf who enjoys slaughtering pret-

Devil's Bouncing Ball Song (1977)

ty models was just too silly for contemporary audiences. This '56 entry remains *Ryo Ikebe*'s only attempt at the Kosuke role.

Eight different actors played the brilliant detective over 30+ years in sixteen feature films. **Chiezo Kataoka** was the most prolific, portraying *Kindaichi* six times between 1947-1956. **Koji Ishizaka** is a close second with five outings from '76 thru '79. But neither of these is the most famous, rather it's **Ikko Furuya**, recognized by thousands of Japanese fans as *the* Detective Kosuke Kindaichi. He stars in the television series based on the *Seishi Yokomizo*'s novels (*i.e.*, in America **Raymond Burr** will always be *Perry Mason*, few people even remember **Warren William** in his four Perry Mason movies). Two motion pictures, edited from the TV series, were released to the theaters: the episodic **Adventures Of Kosuke Kindaichi** (1982) and **Pearl Sprite** (1984) in which the detective's girlfriend is possessed by the spirit of a dead prostitute murdered by a suicidal client. Cult filmmaker **Nobuhiko "Obi" Ohbayashi** (*House* [1982]) directs both pics.

Even though **Kon Ichikawa** promised in 1979 he'd never do another one of these, he came back to the series in 1996 with a classy rehash of **Eight**

Tombstone Village. It stars **Etsushi Toyokawa** as detective Kindaichi. This one benefits from **Yuko Asano**'s wild-eyed, scenery-eating performance; however some critics complained that she was miscast in the role.

The following *Kosuke Kindaichi* films are listed in chronological order; the ones marked with [■] are considered the best:

■ **Man With Three Fingers** (1947)
 [Sanbon Yubi No Otoko]
 director: Sadaji Matsuda
 Chiezo Kataoka • Setsuko Hara

■ **Gokumon Island** (1947)
 [Gokumon-jima]
 aka **Island Of Horror**
 director: Sadaji Matsuda
 Chiezo Kataoka • Chizuru Kitagawa

□ **Yatsuhaka Village** (1951)
 [Yatsuhaka-mura]
 aka **Eight Tombstone Village**
 director: Sadaji Matsuda
 Chiezo Kataoka • Chieko Soma

■ **Queen Bee** (1952)
 [Joo-bachi]
 director: Sadaji Matsuda
 Joji Oka • Chizuru Kitagawa

□ **Devil Comes Down
 And Blow The Flute** (1954)
 [Akuma Ga Kitarite Fue O Fuku]
 director: Sadaji Matsuda
 Chiezo Kataoka • Mitsuko Miura

■ **Secret Of Inugami Family:
 Devil Is Dancing** (1954)
 [Inugami-ke No Nazo:
 Akuma Wa Odoru]
 director: Kunio Watanabe
 Chiezo Kataoka • Shinobu Chihara

□ **Mitsukubi Tower** (1956)
 [Mitsu-kubi-tou]
 aka **Three-Headed Tower**
 director: Tsuneo Kobayashi
 and *Shigehiro Ozawa*
 Chiezo Kataoka • Shigehiro Ozawa

■ **Bloodsucking Moth** (1956)
 [Kyuketsuga]
 director: Nobuo Nakagawa
 Ryo Ikebe • Asami Kuji

□ **Devil's Bouncing Ball Song** (1961)
 [Akuma No Temari-uta]
 director: Kunio Watanabe
 Ken Takakura • Shigemi Kitahara

□ **Honjin Murder Case** (1975)
 [Honjin Satsujin Jiken]
 aka **Man With Three Fingers**
 director: Yoichi Takabayashi
 Akira Nakao • Takahiro Tamura

■ **The Inugami Family** (1976)
 [Inugami-ke No Ichizoku]
 director: Kon Ichikawa
 Koji Ishizaka • Mieko Takamine
 Yoko Shimada • Rentaro Mikuni

□ **Devil's Bouncing Ball Song** (1977)
 [Akuma No Temari-uta]
 director: Kon Ichikawa
 Koji Ishizaka • Tomisaburo Wakayama

■ **Island Of Horrors** (1977)
 [Gokumonto]
 director: Kon Ichikawa
 Koji Ishizaka • Reiko Ohara
 Mitsuko Kusabue • Yoko Tsukasa

□ **Queen Bee** (1978)
 [Joobachi]
 director: Kon Ichikawa
 Koji Ishizaka • Kie Nakai

■ **Death House On
 Hospital Hill** (1979)
 [Byoinzaka No Kubikukuri No Ie]
 director: Kon Ichikawa
 Koji Ishizaka • Yoshiko Sakuma

■ **Devil Comes Down
 And Blows The Flute** (1979)
 [Akuma Ga Kitarite Fue O Fuku]
 director: Mitsumasa Saito
 Toshiyuki Nishida • Isao Natsuyagi
 Tomoko Saito • Haruko Wanibuchi

Eight Tombstone Village (1996)

King Kong Escapes

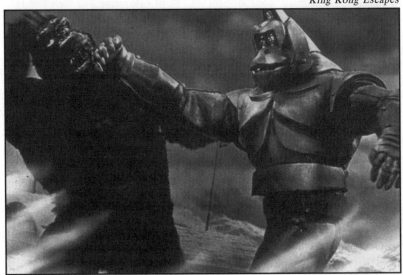

■ Yatsuhaka Village (1980)
 [Yatsuhaka-mura]
 aka **Eight Tombstone Village**
 director: Yoshitaro Nomura
 Kenichi Hagiwara • Mayumi Ogawa
 Tsutomu Yamazaki • Etsuko Ichihara
■ Island Of Evil Spirits (1981)
 [Akuryo-to]
 director: Masahiro Shinoda
 Takeshi Kaga • Hideo Murota
 Masato Furouya • Shima Iwashita
□ **Adventures Of**
 Kosuke Kindaichi (1982)
 [Kindaichi Kosuke No Boken]
 director: Nobuhiko Obi Ohbayashi
 Ikko Furuya • Kunie Tanaka
 Isamu Nagato • Jin Nakayama
■ Pearl Sprite (1984)
 [Shinjuro]
 director: Nobuhiko Obi Ohbayashi
 Ikko Furuya • Isamu Nagato
 Naoko Otani • Daijiro Harada
■ Eight Tombstone Village (1996)
 [Yatsuhaka-mura]
 aka **New Yatsuhaka Village**
 director: Kon Ichikawa
 Etsushi Toyokawa • Shin Takuma
 Kazuya Takahashi • Yuko Asano

KING KONG ESCAPES (1967)[1]
 [King Kong No Gyakushu]
 translation: **King Kong Attacks Again**
 director: Ishiro Honda
 Rhodes Reason • Mie Hama
 Linda Miller • Akira Takarada
 *

 Director **Ishiro Honda** returns to the *kaiju eiga* genre, but Godzilla is missing and this King Kong story is goofy at best, embarrassing at worst. Perhaps the most interesting aspect of this film is the villains are Japanese, while the heroes are America. In the growing practice of using Anglo bit actors in starring roles, wooden-man **Rhodes Reason** (from TV's **White Hunter** [1958-59]) leads an expedition searching for mighty King Kong and **Linda Miller** (future star of *Paul Mazursky*'s **Unmarried Woman** [1978]) is the girl who steals Kong's mighty heart, figuratively of course. The bad guys, certainly the most charismatic of the bunch, are **Hidyo Amamoto** playing a crazed scientist (named Dr Who in the English version) and his associate sinister Madam Piranha (**Mie Hama**).

The plot finds the villains mining illegal radioactive minerals, using a mechanical replica of King Kong to do it. When the robot goes on the friz, they decide to capture the real Kong for the operation. The plotholes are more than obvious.

¹ This film was planned to coincide with the 35th anniversary of Toho Studios. The producers purposely copied many of the same techniques used by RKO pictures for the original **King Kong**, including the same editing techniques and scene segways.

KING KONG VS GODZILLA (1963)
[King Kong Tai Gojira]
director: Ishiro Honda
Tadao Takashima • Mie Hama
Yu Fujiki • Kenji Sahara
English language version only:
Michael Keith • James Yagi
**

This one marks the point where *Godzilla* movies became silly. Essentially, the climax finds two men in monster suits wrestling and hamming it up for the camera. Lots of laughs when Godzilla and King Kong play ball with a boulder. And belly laughs when Godzilla *gooses* Kong with his fire ray.

There are some differences between the Japanese and American versions, mostly inserted segments featuring a

native dance in *King Kong Vs Godzilla*

scientist, Dr Johnson (**Michael Keith**), discussing the perils-at-hand with a Japanese newscaster played by **James Yagi**. These English language sequences were filmed in the United States by an otherwise unknown director, **Thomas Montgomery**. Rumors of significantly different endings have persisted for years, with Godzilla winning in the Japanese edit and King Kong victorious in the USA version. While it may be colorful chitchat, it is not accurate. In both prints, an earthquake interrupts the boxing match, tossing the creatures into the ocean. Kong emerges from the sea, Godzilla does not.

King Kong returns to the Japanese screen in 1967 with **King Kong Escapes**; Godzilla comes back sooner to fight Mothra in **Godzilla Vs The Thing** (1964).

KISSES FROM THE MOON (1989)
[Mangetsu No Kuchizuke]
director: Ryu Kaneda
Rie Takahara • Yasufumi Terawaki

This debut film by **Ryu Kaneda** (future director of **Video Girl Ai** [1991] *et al*) is essentially a variation of *Kevin S Tenney*'s **Witchboard** (1985) and all the other *Ouija board* thrillers. A giddy bunch of teen girls try to contact Cupid, the spirit of love, on their Magic Spelling Board. But as these stories go, they have actually awakened an evil spirit. Initially this demon masquerades as the beatific angel of love. But then after the girls give him permission to manifest, all hell breaks loose. He attacks them with a black fury, raping and slaughtering the girls, as they try to escape.

Despite the derivative plot, the FX are quite good and the horrific action is much more *white-knuckle* than the American-made counterparts. The film has received numerous International

Kisses From The Moon

awards, including grand winner of
Italy's 1990 International Film Festival
where it swept the *best film* and *best
actress* categories. It was also a big
commercial hit in Hong Kong, probab-
ly the inspiration for the very similar
Thou Shalt Not Swear (1992) with *Lau
Cheung Wan* and *Joyce Jiang*.

KOHEIJI IS ALIVE
 see **HORROR:**
 KOHEIJI IS ALIVE

KONTO[1] 55:
 SPACE ADVENTURE (1969)
 [Konto 55-go: Uchu Daiboken]
 director: Jun Fukuda
 Kinichi Hagimoto • Jiro Sakagami
 Carousel Maki • Noriko Takahashi
 *

 Director **Jun Fukuda** continues to
underwhelm audiences with his own
unique brand of cinematic rubbish. He
is best known for truly awful contribu-
tions to the *Godzilla* genre (with
Godzilla Vs Megalon, **Son Of
Godzilla** and **Godzilla Vs The Sea
Monster** being the worst). But this
director, the *all-time bad-movie champ*,
reaches unimaginable levels of terrible-
ness with his non-*Big G* stuff {also see
separate listing for **ESP Spy** [1974]}.
Even notorious international hacks like
America's *Ed Wood* and Italy's *Miles
Deem* would be jealous.

A geisha (**Noriko Takahashi**) and two
samurai warriors, Sakamoto and
Serizawa (**Kinichi Hagimoto** and **Jiro
Sakagami**), are captured by extrater-res-
trials from the distant Bardot Planet.
Seemingly, these peaceful aliens are
kidnapping "violent and prurient crea-
tures from Earth" and taking them back
to Bardot in hopes that their "animalis-
tic presence will rekindle natural com-
petitive instincts" in their people, a race
of beings who have become too peace-
ful and conciliatory for their own good.
Essentially, the inhabitants of Bardot
lost their will to fight. Thus, they risk
annihilation at the hands of an aggres-
sive neighboring planet. Senseless junk
in the *Fukuda* vein.

[1]Konto is a Japanization derived from the French
word "conte" meaning a comedy skit performed by
a team or troupe of players.

KOYA MOUNTAINS:
 CHOKEN MEMORANDUM (1993)
 [Koya Choken-bou Oboegaki]
 director: Tetsutaro Murano
 Yuko Natori • Daisuke Ryu
 **1/2

 Modern setting. Art historian Yoko
Akizuki (beautiful **Yuko Natori** from
Summer With Ghosts) visits the forbid-
den[2] Koya Mountains for research. She
unearths documents recounting the story
of a Choken monk (**Daisuke Ryu**, later
to become famous as *Black Jack* [see
separate listing]) who was excommuni-
cated for having an affair with a
woman. Yoko becomes obsessed with
the young monk and eventually discov-
ers a book of his memoirs. As she
begins unraveling his impassioned life,
Yoko slips into a timewarp and finds
herself face-to-face with the fervent
monk. When she becomes his lover,
Yoko realizes that she is the very per-
son who caused the celebrated scandal
many generations before.

 Actress **Natori** steals the film as she
plays four different roles, delivering

rave performances in each. The movie itself is too reminiscent of *Jeannot Szarc*'s **Somewhere In Time** (1980) to be called original. And, like its inspiration, this one also suffers from being overly arty and, at times, pretentious.

[2]The Koya Mountains was a sacred retreat area reserved exclusively for members of religious orders and their male guests. No females were permitted on the grounds until that taboo was broken in the later part of the 20th Century.

KURONEKO (1968)
[Yabu No Naka No Kuroneko]
translation: **Black Cat In The Bushes**
director: **Kaneto Shindo**
Nobuko Otowa • Kiwako Taichi
Kichiemon Nakamura • Kei Sato

This is the notorious Japanese anti-Samurai horror film. In feudal Japan, an old woman and her daughter-in-law are raped and killed by samurai. They return from the grave as "ghost-cats" determined to kill all the warriors they meet. They spend most of the film ripping out the throats of many victims until, in a moment of "Oedipus-type" irony, they find themselves about to kill a samurai who is both their son and husband, respectively.

An interesting combination of visual imagery and gross-out special effects, seasoned with a tad of dime-store psychology. A fun film, but not in the

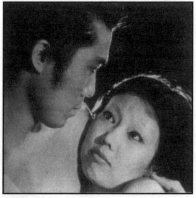

Kuroneko

same league as director **Shindo**'s companion movie, **Onibaba** (1964). Both movies star **Nobuko Otowa**, the director's wife.

Kwaidan (Kaidan)

KWAIDAN [Ghost Stories] (1964)
[Kaidan]
director: **Masaki Kobayashi**
Rentaro Mikuni • Michiyo Aratama
Noboru Nakaya • Tetsuro Tanba

Although this was a dismal failure in Japan, it's one of a handful of Nippon "non-rubber monster" movies to enjoy a successful widespread release in the United States. Playing mostly to the Art Theatre crowd, this film received rave reviews from tough critics throughout the states and went on to win the Best Picture Award at the Cannes Film Festival. Japanese reviews criticized the motion picture for it's "style-over-substance" and its deliberately slow pace, claiming that it was "intentionally designed for Western audiences."

It's a collection of four traditional *Japanese* ghost stories, each based on the writings of British-born **Lafcadio Hearn**. The tales symbolically describe a different season of the year. The first one **Kurokami** (representing Fall) tells of a samurai who returns from battle to find his home destroyed, yet his wife living unscathed among the ruins. He beds her. In the morning he is horrified to find himself sleeping with her rotting corpse. The second story **Yukionna**

(Winter) tells about a female witch who lures travelers to a snowy death, while the third, **Chawan No Naka** (Summer), introduces a warrior haunted by a reflection in a cup of tea. The fourth story, and easily the best one, is **Miminashi Hoichi No Hanashi** (Spring). A blind musician is forced to perform for the ghosts of dead warriors. To protect him from the demanding audience, monks cover the young man's body with passages from Holy Buddhist writings. Unfortunately they forget to inscribe upon his ears and the hungry ghosts rip them off his head during the concert.

The original version is ridiculously long at 164 minutes, especially in light of director **Kobayashi**'s preference for slight camera movement and deliberately minimalistic action sequences. The United States theatrical version is missing the second story and runs 125 minutes. As beautiful as it may look, it's still too long for one sitting.

Also see: **Ghost Story of Snow Girl**.

LABYRINTH (1996)

[Meikyu]
director: Yonosuki Minamoto
Takeshi Maya ● Kanori Kadomatsu
**

When two friends (**Takeshi Maya** from *Hard Helmets: Bee Fighters* [1995] and **Kanori Kadomatsu** of *All Night Long* [1994-1996] fame) vacation together in Hong Kong, Takeshi is exposed to a virus which makes him invisible.

LADY BATTLE COP (1991)

[Onna Batoru Koppu]
director: Akihisa Okamoto
Azusa Nakamura ● Kisuke Yamashita
Yuki Kitazume ● Shiro Sano
**½
Female cop Kaoru is seriously wounded in the line of duty. Rather than existing as a vegetable for the rest of her life, she opts to become Lady Battle Cop. The salvageable parts of her torso (plus brain, of course) are squeezed into a cybernetic shell not unlike the interna-

Kurokami, the first story in *Kwaidan*

tionally famous *Robocop*. In fact, Kaoru looks so much like her more famous counterpart, one wonders why **Orion** didn't sue. Perhaps, it's because **Rob Bottin**'s designs were initially inspired by Nippon Space Sheriff TV shows like **Gavan** and **Jaspion**. The USA studio probably figured *why open that can of worms?*

Regardless, this film doesn't take itself too seriously. As critic **Patrick Macias** observes: "*Lady Battle Cop* offers enough cheap thrills to satisfy any fan's daily quota of girls, guns, gadgets, and gangsters." It's basically a brainless actioner about a tough group of military extremists known as the Karuta Cartel taking over Neo-Tokyo through excessive violence. And Lady Robocop (er, that is, *Battle Cop*) goes after them. In the process she also confronts their cyborg, Amadeus. The end result is a bloody free-for-all with an amazingly high body count.

Director **Okamoto**, who broke on the movie scene with a splash in 1976 {see reviews for **Male Detention Squad** and **Violent Classroom** in *Japanese Cinema: The Essential Handbook* for an overview}, joined Nihon Television a year later. He produced and directed an impressive string of award-winning documentaries for *Toei* before accepting this unassuming project in 1991.

The LADY WAS A GHOST (1958)
[Kaidan Dochu]
director: Tadashi Sawashima
Kinnosuke Nakamura • Keiko Ohkawa
**

A surprisingly restrained performed from hammy **Kinnosuke Nakamura** makes this humdrum *chambara* ghost story tolerable. After a lengthy battle, a samurai returns to the arms of his wife. In the morning — after a night of love making — he discovers that she was a ghost. The same *Lafcadio Hearn* story

served as the source material for the first episode in the 1964 omnibus film **Kwaidan**.

LADY POISON: BEASTS OF THE UNDERGROUND (1994)
[Powazon Bodi: Dokufu]
aka **BODY POISON**
director: Kazuya Konaka
Tomoko Mayumi • Ren Osugi

Yuka Miroku (**Tomoko Mayumi**) is Lady Poison. Nobody actually calls her that. But when she's alone, reminiscing on her life, thinking about her daily routine, Yuka must see herself as *poison*. And it probably brings a smile to her lips.

She's a female Jack-the-Ripper who enjoys slicing up men while having sex with them. And, since she's also a photographer by trade, Yuka likes to secretly set her camera on auto-snap and turn the whole thing into a grisly Kodak moment. After the festivities, she anonymously feeds the photos into the underground via her computer and the Internet. Two gay cops (partners by day, partners by night) are on the trail of the female slasher, but they're not having much luck. Rather, there's a mystery writer named Sogabe (**Ren Osugi**) who hunts Yuka down and decides to use her in his own sadistic sex games. He takes the girl to his private chamber in the rear of a decadent nightclub where he gets his kicks by torturing her until she's finally rescued by a secret admirer.

Director **Konaka**'s film is another entry in a growing collection of vicious anti-social thrillers, seemingly popularized by the success of 1992's **All Night Long** and it's companion, **Atrocity** [1995] {see separate reviews}. The director is also responsible for the popular **Black Jack** series (1995-96) and the *Tetsuo*-inspired **Defender** (1997).

LAKE OF DRACULA
see **BLOOD THIRSTY EYES**

LAKE OF ILLUSIONS (1982)
[Maboroshi No Mizuumi]
director: **Shinobu Hashimoto**
Reiko Nanjo • **Daisuke Ryu**
☐ pick your own rating

Lake Of Illusions

This is the Japanese equivalent to *Plan Nine From Outer Space*. For years critics and audiences have discussed the film, while marvelling at it ineptness. Generally everyone seems to agree, this is the worst Japanese film of all time, *but* it's must-see stuff. For a motion picture to be revered as *the best worst movie* or *so bad it's good*, the film must meet certain criteria. For instance, 1) it must be the brainchild of people who should've known better; or 2) it must take itself seriously, even though no one in the audience can; or 3) it must simultaneously devour so many different genres that even the hippest fan will cry for homogeneity. This film manages to do all three.

Director/scriptwriter **Shinobu Hashimoto**, celebrated scripter for *Akira Kurosawa*'s **Rashomon**, enjoyed three decades of hit films (**Submersion Of Japan** [1973] and the record-breaking **Hakkoda Mountain** [1976], to name but two). In fact, **Hashimoto** was considered such a *golden boy* that the studio gave him a green light for this project without even seeing a script.

After a busy day servicing clients, bath-house prostitute Michiko (**Reiko Nanjo**), relieves her tension by jogging around the lake with her dog. But, one day, when doggie turns up dead, Michiko puts on her detective hat and investigates. She uncovers the murder weapon, a kitchen knife. Through psychic vibes, she learns that her dog was killed by a musician/fisherman visiting the lake while on vacation. Apparently the mutt had tried to steal a fish from

the man and ended up getting killed for the effort. Michiko figures that a professional musician must live in Tokyo and so she takes a mini-vacation from the whorehouse goes to the big city to find him.

The female vindicator is roaming around Tokyo when she runs into Rosa, a girl who also used to work in Soapland. Rosa has come-up in the world. No more soapy penises for her, no sir. Now she's working for the American CIA and has just uncovered a terrorist's plot to blow up the space shuttle. Rosa is scheduled for the next plane to the States. But then, after remembering all the favors she owed Michiko (like the time she "finished off" a particularly kinky john after a migraine headache suddenly hit), Rosa decides to help her friend find the dog-killer. She postpones her trip.

Through Rosa's secret-service connections, Michiko locates the musician, a man named Saburo. The next morning, she follows him while he's jogging. When the man realizes that someone is on his tail, he picks up speed. This turns into a jogging competition. Even though Michiko is in great shape, she loses because she's not used to the polluted Tokyo air. Saburo is swallowed up by the city. Disappointed, Michiko bids *sayonara* to Rosa, who jumps on an airplane to the United States. Michiko leaves Tokyo.

Back home, the girl is walking around the Lake, thinking about how much she misses her dog, when Michiko meets a young man, Nagao (**Daisuke Ryu**), sitting in the grass playing a flute. He tells her a story about the dark legend of a castle near the lake. At this point, the movie flashes back to ancient Japan and the audience is introduced to Mitsu (**Tomoko Hoshino**), an unhappy girl, destined to die unfulfilled; she drifts from one reincarnated life to another searching for her soulmate, finding him and then dying just before she can marry him. As the story progresses, it's obvious that Nagao is the man-of-her-dreams. But the significance of this story-within-a-story, this flashback, is lost — unless, as some fans have suggested, Michiko's dead dog is the 20th Century reincarnation of Mitsu and Nagao is in mourning once again. But regardless, *this Nagao* is a NASA scientist (maybe, somehow, there's supposed to be connection between him and Rosa with her space shuttle assignment, but it's anybody's guess). Michiko leaves Nagao to his muses and she continues strolling around the lake until she bumps into a banker on his lunch break. He is instantly infatuated with Michiko and invites her to visit the castle to see a Buddhist "goddess with 11 faces" sculpture. The holy statue fills Michiko with peace and serenity; she decides to give up her quest for vengeance and soap-suds sex. Inexplicably, she decides to marry this banker.

Then on her last day of work at Soapland, she spots a client who is— yes, the dog-killer from Tokyo! All her hate intensifies. She jumps into Saburo's bath and tries to kill him. But the man escapes. Suddenly they're both running around the lake. Michiko pretends to give up the chase, but then she sneaks up behind him and, using the same knife he used to kill her dog, she stabs the Saburo repeatedly. While he's struggling in a pool of blood, the man begs to know why she's done this to him. But Michiko refuses to answer.

How can all this be packed into one movie? True, it lasts 2 hours and 44 minutes. But still....

Music is provided by **Yasushi Akutagawa**, a highly respected classical composer and director of the Tokyo Philharmonic. But the over-produced, bombastic score only calls attention to the inept production.

The *icing on the cake* is **Reiko Nanjo**'s pathetic debut. She secured the role after winning first place in a nationwide talent showcase; she competed against 1600 trysts in a public audition. Unfortunately her acting is wooden in a performance that reeks of inexperience. Director **Hashimoto**'s reputation was severely wounded by this film. He continued writing scripts for an occasional film. But, after an unsuccessful run, he retired in 1986.

LAST CHRISTMAS
see **MEMORY OF THE FUTURE**

**LAST DAYS OF
PLANET EARTH** (1974)
[Nosutoradamusu No Daiyogen]
translation: **Prophecies of Nostradamus**
aka **CATASTROPHE 1999**
director: Toshio Masuda
Tetsuro Tanba • Toshio Kurosawa
So Yamamura • Kaoru Yumi
*½ (or ***)

Camp or Crap. Depending on your reason for watching genre movies in the first place, this one is either great or awful. Made six years before **Orsen Welles** narrated the 1980 pedantic **Nostradamus: Man Who Saw Tomorrow**, director **Masuda** assembled this docu-drama from the predictions of the famed foretelling monk.

Last Days Of Planet Earth

Of course, taken at face value, the movie is terrible. Children attending school in gas masks, parents zoned out on LSD, pollution causing downpours of acid rain, and giant monster-slugs invading the coastline are but a few of the wacky delights in this straight-faced sermon from *Toho Studios*. But, for audiences with a cockeyed sense of humor, it would be difficult to find a more enjoyable, unintentionally funny, film.

21 years later, the religious organization, *Kofuku No Kagaku*, financed the equally awful **Nostradamus: Fearful Prediction** (1995). And for more in this distorted genre, try **Tetsuro Tanba's Great Spirit World** series *(see listing under Tanba)*.

LAST DINOSAUR (1977)
[Saigo No Kyoryu: Kyokutei Tanken-sen]
director: Tom (Tsugunobu) Kotani
 and Alex Grasshoff
Richard Boone ● **Joan Van Ark**
Steven Keats ● **Masumi Sekiya**
William Ross ● **Tetsu Nakamura**
**½

While on an expedition in the Artic, an international group of scientists and journalists – led by a weathered **Richard Boone** (best remembered as the gentleman bounty-hunter Paladin on CBS television's *Have Gun Will Travel*

1957-1963) – discover a Tyranosaurus Rex living in a lake at the base of a volcano.

Here's an often-ignored Japanese/USA co-production, condemned to obscurity because of its "Made For *American* Television" reputation. In reality, the movie was financed by the American Broadcasting Corporation (ABC) as part of their now-defunct motion picture branch. When their distribution system crashed, the network premiered this film in the *Sunday Night At The Movies* slot (9:00-11:00 EST). But the *made-for-TV* stigma was too severe for any long-term reputation the movie may have deserved. Other projects directed by **Tom [Tsugunobu] Kotani** were cursed by the same fate, including his ambitious "Marco Polo musical" with **Zero Mostel** and **Desi Arnez Jr** called *Marco* (co-directed with **Seymour Robbie** in 1973) plus *Bermuda Depths* (1978) and *Ivory Ape* (1980).

Regardless, *The Last Dinosaur* was filmed on location in the Artic with interiors shot in Japan. The creature was produced by **Eigi Tsuburaya**, the wizard responsible for all the early Toho rubber monsters (*e.g.*, Godzilla, Rodan, Mothra, *et al*). Director Kotani was the logical choice for this co-production due to his unique language proficiency. As a laureate graduate from the prestigious Tokyo University, majoring in literature and language arts, he had no trouble communicating with the predominately English speaking cast {he also helmed the International actioner **Bushido Blade** in 1978}.

LAST FRANKENSTEIN (1992)
[Rasuto Furankenshutain]
director: Takeshi Kawamura
Akira Emoto ● **Yoshio Harada**
Aya Otabe ● **Juro Kara**

Tokyo is ravaged by a plague which causes all of its carriers to commit suicide within a 3-5 year incubation period. As the city is engulfed with maniac cult groups roaming the streets extolling the "joys of suicide," college science professor Sarusawa (**Akira Emoto**) believes he is also infected. Sarusawa seeks a cure from Professor Aleo (**Yoshio Harada**), a bitterly misanthropic maverick conducting research in an isolated mountain lab. He's the *Last Frankenstein*.

Aleo resides in his dark retreat with his strange wife Kurara (later revealed to be an earlier creation) and a hunchback assistant Haruo who steals corpses from the university to aid his master in the creating of a "super Adam and Eve" (*i.e.*, beings not controlled by their emotions). Unfortunately for Aleo, the newly developed creatures don't find each other sexually attractive and refuse to mate even when threatened with a shotgun. This results in a bloody free-for-all diametrically opposed to Aleo's philosophies of emotionless behavior.

Takeshi Kawamura also wrote the unusual variation on the Dracula myth, **My Soul Is Slashed** {see separate review}. He is the founder of *Gekidan Dai San Erochika* (Third Erotic Theater), a popular cult playhouse in Tokyo, where **The Last Frankenstein** originally ran as a play. The live-theater version starred director **Kawamura** in the lead role.

Two other members of the motion picture cast came from Tokyo Theater. **Juro Kara** is the director of the *Joukyo Gekijo Playhouse* and **Akira Emoto** is the leader of *Tokyo Kandenchi [Battery] Theater*. He also stars in the cult film **Battle Heater** (1990). **Yoshio Harada**, who is unforgetable as Dr Aleo {Frankenstein}, has made a diverse collection of films, ranging

from high art (*e.g.*, **Seijun Suzuki**'s acclaimed masterpieces **Zigeunerweisen** [1980] and **Mirage Theatre** [1981]) to exploitive horror, like **Ring** (1996).

LAST ROBOCOP
 see **WATCHDOGS FROM HELL**

LAST WAR (1961)
[Sekai Daisenso]
director: Shue Matsubayashi
Frankie Sakai • Nobuko Otowa
Akira Takarada • Yumi Shirakawa

Inspired by the success of Toei's **World War 3 Breaks Out** (1960), *Toho Studios* basically took the same plot and infused a big budget. The result is one of the World's first *Doom-n-Disaster* epics, predating other so-called groundbreaking cult films (*i.e.*, **Fail Safe** [1964], **Dr Strangelove** [1964], **War Game** [1967]) by years.

In this one, the United States and Russia have nuclear missiles poised at one another, seemingly anxious for an excuse to attack. When trouble erupts at the border between North and South Korea, a world war seems inevitable. But peace talks ensue. Just as the two super powers come to a new agreement, military aircrafts collide over the Arctic resulting in a declaration of war. Instantly major cities of the world become targets and explode in horrific

Last War

fire storms. In **On The Beach** (1959) fashion, the only survivors are those people living in rural areas and they spend the rest of the film waiting for the radiation fallout to finish them off.

The special effects are the brainchild of **Eiji Tsuburaya**, the man who destroyed Tokyo in many Godzilla films. But this is his masterpiece. Eiji's work here with miniatures representing more than twenty international cities is unparalleled.

The original Japanese version runs close to two hours (110 minutes). The English Language edit is an abortion at a scant 80 minutes.

LATITUDE ZERO (1969)

[Ido Zero Daisakusen]
translation: **Latitude Zero Project**
director: Ishiro Honda
Joseph Cotten • Cesar Romero
Akira Takarada • Richard Jaeckel
**½

One of two Captain Nemo films made in 1969 (the other being the British produced **Captain Nemo And The Underwater City**, directed by **James Hill**). Whereas the UK version is fairly accurate to the **Jules Verne** 19th Century story, this one sets itself in the "near future" and bares little resemblance to the source material.

Joseph Cotten, veteran of many **Orsen Welles** and **Alfred Hitchcock** films, became disillusioned with Hollywood in the mid-60s and turned his focus to the more lucrative world of International exploitation cinema. He became a familiar face in Italian spaghetti westerns, British thrillers, German mysteries, and— this Japanese deep-sea adventure.

Cotton plays Captain Nemo, a stoic commander of a relic submarine, who rescues a group of scientists from their underwater city after a volcanic explosion. The group is attacked by demented Dr Malic (wild-eyed, crazed Latino **Cesar Romero**, the original *Joker* in TV's **Batman** [1966-68]) and his band of hybrid monsters. In the end, Malic is finished off by one of his experiments, a lion with a brain transplanted from his ex-mistress.

Director **Ishiro Honda** proves he hasn't lost his touch. He seems much more comfortable with the creative eccentricity of this oddity, than with his *kaiju eiga* slug-fest **Destroy All Monsters**

Joseph Cotton (center) as Captain Nemo runs a no-nonsense sub in *Latitude Zero*

made earlier in the year. Unfortunately, Honda jumped from this successful venture to the worst Godzilla film of the entire series, **Godzilla's Revenge** (also 1969).

Interestingly, Italian filmmaker **Sergio Martino** hired **Joseph Cotten** in 1978, refurbished his character, and borrowed some of **Honda**'s ideas for **Island of the Fishmen** [aka as **Screamers** in the United States].

LEGEND OF THE DINOSAUR AND GIANT BIRD (1977)
[Kyoryu, Kaicho No Densetsu]
director: **Junji Kurata**
Tsunehiko Watase • Tokichi Maki
**

The dinosaur is a Plesiosaurus and the bird is a Rhamphorhynchus. These two extinct creatures are discovered in Lake Sai near Mt Fuji. The prehistoric monsters fight each other, for no apparent reason, until they are sucked into a crevice when a volcano erupts.

Well-photographed fun from Toho, but director **Kurata**'s special FX are sadly dated and very cheesy.

LEGEND OF THE EIGHT SAMURAI (1959)
[Satomi Hakken-den]
director: **Koukichi Uchide**
Sentaro Fushimi • Kotaro Satomi
**½

Eight pieces of jade emerge from the body of the king's dead dog. The gems transform into fighting warriors who protect the empire of Satomi against monsters, witches and ghosts.

An epic fantasy tale, initially based on the mammoth Chinese volume *Suikoden (Suiko Legend)*, was later modernized for the Japanese culture by Edo author **Bakin Takizawa** {see the entry for *Kinji Fukasaku*'s **Legend Of The Eight Samurai** for more details}. This production, designed by *Toei* to pro-

mote their new stable of young stars, was given the Red Carpet Treatment. It consisted of three cinematic chapters with an intermission between each one. *Part One:* **Birth Of The Eight Samurai** [Hakken-den] (58 minutes); *Part Two:* **Dance Of The Monsters** [Yokai No Ranbu] (57 minutes); and *Part Three:* **Eight Samurai's Victory Song** [Hakkenshi No Gaika] (57 minutes).

LEGEND OF THE EIGHT SAMURAI (1984)
[Satomi Hikken-den]
translation: Legend of Eight from Satomi
director: **Kinji Fukasaku**
Hiroko Yakushimaru • Sonny Chiba
Hiroyuki Sanada • Etsuko Shiomi

The *Star Wars* of samurai movies— hated by the purists, loved by action fans. Director **Fukasaku** gathers an impressive cast of top stunt/actors for this horror fantasy about a princess (**Hiroko Yakushimaru**) and her gang of supernatural samurai in a battle against a witch and her ghost army. It's all based on an ancient Chinese legend, "modernized" for the Japanese by **Bakin Takizawa** in the Edo Era. Big-budget epic at 130 minutes; a remake of a 1959 release {see previous entry}.

LEGEND OF THE STARS
see **ULTRA Q: THE MOVIE**

LEGEND OF THE WHITE LION
see **BEYOND GREAT PYRAMID**

LEGENDARY PANTY MASK (1991)
[Maboroshi Panti]
director: **Takafumi Nagamine**
Miyuki Katori • Kanako Fujitani
Yoko Oshima • Suzumi Hanai
☐ pick your own rating

From **Go Nagai**, one of Japan's most outrageous writers[1], comes another

Legendary Panty Mask

Mask. But this one has something **KM** doesn't have: a big *musical* finale. The young girls, tired of being mistreated, decide a revolution is in order. They begin singing a rousing disco version of **Ten Little Indians**. Soon the Mother Superior, using her crucifix as a microphone, joins with a counter-chorus. Then in campy bad taste, the town whore sings a verse in *black-face*. As the musical number escalates, the nuns capture the girls, tie them up and start whipping them in the town square. Of course, Panty Mask comes to the rescue.

Those offended by irreligious humor shouldn't even think about watching.

[1]**Go Nagai** is the undisputed king of Japanese animation. He has created many of the most popular entries including *Cutie Honey, Masinga Z, Harenchi Gakuen, Kekko Kamen [Keko Mask]* and one of the first adult anime features, *Devil Man.*

**LISTEN TO THE
 VOICE OF THE SEA GOD:
 LAST FRIENDS** (1995)
 [Kike Wadatsumi No Koe:
 Last Friends]
director: Masanobu Deme
Naoto Ogata • Toru Nakamura
**½

Here's a fantasy remake of 1950's deadly-serious anti-war drama **Listen To The Voice Of The Sea God** about young pilots who die in a kamikaze raid during WW2. This time, a group of kids — playing rugby in the neighborhood park — time-slip into the 1940s, sliding directly into war fever of nationalistic Japan. Quickly, each of the students are drafted into the military. This movie, like the original, is told through the letters these wide-eyed boys write to their parents, in this case, letters their folks will never receive.

mind-blowing film. Nuns (yes, habit-wearing *Catholic* nuns) have taken over the desert town of Tombstone (yes, *the* Tombstone in America's old West). They've killed all the men and the good sisters are running a very strict girl's school there in the desert.

Similar to **Nagai**'s **Keko Mask**, these persecuted girls have a super-hero protector. She's *Panty Mask*, dressed in very chic indian garb, concealing her identity with a mask made from a pair of girl's leather underwear.

The production, the jokes, the attitude are also comparable to **Keko**

LITTLE SAND BOAT
 see **TANBA'S GREAT
 SPIRIT WORLD**

**LIVING DEAD IN
TOKYO BAY** (1992)
[Batoru Garu]
aka **BATTLE GIRL**
aka **TOKYO CRISIS WARS**
director: (Gaira) Kazuo Komizu
Cutei Suzuki • Kera
Keiko Hayase • Kenzi Ohtsuki

Gaira (familiar pseudonym for **Kazuo Komizu**) is responsible for a variety of low-budget shockers, including **Entrails Of A Virgin** (1989) and **XX: Beautiful Weapon** (1993). Mostly, he works outside the corporate studio system and is forced to accomplish a lot with very little money. The result is a collection of over-reaching efforts which can't possibly be realized on such a miniscule budget. So, the special FX suffer. And grandiose confrontation scenes are usually shot in darkness, where shadows conceal more than bad acting. But, on the other hand, **Gaira** brings something special to his films. Something that money can't buy: Ingenuity.

He fills his movies with so many kinky characters, high-tech gadgets and unique camera angles that it's easy to overlook the problems resulting from limited funds.

This film is easily his best to date, mixing a devastating apocalyptic view of zombie-riddled Tokyo with the mad zeal of military fascists anxious to capitalize on the mayhem. And then there's Keiko (former female wrestler, **Cutei Suzuki**), the pretty ass-kicking heroine who's stuck in the middle. She's on a rescue mission to save a community under attack by the flesh eating monsters, but she's also been fingered for execution by General Hugioka who wants to use the zombies in his own plan for world domination.

Kenzi Ohtsuki chews up the scenery in his portrayal of the power-hungry

military leader; often, he steals the show. **Cutei Suzuki**, is not much of an actress. But, as her name suggests, she is cute. And the girl gets to wear a great bulletproof blades-n-leather outfit, absolutely the c-o-o-lest, plus a *robocop* helmet complete with computer readouts and sensory devices indicating whether the target is human or zombie (*i.e.,* warm or cold).

If there's a problem with the movie, it's the relatively short running time (73 minutes). Simply, the film ends too soon. Yes, Keiko eliminates General Hugioka but there's much more at stake. Toyko remains under siege by legions of zombies, punk gangs are running wild in the streets, thousands of civilians are struggling to reach safety, and there is still no cure for the virus which started the mess in the first place. No matter what the closing credits may insist, it's not The End. Is it?

Living Dead In Tokyo Bay

LIVING SKELETON (1968)
[Kyuketsu Dokurosen]
translation: **Bloodsucking Pirates**
director: Hiroshi Matsuno
Akira Nishimura • **Kikko Matsuoka**
Masumi Okada • **Nobuo Kaneko**
**½

Two pirates murder the crew of a ship and steal the gold treasure. But then, they are lured back to the Death Boat by a ghostly siren, the sister of a dead

sailor. This time they are confronted by the ship's doctor who has become a vampire, after surviving on the bodies of the slain shipmates.

The real treat, however, is director **Matsuno**'s expert use of black-and-white photography. He expertly creates a homage to the European thrillers through his stark imagines camouflaged by thin layers of fog. It's an atmospheric netherworld made even more terrifying by the Japanese unflinching perchance for excessive blood and gore.

This was the second horror/scifi film from Shochiku Studios, produced after their successful **Goke: Bodysnatcher From Hell** in 1968

LOTS OF KILLING (1993)
[Satsujin Ga Ippai]
director: Genji Nakamura
Yumi Takigawa • Kaori Takahashi
**

As the title insists, there's a truck-load of killing in this one. In fact, it's a veritable parade of gruesome, gory murders each based on a different Mother Goose nursery rhyme. A mom-n-daughter sleuth team follow the bloodsplattered trail and solve the mystery before the police even realize there's a pattern to the mayhem.

Yumi Takigawa who spent most of her early career playing mousy *"good girl"* roles {**Convent Of The Sacred Beast** [1974] being one notable exception) has matured into a beautiful woman, both sexy and confident. She adds an air of distinction to the tongue-in-cheek premise.

This is director **Nakamura**'s first solo project after the breakup of *Yu Productions* {see **Captured For Sex 2** for background information}. He also made the female-biker parody of *Seven Samurai* called **V Madonna: The Great War** (1984) and **Sadistic Song** in 1996.

LOVE POTION TRAP (1967)
[Biyaku No Wana]
director: Koji Seki
Nami Katsura • Koji Satomi
Kaoru Miya • Keiko Naruse
**

A needlessly confusing tale starring **Kaoru Miya** as the wife of a cemetery caretaker who uses a love potion to seduce and destroy the lives of men who raped her daughter. One of her "victims" is Takeo (**Koji Satomi**). His wife, Ayako (**Nami Katsura**) counterattacks against the cemetery witch.

Low rent terror from *Shin Nihon* studios.

LUCKY STAR DIAMOND
see **BLOODY FRAGMENTS ON WHITE WALLS**

LUMINOUS MOSS (1992)
[Hikarigoke]
director: Kei Kumai
Rentaro Mikuni • Eiji Okuda
Kunie Tanaka • Tetta Sugimoto
**½
Loosely based on a real occurrence taking place during World War 2. Captain Kosuke (**Rentaro Mikuni**) survives a shipwreck and is hailed as a hero until authorities find a wooden box of human bones inside a cave where he had taken refuge. Kosuke is arrested and put on trial. The facts prove he feasted on his fellow shipmates and was responsible for five deaths. The Captain is also pressured to reveal the whereabouts of two more missing crew members. Did he kill them? Did he also eat them?

This story is recounted, in modern times, by a high school principal (also inexplicably played by **Rentaro Mikuni**) as he escorts a journalist through Hokkaido. These two men visit the cave "where it all happened." Today, a beautiful luminous moss covers the cav-

ern walls, apparently symbolizing how something beautiful can grow out of a deed so horrible. Throughout the film, the journalist travels around the countryside and interviews a seemingly endless array of people who knew the cannibal Captain (including his lawyer, teachers, friends and relatives of the victims).

The film is beautiful to watch, but overly long at its two hours running time. There's a conscious effort by director **Kumai** to take the high road. Despite the controversial subject matter, he never opts for gory special effects, fast edits, cheap thrills, nor on-screen action. This is an art film; its exploitive theme plays more like an after-thought.

MAGIC SERPENT (1966)
[Kairyu Daikessen]
translation: **Sea Serpent Wars**
director: Tetsuya Yamauchi
Hiroki Matsukata • Tomoko Ogawa
Ryutaro Otomo • Nobuo Kaneko
**

One of two attempts by *Toei Studios* {the other being the more successful **Terror Beneath The Sea** [also 1966]} to compete with the popular *kaiju eiga* genre created and dominated by *Toho*.

This one mixes fantasy and monsters with a standard samurai action theme. Interestingly, the plot is not derived from Japanese folklore, but rather it's an original story written by **Mokuami Kawatake**. Unfortunately, it's not a very convincing tale of a young lord who tries to regain his thrown usurped by an evil warlord. Both warriors use unbridled magic in the process, creating dragons, giant spiders and the like in an attempt to destroy one another.

MAD MONK (1963)
[Yousou]
aka **THE WIZARD**

director: Teinosuke Kinugasa
Raizo Ichikawa • Yukiko Fuji

Through his rigid Buddhist training, monk Gyodo (**Raizo Ichikawa**) develops magical and spiritual powers unequalled by his peers in ancient Japan. When he cures the empress (**Yukiko Fuji**) from a near fatal illness, Gyodo is rewarded with the *Palace Doctor* position (and with a new *noble* name, Dokyo). Meanwhile, the empress is obsessed with his unworldly radiance (perhaps, she was *possessed* rather than *obsessed*, remarkably similar to the classic Russian tale of **Rasputin**). Eventually, Gyodo controls the empress and the entire kingdom from his position as the High Priest of the palace. Breathtaking cinematography adds luster to a production, already acclaimed for terrific performances by both Ichikawa and Fuji .

MAGICAL MONSTER CITY
 see **FEMALE NEO NINJAS 2**

MAJIN:
 MONSTER OF TERROR (1966)
 [Daimajin]
 translation: **Monster Majin**
director: Kimiyoshi Yasuda
Miwa Takada • Yoshihiko Aoyama
Jun Fujimaki • Ryutaro Gomi
***½

Majin Monster Of Terror

MAJIN: RETURN OF MAJIN (1966)
[Daimajin Ikaru]
translation: **Furious Monster Majin**
director: **Kenji Misumi**
Kojiro Hongo • **Asao Uchida**
Shiho Fujimura • **Taro Murai**

¤

MAJIN STRIKES AGAIN (1966)
[Daimajin Gyakushu]
director: **Issei Mori**
Hideki Ninomiya • **Masahide Iizuka**
Shinji Horii • **Tanie Kitabayashi**
**½

It's easy to see the inspiration for this
popular series about a giant stone idol
coming to life and wrecking havoc.
Anyone who ever visited the temples of
Kyoto, anyone who starred in awe at
the gigantic sculptures of angry gods,
must've also wondered what it would
happen if one of these things suddenly
came to life.

That's the premise. These movies are
essentially 18th century action pics with
a monstrous vindicator. Each deals with
a wicked ruler mistreating and enslav-
ing his subjects. When the abuse reach-
es a crescendo, the stone god Majin
responds to the prayers of the wretched
and seeks vengeance.

All three of these films were shot
simultaneously in 1966 but released in
'67 and '68 respectively. This was
probably a money saving ploy by *Daiei*.

Majin Strikes Again

But inadvertently the decision caused a
comfortable affinity within the series,
and although each project was helmed
by a different director, the audience
favorably responded to instant familiari-
ty. The success of the series lies square-
ly on the shoulders of the three young
filmmakers. Each of the talented direc-
tors went on to develop important chap-
ters in Japanese cinema. **Issei Mori**
reworked the traditional *Ghost of
Yotsuya* story into yet another screen
adaption in 1969 [**Yotsuya Kaidan:
Oiwa No Boreo**]. Director **Kimiyoshi
Yasuda** delivered his masterpiece,
Hundred Monsters in 1968. And **Kenji
Misumi** will always be remembered for
his amazing **Lone Wolf With Child**
series begun in 1972.

Yoshiyuki Kuroda's special effects are
surprisingly good, incorporating a mix-
ture of stop action and miniatures with
a "monster-suited" Majin used sparing-
ly. Due to his excellent work in these
films, **Kuroda** graduated to "director"
status for *Daiei Studios*, giving them
one of their biggest hits with **Big Ghost
War** in 1968.

MAJIN WITH ONE LEG
see **AKADO, Suzunosuke** series

MAN WHO
INHERITED A STAR (1990)
[Hoshi O Tsugumono]
director: **(Gaira) Kazuo Komizu**
Kunie Tanaka • **Jitsuko Yoshimura**
Yoriko Horaguchi • **Beat Takashi**
**½

Produced by **Beat Takashi** and direct-
ed by **Gaira** (pseudonym for **Kazuo
Komizu** who, during his *Entrails Of A
Virgin* days called himself "the
Japanese **Herschell Gordon Lewis**").

Businessman Kenji is close to retire-
ment when a heart-attack hospitalizes
him. While in a coma, his mind drifts
back to his childhood and memories of

Man Who Inherited A Star
with Beat Takeshi

youth camp.[1] It's not clear if this is bonafide recollection or if Kenji has shifted into a time slip, but he has transformed into a homesick child who wants to run away from the camp and see his parents. Six children plan their escape through the Nagano Mountains where they encounter many dangers, including a bout with starvation. Eventually they're rescued by a hunter (**Beat Takashi**) who teaches them how to survive in the wilderness. After learning their lessons well, the children set off for Tokyo again. The *dream* ends abruptly when Kenji comes out of his coma.

The movie stops on a heart-warming note as Kenji is discharged from the hospital and then spots the hunter smiling at him from across the street (is **Beat Takashi** supposed to be a guardian angel?). Despite a sugary-sweet message and all the *true-life adventure* trappings, this is a surprisingly well made film, probably **Gaira**'s best looking venture. It was also a surprise boxoffice hit, seemingly due to the nostalgic histrionics geared towards the many Japanese who spent time in the children camps.

[1]In the '40s, during WW2, urban children were separated from their parents and forced to live in country camps where they would be kept safe from the threat of inner city bomb attacks.

MAN WITH THE EMBOSSED TAPESTRY (1994)
[Edogawa Rampo Gekijo: Oshie To Tabisuru Otoko]
aka **EDOGAWA RAMPO THEATER: MAN WITH EMBOSSED TAPESTRY**
director: **Toru Kawashima**
Jun Hamamura • **Isako Washio**
****1/2**

"I met the old man on the train. He told me an incredible story about himself." This psychological horror film begins with those words, supposedly uttered by writer **Edogawa Rampo** {see **Rampo** review for background information}. The movie deals with an old guy who falls in love with a beautiful woman as he spies on her with a pair of binoculars from his highrise. He eventually discovers a way of "capturing her essence" by skinning the girl and entrapping her soul in a tapestry. The film was originally made in 1992 and purposely delayed by the distributor until it's 1994 release to coincide with Japan's commemoration of Rampo's 100th birthday. There is also a companion film, **Human Chair** (1997), based on a similar Rampo story {see separate listing}.

Isako Washio in
The Man With The Embossed Tapestry

MAN WITH THREE FINGERS
see **KINDAICHI series**

MANSTER (1959)
[Kyofu: Manster]
director: **Kenneth Crane** with
George Breakston & Akira Takahashi
Peter Dyneley • Jane Hylton
Satoshi Nakamura • Toyoko Takechi
** (or **½)

Perhaps the first Japanese/American co-production, obviously inspired by the success of the *Toho* monster films in the United States. **Kenneth Crane**, director of **Monster From Green Hell** (1957), went to Tokyo with his producer/writer **George Breakston** to make a film for *United Artists of Japan*.

Larry Stanford (**Peter Dyneley**) is a "brilliant but highly underpaid foreign correspondent for the Royal Newspaper Syndicate." He visits Dr Suzuki (**Satoshi Nakamura**) on a routine feature story, but is secretly drugged and injected with a mutation serum. Larry's personality changes in the next few weeks. He becomes an alcoholic, womanizing ruffian with a penchant for murder.

For the first 45 minutes, until an extra head pops out of Larry Stanford's shoulder, this film is terrific. "He will be a species that's never walked the earth before," the mad doctor Suzuki boasts. But, is there really a need for a two-headed monster in the world today?

The crew and most of the cast are Japanese, giving an overall *exotic* quality to this horror opus. **Hiroki Ogawa**'s ultra-hip Space Age Pop soundtrack is tremendous, reminiscent to his **Fear Of The Mummy** score. Co-director **Akira Takahashi** moved into acting and can be seen in a number of *Nikkatsu* pink films. The American theatrical print runs 78 minutes; a bloodier, more lurid version was released in Japan at 89 minutes.

The star of the film, **Peter Dyneley**, is a competent but unrecognized British actor who has done everything from

blaxplotation (**Soul Patrol** [1980]) to Shakespeare (**Romeo And Juliet** [1988]). **Jane Hylton** is best remembered for her bitchy role in **Circus Of Horrors** (1960). She ended her career with **The Manster**.

MANDALA[1] (1971)
[Mandara]
director: **Akio Jissoji**
Koji Shimizu • Akiko Mori
Ryo Tamura • Hiroko Sakurai
and **Shin Kishida**
**½

[1]Mandala is a word referring to the sacred tapestry which depicts the various levels of Buddhist Heaven.

Here's a familiar story of counterculture fanatics who dream the impossible dream but find nothing except annihilation at the end of the rainbow. It could have been inspired by any number of '60s *hippie* films (*i.e.*, **Psych-Out** [1968], **Scream Free** [1969], **Strawberry Statement** [1970], *et al*), but the film is decidedly *Japanese* in concept. **Akio Jissoji** is a filmmaker of extremes, responsible for such diverse projects as the **Ultraman** TV series (1971-1974) and the epic SciFi masterpiece **Capitol Story** (1988). But here, he creates a highly unusual horror tale nestled comfortably in a stark, yet surrealistic, landscape.

Two couples are sharing a room at a secluded love motel. Manager Maki (**Shin Kishida**, best known for his vampire roles in the **Toho** Bloodthirsty series) is a hopeless voyeur who spies on the young lovers. He also happens to be the leader of a semi-religious cult known as the Utopia Watchers (never try to separate a man and his fetish).

A member of his congregation becomes overly excited by the steamy action in Room 105. He attacks and rapes one of the promiscuous city girls as she takes a seaside stroll between orgies. The girl commits suicide. This

angers the remaining three and they concoct a plan against the cult. One of the boys rapes Maki's wife, the priestess of the clan. This causes the woman to lose all her magical power and she also kills herself. Maki surrenders. He and his followers board a boat, setting sail into the black ocean. Days later their bodies are washed ashore.

▶ MANIAC R (1995)
[Maniac R A:R]
director: Kazuyuki Yoshida
with Shigeaki Izumi
*

❖

▶ MANIAC:
 CAPTURED STARLET (1996)
[Maniac: Aidoru Yukai]
director: Kazuyuki Yoshida
Shigeaki Izumi • Yu Kawai
**

These two features are essentially the same movie. The first one is a grade Z production, interesting only as a curiosity item. A year later, director Yoshida remade the quirky sado-horror story under much better conditions. While the budget still couldn't pay for a typical Hollywood dinner party, it managed to finance this mean-spirited excursion into exploitation sleaze. A man begins dating a young pop singer, but she can't deal with his fits of jealousy. Eventually, the lovesick psycho kidnaps the girl and keeps her in a cage in his basement where he alternately rapes and flogs her.

Seemingly the film was inspired by *Noribumi Suzuki*'s Star Of Dave: Beauty Hunting (1979), but it fumbles all the psychological implications. On the plus side however, Shigeaki Izumi is quite convincing as the maniac (reminiscent of the late *Joe Spinell*). Yu Kawai does little besides scream and cry, but what more could one expect?

MARIA'S STOMACH (1990)
[Maria No Ibukuro]
director: Hideyuki Hirayama
Haruko Sagara • Akira Emoto
 and Han Bun-Jak as Maria

Here's a movie which takes itself very seriously, fully aware that the audience won't. The new-wave of Japanese filmmakers are masters at this sort of cinema (*i.e.*, such recent hits as Female Neo Ninjas [1991], Keko Mask [1993], Rapeman [1990], *et al* are prime examples). These films take a

Maria's Stomach

patently absurd premise and gingerly insert it into a conventional setting. They become the epitome of campy adult humor.

This time, a carnivorous monster lives on the tropical resort island of Sipang. This creature enjoys chomping on a steady diet of cute Japanese girls who go there for party weekends. Upon developing this premise, the story follows a group of office ladies who band together to fight the monster after a co-worker is devoured. Akiko (**Haruko Sagara**, best known as one of the original *Sukeban Deka* side-girls) leads these diva-sleuths to the island where she discovers the bloody secret after coincidently running into Ejima (**Akira Emoto**). Ejima used to be Akiko's business associate, but he and his girlfriend, Maria, had been killed in accident during a vacation in Sipang. Apparently, they aren't dead after all. Maria is now an obese, ravenous monster; and Ejima is the one who captures the girls for her supper. Akiko decides to free their tortured spirits with an exorcism. After some harrowing chills, the rite is successful; Ejima and Maria are released to heaven. Or wherever.

The setting, especially the ancient ruins in Sipang, is quite effective for the grotesque adventure tale. And FX for Monster Maria are surprising good. Director **Hirayama** went on to make the acclaimed **Elementary School Ghost Story** in 1995.

MATANGO
 see **ATTACK OF
 THE MUSHROOM PEOPLE**

MEDAL FROM THE DEVIL (1967)
 [Akuma Karano Kunsho]
director: Mitsuo Murayama
Jiro Tamiya • Kyoko Enami
Eiko Azusa • Yuko Hamada
**

A less than successful blend of mystery and science fiction, as Private Detective Goro Akune (**Jiro Tamiya**) is hired to find the bad guys who stole a secret formula for rocket fuel. Reminiscent of *Alistair MacLean*'s **Satan Bug** (produced as a movie in 1965, directed by **John Sturges**) but officially based on a novel by **Shinji Fujihara**.

Actor **Jiro Tamiya** starred in many Yakuza films (*i.e.*, **Bad Reputation** series, *et al*) after winning the *Mr Japan* award in 1960. The handsome actor was the victim of a suicide in 1980.

**MEMORY OF THE FUTURE:
 THE LAST CHRISTMAS** (1992)
 [Mirai No Omoide: Last Christmas]
director: Yoshimitsu Morita
Shizuka Kudo • Misa Shimizu
Motoya Izumi • David Ito
**

Based on a multi-volume manga by *Fujiko Fujio* (pseudonym for a comic-book team of Fujiko Sawa and Fujio Yasuda), dealing with complex issues of reincarnation and dimension of time (remarkably close to *Harold Ramis'* **Groundhog Day** [1993] with **Bill Murray**).

On Christmas Eve 1992, unsuccessful manga writer Yuko (**Shizuka Kudo**) and fake psychic Ginko (**Misa Shimizu**), are swallowed up in a time

Memory Of The Future: Last Christmas

slip. They emerge ten years earlier. Now it's 1982, and both girls have complete knowledge of the future. At least, of the next ten years. Yuko takes advantage of the situation by *stealing* a story which would be written by a rival author in 1985; she calls it her own and publishes it in 1982. Ginko can be a real psychic now, *predicting* world events. But quickly she finds herself taking the low road, *i.e.*, betting on horseraces and sporting events for which she already knows the outcome. And then, when Ginko sees Yuko's bestselling manga, she even resorts to blackmailing the phony author.

Ten years passes, and both girls die on Christmas Eve '92. But once again they awaken in 1982. This time, they decide to be friends and improve on the mistakes they made the previous go-around. However Yuko and Ginko live with a constant nagging fear, knowing that *the end* looms on the horizon, Christmas Eve 1992. Will they die for real this time or are they destined to repeat the same ten years forever? Even in the flexible world of SciFi, this is a chaotic concept.

Filmmaker **Morita** is a major TV sit-com director (similar to USA's *Gary Marshall*). This project marks his first attempt at science fiction. 18 Year Old actor **Motoya** is slumming in this picture. He's better known for his work on the Kyogen stage (consisting traditional Japanese folk music and plays). His talent is wasted here in a throwaway role as he plays Ginko's main squeeze.

MERMAID IN A MANHOLE
 see **GUINEA PIG** series

MERMAID LEGEND (1984)
 [Ningyo Densetsu]
director: Toshiharu Ikeda
Mari Shirato • Kentaro Shimizu

Mermaid Legend

Based on a *gekiga* (adult-oriented manga) penned by **Angel Guts** creator **Takashi Ishii**, this is director **Ikeda**'s first movie after leaving **Nikkatsu**. It's a unique variation of the standard vengeance theme, sort of a classy (albeit very bloody) version of **I Spit On Your Grave** (1981).

A fisherman, opposed to the construction of a nuclear power plant, is murdered by a gang of right-wing extremists who are puppets of the corrupt contractor. The dead man's devoted wife concocts a plan of revenge against everybody involved. She slaughters the men in the goriest, the most grisly ways imaginable, thus removing any suspicion from her. In fact, the newspapers soon begin reporting stories of "a blood-fiend from the lake" and "a ghost mermaid."

Mari Shirato is excellent, playing a wide range of emotions. Shirato drifts effortlessly from cautious circumspection to wild abandonment, as she delivers an amazing performance. And fortunately, she also has no qualms about shedding her clothes. One of the best parts of the movie finds her totally nude, having sex with a smarmy yakuza guy. In the blink of an eye, her mood switches and suddenly she's butchering the poor sap. Blood splashes every-

Kinji Fukasaku's *Message From Space*

where, until she's covered in the crimson stuff. This gory scene is symbolically reconstructed at the end as Ms **Shirato** lies naked on the beach with waves splashing and cleansing her weary body. Here is a remarkable good-looking picture from one of Japan's best cult directors, **Toshiharu Ikeda**, who would later make the horror masterpiece **Evil Dead Trap** (1988) and its second sequel **Broken Love Killer** (1993), not to mention the best of the **XX** series, **Beautiful Prey** (1995) and **Beautiful Beast** (1996).

MESSAGE FROM SPACE (1978)
[Uchu Kara No Messeji]
director: Kinji Fukasaku
Vic Morrow • Shinichi (Sonny) Chiba
Tetsuro Tanba • Peggy Lee Brennan
Philip Casnoff • Etsuko (Sue) Shiomi

This story of a planet about to be destroyed by a villainous empire borrows heavily from *George Lucas'* **Star Wars** (1978). But it also gives more than a passing a nod to Chinese legend **Suikoden** and **Seven Samurai** (1954), as the captive planet hires outlaw mercenaries to fight the bully war mongers.

Consistently successful **Kinji Fukasaku** (he previously made such feature films as **Black Lizard** [1968] and **Fight Without Honor** [1973]) was given the largest movie budget in Japan's cinematic history for this film, $5 million dollars (a hefty sum but pale when compared to Hollywood budgets). The success of the movie secured his position in Japanese Cinema and cleared the way for his next, even more expensive, production **Virus** (1980).

Vic Morrow is best remembered as Sgt Chip Sauders in American TV's *Combat* (1962-67). This film is the debut for **Philip Casnoff** who has since starred in numerous TV movies (from **Hamptons** [1984] to **Sinatra** [1992]).

MIKADROID
see **ROBOKILL BENEATH
DISCO CLUB LAYLA**

MILITARY COP AND THE
DISMEMBERED BEAUTY (1957)
[Kenpei To Barabara Shibijin]
director: Kyotaro Namiki
Shoji Nakayama • Shigeru Amachi
Fujie Satsuki • Hiroshi Ayukawa
**½

When **Mitsugu Ookura** ran *Shintoho Studios* nothing was sacred. If bucks could be made with a less-than-flattering expose of the Japanese Emperor, then the project would go into production immediately (in fact, he did finance such a film in 1957 called **Emperor Meiji And The Russian War** [Meiji Tenno To Nichiro Senso] despite threats and warnings from the government and the conservative community).

But CEO **Ookura**'s unrefuted fascination was for sadistic sex-n-horror movies. He referred to them as his *Erotic Grotesque* features. And soon everyone had coined the phrase *Ero-Gro*. Most critics dismissed this new genre as "crude and indulgent," but the public responded with big dollars at the box office. And so, Ookura led his studio down the iniquitous path to enormous profits. He could be called the *"Larry Flint* of Japan," but that would probably be too kind.

Military Cop & The Dismembered Beauty

In this film, soldiers from Sendai Station are dispatched to the Chinese Front. Local Japanese officials enter the abandoned base and begin cleaning things up. To their shock, a limbless headless body of a pregnant woman is found stuffed in the water well. This begins a massive investigation, as a military detective tries to follow the sparse clues. Eventually, the truth is revealed when some soldiers admit to operating a secret S&M club inside the barracks.

MILITARY COP
AND THE GHOST (1958)
[Kenpei To Yurei]
director: Nobuo Nakagawa
Shigeru Amachi • Shoji Nakayama
Naoko Kubo • Yoko Mihara
*

A follow-up to the surprise hit, **Military Cop And The Dismembered Beauty** (1957) {see separate listing}, it features the same players. However, this time, the Military Cop hero (**Shigeru Amachi**) is the bad guy.

He's been promoted to lieutenant after solving the "dismembered beauty case." But his new position has corrupted him. When he becomes jealous of a co-worker's girlfriend, this MP frames the poor bastard and accuses him of being a spy. Despite cries of innocence, the hapless victim is executed for his alleged disloyalty. Then a replacement shows up, but he looks exactly like the dead man. Is this a ghost? or what? The bad cop freaks out (occasionally relieving his tensions by torturing and whipping the co-worker's girlfriend) before he discovers the new arrival is really the dead man's brother.

Lots of cruelty and mean-spirited brutality in this *make-it-up-as-you-go* plot. But no matter, this is a remarkably botched up sequel. It's the very definition of a "missed opportunity" for everyone involved.

Miraculous Baby

MIRACULOUS BABY (1988)
[Fushigina Baby]
director: Masayoshi Nemoto
Kazumi Moroboshi • Hiroyuki Sato
Jun Yamamoto • Akira Akasaka
*

What could possibly be worse than a **Jun Fukuda** film? Well, how about a movie directed by his underling, assistant director **Nemoto**? Apparently, apprentice **Masayoshi** has learned his distorted craft well; this film proves he's as terrible as his teacher.

Regarding the story: members of the Japanese singing group, *Hikaru Genji*, become instant fathers when they stumbled upon an abandoned baby. They soon discover the infant possesses supernatural powers, and the kid bestows a lucky-streak on the boys. However, there's a gang of bad guys who try to snatch the baby from the *Genji Group*.

After this film, director **Nemoto** mercifully gave up the big screen and settled for Japanese TV. His sitcoms are better suited for his dubious talents.

MIRACULOUS STORIES:
 FANTASTIC COLLECTION (1988)
 [Fukashigi Monogatari:
 Fantastic Collection]
director: Akiyoshi Imazeki • Kaoru Ito
 Shinichiro Nakata • Naoto Yamakawa
**½

An omnibus collection, featuring eight "stories of the occult" directed by four different experimental filmmakers. Most of the entries feature attractive— but talentless — young singers or *actress wannabes*. Their presence seems to detract from the overly heaviness of the project. Here are the entries:

 Watermelon (starring *Yumi Morio*) and **TV** (with *Saori Tsuchiya*) directed by *Akiyoshi Imazeki*;

 The Catalog of Life And Death In Urban Society (starring *Yoshihiro Shibata*) and **Family** (with *Eisaku Shindo*) by *Shinichiro Nakata*;

 Sweet But Stupid (starring *Akiyo Shiina*) and **Vanished In The Waves** (*Akiko Hayakawa*) directed by *Kaoru Ito*;

 One Step Beyond (starring *Kouji Yamaguchi*) and **The Cat Comes Back At Dawn** (*Shigeru Muroi*) directed by *Naoto Yamakawa*.[1]

[1] Director **Naoto Yamakawa** is a protegee of **Toshihiro (Sogo) Ishii** (Yamakawa's short films were also included in *Ishii's* **J-Movie Wars** [1992]

Miraculous Stories

MIRAGE THEATER (1981)
[Kagero-za]
director: Seijun Suzuki
Yusaku Matsuda • Michiyo Ohkusu
Mariko Kaga • Yoshio Harada

Another tremendous hit by **Seijun Suzuki**, a follow-up to his award winning **Zigeunerweisen** (1981). It also features an all-star cast, headed by **Yusaku Matsuda** who reportedly took the role at a fraction of his usual fee

Seijun Suzuki's Mirage Theater

because he wanted the opportunity of working with "Japan's greatest living director."

After a writer falls in love with a mysterious woman, he looses touch with reality. Instead he becomes obsessed with her dream-like existence and wants nothing more than a life of carnality and excessive passion.

For this film, **Suzuki** developed a variation on his already peculiar cinematic style by adding elements of *Taisho Romanesque*, a modern adaption within a turn-of-the-century style. The acting is slightly exaggerated in the tradition of the *Kabuki* theater (in fact, **Suzuki** describes this venture as "Film Kabuki"). But perhaps the most remarkable aspect of the film is the eroticism. The sex scenes are as poignant as they are plentiful. *Mirage Theater* will always be remembered for the symbolic lovemaking scene where the lovers reach orgasm while gyrating back-to-back.

MISS SPY (1997)
(Mesupai[1])

> [1]*Mesupai* is a double entendre; *Mesu* is Japanese for "female animal" while *pai* is "breasts." The two words together sounds like the English words "Miss Spy."

director: Minoru Kawasaki
Mio Saegusa ● Atsuko Sakuraba

**

High school student Yumiko (**Mio Saegusa**) becomes a guinea pig for a mad scientist. He feeds her a serum which rearranges her molecular structure. Now her breasts grow to gargantuan size whenever she gets excited or agitated. Besides the inconvenience (poor Yumiko rips a lot of blouses), she learns to live with the abnormality. In fact, sometimes, instant *big hooters* can be a major asset. For instance, Yumiko is very successful as an athlete. She's #1 on the school track team, often winning by a nose — er, rather, by a tit. Yumiko later becomes a singing star. (Everybody knows *big lungs* are a definite plus in that profession!) Finally

Miss Spy

Yumiko becomes a spy pitted against a team of wicked females from the dark-world who are trying to control the entertainment business.

Some tasteless humor, but most of it is like reading the cartoons in *Playboy*. Director **Kawasaki**'s script is fresh; his funny stuff is very hip. But he has the same problem as many other under-financed filmmakers. His special FX — certainly the backbone of a *transformation* movie — are cheap and ineffective.

MISSING HEART (1992)
[Shizonuki]
director: Gen Takahashi
Takeshi Ito • Nao Suzuki
 and **Akito Fujii**
*½

Newspaper reporter Kenji (**Takeshi Ito**) is walking down the street when he sees a man keel over and die right in front of him. When Kenji moves in for a closer view, he's shocked to see that the dead man looks like a friend's fiance. The journalist becomes even more curious when he discovers that the

victim is not the person he thought it was. The fiance, as it turns out, is alive and well. Kenji starts researching the dead man. But every step of the way, information is being suppressed. It seems someone is trying sabotage the investigation.

The deeper Kenji digs, the more out-landish everything becomes. Soon the reporter realizes he's pried the lid off a top secret operation. The "dead man" is actually a cyborg, created by a mysterious organization.

Same old, same old. There's nothing here that hasn't already been done better in **Twilight Zone** or **Ultra Q**. This film was originally produced as a 16 mm experimental short, later expanded to feature length by director **Takahashi** when a distributor took an interest. Everyone should have left well enough alone.

Missing Heart

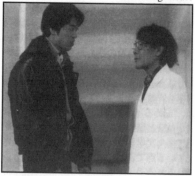

MISTY (1991)
[Misty]
director: Toshiharu Ikeda
Toshiyuki Nagashima • Miho Tsumiki
**½

Director **Toshiharu Ikeda**'s follow-up to **Evil Dead Trap** (1988) is a hard-boiled mystery inspired by *Clint Eastwood*'s **Play Misty For Me** (1971). The film, constructed in a similar pattern, even uses *Erroll Garner*'s original jazz recording of **Misty** for the main

Toshiharu Ikeda's *Misty*

title theme. Of course, as always, **Ikeda**'s incredible camerawork is the film's biggest treat. He's consistently the most dependable genre director in the business.

Fujikawa (**Toshiyuki Nagashima**) is a yakuza gangster who returns to his hometown after learning of his sister's death. According to the police, she committed suicide. But he doesn't believe it for a second. In his own insolent fashion, Fujikawa conducts an unsanctioned and quite unorthodox investigation. However, friends and witnesses also start turning up dead. And the ending? —well, anyone who saw the *Eastwood* thriller already has the answer.

MITSUKUBI TOWER
see **KINDAICHI** series

MONSTER CITY
see **BEAST CITY**

**MONSTER FROM
 A PREHISTORIC PLANET** (1967)
[Daikyoju Gappa]
translation: **Dinosaur Gappa**
director: **Haruyasu Noguchi**
Tamio Kawaji • Yoko Yamamoto
Yuji Okada • Koji Wada

Less than memorable monster fluff from **Nikkatsu** Studios, a company who later become known for its unique line of S&M adult films (*i.e.*, Pink Movies) and violent Yakuza pics. This rubber monster opus was their only *kaiju eiga* entry.

The story, obviously inspired by the British **Gorgo** (1961), deals with two dinosaur parents who rescue their off-spring from a Tokyo freak show. It was originally conceived as a parody, but by the time this feature hit the theaters the genre had become a parody unto itself. Afterall, it's difficult to satirize a genre that already spawned a flying turtle who protects children from bad monsters [**Gamara** 1966) or a football scrim-mage between Godzilla and a giant shrimp (**Godzilla Vs Sea Monster** 1966).

**MONSTER HEAVEN:
 GHOST HERO** (1990)
[Youkai Tengoku: Ghost Hero]
director: **Makoto Tezuka**
Masao Kusakari • Masato Ibu
Sara Asahi • Kaori Mizushima

Monster Heaven: Ghost Hero

On the moon, a Russian cosmonaut finds an ancient samurai sword buried in the lunar landscape. When he looks into the blade's hypnotic glare he sees the image of a woman (**Sara Asahi**).

She is known as "the fable queen" because she's the best fantasy storyteller in the empire. But the lord is threatened by the woman's popularity and he decides to kill her. She delays her death by— of course— telling him stories. In her first tale (as the movie becomes a story within a story) a man slices up his cheating wife and her lover. He's haunted by their ghosts, but it's actually his abused monster bird that finishes him off.

The lord is not particularly amused fable. Just as he's about to stab the storyteller, she begins spinning another, more complicated tale. In it, an old blind man rescues a deformed creature from some bullying kids. At the same time, his daughter is being raped and killed by two samurai ruffians. To spare the blind man's feelings, the mutant assumes the role of his daughter, imitating her voice and doing the household chores. The blind man never realizes that his daughter is dead. The creature eventually finds the evil samurai and kills them by performing a *funny* soft-shoe dance routine (not unlike a demented *Ronald McDonald*) which makes them laugh until they croak.

This story amuses the lord, but he's determined to kill her anyway. He cuts off her head. But then a monster army invades his house and gets revenge. The cosmonaut shakes out of his hypnotic trance and accidentally (but fatally) stabs his partner with the sword. When he returns to the rocket, it's filled with monsters anxious to meet him.

No. It's not a particularly cohesive storyline. However, gorehounds will be happy; the excessive effects are rather shocking.

MONSTER SNOWMAN
see **HALF-HUMAN**

MONSTER ZERO (1965)
[Kaiju Daisenso]
translation: **Giant Monster War**
director: **Ishiro Honda**
Nick Adams • **Akira Takarada**
Akira Kubo • **Keiko Sawai**
*½

Nick Adams stumbles through his role like a zombie {perhaps, one of the best arguments against drugs abuse, as he died from an overdose two years later}. His wretched performance forced American producer **Henry Saperstein** to reshoot many of his scenes stateside before ***American International*** would release the film.

The story is almost as awful as **Adam**'s performance. An alien planet is under attack from a three headed flying dragon named Ghidrah (*Ghidorah*, in Japanese) and they request aid from Earth. Specifically, they want the Earth to send their two best monster fighters, Godzilla and Rodan, to their planet. The Earth agrees and the monsters are escorted to Planet X. But wait! It turns out the aliens are really bad guys who want to use all three monsters in a massive counterattack against the Earthlings. Hardly a surprise, eh?

Godzilla & Ghidrah in *Monster Zero*

All the action (*i.e.*, wrestling monsters) takes place on Planet X. **Nick Adams** is a starfleet commander who subdues the giant monsters with supersonic sound and escorts them back to Earth. They return in time for a sequel, **Ghidrah the Three Headed Monster** (also 1965).

MONSTER IN THE MOONLIGHT
see **AKADO, Suzunosuke** series

MONSTER ON CAMPUS
see **SEX BEAST ON CAMPUS**

▶ **MOONBEAM MASK** (1958)
[Gekko Kamen]
aka **Moon Mask Rider**
director: Tsuneo Kobayashi
Fumitake Omura • Junya Usami
Hiroko Mine • Mitsue Komiya
**

Skullfaced creatures try to gain control of a powerful nuclear weapon but they are brought to their knees by *Moonbeam Mask* (**Fumitake Omura**), a superhero who zooms to the rescue on his solar powered motorcycle.

This is actually a feature-length version comprised from episodes of a popular serial, *Gekko Kamen* [Moonbeam Man] (1957/58). It spawned five sequels of similar mix-n-match patchwork. A new, updated version of *Gekko Kamen* was released in 1981 with **Daisuke Kuwahara** in the lead role {see separate review}. In 1991, famed manga author **Go Nagai** created a parody called *Kekko Kamen* (*Keko Mask*) which featured a nude female freedom fighter {see separate listing}.

Other films in the **Moonbeam Mask** series:

▶ **MOONBEAM MASK (Pt 2)** (1958)
[Gekko Kamen: Dai Ni-bu]
director: Tsuneo Kobaysashi
all episodes star **Fumitake Omura**
**

ad mat for *Moonbeam Mask (Gekko Kamen)*

#1's story continues, the skull masks persist in their attempt to steal the bomb. They kidnap the inventor, Dr Nakayama, and take him to his secret cave where he keeps the paperwork on his experiments. Moonbeam Mask foils the kidnaping and saves the day

❖

▶ **MOONBEAM MASK:**
 SATAN NAILS (1958)
[Gekko Kamen Satan No Tsume]
director: Eijiro Wakamatsu
**

The action switches to Southeast Asia, to a country called Paradai. The King is assassinated by arch villain Satan Nails. A map showing the locale of the country's gold reserve is stolen at the same time. Moonbeam Mask takes on the supreme bad guy and recovers the gold.

❖

▶ **MOONBEAM MASK:**
 MONSTER KONG (1959)
[Gekko Kamen Kaiju Kong]
director: Satoru Ainoda
**½

An International Assassin Gang helps eight convicts escape from Death Row. These prisoners are then programmed to kill important Japanese leaders. This gang also uses monster monkey Kong to attack top level government officers, until Moonbeam Mask spoils their fun.

❖

▶ MOON MASK RIDER:
 GHOST GANG'S
 COUNTER ATTACK (1959)
 [Yurei-to No Gyakushu]
 director: Shoichi Shimazu
 *½

Ooka, a famous scientist who understands the secrets of the mind, is attacked by the Ghost Gang. His daughter, Haruko, is kidnapped. Moon Mask Rider shows up and eliminates all the bad guys.

❖

▶ MOON MASK RIDER:
 LAST OF THE DEVIL (1959)
 [Gekko Kamen Akuma No Saigo]
 director: Shoichi Shimazu
 **

A serial killer, known in the media as the *White-Haired Devil*, is finally identified as a top ranking WW2 military officer, Doctor Shirakami. He was supposed to have died during the war but he's alive. And pissed off. Dr Shirakami is avenging himself and "cleansing his country" by eliminating the soldiers who abandoned him on an uninhabited island during the Second World War.

MOONBEAM MASK (1981)
 [Gekko Kamen]
 director: Yukihiro Sawada
 Daisuke Kuwahara • Etsuko (Sue) Shiomi
 **

An updated version of the adventures of Japan's premier superhero, **Moonbeam Mask** (Gekko Kamen). This time, with the aid of a feisty sidekick (played by action diva **Etsuko "Sue" Shiomi** of *Sister Streetfighter* fame), he fights the Red Mask Group. This ultra-liberal gang is involved in a project to turn a downtown building into a "love paradise," sort of a sexual theme park. The Red Mask Group raises money to finance their dream project by robbing Brinks trucks all over Japan.

the original *Mothra* (1961)

the new Queen *Mothra* (1996)

Lots of hi-tech action. Farfetched story tries too hard to be hip.

MOTHRA [original version] (1961)
 [Mosura]
director: Ishiro Honda
Frankie Sakai • Hiroshi Koizumi
Kyoko Kagawa • Ito Sisters

Mothra, to this date, remains the only female monster in the *kaiju eiga* genre. Significantly, she was also the first of the *good* creatures. And although she manages to destroy most of Japan, Mothra's destructive behavior is sparked by righteous paternal rage, coupled with the clumsiness of her awkward size. Unlike her predecessors, she does not kill for fun (*e.g.*, Rodan) nor for domination (*e.g.*, Godzilla). Instead, Mothra is only interested in rescuing her kidnapped guardians, two miniature fairies known as the *Peanuts* {Ito Sisters, real-life pop singer twins; later they were called *Pair Bambi* in Godzilla vs Sea Monster [1966] and *The Cosmos* in Godzilla vs Queen Mothra [1992]} Her path of destruction, while quite intensive, is not a personal vendetta against mankind. Mankind just happens to be in the way.

Mothra was the fourth original Toho creature (not counting Mogella from the Mysterians [1957], the liquid-blob in H-Man [1958] nor the invisible man in Human Vapor [1960]). She returned in 1964 (Godzilla vs The Thing), in 1965 (Ghidrah the Three Headed Monster), again in 1966 (Godzilla vs The Sea Monster), two years later in Destroy All Monsters (1968), and is a constant co-star in the Godzilla '90s series, including Godzilla Vs Queen Mothra (1992) and Godzilla Vs Space Godzilla (1994). After Godzilla was sold to *Tristar/Sony* in the States, Mothra became *Toho*'s primary player in the less-than-memorable new Mothra (1997).

Mothra is one of two *kaiju eiga* creatures **not** played by a man in a rubber suit. The other, of course, is Rodan.

MOTHRA (1996)
 [Mosura]
 aka QUEEN MOTHRA
director: Okihiro Yoneda
Megumi Kobayashi • Kazuki Futami
Sayaka Yamaguchi • Maya Fujisawa
**

After *Toho* sold the Godzilla rights to America's *Tristar* in 1996, they

developed a new *Giant Monster* series, elevating Mothra from a supporting role to starring position. Yet, with the trade-off, there's virtually no horror left in this *kaiju eiga*. Rather, the new **Mothra** is "a human interest creature," as observed by critic *Satoshi Yamashita*, "Mothra represents the typical family as she takes care of her baby, nurturing it and protecting it, only to have the baby grow into an adult and take care of her." Unlike the previous **Godzilla** movies, this is a family film – Rated G, intentionally designed for *Eppan* (general) audiences, complete with children in the main "human" roles.

A strange metal shield is unearthed at a Hokkaido construction site. Not only is this a nifty artifact, but it also harbors the secret to controlling the destructive power of a space monster called Death Ghidorah (apparently a distant relative of King Ghidorah). Two children, Taiki and his sister Wakaba (**Kazuki Futami** and **Maya Fujisawa**), had been guarding this shield, but the adults pay no attention to the concerned pleas of doom from the youngsters. Two miniature fairies,[1] Mora (**Megumi Kobayashi**) and Rora (**Sayaka Yamaguchi**), are also aware of the seriousness of the situation and try to protect the shield. In the meantime, there's a bad Nymph named Berubera (**Maki Hano**) who steals it. Berubera has Death Ghidorah under her spell and she needs the shield to fully control him, which of course could lead to a very bad scenerio for planet Earth. So, the good Nymphs call their protector, Queen Mothra, for help. This leads to the first major battle of the film. In it Mothra is hopelessly outmaneuvered by the three-headed dragon. She is no match for Death Ghidorah. When times get tough, Mothra lays an egg and the larva helps her fight the mighty foe. Eventually Mother Mothra realizes it's

an exercise in futility; she can't possibly win the battle. She grabs her caterpillar and they fly to Yakushima Island where the young one grows into a powerful *upgraded* Mothra. The new creature enters into battle with Death Ghidorah and, of course, wins.

Like the previous Godzilla movies, this film has it's share of unintentionally funny lines. "A worm is a worm – no matter how big it is" could be one of the goofiest. It also suffers from a steady patter of environmentalist jargon, the kind of trite diatribe that ruined **Godzilla vs Space Godzilla**.

The Nymphs are given more to do this time around. Instead of being acquiescent twins with limited characteristics, they have distinctive– even conflicting– personalities. Easily, their bickering is the most fun in the movie.

[1]For this version, the fairies are called The *Nymphs*; previously they were known as The *Peanuts* {in the original 1961 *Mothra*}. Later they were called *Pair Bambi* {in **Godzilla vs The Sea Monster**} and The *Cosmos* {**Godzilla vs Queen Mothra**}.

MR MOONLIGHT
see **FULL MOON**

MURDER FOR PLEASURE: FEMALE DETECTIVE (1996)
[Kairakusatsujin: Onna Sousakan]
aka **MURDER IS THRILLING**
director: Masaru Konuma
Itsumi Ohsawa ● Masataka Hirose

Masaru Konuma may not be a familiar name to horror enthusiasts, but he's a long-established *Nikkatsu* pink director, responsible for many of that company's best known movies (*e.g.*, **Afternoon Affair** [1973], **Wife To Be Sacrificed** [1974], **Flower And Snake** [1975], *et al*). In the 1980s, he became involved with interchangeable S&M projects, all flaunting titles like **Slave Contract** (1982) and **Rope And Breasts** (1983), until he finally quit and

took a position with Nihon Television. There, under stricter *acceptability* guidelines, **Konuma** toned his craft and flourished as an action director.

With **Murder For Pleasure: Female Detective** he returns to the big screen, delivering a misogynist mean-spirited story within the standard cop story framework. A female detective (**Itsumi Ohsawa**) is on the trail of a psycho serial killer. This mysterious sadist, with a twisted Oedipus complex, stabs his female victims, then cuts off the nipples and scrapes out their vagina. Despite the repellent plot-points, this movie marks a return to form for **Konuma**. The camerawork and lighting is reminiscent of his stylish productions from the mid '70s, harrowing and claustrophobic. He hasn't lost his ability to create tension. Hopefully, this will be the first sojourn on a comeback trail.

MY SISTER AND
FRIED TOFU[1] (1990)
[Imouto To Aburaage]
director: Daisuke Tengan
Toshikazu Imamura ● Atsuko Ogawa
**

An incest horror yarn. In the countryside, young man (**Toshikazu Imamura**) and his sister (**Atsuko Ogawa**) become sexually involved after the death of their parents. The majority of the film deals with their illicit relationship — including some torrid love scenes — but then, seemingly from left field, the whole thing shifts gears and it becomes a possession flick. The brother detects that his sister has fallen under the spell of Izuna, a fox ghost. The boy learns to accept the beast-spirit as part of their relationship.

Upon its release, the film was strongly criticized by the Japanese press for "not having the conviction of its own plot" and "being a forbidden sex movie hiding behind a horror facade."

Director **Tengan**'s logic is certainly at stake here. It's difficult to justify the film's absurd detour into the supernatural.

[1]Regarding the movie's *ambiguous* title, it's a Japanese word game. When tofu is fried it takes on a reddish hue similar to the coat of a fox. Because of this, the popular slang word for the dish is "fox."

MY SONG IS YOUR SONG
see **ANGEL**

MY SOUL IS SLASHED (1991)
[Kamitsukitai]
translation: **He Likes To Bite**
director: Shusuke Kaneko
Ken Ogata ● Narumi Yasuda
Hikari Ishida ● Hideyo Amamoto
***½

Dad works at a pharmaceutical company. He becomes suspicious of certain improprieties and so his superiors arrange for him to meet the bumper of an automobile. Meanwhile, the blood of

My Soul Is Slashed
with Ken Ogata & Narumi Yasuda

Dracula has been smuggled out of Transylvania and is being stored at the Tokyo hospital. Inadvertently, when dad is rushed to the clinic... yep, he gets the vampire's blood in a transfusion. The attempt to save his life fails.

A woman scientist (and vampire groupie) tracks down the grieving daughter and informs her that if she is a virgin, a few drops of her blood on dad's ashes will revive him. Luckily for everyone involved, she is a virgin and she can follow directions. The father returns, totally unaware that he's been dead for an entire year. At first, dad rebels against his new "state of being" and acts bewildered. However, as the movie progresses, his vampire nature takes hold and soon it's vengeance time with the villains running for cover.

This film, written by **Takeshi Kawamura** (director of **Last Frankenstein** [1992]), offers new twists on the exhausted genre. Here, being a monster is a positive experience. When he was human, Ken was terrible at being a dad. But as a vampire, he becomes an affectionate father. It's not monsters who are evil, but rather, the monsters' creator: man. It's the conniving corporate executives, gun-happy mobsters, negligent parents who set the stage for the tragedies. The real monsters are the people out-of-sync with their own emotions; they act with the utmost cruelty to one another. The vampire says: "I am a saint by comparison to those around me."

It's an exceptional movie from director **Kaneko**, who started in *pinku eiga* (**Shoot And Wet** [1984]) and made **Gamera, Guardian Of The Universe** in 1995. His camerawork is terrific, an exhilarating combination of the traditional Japanese eye for detail mixed with the more kinetic Western style. The performances are also especially good, with special kudos to **Ken Ogata**

for his multi-dimensional portrayal. Lastly, the music is a major treat, reminiscent of the best **Hammer** Film scores, plus the title theme, sung by French diva **Mylene Farmer**, adds a contemporary luster to the film.

MYSTERIANS (1957)
[Chikyu Boeigun]
translation: **Earth Security Force**
director: **Ishiro Honda**
Kenji Sahara • **Yumi Shirakawa**
Takashi Shimura • **Akihiko Hirata**
**½

Here's a SciFi movie best remembered for the giant bird-like robot [called *Mogella*] which destroys everything in sight during the movie's first 20 minutes. The creature is a terminator controlled by the Mysterians, aliens who arrived in a flying saucer from the depths of space. The real reason these extraterrestrials have come to earth is to breed with the women and repopulate their own dying planet. The Mysterians have chosen Japan as *party headquarters*, because (we are told) the Japanese represent the best qualities of humanity.

Mogella from *The Mysterians*

Although the plot isn't particularly original, the concept of aliens using monsters as instruments of domination was quite unique. After this film, the idea has been used and re-used in many Japanese rubber-monster pics, including the cult fave **Destroy All Monsters** (1968), **Monster Zero** (1965) and **Space Monster Gamera** (1980).

Mysterious Love Of Lady White

MYSTERIOUS LOVE OF LADY WHITE (1956)
[Byaku Fujin No Youren]
director: Shiro Toyoda
Ryo Ikebe • Toshiko Yamaguchi
**

This is the first color SFX movie from *Toho Studios*. It's based on an obscure Chinese legend *White Snake*, initially "modernized" for the Japanese market by *Bakin Takizawa* during the Edo Period (19th century).[1] In this one, a young warrior (**Ryo Ikebe**) lives by Saiko Lake where he meets a beautiful maiden (**Toshiko Yamaguchi**) and falls in love with her. However, this deceptive virgin is really a white snake.

The film is obviously dated and the special effects are functional, at best. But, from an historical perspective, it's an important fantasy production from a director who became one of Japan's best (see **Hell Screen** [1969] and **Ghost Story Of Yotsuya** [1965]).

[1]Bakin Takizawa also popularized the Chinese tale **Suiko-den**, which was brought to the screen as **Legend Of The Eight Samurai**.

MYSTERIOUS SATELLITE
see **COSMIC MAN APPEARS IN TOKYO**

MYSTERY OF RAMPO
see **RAMPO**

NAKED BLOOD
see **SPLATTER**

NARCISSUS OF LUST (1967)
[Joyoku No Kurozuisen]
director: Koji Wakamatsu
Mari Mukai • Masayoshi Nogami
 and **Hideo Saeki**
**

This is one of eight movies directed by **Koji Wakamatsu** in 1967. Four of them are quasi-horror films {**Violated Angeles**, **Dark Story Of Rape**, and **Sex Crimes**; see separate listings}, the rest are more typical of his fascination with the sado sex genre.

Wakamatsu started making films in 1963 for *Nikkatsu Studios*,[2] specializing in quickie exploitation pics dumped into the theaters to capitalize on the popular headlines of the day. After the success of *Tetsuji Takechi*'s erotic **Daydream** for *Shochiku Studios* in 1964, Wakamatsu's films noticeably took on an adult flare with more nudity and sexual content. When the studio refused to support him in a confrontation with the government censors over **Skeleton In The Closet** (1965), Wakamatsu quit *Nikkatsu* and formed his own production/distribution company. He found immediate success four months later with a vicious S&M film, **When Embryo Goes Poaching**. Most of his movies, *Pinku Eiga* or *Ero-Gro*, don't stray far from that formula.

This one is a triangle-sex tale camouflaged as a thriller. Yamgami, the president of a big Utility Company, tries to secure a divorce from his wife by arranging an affair between her and his

assistant. Then everything takes a very ugly twist. **Hideo Saeki** is the powerful executive, while **Mari Mukai** plays the wife and **Masayoshi Nogami** steams things up as Nakajima.

[2] *Nikkatsu* of the '60s, under the iron-fist rule of CEO **Kyusaku Hori**, was a much more conservative production company than the free-spirited *pinku eiga* studio of the '70s. Ironically, director Wakamatsu would have fit nicely in the Nikkatsu family ten years later.

NEW GHOST IN A TAVERN
see **GHOST IN A TAVERN 2**

NEW RASHOMON
see **IN THE THICKET**

NEW STUDENT (1982)
[Tenkosei]
aka **Transferred Student**
director: Nobuhiko "Obi" Ohbayashi
Satomi Kobayashi • Toshinori Omi
Mitsuru Sato • Kirin Kiki

Another of **Obi**'s *Onomichi*[3] films {also see **House** and **Girl Who Could Travel Beyond The Time Barrier**}. Kazuo Saito is the class bully, more interested in causing mischief than doing his studies. Then one day at school he runs into a new female transfer student named Kazumi *Saito* (inexplicably, this girl has the same last name as Kazuo). They begin seeing each other socially, and one day while frolicking at a shrine the two students

New Student

accidentally fall off a stone wall. During the accident, their souls are *shocked*, resulting in the switching of bodies. The rest of the film is a series of gags springing from *gender-bender* situations and mixed-identities.

What was in the air in the early '80s? World cinema produced a variety of similar *body-switching* comedies ranging from the **Steve Martin/ Lilly Tomlin** vehicle **All of Me** (1984) to the French film **Gimme Me Back My Skin** (1983).

[3] Onimishi is **Nobuhiko Ohbayashi**'s home town, a Japanese city on the western coastline which received little damage from the assault of the Second World War; today it's a *vacation city*, rich in tradition and still alive with legendary customs. Ohbayashi's movies shot in this area tend to benefit from the innocence and naivete of the culture.

NIGHT DECAY (1967)
[Yoru No Tadare]
director: **Shinya Yamamoto**
Miki Hayashi • Shusaku Muto

An early project from **Shinya Yamamoto**, who became a successful *Nikkatsu* "pinku eiga" director in the '70s and continues working as an independent filmmaker today. Yamamoto helped *Shintoho* launch their *Hard Porno* line in 1992 with a soft-core *Ero Go* production, **Cruelty Of The Female Inquisition**.

In the '60s, Yamamoto was more interested in the thriller genre; **Night Decay** is an excellent example of his unique brand of psychological horror. **Miki Hayashi** plays a young woman who inadvertently gets involved in a fatal traffic accident. Initially she is dazed. Her first reaction is to get the hell out of there. But, suddenly, a man appears and threatens to blackmail her. She panics. The girl intentionally runs over the witness, killing him too. She flees the scene. However, soon the scared woman starts getting blackmail threats from an unknown witness who

knows about both deaths. Conceptually similar to **Dario Argento**'s **Four Flies On Grey Velvet** (1972), with an equally familiar denouement. Is this more than mere coincidence?

Night Head

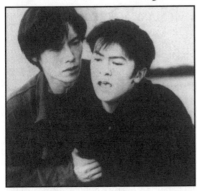

NIGHT HEAD (1994)
[Naito Heddo]
director: Jouji Iida
Etsuji Toyokawa • Shinji Takeda

From **Jouji Iida**, the director of the wonderfully absurd **Battle Heater** (1990), comes a disappointing variation of the Nihon Television series, **Psychic Drama: Night Head**. In fact, the movie is little more than various episodes of the TV program edited together with a tailor-made wrap-around.

Naoto has psychic *healing* powers and his younger brother has psychic *prophesy* powers. After years of living like guinea pigs, locked inside a laboratory and studied by scientists, they decide to join society as therapy psychologists. They hang a shingle and start a counseling service. The movie intercuts between case studies of four clients. The most interesting one is an autistic girl who has psychic abilities of her own. It seems she accidentally killed five students who were picking on her. The brothers help the girl deal with her *gift* by making her aware of her unique abilities.

NIGHT OF THE ANATOMICAL DOLL (1996)
[Jintai-mokei No Yuru]
director: Toshiyasu Sato
Hitomi Shiraishi • Yoshiki Arizono
***½**

A young woman (**Hitomi Shiraishi**), with an extremely sensitive sense of smell, undergoes some eerie moments—maybe even a supernatural experience—after moving into a new apartment. She smells death after being visited by a ghostly specter.

Certainly a throwaway film for director **Sato** who scored high points with **In The Thicket**, the *Rashomon* remake, earlier the same year.

NIGHT OF THE VAMPIRE
see **BLOODY THIRSTY DOLL**

NIGHTY NIGHT: (1990)
[Nighty Night]
director: Hirohisa Kokusho
Shino Wakui • Takako Yoneyama
Sachiko Naka • Yukari Matsuzaka
☐ pick your own rating

Here's something of a cinema rarity, a cheaply-made grade-Z horror film from Japan. It's an omnibus project, four shorts by budding filmmaker **Kokusho** (probably shot on 16mm, but God knows, it could be Super 8). The first two are throw-away junk. One about a birthday party that turns into a bloodbath; another about a guy who falls to his death after trying to catch a ghost-girl at his window. But the third and fourth segments are worth a marginal recommendation.

In **#3** a girl receives a floppy disc in the mail. She downloads it into her computer and discovers a game called *Survival: Monster Kill*. Later, while she's sleeping, the computer spits out a

spider-like monster with a human head {very similar to the creatures in *Shinya Tsukamoto*'s **Hiruko** [1991]}. The girl, trapped in her apartment must figure out how to stop the beast before it kills her. This is an ambitious project with some wonderful stop-motion animation. But the ending, with the girl *winning* the *opportunity* to advance to the next level is grimly predictable.

On the other hand, the **4th** story has the innovation of a nightmare. A love-sick girl transforms into a hideously deformed monster every night at 9 o'clock. By 9:05 she's back to normal again. But during those five minutes her scalp splits open, an eyeball blinks in her forehead, and extra mouths fill the hollow of her cheeks. Eventually, she kills herself rather than allow her boyfriend to see the disgusting trans-formation. She dies never realizing the same thing is happening to him. Ironic horrors.

This isn't great filmmaking. Nor does it pretend to be. But there are worse ways to blow 75 minutes.

NINETEEN (1987)
[19]
director: Kensho Yamashita
Kazukiyo Nishikiori • Natsuki Ozawa
Katsuhide Uekusa • Noriyuki Higashiyama
*½

Three young men (real life members of *Shonen-tai* pop group) play the roles of Time Patrol Rangers, superheroes dedicated to saving the Earth from dis-aster. In 1998, Tokyo is targeted for destruction by 19 monsters who invade from the future. The Time Patrol comes to the rescue.

An early monster *demo-pic* for future Godzilla director **Kensho Yamashita** {see *Godzilla Vs Space Godzilla* [1994]}. Good special effects, but gaw-dawful cutsie shenanigans from *Shonen-tai*.

NINJA MOON SHADOW
see FEMALE NINJA:
MAGIC CHRONICLES #6

NINJA WAR
see BLACK MAGIC WARS

NOH MASK MURDERS (1991)
[Tenkawa Densetsu Satsujin Jiken]
translation: **Tenkawa Legend Murder Case**
director: Kon Ichikawa
Takaaki Enoki • Takeshi Kusaka
Keiko Kishi • Rei Okamoto
**

Three seemingly unrelated events (a Tokyo businessman dropping dead; a young couple's accident in the snow during a mountain vacation; a boy's infatuation with an older woman) are in fact, part of destiny's game. It has to do with picking a successor to the Noh Family ancestral line and murders caused by the curse of a ancient evil mask.

Described as a "horror film for the art crowd" by snooty critics or a "nothing-new bore-fest" by the counter-culture reviewers. Take your pick.

NON-CHAN: RIDING ON THE CLOUDS (1955)
[Non-chan Kumo Ni Noru]
director: Fumito Kurata
Haruko Wanibuchi • Setsuko Hara
*½

Before landing the starring role in this motion picture, 10 year old **Haruko Wanibuchi** was critically acclaimed as a genius violinist, a natural born musical talent. However, this disastrous movie smothered her acting aspirations and she returned to the more reputable world of classical music. Occasionally, in the 40 years that followed, she con-tinued to star in various projects which caught her interest (*i.e.,* *One Eyed Swordsman* (1963) with **Tetsuro Tanba**, *Devil Comes Down And Blows*

The Flute {*Kindaichi* series} (1979), *Zipang* (1990), *et al*).

In this one, Ms Wanibuchi plays Non-chan, a little girl who tumbles from a tree while playing. But her fall is broken by a cloud. There she meets an old man with a long beard who may or may not be God. A fantasy for the **Little Prince** generation. An animated series popped up in the late '80s {**Riding On Clouds**} based on this film.

NORTH 45° (1994)
[N 45°]

Four stories directed by new-wave filmmakers (promoted as a sequel to **J-Movie Wars** [1992]), relying heavily on quirky relationships and special effects. Each of the four projects focus on a fictitious town located at N 45° parallel:

Lavish Wonder

▶ **Lavish Wonder**
[Wanda Rabisshu]
director: Kyoji Saishu
Keiichi Endo • Reona Hirota

Avant garde director **Saishu** tells the story of a girl who meets a political activist at a fast-food diner. The two journey into the snowy wilderness together.

▶ **Revenge With Pao**
[Pao-san Tono Fukushu]
director: Takao Komine
Hiroyuki Sato • Shinichi Ono

Loner Pao drifts to a bitterly cold

Revenge With Pao

wintertown where he helps a convenience store clerk take revenge against a gang of young delinquents who killed a girlfriend. **Arnold Schwarzenegger** does the narration, in English, during the blazing gunfest conclusion.

▶ **Passionate Wasteland**
[Jonetsu No Koya]
director: Hirohisa Sasaki
Masao Kusakari • Hiroko Nakajima

It's the world of the future; the Earth is scorched from too many devastating wars. The *Togo*, a motorcycle gang of nuclear mutations, controls the highways. Mayor Kiriko recruits the aid of a bounty hunter to help him exterminate the freaks from his community.

▶ **However the Wind Blows**
[Kaze Wa Docchi Ni Fuiteiru]
director: Takehiko Nakajima
Hiromi Kuronuma • Tomorah Taguchi
Youichi Sai • Haruko Wanibuchi

However The Wind Blows

Insurance salesman Suzuki knows there's something wrong with his life. Last night he had a one-night-stand with a girl who stole all his money. Today, he's been car-jacked, barely escaping with his life. And right now his brain is making squeaking noises and he can feel the cells shutting down. Stylistically similar to the works of **Shinya Tsukamoto** {see listing for *Tetsuo* also starring Tomorah Taguchi}.

NOSTRADAMUS:
FEARFUL PREDICTION (1995)
[Nosutoradamusu: Senritsu No Keiji]
director: Yumiko Awaya
Ryushi Yamane • Yoshimi Ashikawa
*

Here's something we don't see everyday, a Japanese movie directed by a woman. But unfortunately, this film is so bad it can't be regarded as a step forward for the women's movement.

It's financed by a religious organization, *Kofuku No Kagaku* and features performers who have converted to the cult faith. Big dollars were spent on the computer graphics and the amazing special effects, but that can't compensate for the absolutely horrendous storyline.

The year is 1999. The world is living in perpetual darkness, a condition caused by war, nuclear weapons, and excessive carnality (yes, you read that correctly). Somehow, negative energy has created a mist which covers the entire earth, keeping sunlight from getting through. Without nourishment, everything will die, just as Nostradamus predicted.

Angels from heaven try to save the planet. Sadly, their efforts fail and world cities continue to fall. When Washington DC crumbles, a doomsday machine is activated and a nuclear missile is launched, destination Japan. *(There's no explanation why a missile is aimed at Japan in the first place.)* The people of Japan gather in the streets and through their demonstration of "genuine love for fellow man" they create a shield which stops the war-head in midair, keeping it from dumping it's deadly cargo on Tokyo. The Beatles said it best: "All you need is love."

O RANGERS:
SUPER POWER UNIT (1995)
[Choryoku Sentai: O-ranger]
director: Yoshiaki Kobayashi
Masaru Shishido • Kunio Masaoka
Masashi Aida • Mayumi Aso
Tamao • Hiroshi Miyauchi
**

A movie variation of the *Go-Rangers* television program (popularized in the American market as *Power Rangers*) released to celebrate *Toei*'s 20th anniversary of the TV series. In this big screen version, the five super-heroes fight Prince Buldont from Empire Paranoia in an attempt to stop his perverse kidnapping scheme.

Prince Buldont wants to make the ultimate SciFi FX movie, so he has captured children from everywhere and ships them to a special high-security motion picture studio where all the special effects are real. When the Rangers try to save the children, Buldont sends his monsters to stop them.

The "O" superheroes are all named after colors (in English). They are: O-Red (**Masaru Shishido**), O-Green (**Kunio Masaoka**), O-Blue (**Masashi Aida**), plus the two girls (with decidedly feminine color names) O-Yellow (**Mayumi Aso**) and O-Pink (**Tamao**). It's mere supposition whether the name *O Rangers* is supposed to be part of this color-coordinated joke [as in *Oranger*].

A sequel appeared the following year:

▶ **O RANGERS:**
 SUPER POWER UNIT
 VS KAKU RANGERS (1996)
[Choryoku Sentai O-ranger vs Kaku Ranger]

Onibaba (Old Bitch Woman)

director: Shohei Tojo
Masaru Shishido • Kunio Masaoka
*½

The O Rangers and Kaku Rangers are adversaries but they become allies to fight a common enemy, the Mechanical Beast and Super Ghost. After the enemies are defeated the two ranger units become opponents again.

OCCULT SHOP FROM HELL
see **SPIRITUAL REPORT**

ONE HUNDRED MONSTERS
see **HUNDRED MONSTERS**

ONIBABA (Old Bitch Woman) (1964)
director: Kaneto Shindo
Nobuko Otowa • Jitsuko Yoshimura
Kei Sato • Jukichi Uno

A classic Japanese horror film distributed in the United States under a variety of pseudonyms, including **The Hole**, **The Demon**, and **Devil Woman**. It was also one of the first non-**Godzilla** horror films from Japan to see major circulation in the West, perpetuated by an advertising campaign that promised "more nudes...the sexiest yet."

Two female peasants, a mother and her daughter-in-law, make a living by attacking soldiers and selling their armor. One night, a samurai wearing a grotesque mask comes along. Mom kills him. Upon removing the mask, she finds the remains of a decaying face. However, this doesn't stop her from wearing the disguise to scare her daughter-in-law from having an illicit affair with the neighbor. The problem is, now, mom can't get the demon mask off.

In retrospect, this atmospheric black-and-white motion picture is a very strong, well-acted, horrific period piece. Even when viewed today.

A companion film, **Kuroneko** (also directed by **Kaneto Shindo**) was released in 1968.

ORGAN (1996)
[Organ]
director: Kei Fujiwara
Kenjin Nasa • Kei Fujiwara
Kimihiko Hasegawa • Reona Hirota

Two mean-spirited, blood-drenched stories intertwine within this film. The first deals with Numata (**Kenjin Nasa**) a Tokyo police detective, searching for his missing undercover-cop brother. But he's been the victim of foul play, a hap-

Kei Fujiwara's *Organ*

less target in a yakuza-run body-parts ring. Numata's investigations lead him to Yoko (**Kei Fujiwara**), the queen-bitch of the organ sellers.

The second plotline concerns Yoko's brother and partner-in-crime, Saeki (**Kimihiko Hasegawa**), as he experiments on the reanimated, limbless body of the missing cop, keeping it "alive" off the blood of school girl virgins. Luckily, Saeki is a High School biology teacher so he has a healthy supply of nubile cuties for his continuing experiments.

The film crescendos into a gory, bloodbath when the yakuza tries to eliminate Yoko and her gang of body carvers. But between the opening scenes and the closing credits, the audience is subjected to an endless array of hideous and grotesque imagery, perhaps the most perverse scenes ever captured on film. British critic *Pete Tombs* wrote: "**Organ** is not a film to see on a full stomach. Its fetid atmosphere of abnormality will have you screaming to be let out. And yet, you keep watching, fascinated... **Organ** is a perfect example of the power of contemporary Japanese horror— to revolt, amaze, and intrigue the viewer, all at the same time."

This is **Kei Fujiwara**'s debut as a director, after her starring role in *Shinya Tsukamoto*'s **Tetsuo** (1990). Ms Fujiwara is the owner/manager of the *Organ-Vital* playhouse in Tokyo,

where she continues to write, produce and direct underground plays. **Organ** was originally performed on stage in her avant-garde theater, where it ran for two years. Fujiwara then made some conceptual changes, rewrote the script, and shot it on film. The original version, a 110 minute 16 mm print (premiered at the Toronto film festival in 1996), was not shown theatrically in Japan due to rating trouble with the Nippon film board, *Eirin* (instead, the Japanese saw an edited 102 minute version.) However in 1997, Ms Fujiwara joined a group of militant independent filmmakers rebelling against Eirin's "iron fist." She ignored their threats and released the original uncut version of **Organ** direct to video.

PARASITE: EVE (1997)
[Parasite Eve]
director: Masayuki Ochiai
Hiroshi Mikami ● Riona Hazuki
＊＊

This movie is based on a bestselling novel by **Hideaki Sena**, one of Japan's premiere thriller writers. It also marks the motion picture debut for former television director **Masayuki Ochiai**. But unfortunately Ochiai brings too much his TV baggage with him. He manages to create little more than a condensed, passionless tale. The nuances of the original story (*i.e.,* the torment, anxiety and issues of retribution) are gone, replaced by a rather standard skin-graft/cloning tale, more comparable with the B-actioner **The Clonus Horror** (1978) than *Sena*'s terrifying novel.

Toshiaki (**Hiroshi Mikami**) is a young scientist at the University School of Medicine. He specializes in mitochondria, the study of cell division. After his wife is injured in a near fatal car accident and diagnosed as brain-dead, he removes one of her liver cells,

codename *Eve*. The scientist attempts to cultivate Eve in a cloning experiment but the cell starts multiplying at an astonishing rate.

PASTORAL:
TO DIE IN THE COUNTRY (1974)
[Denen Ni Shisu]
director: **Shuji Terayama**
Kantaro Suga • Hiroyuki Takano
Kaoru Yachigusa • Masumi Harukawa

Similar to **Throw Away Your Books And Go Out** (1971), director **Shuji Terayama** uses his best-selling counter-culture book as the source material for this movie. Terayama was a notorious underground poet/playwright from the '50s who became the chief scriptwriter for filmmaker **Masahiro Shinoda** through-out the '60s. He turned director with the forementioned **Throw Away Your Books** in 1971 and later found world-wide success with **Fruits Of Passion: Story Of O** (1980).

All **Terayama** films have moments of fantasy (and sometimes horror, *i.e.*,

Pastoral: To Die In The Country

Grass Labyrinth), but this one, con-sisting of dark pieces from his tormented childhood, is a collection of dream motifs with very disturbing terror symbolism. The story, as told though the eyes of young Terayama, is set in northern Japan where the boy tries unsuccessfully to break the ties of an overly protective mother. At one point he visits a medium, a crusty old fortune teller, who says she can put him into contact with his dead father. The resulting seance drastically threatens his

Hiroshi Mikami and Riona Hazuki in *Parasite: Eve*

Shuji Terayama's personal nightmare is *Pastoral: To Die In The Country*

already tenuous grip on reality. Another sequence depicts an imaginary, torrid liaison between the boy and a neighbor's sexy wife, culminating with a vicious beating from his mom. These snips of life continue to haunt Terayama today as he tries to remember things in a better, healthier way, only to have the horror constantly bleed through, destroying the more pleasant memories. And he doesn't know which is closer to the truth.

A poetic, troubled look at life, as the director creates a masterpiece of contrasts, illusions and dilemma. The supernatural overtones plant this cult film in the Fantasy genre; some of the images are nightmarish to the point of horrific. Perhaps the foreboding sense of torment and anguish has never before been brought to the screen so effectively.

PATH TO HELL
see **DARKSIDE REBORN 2**

PATIO (1992)
[Patio]
director: Yasuyuki Kusuda
Momoko Kikuchi ● Taishu Kase
**

More than an interesting movie, this is an *interesting* marketing ploy. *Fuji*

Television broadcasted the first two parts of this adventure/fantasy miniseries and then — after a particularly exciting "cliffhanger" ending — they premiered the conclusion theatrically, amid a tremendous television advertising blitz. The strategy was successful, transforming a rather humdrum "made for TV" actioner into a sizable box-office hit.

Yu (**Taishu Kase**) is an archaeologist {think *Indiana Jones* here}; Mari (**Momoko Kikuchi**) is his pretty guide. They're looking for a precious red stone called the Patio {a plot uncomfortably close to the **Romancing The Stone / Jewel Of The Nile** films of the mid 80s}. Their quest takes them on a series of high adventure jaunts spanning from Hong Kong to Singapore, Australia to Indonesia. The more they travel, the more they learn about the sacred Patio legend, which — coincidently — is not unlike the mythology surrounding the *Ark Of The Covenant* in **Raiders Of The Lost Ark** (1981).

PEARL SPRITE
see **KINDAICHI series**

PHANTOM WITH 20 FACES
and **PHANTOM sequels**
see **BOYS DETECTIVE TEAM**

PHILIP (1993)
[Philip-kun]
director: Tomohiko Iwasaki
Keiko Kubo • Yukiyoshi Iwami
**½

Here's a SciFi fantasy about a robot named Philip (**Yukiyoshi Iwami**) who falls madly in love with flesh-n-blood research assistant Taeko (**Keiko Kubo**). However, after a freak accident, she dies. Obviously everyone grieves and the girl is missed — for awhile. But human nature has a way of padding life's depressions with a fading memory. Over time, everyone has forgotten about Taeko, commenting off-handedly that "she's up in heaven now." However, robots don't have the luxury of a *fading memory*. Philip continues to live with the acute, ever-present sorrow until he can no longer function rationally. The cyborg becomes obsessed with seeing Taeko again. Philip secretly builds a rocket and sets his sites for Heaven. Heartbeeps.

PINNOCHIO 964 (1992)
[964 Pinnochio]
director: Shozin Fukui
Hage Suzuki • Onn-Chan
Kyoko Hara • Ranyaku Mikutei

A product of the same *Cyberpunk Cinema* that created **Tetsuo** (1990) and **Death Powder** (1993), this one tells the story of an android sex slave and the girl who befriends him. A high-tech company creates super-human "love" cyborgs (known as the *Pinnochio series*) and sells them to sexually frustrated older women.

The movie begins when a dissatisfied customer kicks one such sex-android into the Tokyo streets because she found him inadequate for her bizarre tastes. The creature wanders aimlessly until a young streetgirl adopts him. The waif, Himiko (**Onn-Chan**), helps him

regain his memory but with it comes unbridled anger and, ultimately, vengeance.

Viewers beware. Some of the proceedings are extremely graphic, not to mention disgusting. Excessive bodily fluids, brutal sex, dismemberment, ultra gore, and the inclusion of one exaggerated vomit sequence make this film an endurance test. However, it has also achieved the notoriety of being one of Japan's most important underground films. {Also see listing for director Fukui's *prequel* **Rubber's Lover**.}

Hage Suzuki in *Pinnochio 964*

PORTRAIT OF HELL
see **HELL SCREEN**

PORTRAIT OF
PERSIAN BLUE (1986)
[Persian Blue No Shozo]
director: Hidenori Taga
Koji Tamaoki • Kaori Takahashi
**

During summer break, young students start disappearing. Then a teacher's dead body is found. All the grisly mayhem is apparently tied to the janitor of the local elementary school. Although a profusion of evidence points directly

at him, the caretaker (played by **Koji Tamaoki**, the popular lead singer of *Anzen Shitai* [Safety Zone]) is proven innocent in the end.

PRINCE OF SPACE (1959)
[Yusei Oji]
director: **Eijiro Wakabayashi**
Tatsuo Umemiya • **Joji Oda**
*

This is an attempt to capitalize on the success of **Gekko Kamen** (*Moonbeam Mask*, 1958) directed by it's scriptwriter **Eijiro Wakabayashi**. But complete disregard for continuity, coupled with a minuscule budget, make it a film to avoid.

Planet Prince (**Tatsuo Umemiya**) comes to Earth as its self-appointed superman. He battles an arch-villain named Phantom, a magician who is determined to rule the universe with his army of giants.

PSYCHIC: TRAVELER
TO THE UNKNOWN (1994)
[Chonoryokusha Michi Eno Tabibito]
director: **Junya Sato**
Tomokazu Miura • **Mieko Harada**
**

Conservative filmmaker **Junya Sato** (best known for his acclaimed drama about Chino/Nippon relationships, **Go-**

Psychic: Traveler To The Unknown

Masters [1982]), adds an air of respectability to *Ki*, the Chinese scientific study of extrasensory perception. He recounts the true story of psychic *Hikaru Takatsuka* (as played by **Tomokazu Miura**) who becomes obsessed with *Ki* and associated philosophies.

As the story goes, Hikaru was an ordinary man, completely unaware of supernatural powers laying dormant inside his brain [soul?]. One day, his mother is hospitalized after a heart attack. Unknowingly, Hikaru activates his *Ki* healing power when he places his hands on her chest and she awakens from a coma, cured.

Unfortunately for the audience, after the psychic learns of his unique ability, nothing happens. Actually, for Hikaru personally, a lot happens. He reads everything he can find about *Ki* and then he journeys to China where he reads even more. But is watching a man read really the makings of a good movie?

PU (1995)
[Pu]
director: **Mikio Yamazaki**
Kouichi Sato • **Tomorah Taguchi**
**

The Pu tribe has a village on a small mountainous tropical island. Once it was prosperous due to a successful coal mining operation. But the harsh industry raped the environment and the community. When the mine dried up, so did the village. Today, the tribe wants to refurbish the area. The village authorities plan to build a theme park in hopes of attracting tourism.

Kishoure (**Kouichi Sato**) and his son Pakuchon wander into the village one day. They claim to have come from a 500 year old Pu community, "beyond the limits of time," magically transferred by warlock Ujaki. Kishoure revitalizes the village when he tells them

about a treasure hidden somewhere in their community (sorta like a fusion of **The Gods Must Be Crazy** and **It's A Mad Mad Mad World**). The *treasure* turns out to be an ancient scroll with a parable about living within the boundaries of nature.

Meanwhile, son Pakuchon meets the village beauty, Ririko, and falls in love. Apparently, the girl is really the reincarnated spirit of Ujaki. She enlists Pakuchon's help in constructing an *"ancient"* machine which will broadcast environmentalist messages to the entire world.

How any of this will save the village from disaster is unclear. In fact, it's difficult to tell whether director **Taguchi** is serious about the overall "back to nature" message or if he's merely poking fun. That ambiguity is the biggest problem with the film. Plus the characters behave in such extremes that the impact of the rhetoric is lost. **Tomorah Taguchi**, an actor seemingly dedicated to being included in every possible avant-garde film, is strapped with a thankless role here. His chieftain character has no dimension beyond the stereotypical {see *I Hate You... Not* entry for Taguchi overview}.

QUEEN BEE
 see **KINDAICHI** series

QUEEN MOTHRA
 see **MOTHRA**

▶ **RAMPO** (Okuyama Version) (1994)
 [Rampo]
 aka **MYSTERY OF RAMPO** (USA title)
director: Kazuyoshi Okuyama
Naoto Takenaka • Masahiro Motoki
Michiko Hada • Mikijiro Hira
***½

❖

▶ **RAMPO** (Mayuzumi Version) (1994)
 [Rampo]

Rampo

director: Rintaro Mayuzumi
Naoto Takenaka • Masahiro Motoki
Michiko Hada • Mikijiro Hira
**

This is a movie loosely-based on the life of **Edogawa Rampo**,[1] a popular Japanese horror novelist (played by **Naoto Takenaka**) who started writing books in the mid-1930s. As the movie begins, he is constantly running into trouble with the government censors because of the huge helpings of excessive violence and sex. Rampo's literary agent meets with him to discuss the newest work-in-progress. But the most amazing thing has happened. Rampo is totally unaware that his current project **Enter Otose** [*a woman's husband suffocates in a trunk— planned or accidental?*] is mirroring actual events in the news.

The movie then drifts decidedly into fantasy as Rampo's fictional detective character, Kogoro Akechi (**Masahiro Motoki**), appears on the scene to investigate. Through his eyes in an equally imaginary world, Rampo begins a bizarre relationship with the mystery woman who *killed* her husband. In this strange setting, he also meets a Count of dubious sexuality (**Mikijiro Hira**) engulfed in a sadistic if not suicidal relationship with his new love.

Mega-producer **Kazuyoshi Okuyama** bankrolled this movie in 1992, appointing versatile television director **Rintaro Mayuzumi** to ride helm. But the powerful executive was not pleased with the

final product and he shelved it. He then decided to resurrect the film and release it in 1994 to coincide with the 100 year anniversary of Japan's motion picture industry and to commemorate *Edogawa Rampo*'s 100th birthday. It became his pet project; many insiders say he became obsessed with it. **Okuyama** personally re-shot about 40% of the movie. He also re-edited the existing footage and added most of the surrealistic overtones.

In addition, there are six noteworthy differences between the two versions: 1) *Bruce Joel Rubin*, director of the *Michael Keaton* movie **My Life** (1993), was hired to narrate a new introduction *in English*; 2) an animated short film, drawn by *Yasuhiro Nagura*, depicting the storyline of Rampo's **Enter Otose** is inserted; 3) there's a completely new beginning which features a snooty "show-biz" party where Rampo is talking about the inspiration for his latest screenplay but nobody is paying any attention. **Okuyama** also sprinkled the audience with recognizable industry superstars [*i.e.,* best-selling female novelist **Mariko Hayashi**, director **Kinji Fukasaku**, manga writer **Riyoko Ikeda**, *etc.*]; 4) the original soundtrack was scrapped, the new score with a jazz rendition of the song **All Of Me** is added; 5) individual *subliminal* frames were edited into the print, specifically for the footage inside the Count's mansion, to "create an uncomfortable erotic tension;" 6) a special fragrance, chosen specifically by **Okuyama** to "recreate the sensuous scent of musk," was sprayed inside the theater before each showing.

Director **Mayuzumi** fought for and won the right to release his original version. Both movies opened on the same day in June of 1994. Critically and commercially, **Okuyama**'s cut was an irrefutable success. **Mayuzumi**'s ver-

sion disappeared after a minimal run.

[1]**Edogawa Rampo**'s real name is unknown. He chose this pseudonym because of his affinity for the American horror writer **Edgar Allan Poe**. His name is an intentional Japanization. When read aloud it *sounds* like **Edgar Allan Poe**.

Akira Kurusawa's *Ran*

RAN (1985)
[Ran]
translation: **Rebellion**
director: Akira Kurosawa
Tatsuya Nakadai • **Satoshi Terao**
Jinpachi Nezu • **Mieko Harada**

Kurosawa again returned to his roots for this production. Just as he adapted **Shakespeare**'s **Macbeth** for his own samurai epic **Throne Of Blood** (1957), this time he uses **King Lear** as the basis for **Ran**. An aging lord (**Tatsuya Nakadai**) gives the keys of his kingdom to his eldest son but it causes a major rebellion and bloody conflict within the family. The younger two sons (not daughters as Shakespeare would have it) turn against the clan and organize a massive retaliation.

Mieko Harada won a best supporting actress award at Cannes for her evil incarnate role. And **Kurosawa** claims, even though the film liberally borrows from **Shakespeare**, the story is actually based on a 16th Century warlord in Japanese history.

RAPED IN HEAVEN: BEAUTIFUL HUMILIATION (1995)

[Kankin Tobo: Utsukushiki Emonotachi]
director: Shinsuke Inoue
Reiko Hayama • Koji Minagami
Mari Kanzuki • Tofu Matsumura
**

A traveling cosmetic saleswoman stops to help a stranded motorist. He turns out to be a dangerous rapist who escaped from a nearby prison. After being sexually violated, she manages to escape into the woods. There, the girl is *rescued* by an eccentric hermit who introduces her to a whole new set of problems. Twisted psychological horrors from **Shinsuke Inoue**, son of the more famous director **Akira Inoue**. Shinsuke also made **Beast City** later in 1995 {see separate listing}.

RAPEMAN series (1990-1997+)

[Rapeman] 7 Episodes

▶ all episodes:
 director: Takao Nagaishi
 starring **Hiroyuki Okita** and
 Sakae Umezu (as the Uncle)

Kindly Uncle Shotoku complains to his nephew: "We can't trust politicians anymore. Bribes and embezzlements are commonplace. That's why we're here." Then he adds: "Keep your penis strong." Uncle and nephew Keisuke (**Hiroyuki Okita**) run an underground business known as Rapeman Services, a company with the motto: *Righting wrongs through penetration.*

The premise is quite simple, and obviously inspired by the popular **Hissatsu!** television series {see *Professional Killers* listing in *Japanese Cinema: Essential Handbook* for information}. For this variation, clients come to them with tales of humiliation or mistreatment (*e.g.*, a groom is embarrassingly abandoned at the altar, a deceitful secretary has stolen a boyfriend, a wife is having an affair with a lesbian, *etc.*). If

the case warrants it and our heroes accept the assignment, they correct the injustice through a rape. "When the law is powerless, I will punish the guilty," Keisuke says while attacking a girl during the opening sequence of *#2*. Of course, they also accept money for this service. The funds are used to help finance the Sunflower Orphanage where Keisuke spent his youth.

Rapeman could never be made in the *politically correct* environment of the United States. But not only has it been made in Japan but it's also highly successful, already seven episodes strong with no indication of a slowdown. In fact, series is doing so well that a "spin off" has already been released (#7) which takes the **Rapeman** concept and puts it in a samurai setting (*Edo Rapeman*).

Regarding these films, it's easy to see why they are so popular. Director **Takao Nagaishi** has taken a patently offensive premise and cleverly twisted it into a wickedly funny black-comedy for adults. But that's not all. His camerawork is slick, and the music is hypnotic. Plus he has designed well-written scripts with surprisingly intricate plotlines. And, most importantly, **Nagaishi** has taken the time to develop a group of characters who are actually very likable. Both of the lead performers are entertainment veterans. **Sakae Umezu** (Uncle) is a popular character actor who brings experience and dignity to this arguably inelegant undertaking. **Hiroyuki Okita**, a former teen-idol pop singer, is the perfect **Clark Kent** choice for the *Rapeman* role, mild-mannered school teacher by day, and by night a black-clad hockey-masked vigilante rapist.

Much could be written about the social ramifications of such a series and whether *rape* should be tolerated as a suitable subject for a lampoon fantasy

film. While it's true that there is nothing funny about rape, there's nothing funny about murder either. But yet it's treated humorously in a zillion comedies.

RED PEACOCK,
FEMALE UNDERTAKER (1996)
[Onna Tomurai-shi, Beni-Kujaku]
director: **Masaru Tsushima**
Fumi Yokosuka • **Saori Taira**
**

Another film most probably inspired by the success of the **Female Ninja: Magic Chronicle** series {see separate listing}. In the samurai era, a superheroine assassin called Red Peacock (**Fumi Yokosuka**) conjures her magical powers against crime and corruption, often using her body to capture the bad guys. Her identity remains a secret, masked behind the respectability of a professional undertaker.

REQUIEM FOR
A MASSACRE (1968)
[Minagoroshi No Reika]
director: **Tai Kato**
Mitsuru Sato • **Chieko Baisho**
Yuki Kawamura • **Sanae Nakahara**
Ranho Oh • **Kin Sugai** • **Eriko Sumi**

An interesting film that revels in mind tricks. Director **Tai Kato** seems to enjoy fooling the audience, and he does it with all the finesse of a *David Copperfield*. Prior to this film he directed the boxoffice smash, **Ghost Story Of The Curse Of Oiwa** (1961), but it wasn't until his *chambara* period of the '70s (*i.e.,* **Miyamoto Mushashi: Swords Of Fury** [1972], *et al*) that Kato found critical acclaim.

Requiem For A Massacre, while popular with cult audiences, was simply too gruesome for mainstream acceptance. A tormented man brutally kills five middle-aged wives. Initially, there

appears to be no relationship between the five women and the killer. But soon a common denominator is discovered: there was a young boy who committed suicide after being sexually abused by the five.

The film is brilliantly constructed. At first the audience is shocked and alienated by the savage massacre. Because director Kato photographed each murder in graphic detail, there seems to be no justifying the killer's frenzy. But as the movie spins its methodical web, the audience is sucked into the perverse center of the story. And by the conclusion, the killer is almost canonized. He's absolved of the crimes; his bloodlust exonerated.

REMUNANTO 6
see **SPACE CARGO**

RENEGADE ROBO NINJA
& PRINCESS SAKI (1988)
[Mirai Ninja: Kinin Gaiden]
aka **RENEGADE NINJA**
aka **WARLORD**
aka **WARLORD DESTROYER**
director: **Sadao Nakajima**
 and **Keita Amamiya**
Fuyukichi Maki • **Hanbei Kawai**
Kensaku Morita • **Megumi Yokoyama**
**

Shiranui is an invincible robot ninja created by an evil scientist from outer space named Karenei. But slowly, the

Renegade Robo Ninja & Princess Saki

Earth's cosmic rays are destroying the cyborg's artificial memory block. He is beginning to remember bits-and-pieces of a previous human life. And so, he starts plotting against his extraterrestrial creator. Meanwhile, Dr Karenei (looking like a cross between **Flash Gordon**'s Ming the Merciless and a giant spider) is informed that the *Supreme Ruler of the Galaxy* is heading for Earth in need of a "mortal transfusion."

This news causes Karenei's ugly assistant to ask the mystifying question: "How will the human flesh inside the *Tree Of Life* enter into the body of our emperor?" The answer, says Karenei, is simple (?): "Through the soul of Princess Saki," a feisty leader whom he has recently kidnapped from the Earth rebel forces. Shiranui, the notorious renegade robo ninja, together with a macho samurai, embark on a mission to rescue the Princess and destroy the alien fortress before the essential "life operation" can take place.

The fact that the plot makes little sense is, of course, the biggest problem with the film. The effects are terrific. But the story is irritatingly nonsensical. Director **Nakajima** fared much better with his gangster movies like **Modern Yakuza** (1971), **Gokudo** (1974) and **Unofficial Story Of Ando And Family** (1980). He should steer clear of SciFi. Co-director, **Keita Amamiya**, continued to flourish in the SciFi arena with the hits **Zeiram** (1992-95) and **Kamen Rider** (1993-1995). Unfortunatey he also directed the miss, **Humanoid Hakaida** (1995).

Megumi Yokoyama, who plays Princess Saki here, went on to star in **Evil Dead Trap 3** in 1993 {see separate listing}.

REVENGE OF DR X
see **DEVIL GARDEN**

Return From The Moon

RETURN FROM THE MOON (1993)
[Tsuki Yori Kaeru]
director: Hiroaki Jinno
Koichiro Mitsuda • Yuko Takahashi
*½

The movie opens with a colony of people living in an underground simulated space-center. They are preparing for the adverse conditions of life in Outer Space. When the experiment concludes, certain members are dispatched for the moon. The rest are sent home; the research center is closed. Then, one of the astronauts returns from space, drawn by a powerful force in the abandoned facility. He realizes that he's been "called" to open a space-therapy center there. It's supposed to be funny in a *Monty Python* sort of way. But it's just a bunch of special effects looking for a home.

RETURN OF GODZILLA
see **GODZILLA '85**

RETURN OF MAJIN
see **MAJIN: RETURN OF MAJIN**

REX: A DINOSAUR STORY (1993)
[Rex: Kyoryu Monogatari]
director: Haruki Kadokawa
Yumi Adachi • Shinobu Ohtake
*½

A dinosaur egg is found deep inside a cavern. It hatches. The archeologist's little daughter Chie (**Yumi Adachi**) wants to keep the baby Tyrannosaursus Rex and raise it like a pet dog. But the media and crooked politicians make life impossible for the girl and her pet. The bad guys try to steal dinosaur Rex for their own money-grabbing agenda.

Haruki Kadokawa is the owner of *Kadokawa Studios*, a division of his father's extremely profitable *Kadokawa Book Publishing Company*. After producing movies for ten years, he got the urge to direct, making his first film in 1988. *Rex: A Dinosaur Story* is his fifth attempt. It'll also be his last, for awhile anyway. In late '93, he was arrested, convicted, and imprisoned on drug charges.

RING (1996)
 [Ring]
director: Chisui Takigawa
Katsunori Takahashi • Ayane Miura
Yoshio Harada • Tomoroh Taguchi

Ayane Minra in *Ring*

Once, Asakawa (**Katsunori Takahashi**) was a hot-shot journalist for a major Tokyo newspaper, but he gets demoted to a lowly office position because of his friendship with a college professor (**Yoshio Harada**) who is acquitted of murder in a high-profile case. However, Asakawa can't ignore his nose-for-news and he becomes obsessed with a controversial multiple-death case. The official police report insists "these four teenagers died from heart attacks, although none of them had a history of cardiac problems." Further, the police can show no relationship between the four people, calling it a coincidence that they died at the same time — in the same fashion — miles apart from one another.

In his private investigation, Asakawa eventually discovers a link between the four teens. It has to do with a video tape they watched, together — a week before — while partying at an isolated hotel. Asakawa gets his hands on the tape. He is instantly horrified and repulsed by the grotesque images; it's a parade of violent surrealism, unlike anything he's seen before. Asakawa is especially intrigued over a technical glitch. There's an instantaneous flicker every 20 seconds or so, "*systematic, like a code.*" Then the tape culminates with a curse: "Damn you to death! You will die in exactly 7 days, unless...." It abruptly ends before the counteractant is revealed. Asakawa knows he must take this threat very seriously, so he seeks help from his professor friend. The two of them examine the video as they try to decipher the code before time runs out.

Without giving away the ending, a truly frightening moment comes when the professor realizes that he knows what the split-second flickers are. "Asakawa," he says, "this video isn't special effects like some horror movie.

We're seeing somebody's private hell. I mean... we're really *seeing* it. Somehow we're watching the image from inside someone's head. Those blackouts are *blinks!"*

A classy horror film based on thriller written by *Kouji Suzuki*, originally made for *Fuji Television Network* (broadcast in 1996) and then — by popular demand — released theatrically toward the end of the year.

ROAMING
TORTURED BRAIN (1993)
[Samayoeru Nouzui]
director: Sadaaki Hagiba
Reiko Takashima • Masaki Kanda
Tamotsu Ishibashi • Shun Shioya
**

A suspense thriller based on a best-selling novel by **Tsuyoshi Aisaka**. Female clinical psychiatrist Aiko Minagawa (**Reiko Takashima**) is given a special case by the District Attorney's office. Dr Minagawa is hired to conduct an indepth analysis of convicted sex criminal Oiwake. He has been found guilty of multiple rapes and several other vicious assaults. Aiko is looking forward to the opportunity of *picking this man's brain.*

Meanwhile, there's a serial killer loose in Tokyo, a brute who kills women and then removes their eyelids. Police detective Kaido (**Masaki Kando**) is in charge of the case; he also happens to be Dr Minagawa's boyfriend. In a plot reminiscent of *Silence Of The Lambs*, Aiko receives valuable information dealing with sex-slayer behavioral patterns from her convicted patient. The more she finds out, the more she realizes that her boyfriend fits the profile perfectly.

In similar fashion to many American thrillers of the *politically correct* '90s, the heroic victim is a strong-willed female and the villain is the one person she should, under normal circumstances, trust the most (a disturbing trend, eh?). While the plot may share a philosophical bond with its American counterparts, the execution is distinctly Japanese, with huge helpings of gore, graphic violence and vivid rape scenes.

ROBOKILL BENEATH
DISCO CLUB LAYLA (1993)
[Mikadroid]
director: Satoo Haraguchi
Yoriko Haraguchi • Yuki Yoshida

During WW2, the Japanese are secretly at work on the Jinra Project, an attempt to create soldier Cyborgs. As defeat appears imminent, the laboratory is ordered shut down and all the evidence must be destroyed. The doctor in charge of the project helps two of the humanoids escape before he destroys the facility.

Cut to the present. A power shortage at a local disco club causes all kinds of problems, the most serious being the revitalization of an inactive cyborg (the disco was built on top of the old lab site). A guy and a girl are stalked by the killer robot when two mysterious men (the original humanoids), armed with an arsenal of weapons, appear on the scene to do battle with the out-of-control creature.

More and more, Japanese exploitation pics resemble comic books come to life. Perhaps this stems from the strong *manga* influence in everyday life. Director **Haraguchi** has knowingly created a pop-art movie filled with moments gratuitous gore and nudity. For example, there's a segment where the robot attacks a pretty victim in the deserted parking garage. Wielding his samurai sword, the cyborg slashes away her clothes while viciously slicing her body. She begins twirling from the impact, like a ballerina dancing to the

the original *Rodan* (1956)

rhythm of the sword. This is the veritable image of a *blood ballet*.

RODAN (1956)
[Sora No Daikaiju Radon]
translation: **Radon: Monster From Sky**
director: Ishiro Honda
Kenji Sahara • Yumi Shirakawa
Akihiko Hirata • Akio Kobori

Toho reunited director **Ishiro Honda** with special FX wizard **Eiji Tsuburaya** (and the rest of the original Godzilla staff) for this giant monster feast. Rodan (called *Radon* in Japan) is a pterodactyl, a flying dinosaur, hatched from a prehistoric egg found at the bottom of a Japanese mineshaft. His goal is to reunite with a mate guarding eggs inside Aso Volcano and he destroys Tokyo in his zeal to reach her side.

Although Rodan and his girlfriend are destroyed in a volcanic eruption, he does return in **Monster Zero** (1965), **Ghidrah the Three Headed Monster** (1965), **Destroy All Monsters** (1968) and **Godzilla vs Mechagodzilla** (1993).

Rodan, the movie, is especially significant for being the first Japanese monster production filmed in color. **Rodan**, the creature, is notable for being one of two *kaiju eiga* monsters not played by an actor in a rubber suit. The other, of course, is **Mothra**.

ROSE: CARNAGE OF
THE PANTHER (1996)
[Rose: Satsuriku No Mehyo]
director: Futoshi Jinno
Kaori Shimamura • Hirotaro Honda
**

An incoherent thriller that tries desperately to capitalize on the trendy "fighting diva" films, popularized by the **XX** series and the wave of Hong Kong *Girls-n-Guns* actioners which invaded the marketplace in the early 90s.

After a fatal accident, Rose (**Kaori Shimamura**) is revived from the dead by a forensic scientist who programs her as a sniper for the government. The supernatural twist on *Luc Besson*'s **La Femme Nikita** is conceptually clever, but the execution is intellectually bankrupt. However, an abundance of nudity and steamy sex scenes tends to camouflage the plot inconsistencies.

RUBBER'S LOVER (1997)
[Rubber's Lover]
director: Shozin Fukui
Yota Kawase • Nao
Sosuke Saito • Mika Kunihiro
*** or □ *pick your own rating*

the rubber creature in *Rubber's Lover*

Many people will not be amused by the excess of this unrestrained cyberpunk frenzy. It is director **Fukui**'s first motion picture since his underground hit, *Pinnochio 964*, in 1992 {see separate listing}.

There are a group of scientists — each of them more crazy than the other — conducting experiments dealing with psychic communication. They seal a man inside a rubber suit, strap him to an operating table and torture him mercilessly. At one point, due to their own zeal and miscalculations, these doctors inadvertently blowup his body. However, the experiments continue — albeit in a slightly revised fashion — as they "recruit" one of their own, Shinuka (**Yota Kawase**), for the deadly session.

Meanwhile, their sponsor sends his secretary (**Nao**) to the laboratory with instructions to shut the project down. This only infuriates the scientists. They capture the girl, rape her, beat her and then, with electrodes, they link the poor secretary to the *Shinuka Experiment*. While she is seduced by one of the female doctors, the psychic experiment takes hold. Rubber creature comes alive. And he's not happy. In fact, he counterattacks the scientists with his extrasensory power, eventually eliminating most everyone in a graphic bloodbath. Shinuka sheds his rubber suit, but he is still sharing at least half of his personality (soul?) with the young secretary. This, of course, unites the two in an overpowering emotional bond; they are plagued with nightmares of brutal sex games and savagery.

The wealthy sponsor shows up to see what happened to his secretary and he's

Nao in Shozin Gukui's *Rubber's Lover*

slaughtered for his trouble. The film ends as the girl eliminates the remaining scientist and escapes from the laboratory. The final scene with the young waif sitting on the sidewalk of a busy Tokyo street is the same shot as the one in the beginning of *Pinnochio 964*. Interestingly, in the midst of the madness, director **Fukui** has created a *prequel*, finally giving background information on the original film's enigmatic central character.

Rubber's Lover is short on narrative (perhaps in response to some criticism that *Pinnochio 964* was too complicated with its multidimensional subtext) but it's long on visual stylings— closer to **Tetsuo** than **Pinnochio**. There's lots of screaming and unintelligible language, but Fukui isn't interested in telling his story with dialogue. He only wants to *show* it to the audience. And the images are as fascinating and revolutionary as anything *David Lynch* did in **Eraserhead** (1978). The weakness of the film — the thing that will keep Fukui from getting the notoriety he deserves -- is its overindulgence. This time, the director has gone far beyond the *Pinnochio* quirkiness. His mania for bodily fluids, exploding arteries, rupturing eyeballs is exorbitant to the point of gluttonous. Gorehounds will be delighted. Others will be offended.

RUBY FRUIT (1995)
 [Ruby Fruit]
director: Takumi Kimizuka
Kaho Minami • **Tsugumi Arimura**
Jun Togawa • **Reiko Takashima**

Sculptress Maiko (**Kaho Minami**) is such a workaholic that she looses her boyfriend. The split-up is the last straw in a sequence of personal disasters. Maiko realizes it's time to change her life and she decides to take an extended vacation to Bali Island. Once Maiko

arrives in the tropical paradise, she inadvertently becomes involved in a *missing girl* case. Seemingly, a girl named Yaoyo (**Tsugumi Arimura**) is lost in the jungle and Maiko realizes there's a psychic link between the two of them. Maiko also senses a terrible power associated with this extrasensory relationship.

Actually, *missing* girl Yaoyo has discovered immortality after eating the flesh of a mermaid (a common theme in Japanese fairy tales, but also used in *Koji Wakamatsu*'s **Sacred Mother Kannon** [1977]). In the jungle, Maiko meets three women who are also under Yaoyo's hypnotic control. The girls are all part of a return-to-nature lesbian tribe and soon Maiko is inducted to the sacred cult. Eventually, Maiko asks Yaouo to leave the jungle and return to Tokyo with her. But the three other cultists are jealous and they convince Maiko to kill their leader with a sacred knife. After tasting the blood of her queen/lover, Maiko also gains immortality. At the film's conclusion, upon returning to Tokyo, Maiko discovers — remarkably — that she's pregnant.

Kaho Minami (R) with Tsugumi Arimura in *Ruby Fruit*

Eiko Matsuda in Koji Wakamatsu's *Sacred Mother Kannon*

Actress **Minami** turns in an eminently complex performance here, despite the ignoble nature of the role. She seems unaware of the obvious pitfalls inherent in playing such exploitive parts; her natural, perky good looks accentuate a naively which critics have praised and embraced over the years {also see **Angel's Dust** [1994] and **Capitol Great War** [1989] for two more unconventional outings by Miss **Minami**}.

SACRED BOOK OF
SEXUAL POSITIONS
see FEMALE NINJA:
MAGIC CHRONICLES #3

SACRED MOTHER
KANNON (1977)
[Seibo Kannon Daibosatsu]
director: Koji Wakamatsu
Eiko Matsuda • Taiji Tonoyama
Keizo Kanie • Renji Ishibashi
***½

In a remote fishing village, the daughter of a wealthy landowner becomes immortal after she eats the flesh of a mermaid. She proclaims her divinity and takes residence in a rural shrine where she initiates a sexually oriented religious cult. Calling herself *Kannon, the mother of Buddha*, this goddess shares her "carnal essence" with a string of men who come to worship her (the lovers include a quirky crosssection of society ranging from a nuclear scientist to an Ainu Indian, a right-wing activist to a survivor of the Hiroshima Holocaust). She willingly gives herself to the lusty pilgrims but they don't inherit her power of immortality. The goddess becomes increasingly melancholy as her followers grow old and die while she continues to live unchanged.

This one is considered among **Wakamatsu**'s best movies.[1] Japanese film enthusiasts have called it a *text book example of the genre* for its use of metaphor and symbolism. Much has been written by the critics about how the village represents a microcosm of the Japanese society. And how the plight of the cultural minorities {especially that of the Ainu Indian, but also

prejudice in general} is reflected through the parade of cultists and misfits as they seduce the earth mother, possessing her carnality but never her essence. On an even broader spectrum, the film has been interpreted as a call for *Isolationism* as a way of life.

[1]Koji Wakamatsu has made more than 200 films, over a 30+ year period. Most of his features deal with S&M brutality and graphic soft-core sexual material. His masterpiece would either be **Violated Angels** (1967) or **When Embryo Goes Poaching** (1966), depending on who's making the choice. Today he is considered one of Japan's most influential cutting-edge directors.

SACRED SWORD
OF SHURANOSUKE (1996)
[Shuranosuke Zanma-ken]
director: Masaru Tsushima
Masaki Kyomoto • Rie Imamura
**½

This one was promoted as *"an SFX Nemuri."* But despite a deliberate attempt to lure an adult clientele, the film was generally regarded as a kid's movie and failed to generate much enthusiasm from the media. This was a major disappointment for director **Tsushima** who has forged a career from adult-oriented fantasies (*e.g*, **Female Ninja: Magic Chronicle** series).

Shuranosuke is a super hero (a cross between *Conan* and *Sir Lancelot*, a warrior obviously inspired by such recent Japanese hits as **Yamato Takeru**) who accepts a mission from the emperor to rescue a captured princess. He challenges a vicious monk who actually masterminded the kidnapping to lure Shuranosuke into a trap. The monk is really after the superhero's Holy Sword which can point the way to a hidden treasure.

SACRIFICE (1996)
[Ikenie]
director: Shinobu Murata
Yuko Sakaki • Kazuyoshi Ozawa
**

After the daughter of a sculptor is brutally raped and murdered, dad creates a statue in her image using a special mixture of cement and his own blood. Like Giant Majin in the '60s, the statue comes to life, tracking down the person who killed her. The father, of course, has sacrificed his own life so that his daughter can seek vengeance.

Cheesy special effects — essentially **Yuko Sakaki** is a blanket of white make-up — mar the sinister tone of the film. This is another example of an interesting idea stymied by a miniscule budget.

SADISTIC SONG (1996)
[Sadist Song]
director: Genji Nakamura
Takashi Mihashi • Asami Katsuragi
Reiko Hayama • Tomoroh Taguchi
**

Set in near future, a gang of kids develop a "survival game" which they play in the ruined, burnt-out buildings of the city. These wild kids, armed with airguns, hunt down their targets (similar to a futuristic laser-tag game) when, suddenly, somebody begins shooting everybody for real.

Possibly inspired by (among other things) Peter Collinson's **Open Season**, with **Tomoroh Taguchi** playing the *William Holden* role. Filmmaker **Nakamura** is best known for the movies directed under his pseudonym *Go Ijuin* (namely the **Captured For Sex** series). He also made the cult hit **V Madonna: The Great War** (1984). This one, while entertaining, isn't nearly as good.

SAMURAI COMEDY:
GHOST JOURNEY (1967)
[Tenamonya Yurei Dochu]
aka **GHOSTS OF TWO**
TRAVELERS AT TENAMONYA

director: Shue Matsubayashi
Makoto Fujita • Minoru Shiraki
Yumiko Nogawa • Tomoko Kei
**

In Japan, actor **Makota Fujita** will always be remembered as Mondo, the leader of the gang of professional killers from *Hissatsu!*, that country's all-time #1 TV program {more than 1000 episodes over a 30 year period, starting in 1973}. But before he rode that series to fame-n-fortune, Fujita stumbled about in many grade B actioners and throw-away comedies.

The *Tenamonya* series (1965-1969) is a collection of slapstick stories set during Japan's feudal period. They all feature Fujita as a *fearless* nobleman named Tokijiro. In this particular entry, the third and only *horror-oriented* episode in the series of ten, Tokijiro tries to get rid of ghosts who are haunting the royal castle. He and his entourage journey through the Dark Forest to the Black Castle to pay homage to the ghost of angry ancestors.

SAMURAI KIDS
 see **WATER TRAVELER**

SAMURAI REINCARNATION
 see **DARKWORLD REBORN**

SAMURAI SPY:
 CASTLE OF ILLUSIONS (1956)
 [Onmitsu Hicho: Maboroshi-jo]
director: Ryo Hagiwara
Ryutaro Ohtomo • Ushio Akashi
**

Here's a movie version of the hit television series, *Onmitsu Hicho* [Samurai Spy], about a noble warrior who secretly rescues common folk in trouble. The TV superhero, with five different identities at his fingertips, was initially played by **Ryutaro Ohtomo** (who also stars in this big screen version), and then later replaced by **Koichi Ohse**. The *Koichi Ohse* series also generated two movies in the mid 60s. Those films are not included in this volume because they have no supernatural or fantasy elements.

Miyuki Ono in *Sayonara Jupiter*

A wicked king lives in a haunted castle. There, assisted by a wizard and a skull-faced assassin, he makes plans to kidnap a princess and eventually control the world. But fear not, Samurai Spy scales the castle wall and eliminates all the bad guys before they have a chance to do their dirt.

SATAN NAILS
 see **MOONBEAM MASK** series

SATORI
 see **JAPANESE GOBLIN STORY**

SAYONARA JUPITER (1985)
 [Sayonara Jupiter]
 aka **GOODBYE JUPITER**
director: Sakyo Komatsu
 and Koji Hashimoto
Tomokazu Miura • Diane Dangely
Miyuki Ono • Hisaya Morishige

Let's dispense with the obvious comment first — this is a Japanese clone of *Peter Hyams*' 2010 (1984's sequel to *Stanley Kubrick*'s 2001: Space Odyssey). The plot is the same and some of the special effects are strikingly similar.

Whereas **2010** took itself way too seriously, this film is more like old-time pulp science fiction. It could have easily been written by the early SciFi pioneers like *Andre Norton* or *Fredric Browne*. Yet, it wasn't. Director **Komatsu** did the honors. And his story doesn't get bogged down in existential rhetoric nor mindgames. It's a straight-forward adventure yarn, aided by state-of-the-arts special effects and music by *Godzilla* composer, **Akira Ifukube**.

A multi-national organization is assigned the task of converting Jupiter into "another sun" to provide energy to the outer planets of the solar system. Meanwhile, scientists discover a Black Hole heading towards Earth at an alarming speed. Plans are made to move Jupiter into a collision course between Earth and Black Hole, thus *killing two birds with one stone*: The impending explosion will ignite the gaseous atmosphere, turning Jupiter into a sun; and the Black Hole will ricochet away from Earth into the depths of Outer Space. However, when signs of an alien life-form are discovered on the surface of Jupiter, radical groups from Earth try to block the project through violence and sabotage.

If there's a problem with the film, once again it's the terrible English speaking actors, especially a group of *hippie* activists and their flower-child leader, Peter. They sit around a beach in Honolulu drag, singing songs and smoking pot, while planning their next high-tech espionage attack. It's all a bit hard to swallow.

The film was a boxoffice success in Japan, robustly overshadowing its American counterpart. In Osaka, a popular parody of the film called **Miyazu-gumi Shimatsuki** (*translation:* **End To Miyazu**) ran for months in the cult Gekidn Muse No Mori playhouse. It starred **Yuko Mihara**, the co-author of this book.

SCARED PEOPLE (1994)
 [Kowagaru Hitobito]
director: Wada Makoto
Hiroyuki Sanada • Mieko Harada
Shiro Sano • Mami Kumagai
Yasutaka Tsutsui • Kaoru Kobayashi

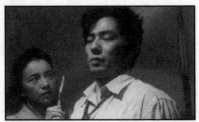

Scared People

Scared People

Five part omnibus written by renowned short story author **Yasutaka Tsutsui**, who also stars in the film. Each story has one common denominator: Fear. This is a collection tales, similar to *Yann Piquer*'s French terror movie **Adrenaline** (1991), dealing with average people who suddenly find themselves in horrific situations and the way they cope with it. The stories range from a mild-mannered man being trapped in an elevator with a psychotic lady to a weary commuter forced to eat cat-soup before he can leave a train station.

The best episode — typical in these type of films — is the last one. A cameraman and a writer go to a deserted island for research but they become stranded by heavy rains. Much to their surprise, a farmer wanders into their campsite and tells them of a special plane ready to take off. When they board, the two men are informed that the pilot is a woman who has never flown before. Realizing their options are limited, they take the flight anyway. It's no big surprise that the journey turns into a terror skyride, but the clincher comes when the cameraman discovers he might not even be alive.

Director **Wada Makoto** has an eye for detail, probably due to his extensive work as a graphic illustrator. He won many awards for his book jacket designs and theatrical handbills. This film is an impressive directorial debut. Of course, Makoto is aided by a terrific cast including former heartthrob **Hiroyuki (Henry) Sanada** and the Japanese *Jody Foster*, **Mieko Harada** (the crazy girl from *Kurosowa*'s **Ran** [1985] and the best actress winner at the 1997 Nippon Academy Awards for *Village Of Dreams* {see separate listing}).

▶ **SCARY TRUE STORIES: NIGHT ONE** (1991)
[Honoto Ni Atta Kowai Hanashi: Dai 1-ya]
director: Nario Tsuruta
Junko Asanuma ● Mai Moriguchi
and **Yumi Goto**
❖
▶ **SCARY TRUE STORIES: NIGHT TWO** (1991)
[Honoto Ni Atta Kowai Hanashi: Dai 2-ya]
director: Nario Tsuruta
Emi Terada ● Arisa Ogasawara
and **June Aizawa**
❖
▶ **NEW SCARY TRUE STORIES** (1992)
[Shin Honoto Ni Atta Kowai Hanashi]
director: Nario Tsuruta
Hitomi Yamanaka ● Shinobu Kosakai
June Aizawa ● Toshiko Yamada
☐ *pick your own rating,*
but don't to too kind

A collection of — supposedly true — ghost stories originally published in

Scary True Stories: Night Two

Japan's "Halloween" magazine. But don't be fooled, the criteria here isn't journalism, it's cheap thrills.

Night One consists of three tales: The first one takes place in a High School locker room where a peeping ghost causes trouble for the girls' swim team; the second story deals with a girl who has an out-of-body experience after the death of her psychic grandmother; and the third is about a girl who becomes exposed to a number of gory deaths after she finds an earing. (50 minutes)

Night Two is also a collection of three stories: Three girls test their bravery in a haunted gymnasium at midnight; then a family moves from Tokyo to a haunted house in the country; and lastly, a nurse on the nightshift discovers ghosts in the hospital. (60 minutes)

New Scary True Stories has four episodes instead of the more customary three: In the first one, an elementary school girl, Yuka, is told not to open the door or window if she hears any unusual sounds— needless to say, she doesn't listen to the advice; next, a tardy girl runs into the ghost of the dead caretaker on a school's haunted stairway; then, in the third story, a girl is frozen by a spector; and, for the fourth one, a group of young kids are attacked by ghosts while exploring the ruins of an old hospital. (65 minutes)

There's not much to recommend. The stories speak for themselves. They're plainly a collection of kids-in-peril vignettes aimed at the prepubescent crowd, who like to squirm and shriek but have no patience for plot or characterization. Director **Tsuruta** displays little creativity and even less style; he might as well be making industrial movies.

SCHOOL GHOST STORY
see **ELEMENTARY
SCHOOL GHOST STORY**

SCHOOL GHOST STORY LAMPOON (1996)
[Gakko No Y-dan]
director: Fujio Mitsuishi
Mitsuyoshi Echigo • Kana Fujitani
*½

Horrific erotic comedy encompassing three short spoofs of 1995's popular **Elementary School Ghost Story** {see separate listing}. But for this one the *action* is placed in a high school and when the students aren't getting scared or scaring each other, they're doing a good amount of the down-n-dirty in the school basement.

This film is the debut for director **Mitsuishi**. And he sells himself short with the subject matter, often opting for the cheap laugh instead of developing a genuinely funny "parody." Mitsuishi's writing is the crux of the problem; it is shallow, juvenile and obvious. Food fights are no longer funny and bathroom scares aren't scary anymore. But without them there's no movie here.

SCHOOL IS IN DANGER! (1996)
[Gakko Ga Abunai!]
director: Hirohisa Sasaki
Yoshie Kashiwabara Ippei Hikaru
*½

Obviously influenced by the rash of ghost-school films sprouting up in the mid '90s {initially sparked by **Elementary Ghost Story** (1995) and then nurtured by **Sex Beast Teacher** and **Sex Beast On Campus**}, this one is set in a prestigious girl's High School where a female teacher fights a sex ghost. It's all geared toward the adolescent crowd, so don't expect the overt sexuality of similarly theme *tentacle* movies.

In real life, **Yoshie Kashiwabara** and **Ippei Hikaru** are former pop singers, who slipped out of the music biz after being exposed for their inability to carry a tune. Their acting isn't much better than their singing.

Sea And Poison

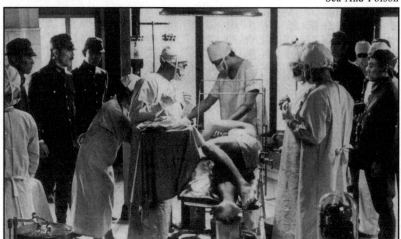

SEA AND POISON (1986)
[Umi To Dokuyaku]
director: **Kei Kumai**
Eiji Okuda ● **Ken Watanabe**
Masumi Okada ● **Mikio Narita**

Toward the end of World War 2, the Japanese military became obsessed with conducting inhuman experiments in the name of "progress and scientific research." Perhaps they were taking precedent from their Nazi allies who conducted similar experiments in the SS death camps, but according to the best selling docu-novel, *Umi To Dokuyaku* by **Shusaku Endo**, the Japanese were using captured American prisoners-of-war as human guinea pigs in cruel and torturous clinical tests. This is a movie based on that book and its horrific disclosures.

The story itself is told through the eyes of a young intern (**Eiji Okuda**) who wrestles with his own feelings of compassion as he witnesses one grotesque experiment after another. The film focuses on his confusion and frustration, but it never shies from depicting the utter cruelty which causes his dilemma. For instance, the doctor

assists in a test to determine how long someone can live with salt water in his veins instead of blood.

Upon it's release, critics coined a new term to describe this movie: *bungei-splatter* [literate splatter], due to the unabashed depiction of bloodletting within an ideological setting. For obvious reasons, the film met with resistance in the international marketplace, many distributors refused to touch it. The movie remains virtually unknown in the United States, Great Britain and Canada. Yet it was the Grand Winner for best picture at the 1987 Berlin Film Festival. Director **Kumai** also made cannibalism seem arty in the controversial **Luminous Moss** (1992) {see separate listing}.

SEASON FOR TEARS (1969)
[Namida No Kisetsu]
director: **Yuji Tanno**
Mitsuo Hamada ● **Yoko Kon**
**

After a TV reporter (**Mitsuo Hamada**) is scolded by his supervisor for inefficiency, he kicks his old TV monitor and breaks it. But seemingly, he has knocked the set into another

dimension. The *ghost* of his dead grandfather appears on the tube and tells Mitsuo what will happen "on the news front" tomorrow. This *prediction* leads to one scoop after another and soon Mitsuo is the number one journalist in the world. But then it's time to pay the piper.

SECRET OF JARAIYA
see **FEMALE NINJA:
MAGIC CHRONICLES #5**

SECRET OF
THE TELEGIAN (1960)
[Denso Ningen]
director: Jun Fukuda
Koji Tsuruta • Akihiko Hirata
Yumi Shirakawa • Tadao Nakamura
**

A soldier learns how to teleport himself and he seeks vengeance against friends who abandoned him in a cave at the end of the Second World War. Although shot and distributed in color in Japan, only a black-and-white version was released theatrically in the United States.

Director **Jun Fukuda** is best known for his Godzilla films **Godzilla versus Megalon** (1973), **Godzilla versus Monster X (Mechagodzilla)** (1974) and the absolutely awful **Godzilla versus The Sea Monster** (1966). As a rule, he's a must-to-avoid.

Secret Of The Telegian

Security Guard From Hell

SECURITY GUARD
FROM HELL (1992)
[Jigoku No Keibiin]
director: Kiyoshi Kurosawa
Makiko Kuno • Yutaka Matsushiro

The slasher film is alive and well, living in Japan. A plot remarkably similar to *Scott Spiegel's* **Intruder** (1988) finds a bunch of trading company workers getting knocked off in grisly fashion while they work the late shift. The bloodthirsty psycho is a mad-as-hell security guard, and perky **Makiko Kuno** plays the good girl who survives to tell the story to the police.

Bloodier than most, with some ingenious gore FX. Director **Kiyoshi Kurosawa** also made the underrated 1989 fright-fest **Sweet Home** {see separate listing}.

▶ **SEX BEAST ON CAMPUS** (1994)
[Inju Gakuen]
director: Kaname Kobayashi
Sayo Hidaka • Migumi Takahashi
Junko Asamiya • Masato Gunji

For those folks who anxiously await a *live action* version of the outrageous adult-oriented animated features (*i.e.,* the **Urotsukidoji** series *[aka Legend Of The Overfiend]*) a Japanese manga company, **Dreamy Express Zone** has produced some. These films are generally considered the first *Tentacle Movies,*

although that distinction should, in reality, go to **Hunting Ash** (1992) or perhaps even **Evil Dead Trap** (1988).

An ancient warrior learns the secret of immortality by making a pact with the devil. As a result, he's still running around today, using erotic magic to satisfy his carnal desires. Enter two modern ninja beauties, Miko and Miyu (**Sayo Hidaka** and **Migumi Takahashi**). They've assumed the solemn responsibility of destroying this devilman. Besides being highly skilled with blades and other assorted gadgets, these girls look positively succulent in their T-Back leather-studded ninja outfits.

The bad guy has the ability to transform into liquid. This is great for Mr Mutant H-Man, allowing him to zip quickly through the city's plumbing system. But it's also great for the audience, providing plenty of opportunities for girls to get naked before being assaulted in a shower, a bath or a skinny-dipping bonanza. But when this sinister warrior attacks, there's no hidden agenda. He wants to rape them. The years of black magic has been deformed his penis into a nest of probing tentacle-creatures hungry for sex. When this guy gets excited these appendages grow to gargantuan if not uncomfortable sizes.

The special effects are created through computer morphing and fancy edits. And the camerawork is far beyond the minimum requirement usually associated with this type of exploitive entertainment. Plus the two female ninjas are comic book divas come-to-life. The weakest link is **Masato Gunji** as devilman Hansaki. Although he *does* scary things, this villain is never very scary.

Other films in the series:

▶ SEX BEAST ON CAMPUS 2:
 BIRTH OF THE DAUGHTER
 WITH DARK SPIRIT (1995)
[Inju Gakuen 2: Masho No Ko Tanjo]

director: **Kaoru Kuramoto**
Sayo Hidaka ● **Mami Jo**
**

Female ninja Miko (**Sayo Hidaka**) returns to fight another beast from the darkside, a female gym teacher who's possessed by the devil. This time, she has a new partner, **Mami Jo**, an expert in exorcism arts.

❖

▶ SEX BEAST ON CAMPUS 3:
 FEMALE NINJA
 HUNTING (1996)
[Inju Gakuen 3: Kunoichi-gari]
director: **Kaoru Kuramoto**
Sayo Hidaka Mami Jo
**½

The plot is almost non-existent, replaced by a steady supply of kinetic action, protruding tentacles, and impressive explosions. Five female ninjas join forces against the dreaded Sex Beast. Soon they discover the creature is merely a puppet manipulated by the Devil himself from his throne in Hell.

▶ SEX BEAST TEACHER (1995)
[Inju Kyoushi]
 aka **BEAST TEACHER**
 aka **ANGEL OF DARKNESS**
director: **Mitsunori Hattori**
Akira Seo ● **Ayu Shinohara**
❖

▶ SEX BEAST TEACHER 2 (1995)
[Inju Kyoushi 2]
director: **Koji Shimizu**
Rika Mizutani ● **Mayu Nakata**
❖

▶ SEX BEAST TEACHER 3 (1996)
[Inju Kyoushi 3]
director: **Mitsunori Hattori**
Kanori Kadomatsu ● **Rika Mizutani**
❖

▶ SEX BEAST TEACHER 4 (1996)
[Inju Kyoushi 4]
director: **Mitsunori Hattori**
Chiyuri Matsuda Marina Yabuki
 ☐ *pick your own rating*

These live-action films, based on an animated series by the same name, *Inju Kyoushi,* are part of a very specific erotic/scifi genre known as *Tentacle Movies*. Initially, they were probably inspired by *H R Giger*'s artistic concepts for the *Ridley Scott* film, Alien (1979). But a more direct correlation can be made to *Hideki Takayama*'s adult-oriented animated series, Urotsukidoji (1987), in which the Earth is besieged by an army of beast-world demons who rape hundreds of nymphets. These marauding creatures violate every orifice of their nubile victim with a network of "tentacles" which — more than coincidently — resemble turgid penises. Most likely, the *tentacle* concept became popular because of Japan's strict censorship laws. While depiction of genitalia was banned (both in animation and live action), the producers could get away with an alien's tentacle — which happened to look a lot like a penis — as it invaded a young starlet's mouth. When the censorship laws dealing with nudity and genitalia were relaxed in mid 1996, it's not surprisingly that the demand for "tentacle movies" also subsided.

The Sex Beast Teacher series is a mixture of high school histrionics with sex-fantasy rape-n-mayhem. Each entry deals with a teacher who is either: 1) a demon in disguise {as seen in the first and fourth entries}; or 2) possessed by a demon {the second and third episodes}. Director Hattori, best known for Hunting Ash (arguably the first live-action *tentacle* movie, 1992) made three of the four features, but he didn't make the best one. Those honors go to newcomer Koji Shimizu who, in #2, managed to insert a substantial plot into the hyper special FX. In this one, a female teacher (Mayu Nakata) develops a parasite in her body after drinking contaminated water inside a cave during a hiking tour. She becomes a lesbian super-sex creature who feeds off the girls in her high school until one of the students finds an antidote for the beastie virus.

SEX CRIMES (1967)
[Seihanzai]
director: Koji Wakamatsu
Ken Yoshizawa • Miya Kozuki
Ryosuke Uriu • Hatsuo Yamatani
*½

This is filmmaker Wakamatsu's project just prior to his notorious Violated Angels (1967), and one of 8 motion pictures directed that year for his own studio, Wakamatsu Productions {see When Embryo Goes Poaching for overview}.

It's a haphazard thriller about a young caretaker (Ken Yoshizawa) at a snooty summer resort who rapes and sexually assaults a number of guests before he accidentally blows himself up in the tool shed.

SNAKE GIRL AND THE
SILVER HAIRED WITCH (1968)
[Hebimusume to Hakuhatsuma]
director: Noriaki Yuasa
Yachie Matsui • Mayumi Takahashi
Yoshio Kitahara • Yuko Hamada
*½

Director Yuasa will always be remembered as a *poor man's Ishiro Honda*, cranking out seven Gamera movies for *Daiei Studios* between 1965 and 1980 {see separate listing}. During his tenure with the flying turtle, he also helmed a few other studio projects. This one, essentially a stab at a fairy tale, met with both critical and consumer disfavor. The tale of two sisters, Sayuri and Tamami (Yachie Matsui and Mayumi Takahashi), and their pact with the Sun Goddess is too confusing for children and too cliched for adults.

Surrounding all the shift-changing (poorly executed stop-motion transformation scenes) there's a message about family values and the golden rule. But the biggest problem lies with the script itself, loosely based on a traditional Japanese folk tale. The two sisters (the Snake Girl and Silver Haired Witch of the title) are forced to become enemies to satisfy the "cosmic plan of the universe;" however, they eventually join forces to defeat the evil Shige Kito (**Sachiko Meguro**).

Twenty-five years later **Mayumi Takahashi** would grow up to become the buxom nurse in **Keko Mask** (1991). Yuchi Matsui, on the other hand, seems to have disappeared.

SIBERIAN SUPER EXPRESS (1996)
[Shiberia Chotokkyu]
aka **SIBERIAN MYSTERY TRAIN**
director: Haruo Mizuno
Rino Katase • Takanori Kikuchi
**

In this variation of *Agatha Christie*'s **Murder on the Orient Express**, a series of baffling murders occur on a Siberian train circa 1938. When Japanese military officers come under suspicion, General Yamashita (played convincingly by director **Haruo Mizuno**) conducts his own investigation. The series of slayings begins with a Russian officer getting poisoned. His death is followed by the "disappearance" of two women, one Chinese and another Dutch, who are suspected of being spies. Things get hot when a British ambassador is found dead from multiple stab wounds. This traditional *locked door* who-dun-it culminates in a conflict between military detective Yamashita and a sinister assassin (incidentally, on a spy mission from Hitler).

With this venture, filmmaker Mizuno — a former movie critic in Japan — finally achieves his dream of directing

Siberian Super Express

his own film. Despite a convenient amount of historical "white-washing" dealing with Japan's hawkish attitude toward the imminent World War, the film received favorable reviews and enjoyed a successful run at the box office. Most of the script, also penned by the director, is in English language. It played in Japan with subtitles.

SIREN
see **SORCERESS LEGEND**

SM SE7EN (1996)
[Kaori Ohnuki's SM Se7en]
aka **KAORI OHNUKI'S SM SE7EN**
director: Makoto Kimura
Kaori Ohnuki • Kana Fujitani
*

Nothing is sacred. This irreverent parody was inspired by *David Fincher*'s **Se7en** (1995), a major hit in Japan ranking in the Nippon Top Five grossing films of 1996. However, this sadistic *sequel* did not fare nearly as well, despite a well-financed advertising campaign.

Kaori Ohnuki, the self-proclaimed queen of S&M, is the government's Mistress Inquisitor in charge of punishing a serial killer who committed crimes based on violating of the Seven Deadly Sins. Her torture tactics also reflect the same Deadly Sins.

Cheaply made junk that does little more than prove **Kaori Ohnuki** is getting too old for this kind of thing.

SNAKE GOD'S TEMPLE (1960)
[Hebigami Maden]
director: Eiichi Kudo
Keinosuke Wakasugi • Keiko Fujita
**

Based on a mystery novel **Snake God** written by *Akimitsu Takagi*, there's a rash of bizarre murders in historic Edo. Black-masked assassins are attacking affluent merchants and their families. No one is safe; everyone is slaughtered. The townspeople begin whispering about the deaths being caused by the curse of the Snake God. But municipal detective Prince Iori (**Keinosuke Wakasugi**) and his assistant Oren (**Keiko Fujita**), a notorious female pickpocket, unearth the real truth and it has nothing to do with the supernatural. Or a snake god.

SNAKE LUST (1967)
[Jain]
director: Haku Komori
Rika Mizuki • Machiko Sakyo
*(or *½)

Koei Studios strikes again with another misogynistic erotic horror tale (*i.e.,* **Virgin Cruelty**, **Ten Years Of Evil**, **Bed Of Violent Desires**, *et al*). This time there's a woman (**Rika Mizuki**) who is sexually satisfied by a very large snake. A wannabe suitor decides to kill the snake in hopes that the lustful woman will share her bed with him. He does; but she won't. The ghost of the snake settles the score.

SNOW GIRL
see **GHOST STORY OF THE SNOW GIRL**

SOLAR CRISIS
see **CRISIS 2050**

SOME STORIES OF ADULTERY: LOVE DREAM (1967)
[Aru Mittsu: Shikimu]

director: Shinya Yamamoto
Michiyo Mako • Yuichi Minato
**½

In 1967, *Nihon Cinema* produced an erotic trilogy, encompassing this film plus **Beauty And Ugliness** [*Bi to Shu*] and **Lipstick** [*Kuchibeni*] {see *Japanese Cinema Encyclopedia: The Sex Films* for additional information}.

Of the three entries, **Love Dream** (the second) is the only one which delves into the horror/fantasy genre. It tells the story of Beauty (**Michiyo Mako**), the child of a supernatural coupling between moonbeams and a rabbit. She meets a married man (**Yuichi Minato**) who is obsessed with her. They begin a cautious affair after Beauty warns the man "never to look at the forbidden area of her body." He promises, but then snatches a peek anyway. His gruesome death is instantaneous.

An unassuming tale, charming in its simplicity. Both of the key players and director **Yamamoto** went on to become familiar names in *Nikkatsu*'s *pinku eiga* arena.

SON OF GODZILLA (1967)
[Gojira No Musuko]
director: Jun Fukuda
Tadao Takashima • Akira Kubo
Beverly Maeda • Akihiko Hirata
*½

There's multiple monsters plus Baby Godzilla, but it was never intended for an adult audience. Due to the growing success of the competition (*i.e.,* *Daiei*'s **Gamera** and *Nikkatsu*'s baby Gappa in **Monster From A Prehistoric Planet**) Toho Studios beefed up this entry with more elaborate special effects, including a rather impressive giant spider and praying mantis. And then they added a tyke Godzilla with big "love-me" eyes and a face that looked like it was smashed by a baseball bat. Godzilla and son talk to each other in this one, but

baby Godzilla blowing smoke rings

not with *real* words (like in **Godzilla's Revenge** [1969]), here they use nonsense syllables. Regardless, the whole thing is hokum but the kids love it.

Original Godzilla director **Ishiro Honda** was still missing-in-action. The official word from *Toho* executives stated: Mr Honda had begun working on new ideas for television programs. In fact, Honda directed **Mirrorman** and many **Zone Fighter** episodes between 1969-1973.

English actress **Beverly Maeda** stayed in Japan where she continued working for *Toho*. She made **Perfect Shot** *(Hyappatsu Hyakuc-ku),* also directed by **Jun Fukuda** in 1968 (released under the international title **Golden Eye** *[Oogon No Me]).* Beverly is also featured in the *Comedy Time* series *(Kigeki),* an episode called **Station Front Plaza** (1968) directed by **Tatsuo Yamada**. Apparently, she retired from acting after that venture.

SORCERESS LEGEND:
SIREN (1996)
[Youjo Densetsu: Siren]
director: Iwao Takahashi
Saori Kozuka • Naomi Morinaga
*

Men are disappearing and the police remain baffled. None of the victims seem to have anything in common, yet they have all vanished — inexplicably — while relaxing in their homes. The culprit is a sex-seductress who contacts men through the Internet and then sucks them into the computer.

Farfetched and nonsensical. Plus **Naomi Morinaga** continues to stumble all over herself, lacking even the most minimal of acting ability. She's even more dreadful here than in **Victim** (1995), if that's possible Perhaps, someday there will be a terrific *computer oriented* horror film. But this isn't it.

SPACE CARGO:
REMUNANTO 6 (1996)
[Uchu Kamotsusen: Remunanto 6]
director: Kunitoshi Manda
Takeshi Yamato • Shoko Tamura

Director **Manda**, after his tenure with the Japanese cable TV network WOWOW, debuted on the big screen with this scifi actioner. After two years on the drawing table – during which time **Manda** and his staff drafted an elaborate genealogy and designed an

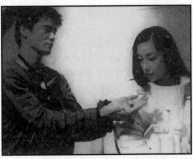

Space Cargo: Remunanto 6

intricate *logical* futuristic civilization— the picture went into production, supported by a huge budget and extended shooting schedule.

A space cargo rocket, returning to Earth from Mars, is crippled by a major collision with meteorites inside an asteroid belt. The ship, leaking oxygen and fuel, is irreparable; it's a virtual time bomb waiting to explode. Every second is precious for the six surviving astronauts in this outer space *Die Hard*, as they defy the odds in a daring escape attempt. And, typical for this type of disaster flick, not all of them make it.

The story is basic — even simplistic — saved almost singlehandedly by a unique collection of colorful, well defined characters. But most audiences won't give a damn about them or their personal problems. They'll be more enchanted with the hi-tech computer graphics. Some scifi fans will insist "the special effects steal the show."

SPIDER MAN (1958)
[Kumo-otoko]
 aka **RAMPO'S SPIDER MAN**
director: Hiroyuki Yamamoto
Susumu Fujita • Joji Oka
**

A thriller based on a novel by Edogawa Rampo about a villainous spider man who kidnaps beautiful girls. Detective Kogoro Akechi (this time played by **Susumu Fujita**) solves the mystery and saves the day, rescuing the girls and their honor in the nick of time.

The movie was heavily criticized for miscasting burly **Fujita** in the role of Detective Akechi, instead of a more conventional lean actor, like **Eiji Wakasugi** who portrayed the sleuth in many features including **Boys Detective Team** (1954) {*e.g.*, by comparison, the situation would be similar to **John Candy** playing *Sherlock Holmes*}.

SPIRIT (1996)
[Shinrei]
director: Junji Inagawa
 and Masayuki Miyake
Junji Inagawa • Yumi Ohta
**

An omnibus film which consists of three *true* stories of the occult, capitalizing on **Junji Inagawa**'s notoriety as "tourguide to the darkside," a reputation garnered from years of TV *ghost-hunting* reports on *Occult Corner*. Here, once again, he's the underworld barker, albeit this time he's showcasing stories which tend to be a bit more compelling than the lightweight froth seen on his television outings..

The first story, *Ex Military Hospital*, takes place at a Japanese clinic, formerly the site of a WW2 military hospital. Lots of torturous experiments went on there. Today, the ghosts of the dismembered victims are attacking young nurses. Believe it or not. The second one, *The Drowning of The Surfers*, examines "what really happened" to an unusually high number of surfers who continue to meet death on Shonan Beach. Both of these episodes were directed by **Masayuki Miyake**.

The third and most ambitious of the entries, *Headless Jozo Statue*, was directed by **Junji Inagawa** himself. It tells the *real story* behind a medieval legend — the curse of the god Jozo and how he lost his head. Seemingly, a poor struggling mom makes a bet with a wealthy businessman that she can snatch the head from a statue in the cemetery. But, as it turns out, she comes back with more than a bag full of cement chunks.

**SPIRITUAL REPORT: OCCULT
 SHOP FROM HELL** (1996)
[Jigoku-do Reikai Tsushin]
director: Hiroyuki Nasu
Suzunosuke Tanaka • Ryuta Ohtake

Takamasa Nakayama • Hirotaro Honda
∗∗½

Splatter

Technically this film is based on a best-selling Japanese children's novel, but it's still little more than an unabashed ripoff of **Ghostbusters** (1984). It all starts creatively enough when three wild kids are pursued by a monster called Nukekubi *(The Head)* after they happen to witness a suicide. The boys scramble over to an occult shop for help. There, the owner gives the kids exorcism tools which, when used properly, will send any threatening spirits back to the other-world. After they successfully zap monster Nukekubi, the three cocky lads decide to become professional Ghostbusters. They take an array of jobs, meeting and destroying lots of ghostly creatures. The highlight of the film is a battle a-gainst the God of Death, a monster who has taken possession of a golf course.

Surprisingly, this movie was critical-ly acclaimed, praised mostly for its "bold storyline" and stylish visual effects, two qualities usually not associ-ated with kiddie flicks. Of course, many of the more conservative critics condemned the film for it's "sleazy and scary subject matter." Eirin (the indus-try "watchdog" rating board) refused to issue a "G" rating; they passed the movie as an "R" (restricted: 16 and older). The tougher rating, however, did not keep the film from becoming a box-office winner.

SPLATTER (1995)
 [Megyaku]
 aka **NAKED BLOOD**
director: Toshiyasu Sato
Misa Aika • Sadao Abe
∗∗½

A boy genius (**Sadao Abe**), following the scientific theories outlined by his deceased father, develops a new medi-cine called Myson. This drug will turn

pain into pleasure. In fact, the more pain, the greater pleasure.

Aika tests the drug on three unsus-pecting girls. Two of them resort to various levels of self mutilation, includ-ing the movie's most notorious scene which features pretty Akiko (**Mika Kirihara**) slicing and devouring the lips of her vagina and nipples from her breasts. Then in a bloody frenzy, she pulls out her eyeball and eats it as well.

The third girl (**Misa Aika**) convinces Aika to join her in a heightened round of virtual sex-reality which concludes in yet another splatter bonanza. It's not great filmmaking by any definition of the term (although director **Sato** did perfect his craft in the years to come, responsible for such fare as **In The Thicket** [1996]). This one is a gore fest, pure and simple. But as such, it's shoul-ders above swill like the **Guinea Pig** series {see separate review}; however there's still little to recommend. The special effects are competently handled and they certainly rate high on the gross-out level. But the story takes itself way too seriously, actually bor-dering on the metaphysical. Exactly who is the intended audience here?

SPLIT MOUTH WOMAN (1996)
 [Kuchisake Onna]
director: Teruyoshi Ishii
Teisui Ichiryusai • Naomi Hagiwara
∗∗

Teisui Ichirysai is the narrator for this omnibus film dealing with "true" stories of the split-mouth woman, a notorious monster in Japanese urban folklore similar to America's bogeyman. The split-mouth woman is a succubus who keeps the lower part of her face hidden behind a veil. She seduces her victims with her eyes and body, asking: "Am I not beautiful?" But then she drops the mask to reveal her hideously distorted mouth. Seemingly, from the 3-stories-in-1 construction of this film, even director Ishii realizes there's not much substance to this villainess. Clever makeup and special effects, not much else.

SPOOK WARFARE
see BIG MONSTER WAR

STORY OF THE
 BAMBOO HUNTER (1987)
[Taketori Monogatari]
director: Kon Ichikawa
Yasuko Sawaguchi • Toshiro Mifune
Ayako Wakao • Kiichi Nakai
*½

Princess Kaguya, the legendary Japanese fantasy tale, is turned into a most improbable SciFi actioner by one of the industry's foremost directors. Initially, Ichikawa established himself with powerful anti-war films (i.e.,

Story Of The Bamboo Hunter

Stranger In Her Eyes

Harp Of Burma [1956], Fire On The Plains [1959], et al) and then in the 70s he took detective stories beyond the point of tedium with his Kosuke Kindaichi (from the heights of The Inugami Family [1976] to the depths of Queen Bee [1978]). During the '80s, he flirted with new interpretations of famous folk tales {also see Crane [1988]} but he failed to duplicate the success of his earlier projects. Most critics were quick to label the Ichikawa fantasies as "beautiful failures."

In this one, an old farmer finds a young girl inside a golden bamboo shoot. He and his wife raise the girl but are amazed at how quickly she grows to maturity. Eventually a prince visits the homestead and falls in love with the Bamboo Beauty. However, the girl says there's no time for romance because she must return to her home on the moon. In this version of the story, an alien spaceship actually lands, and angels escort Princess Kaguya back home.

STRANGER IN HER EYES (1977)
[Hitomi No Naka No Houmonsha]
director: Nobunhiko Obi Ohbayashi
Nagisa Katahira • Jo Shishido

An ambitious film based on Black Jack[1] gekiga series written by Osamu Tezuka, the superstar illustrator/ scripter long considered the god of the manga writers.

In this story, a beautiful woman (**Nagisa Katahira**) loses her vision in an automobile accident. Dr Black Jack conducts an "unscrupulous" operation replacing her cornea with that of a girl recently drowned in a lake. Soon after the operation, with her sight restored, the woman gets overlapping visions of a mysterious man who seems bent on killing her.

Was it merely a coincidence that *Irvin Kershner*'s **Eyes Of Laura Mars** (1978) appeared a year later? Or how about the remarkably similar **Blink** with **Madeleine Stowe** in 1994?

¹*Black Jack* is a multi-volume comic book, designed primarily for adults, telling the story of a brilliant blackmarket doctor who takes cases which the reputable medics won't touch. The *Black Jack* character became the subject of an official motion picture series in 1996 {see separate listing under **Black Jack**}.

SUBMERSION OF JAPAN (1973)
[Nihon Chinbotsu]
U.S. edit: **TIDAL WAVE**
director: Shiro Moritani
Tetsuro Tanba • **Yusuke Takida**
Hiroshi Fujioka • **Ayumi Ishida**

Audiences are initially drawn to this *disaster picture* with anticipation of vol-canos, earthquakes, tidal waves, explosions, tumbling buildings, and general mayhem-in-the-streets. The preconception is a Godzilla movie without Godzilla.

But quickly the viewer realizes the special effects, as good as they may be, play a supporting role to the real story here. This is an ugly parable vividly exposing Japan's distrust for the rest of the world and the inevitable results from their noble desperation.

The facts are simple. The country of Japan is sinking. It's not noticeable at the moment, but every few years this island nation is losing a couple inches of beach real estate. And now the underwater mantle supporting the foundation of Japan is shifting. It can't be stopped. There is no doubt, this country will sink into the Pacific Ocean.

Now what? What decisions can the prime minister of Japan make? Even if it were possible to evacuate 100 million people, where would they go?

When the Prime Minister Yamamoto contacts world leaders to see how many Japanese citizens they would each be willing to take, the Earth becomes a very cold place. The ambassador from

Submersion Of Japan

Australia even says: "If we have to accept Japanese things, I'd prefer them to be art treasures rather than people." A British representative observes: "If we take 5 million Japanese immigrants, they will simply used our land and resources to build themselves another country."

As Yamamoto (**Tetsuro Tanba**) contemplates declaring a territorial war on Africa, volcanos are erupting, the international airports of the world are closed to Japanese flights, dangerous ocean swells are keeping all vessels in port, and citizens continue to riot in the streets. This is a terrifying vision of the world.

A decidedly less terrifying vision was released in America as **Tidal Wave**. This 82 minutes edit (trimmed down from the original 137 minute print) is missing all the subversive political text and scientific jargon. Instead, it features awkward inserts with **Lorne Greene**, from *Bonanza* fame, as a concerned politician.

▶ SUKEBAN DEKA (1987)
 [Sukeban Deka]
 translation: **Bad Girl Detectives**
director: Hideo Tanaka
Yoko Minamino • Akie Yoshizawa
Haruko Sagara • Yui Asaka
Hiroyuki Nagato • Nagare Hagiwara
***½

Sukeban Deka 2

▶ SUKEBAN DEKA 2:
 ZaZOOM (1988)
 [Sukeban Deka:
 Kazama Sanshimai No Gyakushu]
 translation: **Return of the Kazama Sisters**
director: Hideo Tanaka
Yui Asaka • Yuka Ohnishi
Yumi Nakamura • Masaki Kyomoto
Hiroyuki Nagato • Minako Fujishiro

❖

▶ SUKEBAN DEKA 3
 SPECIAL ASSIGNMENT:
 8 TRAPPED SPIRITS (1992)
 [Sukeban Deka III Shoujo Ninpo-cho
 Denki: Hattsu No Shi No Wana]
 translation: Sukeban Deka 3:
 Legend of Female Ninja Magic
 [Eight Fatal Traps]
director: Hideo Tanaka
Yui Asaka • Yuka Ohnishi
Yumi Nakamura • Kazue Ito
Hiroyuki Nagato • Nagare Hagiwara

This collection of feature films was born from a long-running *Fuji* television series, also entitled *Sukeban Deka* (1978-1986). Director **Tanaka** knows the *Deka* world better than anyone. He co-wrote most of the entries and directed every episode, TV and feature film, from the inception.

The first Deka girl was **Yuki Saito**; many fans of the series still swear she was the best. She left the TV program in 1982 to pursue a singing career. **Saito** became one of *Pony/Canyon*'s hottest artists, especially known for her big-production music videos (*i.e.*, the 1991 song **Love Destiny** was supported by a half-hour million dollar clip).

Yuki Saito was replaced by **Yoko Minamino** who added a melancholy somberness to the series. Whereas **Saito** always looked like a girl getting ready to attend a friend's slumber party, **Minamino** was a poor soul without any friends. She is the demure

Yoko Minamino fights a cyborg school-headmaster in *Sukeban Deka*

loner. In fact, one flashback episode of the TV series (**Why? Thunderstorm! Story Of The Metal Mask** [1983]) shows Saki (**Minamino**) being forced to wear a permanent hockey-type mask through-out her childhood so that she isn't recognized by the gangsters who killed her father. "I didn't know what happiness was. A child in a mask has no friends... the only thing I learned was how to fight with other kids," laments poor Saki.

By the time she gets to high school, the cops have caught the bad guys and she is permitted to remove the metal mask. Saki is approached by the head of a special police division (played by **Hiroyuki Nagato** throughout both TV and movie versions) and recruited into the *Sukeban Deka* unit. This is a highly secretive group of girl detectives who "don't live the normal life of a teenager. Instead, they are dedicated to fighting for law and order." Most of their cases deal directly with *teenage* problems like drugs, gangs, thievery, rumbles, student unrest and sometimes, a megalomaniac part-cyborg principle

who wants to take over the world with his army of lobotomized teen soldiers (*feature film #1*).

The *Sukeban Deka* girls are armed with a deadly weapon, a yo-yo. Not just any kind of yo-yo (although in **#1**, Saki does convert an average street-vendor yo-yo into a lethal tool) but these are "metal razor yo-yos." And the girls have learned special throwing techniques, standing positions, and hand movements for optimum efficacy. The whole thing is *too* cool, especially when combined with **Ichiro Nitta**'s flamboyant *James Bond* derivative soundtrack.

The TV series closes with Saki (**Yoko Minamino**) retiring from the squad, anxious to fit into "the real world, the normal world." She followed the footsteps of predecessor **Yuki Saito** and pursued a singing career (with *Sony Records*). **Toei** lured her back into uniform with the first theatrical version of **Sukeban Deka**. She was reluctant and made her resistance obvious through the tailor-made script which concludes with her boss saying: "This time, Saki— for real. Goodbye."

The studio pulled no punches. They were positive that **Minamino** would not be back for any of the proposed sequels, so they took the opportunity to introduce her replacement, **Yui Asaka**. Yui joins the action halfway through **#1**. She is introduced as a Deka girl from a different prefecture. Although tiny, she quickly becomes the focal ready-to-fight character, a *loose cannon* of sorts. Yui is a spunky militant, with seemingly less compunction than her cautious mates. She continues as the lead in both **#2** and **#3**, although her fiery personality is toned down considerably.

#1 tells the story of a powerhungry cyborg/fanatic who has taken over a juvenile detention center. Through brutal training and mind altering experimentation, he is grooming the young delinquents for a political insurrection. The Deka girls attempt to break into the fortress and rescue student prisoners.

#2 deals with a secret police gestapo-type organization headed by the impossibly handsome **Masaki Kyomoto**. Their goal is to create anarchy in the Japanese streets and then usurp the government's authority, thus taking over the country. The highlight of the film is at the conclusion when Yui, armed with her trusty yo-yo, knocks the bad guy's airplane out of the sky.

#3 mixes black magic with inner departmental squabbling, as Yui accepts an assignment against a devil-worshipping terrorist group and also must contend with an overly aggressive female superior. Unlike the first two, this one has an open-ended conclusion which would indicate more to come in the series.

The *Deka* success has inspired a number of unofficial spinoffs including **Sukeban Mafia: Dirty Insult** (1980) and **Female Neo Ninjas** (1991) to name but two. Some *Deka* historians believe

the series was originally an offshoot of *Toei*'s juvenile delinquency anthology called **Sukeban** (1969-1974), but it actually was born from a manga. **Shinji Wada** created the concept with his *girl* comic periodicals **Sukeban Deka Tales** (begun in 1972).

There is a sequel of sorts, also directed by **Hideo Tanaka**, called **Girl Cop** (1993) {see separate review in *Japanese Cinema: Essential Handbook*}. It features **Yuka Ohnishi**, one the Deka side-girls [*Kazama Sisters*] from feature films **#2** and **#3**.

The TV shows from 1983-88 and all three movies were written by **Izo Hashimoto**, the future director of **Evil Dead Trap 2** (1991) and **Bloody Fragments On White Walls** {aka **Lucky Star Diamond**} (1989).

Actress **Yoko Minamino** returned to films in 1991 with **Winter Camellia**, followed by **Whorehouse Women: Fighting For Survival** (1994). To the surprise of her fans, she did nude scenes in both.

SUMMER WITH GHOSTS (1989)
[Ijintachi Tono Natsu]
aka **JAPANESE GHOST STORY**
aka **THE DISCARNATES**
director: Nobuhiko *Obi* Ohbayashi
Morio Kazama • Kumiko Akiyoshi
Tsurutaro Kataoka • Yuko Natori
***½

Director **Obi Ohbayashi** is preoccupied with tales of lost love, both romantic and parental (*e.g.*, **House** [1982] and **Drifting Classroom** [1991]. But this one is his undisputed masterpiece. **Obi** takes a bittersweet story of dead parents attempting to show affection to their living son and combines it with a horrific tale of a spurned lover given a second opportunity to unite with her mate.

A television scriptwriter, the recently divorced Toshi (**Morio Kazama**),

moves to his new apartment. He is not interested in the friendly overtures from a cute but pushy neighbor, and so, he callously rejects her. Feeling sorry for himself, the man visits his hometown of Asakusa. There Toshi meets a young couple who turns out to be the ghosts of his dead parents. At first he's reluctant, but then he accepts their affection completely. In turn, when Toshi arrives back in Tokyo, he begins seriously dating the neighbor (**Yuko Natori**).

Toshi becomes obsessed with the ghosts of his parents, claiming they give him a "new look on life." He's not aware that with each visit he's aging at an accelerated rate. Toshi's girlfriend begs him to "kill" their memory. Eventually, he does. But when he returns home, Toshi discovers an even more terrifying secret. The film, which had been unraveling in a comfortable almost melancholy fashion, suddenly turns very ugly. The bloodbath finale is quite effective, probably because is it so unexpected.

SUPER COMING (1995)
[Super-Coming]
director: Hiroaki Tada
Chapman • Kera • Tomoroh Taguchi
Misato Yonehara • Shinko Hiro
***½

If there's one film that has universally garnered unmitigated raves from the Japanese cult audiences, this is it. Director **Tada** has created an irreverent religious parody, sprinkled with fantasy and horrific overtones. He's added some very chic black humor, and delivered the whole project as a *musical.* Now, granted, this isn't the first time it's been done. Tada was undoubtedly influenced by **Rocky Horror Picture Show** (1975). But **Super Coming** is as important to the Japanese counter-culture movement as *Rocky Horror* was to the midnight movie boom in America.

There's a monster known as Super Coming predestined to lead the world to its fiery end, thus fulfilling the ancient prophecies of the religious fundamentalists. This movie begins in 1998 when

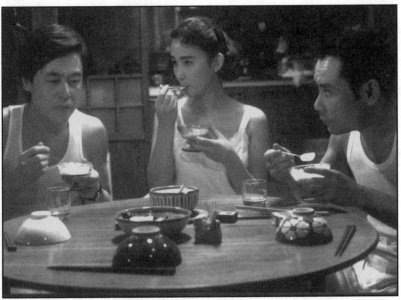

Morio Kazama with his "parents" in *Summer With Ghosts*

Sister Jill (**Shinko Hiro**) finds a baby in a junkyard. As a nun, she is familiar with the Holy Teachings and she believes this child is the one chosen to herald the apocalypse. She names him Chapman (incidentally, the adult Chapman is played by Japanese character actor **Chapman**).

Sister Jill has two other children, Mink (**Misato Yonehara**) and Kerarini (**Kera**). According to the prophesy, Saint Kerarini (think John The Baptist here) will rise among the masses and announce the coming of the new messiah. He leaves home. Kerarini journeys to Tokyorama where he starts wearing dresses and becomes the leading diva in the Grand Opera. Meanwhile his sister Mink finds her mom in carnal embrace with the divine Chapman (apparently he had been her Mother Jill's sex slave for many years). In a fit of anger, Mink chases the "stepson" out of the orphanage. Chapman drifts to Tokyorama where he befriends a ventriloquist. They become a popular comedy act in the city.

The emperor (**Tomoroh Taguchi**) is nervous about rumors "of a new king" spread by Saint Kerarini. He sends his wife to investigate, but she over-reacts by torturing and killing the Opera superstar. News of Kerarini's death, infuriates Chapman. He contacts his mother and asks her to come to Tokyorama. Chapman then rises against the emperor who tries to kill him with a silver sword. But the magic blade transforms Chapman into a fire monster. In the midst of the battle, the emperor dies from a heart attack.

At the same time, Sister Jill prays over the body of Saint Kerarini. He awakens from the dead. But, in a moment of confusion, Kerarini strangles his mother. At the point of death, she reaches an orgasm which causes a "disturbance in nature's chain." The end of the world is very near. Chapman, now the full-fledged Super-Coming monster, leads his parade of disciples into heaven.

Let's do the Time Warp tonight.

Spacegiant

SUPERGIANT (1956-1959)
[Supergiant] 9 serial episodes

Obviously inspired by America's **Superman**, this one tells the story of a superhero who fights everything from space aliens to giant rubber monsters.

Nine chapters, each running approximately 40 minutes, were released theatrically as open-ended serials [cliffhangers] between 1955-1959. These featurettes were then edited into four full length productions. The first, **Appearance of Supergiant** (1956), combined Episode #1 [*Supergiant*] and #2 [*Supergiant Returns*]. This was followed by **Attack of the Flying Saucers** aka **Atomic Rulers of the World** (1957), which consisted of Episode #3 [*Alien's Magic Castle*] and #4 [*Last Minutes Of The Holocaust*]. The next official release in the series was **Supergiant vs the Satellites** (1964), an edited version of Episode #5 (*Satellite And The End Of The Human Race*) and #6 (*Crash Of The Mothership And The Satellite*). The final entry, **Brain From Outer Space** (1965), is a 146 minute opus consisting of Episode #7, 8 and 9 (*Appearance Of The Space Phantom, Transformation Of The Devil* and *Kingdom of the Poisonous*

Moth), completed in 1959. **Ken Utsui** plays the no-nonsense, indestructible superman for each of the nine episodes, all directed by cult filmmaker **Teruo Ishii** who later found fame in the murky world of Japanese *ero-gro* (erotic/grotesque) pink films {*i.e.*, **Joys Of Torture** series 1968-1973}.

Here is a list of the individual entries, later edited into feature films:

▶ **Supergiant** (1957)
[Supergiant] 49 minutes
director: Teruo Ishii
Ken Utsui • Junko Ikeuchi

▶ **Supergiant Returns** (1957)
[Zoku Supergiant] 52 min
director: Teruo Ishii
Ken Utsui • Junko Ikeuchi

▶ **Supergiant:**
Alien's Magic Castle (1957)
[Supergiant: Kaiseijin No Majou] 48 min
director: Teruo Ishii
Ken Utsui • Masao Takamatsu

▶ **Supergiant: Last Minutes of the Holocaust** (1957)
[Supergiant: Chikyu Metsubo Sunzen] 39 min
director: Teruo Ishii
Ken Utsui • Noriko Katsuma

▶ **Supergiant: Satellite & the End of the Human Race** (1957)
[Supergiant: Jinko Eisei To Jinrui No Hametsu] 39 min
director: Teruo Ishii
Ken Utsui • Utako Mitsuya

▶ **Supergiant: Crash of the Mothership and Satellite** (1958)
[Supergiant: Uchutei To Junko Eisei no Gekitotsu] 39 min
director: Teruo Ishii
Ken Utsui • Utako Mitsuya

▶ **Supergiant: Appearance of Space Phantom** (1958)
[Supergiant: Uchu Kaijin Shutsugen] 45 minutes
director: Akira Mitsuwa
Ken Utsui • Chisako Tabara

▶ **Return Of Supergiant: Transformation of the Devil** (1959)
[Zoku Supergiant: Akuma No Keshin] 57 min
director: Nagayoshi Akasaka
Ken Utsui • Reiko Seto

▶ **Return of Supergiant: Kingdom of Poisonous Moth** (1959)
[Zoku Supergiant: Dokuga Ookoku] 57 min
director: Nagayoshi Akasaka
Ken Utsui • Terumi Hoshi

SUPERGIRL REIKO (1991)
[Choshoujo Reiko]
director: **Takao Ohgawara**
Arisa Kangetsu • Ken Ohsawa
*

This is an attempt to combine *Sukeban Deka* with the ultra-hip Psychic Horror genre. Yet it fails miserably. Sultry **Arisa Kangetsu** does her best to look like Deka *Yoko Minamino* as she plays a uniform-wearing high-school student who investigates spooky happenings on the campus. Five fellow students join her "ESP Study Group" in an attempt to reverse the bad karma infecting the school after a student kills herself over an unrequited love. But the poltergeist is too much for them. Or so it would seem.

Filmmaker **Ohgawara** joined the *Godzilla* family the following year; he directed **Godzilla Vs Mothra** (1992) and **Godzilla Vs Destroyer** (1995).

SUPER SONIC SPACE PLANE
see **INVASION OF NEPTUNE MEN**

SWALLOWTAIL BUTTERFLY (1996)
[Swallowtail]
director: **Shunji Iwai**
Chara • Ayumi Ito
Hiroshi Mikami • Tomoroh Taguchi
Mickey Curtis • Andy Hui

Chara (center) with Ayumi Ito and Hiroshi Mikami in *Swallowtail Butterfly*

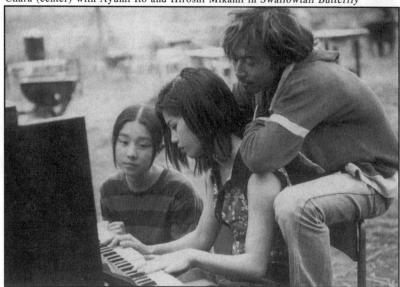

Here's a parable about anarchy and violence in Yentown, a fantasied city in the near future where people live a chaotic, dizzy existence (even their language is a swirl of nonsense, a mixture of Japanese, English and Chinese).

On the outskirts of this vertiginous town, a prostitute named Guriko (**Chara**) and her "family" of outcasts adopts a young girl, Swallowtail (**Ayumi Ito**), after her mom is killed in a drug swindle. Some months later, one of Guriko's brutish clients — a mafia bag man — tries to attack Swallowtail and is pushed out the window to his death. During a makeshift burial in a nearby junkyard, one of the group notices something protruding from the man's ripped stomach. Oddly, the object is an audio cassette with a recording of *Frank Sinatra*'s **My Way**. But even more oddly— they soon discover— the digital pattern on the tape is, in fact, a computer code capable of reproducing a magnetic emblem that converts the value of a 1000 yen bill into a 10,000 yen bill.

The family begins cranking out the bucks. Guriko has always had dreams of being a hit singer. With their new-found wealth they open a nightclub, she puts together a band, and is soon on her way to stardom. As her popularity grows, Guriko is alienated from the rest of the gang and especially from her "sister" who's become bored with the new lifestyle. The girl starts producing illegal bills again (she has a vague plan of buying back the good old days). But the blackmarket yakuza — a bunch of schizoid nutcases who've been sniffing around since their Sinatra tape initially disappeared — are soon on the trail of Swallowtail and Guriko.

Some incredible photography by cinematographer **Norboru Shinoda** elevates the kinky *Streets Of Fire* theme to the realm of high art. Especially remarkable is a breathtaking, free-form scene when Swallowtail is tattooed by the alley doctor (played brilliantly by veteran actor **Mickey Curtis**). Cameraman **Shinoda** has assisted award-winning director **Iwai** since the beginning, from

Undo (1994), through Love Letters (the best film of 1995) and on to Picnic (1996). They are, perhaps, the best team in Nippon cinema. This three hour film is their crowning achievement.

Swallowtail has a *love-it* or *hate-it* reputation. Essentially, in Japan, it's used as a barometer of whether somebody is "young or old," "*with-it or not.*" The movie is the Nippon *Pulp Fiction*, embraced by the youth, the in-crowd, and the country's hipper critics.

Chara, who also starred in Iwai's previous film *Picnic*, is an established Japanese singer/performer. She has released six albums for *Sony Records*, three of which have gone gold. She also sings a number of songs in this film.

SWAMP OF CORPSE CANDLES
see GHOST STORY: SWAMP OF
THE CORPSE CANDLES

SWEET HOME (1989)
[Suiito Homu]
director: Kiyoshi Kurosawa
Nobuko Miyamoto • Juzo Itami
Shingo Yamashiro • Nokko

A deluxe horror film with special effects by award-winning Dick Smith (*Scanners* [1981], *Taxi Driver* [1976], *The Exorcist* [1973], *The Godfather* [1972] *et al*). A mansion owned by dead artist Ichiro Mamiya is haunted. Or is it? That's the question on the minds of a TV news crew when they go to investigate. From the time these guys

Sweet Home

arrive at the house it's non-stop action with a ton of white-knuckle scares. This is the ultimate "house possession" flick. And it's unthinkable that this top-notch film isn't readily accessible to horror enthusiasts in the USA. It's got everything. Explosions. Melting faces. Monsters. Grisly deaths. And at the end, the collapsing floors expose a shaft to hell as the ghost mother herself claws her way towards the stunned survivors.

Nobuko Miyamoto {from Taxing Woman [1988] and Tampopo [1987]} heads an impressive cast which also features her famous director-husband Juzo Itami [who is also this film's producer]. It's directed by Kiyoshi Kurosawa, talented filmmaker who made a number of movies for the Itami production family and acted as Juzo Itami's assistant for the Taxing Woman movies. Young actress Nokko is the familiar star of Keko Mask.

Tetsuro TANBA's GREAT
SPIRIT WORLD series (1980-90)
[Tanba Tetsuro No Daireikai] 3 Episodes
Following the sloven footsteps of Orson Welles (in such *revelational* documentaries as Nostradamus: The Man Who Saw Tomorrow, Late Great Planet Earth, *et al*), famed actor Tetsuro Tanba wears a gravely serious face and examines the ephemeral world of life-after-dead in this series of three films:

▶ *Tetsuro Tanba's* FROM THIS
WORLD TO THE GREAT
SPIRIT WORLD (1980)
[Tanba Tetsuro No Chijo Yori Daireikai]
ORIGINAL TITLE:
SUNA NO KOBUNEL
translation: Little Sand Boat
director: Tetsuro Tanba
and Yuichi Harada
Tetsuro Tanba • Misato Tsuna
and Akihiko Hayashida
**

A 17 year old girl (**Misato Tsuna**) and a 16 year old deaf boy (**Akihiko Hayashida**) discover a small boat stuck in the sand. When they free it, the boat shifts direction and starts moving on its own, heading back into the sea. The two youths jump aboard and suddenly find themselves on a journey through the spiritual dimension, into the world of life after death. Tetsuro Tanba is seen on camera in the beginning and end; he also narrates as the teens explore the *secrets* of Heaven and Hell.

❖

▶ *Tetsuro Tanba's* GREAT SPIRIT WORLD: WHAT HAPPENS AFTER DEATH? (1989)
[Tanba Tetsuro No Daireikai: Shindara Dounaru]
director: **Akira Ishida**
Tetsuro Tanba • Yoshitaka Tanba
Tomisaburo Wakayama • Yumiko Okayasu
**½

This one is based on a script by **Tanba** himself. A young man (played by **Tetsuro Tanba**'s real life son, **Yoshitaka**) dies in an auto accident. *Special hidden* cameras follow him into the afterlife. He travels through the great white light, down a long tunnel, and roams around "Heaven" for awhile before finally returning to the real world. Yoshitaka's "detour with destiny" is treated like a surrealistic sightseeing trip, once again with Dad Tanba narrating the travelogue of the spirit world and beyond.

Some kind critics insisted that the film could be "appreciated as a Beginner's Manual for the philosophies of parapsychology." Many stoic reviewers dismissed it as just "so much religious propaganda" while others wrote: "embarrassing and utterly nonsensical." But unlike **Tatsumi Kumashiro**'s grim view of **Hell** (1979) {see separate review}, Mr **Tanba**'s afterlife paints a unique picture of souls suffering,

describing them as "lost creative dance performers miming their way through life." In the opinion of the authors, this would be an even more unbearable hell than fire and brimstone. Mimes? God forbid.

Ironically, on a grim note, this *view of the afterlife* is the last major film for veteran actor **Tomisaburo Wakayama**. He died at age 62 on April 2, 1992.

❖

▶ Tetsuro Tanba's GREAT SPIRIT WORLD: IT'S AMAZING WHEN DEATH COMES! (1990)
[Tanba Tetsuro No Daireikai: Shindara Odoroita!!]
director: **Mitsunori Hattori**
Tetsuro Tanba • **Yoshitaka Tanba**
Hitomi Nakahara • **Koji Takahashi**
*

Unlike the previous installment which created a somewhat tolerable — if not respectful — view of the afterlife, this sequel takes itself way too seriously. Here's an attempt at human drama which is potentially insulting to any viewer over the age of 10.

A poor sap (once again **Yoshitaka Tanba**) is falsely accused of murdering his wife and he's executed by the State. But after he's dead, Yoshitaka discovers how wonderful the afterlife is! As a ghost, he returns to Earth and finds the man (his attorney) responsible for the original murder. But, unlike many similar Asian ghost stories, he isn't interested in finding the murderer for vengeful purposes. Rather, this ghost returns to

Target: Campus (1981)

thank the killer for allowing him to experience the joys of Heaven prematurely.

As with the previous two entries, **Tetsuro Tanba** wrote the script and narrates the story.

TARGET: CAMPUS (1981)
[Nerawareta: Gakuen]
director: Nobuhiko *Obi* Ohbayashi
Hiroko Yakushimaru • Ryoichi Takayanagi

The Eiko-juku Institution claims to be a "supplementary school," dedicated to giving smart kids that extra education necessary for acceptance to the best colleges. But this school is really a secret organization developing ESP powers in its students. Eiko-juku hopes to control the world with their army of brainwashed students.

In this film, one of institute's subversive girls (played by **Ryoichi Takayanagi**) is dispatched to a normal high school where she is expected to recruit "soldiers" for the forthcoming battle. She locks horns with another psychic girl (**Hiroko Yakushimaru**), resulting in lot of high school pyrotechnics. Mixture of animation and optical computer graphics makes this a successful youth fantasy from *Obi*, but the story is filled with holes. It was remade 16 years later by **Atsushi Shimizu**.

TARGET: CAMPUS (1997)
[Nerawareta: Gakuen]
director: Atsushi Shimizu
Kazumi Murata • Hinako Saeki
**

A direct descendant of **Nobuhiko Ohbayashi**'s film by the same title — but obviously inspired by the success of **Wizard Of Darkness** (1993) and similar fare — as a female agent (**Kazumi Murata**) from a subversive organization controls her high school campus by killing anyone who challenges her

Hinako Saeki in *Target: Campus* (1997)

authority. Another girl (**Hinako Saeki**), who secretly harbors supernatural powers, fights against the popular high school queen. An onslaught of predictable explosions without the endearing *Obi* characterizations.

TARO! TOKYO
MAGIC WORLD WAR (1991)
[Taro! Tokyo Makai Taisen]
director: Teruyoshi Ishii
Yoichi Miura • Hideki Fujiwara
Miyuki Ono • Naoto Takenaka
**

Taro! Tokyo Magic World War

Here's a contemporary SciFi thriller loosely based on *Momotaro*, a traditional Japanese children's story. In this *Toho* version, Taro (**Yoichi Miura**) is a junior high school student who fights against the *Oni* Devil, resurrected by a religious cult. Special effects are astonishingly good, but unfortunately they're limited to the climax of an otherwise dull film.

Teruyoshi Ishii should not to be confused with the other three *Ishii* directors (Sogo, Takashi and Teruo) of considerably more talent. This *Ishii* directed two lesser horror films in 1996, **Horror Newspaper** and **Split Mouth Woman**.

TASTIEST FLESH (1990)
[Gaki Damashii]
director: **Masayoshi Sukida**
Kyozo Nagatsuka • **Ichiro Ogura**
Yosuki Saito • **Kazuyo Matsui**

The biggest negative is it's too damn short. This one clocks in at 70 minutes and it definitely *feels* unfinished. But the premise is so unique, so outlandish that it must be recommended.

While trampling through the wilderness on a news story, a journalist is infected by a tiny alien [ghost] virus. Actually, he has been **impregnated**. Weeks later, after an unusually difficult pregnancy, the fetus pushes up his throat and out the mouth. A baby monster is born! But then, suddenly at the moment of birth, an old man jumps from the shadows, snatches the creature and escapes into the night.

Who is this thief? Some mystical protector? Not quite. Just the opposite. He's a freak who's become addicted to the taste of these little buggers. The plot twists and turns until the old man meets with the once-pregnant guy and introduces him to the *tastiest flesh*. The two begin stalking other "victims."

Eventually, a little creature gets loose in the journalist's house, chases his wife around, and then climbs inside her vagina to hide from the hungry predators.

TATTOOED SWORDSWOMAN
see **BLIND WOMAN'S CURSE**

Teddy Bear From Outer Space

TEDDY BEAR FROM OUTER SPACE (1992)
[Kuma-chan]
director: **Kazuya Konaka**
Masao Kusakari • **Chiharu Kawai**
Tomoroh Taguchi • **Mina Tominaga**
*½

An extraterrestrial, resembling a living teddy bear, looses control of his spaceship and crashes to Earth. Meanwhile, there's a love-sick sculptor (**Masao Kusakari**) who's obsessed with a girl 20 years his junior. But girlfriend **Chiharu** can't decide if such an *autumn/spring* marriage would be a good idea. The cupid teddy bear brings the couple together in marital bliss.

This is a very weak movie for director **Konaka**'s, sorely out of sync with the likes of **Defender** (1996) and **Lady Poison** (1994). It doesn't work as a comedy, opting for the safe road (perhaps it was originally planned as a parody), devoid of any cutting-edge humor. Dark days for accomplished actors **Masao Kusakari** and **Tomoroh Taguchi**.

TEN YEARS OF EVIL (1967)
[Akudama Junen]
director: Haku Komori
Koji Satomi • Kaoru Miya
Noriko Tatsumi • Naomi Tani
**½

Kiei Studios continues their onslaught of sexually oriented "horror" films with this misogynistic story of a Buddhist monk who loses his faith and dedicates his life to carnality. Ex-priest Jikai (**Koji Satomi**) becomes engrossed in sadistic behavior and begins painting pictures of his horrific obsessions. He captures girls to be his models, raping and killing them for inspiration.

Throughout the film, Jikai brutalizes a variety of women, many of whom went on to starring roles in future *legitimate* productions. **Yasuko Matsui** and **Miki Hayashi** became regulars in *Nikkatsu* pink films (including **Eros Schedule Book** {*Matsui*}; **Seduction Of The White Angel** {*Hayashi*}, see *The Sex Films* for further information). **Noriko Tatsumi** starred in *Atsushi Yamatoya*'s crime-noir motion picture **Inflatable Sex Doll Of The Wastelands** (1967). And **Naomi Tani** became the most famous sex starlet of the '70s, often called the *Queen of Nikkatsu Porn*.

Director **Komori** continued to take the low road with such notorious features as **Snake Lust** (1967).

TENTACLE **MOVIES**
see the following:
EXORSISTER
HUNTING ASH
SEX BEAST ON CAMPUS
SEX BEAST TEACHER
WIZARD OF DARKNESS

TERRA SOLDIER: CYBOY (1985)
[Tera Senshi: Sai Boy]
director: Akinobu Ishiyama
Momoko Kikuchi • Hidetomo Iura
 and Naoto Takenaka
*½

Momoko Kikuchi, playing a character named Momoko, is a high school student with psychic powers. One day – quite unexpectedly – she meets a boy from another planet. They instantly "click" and fall in love. For the remainder of the film, Momoko and her alien boyfriend fight against a mad scientist who wants to use the extraterrestrial in an experiment to control the world. Lofty goals indeed.

Escapist fare, constructed solely to revitalize Momoko's tottering singing career. Audiences were underwhelmed.

**TERROR BENEATH
THE SEA** (1966)
[Kaitei Daisenso]
translation:
 Great Battle Under The Sea
director: Hajime Sato
Shinichi (Sonny) Chiba • Peggy Neal
Hideo Murata • Franz Gruber
***½

Toei Studios joins *Toho* and *Daiei* with a monster-fest, decidedly aimed at an adult audience. They also consciously targeted the "International" marketplace by employing an unusually large number of non-Asian actors and by making two different versions of the film, a rougher more violent one for the Japanese release and a softer edit with extended English-speaking performances for the Western screens. Director **Sato** even uses the pseudonym **Terence Ford**[1] for the American release, hoping to convince the cavalier U.S. audience that the film was shot domestically.

The story is a hybrid of *Ishiro Honda*'s **Atragon** and *Jack Arnold*'s **Creature From The Black Lagoon** as a mad scientist creates amphibious gill-men in his futuristic city under the ocean.

If both the Anglo and Japanese versions of this film are available, there

should be no contest over which to choose. The Japanese print maintains a sense of comic-book awe, punctuated by vibrant colors especially when contrasted against the bloody surgical operations and vicious killings. Most of these were trimmed for the shorter American release.

[1]Hajime Sato signed many movies with his real name (*e.g.*, **Ghost Of The Hunchback** [1965] and **Goke: Bodysnatchers From Hell** [1968]) but he used the *Terence Ford* pseudonym for the actioner **Agent X2: Operation Underwater** (1968).

TERROR OF
MECHAGODZILLA (1975)
[Mekagojira No Gyakushu]
aka **ESCAPE OF
MECHAGODZILLA**
director: Ishiro Honda
Katsuhiko Sasaki • Tomoko Ai
Akihiko Hirata • Tadao Nakamura
**

Unfortunately, director **Honda**'s last Godzilla film is just one more excuse for grown men to wear rubber monster suits and wrestle one another.

Godzilla celebrates his 21st birthday with this motion picture, but the magic "21" doesn't mean maturity. He's simply a goofy-n-benevolent giant dinosaur who's accepted the dubious responsibility of being Earth's security guard. Meanwhile, evil space aliens have repaired their Mechagodzilla and they send it, along with a sidekick Titanosaurus, to defeat Big G.

After this film, **Ishiro Honda** left *Toho Studios* to form a production company with his close friend **Akira Kurosawa**. The two directors worked together on many films, including **Ran** (1985), until Honda's death in 1994.

TERROR OF THE MUMMY
see **FEAR OF THE MUMMY**

TERROR ZONE
see **UMEZU'S TERROR ZONE**

▶ **TETSUO** (1990)
aka **IRON MAN**
director: Shinya Tsukamoto
Tomoroh Taguchi • Kei Fujiwara
Renji Ishibashi • Nobu Kanaoka
***½

❖

▶ **TETSUO 2:
BODY HAMMER** (1991)
aka **IRON MAN 2**
director: Shinya Tsukamoto
Tomoroh Taguchi • Nobu Kanaoka
Shinya Tsukamoto • Sujin Kim
**½

#1 is an incredible debut film from director **Tsukamoto Shinya** who, by his own admission, was strongly influenced by **David Lynch** (*Eraserhead* [1976]) and **David Cronenberg** (*Videodrome* [1982].

While shaving one day, a man notices a small metal nail protruding through his cheek. Closer inspection reveals the spike is connected to something else— and soon the man's body begins to transform into a *brave new creature*, part flesh and part machine.

No explanation is given for the bizarre evolution, in fact there are barely five lines of dialogue spoken in the entire film. Rather, the viewer is subjected to a lucid nightmare which quickly infects other members of the cast in cyberpunk fashion. One of the unforgettably grotesque moments of the movie finds Iron Man making love to his girl-

Shinya Tsukamoto's *Tetsuo*

Tetsuo 2: Body Hammer

friend just as his penis transforms into a deadly power drill.

Astonishingly, there is a sequel.

In **#2** director **Taukamoto** makes the mistake of trying to explain himself, of attempting to add sense to the world of **Tetsuo**. In doing so, he's replaced the *dream* with *insanity*, thus losing the personal quality of the film.

Tetsuo is no longer an "everyman" trapped in lucid nightmare. Now he is a specific character, a Japanese business man, attacked by skinheads who gruesomely kill his son. After Tetsuo is shot with a rivet-gun, he mutates into a man/machine, complete with an arsenal growing out of his chest. Revenge, as humdrum of an excuse as it may seem (especially after the psychological trance of **#1**), becomes the motivating factor for Tetsuo's actions. There are also various subplots involving transformations and iron man monstrosities. But it's a far cry from the original.

Also see *Kazuya Konaka*'s **Defender** (1997) for a variation on the same theme.

THREE DREAM STORIES
 see **DANGEROUS TALES**

THRONE OF BLOOD (1957)
 [Kumonosujo]
 translation: **Cobweb Castle**
 director: **Akira Kurosawa**

Toshiro Mufune • Isuzu Yamada
Minoru Chiaki • Takashi Shimura
***½

This ardently visual rendition of **MacBeth** is **Akira Kurosawa**'s first adaption of **William Shakespeare** {also see **Ran** based on *King Lear*}. The sets are absolutely incredible. A collection of surrealistic dreamlike landscapes which seem even more foreboding, more alien today than they did in '57.

In fairness, some critics have complained about **Kurosawa**'s thinly developed characters, particularly referring to **Toshiro Mufune**'s *Lord Taketori Washizu* (the MacBeth character) as one-dimensional and shallow. While it's true the stoic leader appears to be somewhat of a simpleton, this is a reflection of director **Kurosawa**'s personal interpretation. He is more interested in capturing the fable and expanding on the horrific elements of the story. The gifted filmmaker has delivered the ultimate fairy tale for adults.

**THUNDER MAN IN
 VALLEY OF BLACK CLOUDS**
 see **AKADO, Suzunosuke** series

TIDAL WAVE
 see **SUBMERSION OF JAPAN**

TIME-FIGHTER MIKI (1996)
 [Jiku Senshi Miki]
 director: **Hitoshi Matsuyama**
Chisa Yokoyama • **Mitsuru Fukigoshi**
**

A girl (**Chisa Yokoyama**) is framed by her boyfriend for a crime she didn't commit. But instead of going quietly to jail, she breaks free from the authorities and starts a brand new life. Chisa becomes a professional bounty hunter in the landscape of the future. Similar to and obviously inspired by *Keita Amamiya*'s **Zeiram** series (1992-1995). A manga come-to-life but **Hitoshi**

Matsuyama's sluggish direction — not to mention his miniscule budget — keeps it from catching fire. **Chisa Yokoyama**, however, does manage to be both cute and energetic, despite the lackluster production.

TIME OF THE APES (1987)
[Saru No Gundan] (1971-1973)
translation: **Army Of Apes**
director: **Atsuo Okunaka** and
 Kiyosumi Fukazawa
Reiko Tokunaga • **Hiroko Saito**
Masaaki Kaji • **Hitoshi Omae**
** (or **½)

Two kids visit their aunt who works at an isolated cryogenics laboratory. During an earthquake, the three of them hide inside the freezing units. Their frozen bodies are discovered and thawed out by a future generation of scientists. But the problem is— thousands of years into the future— all humans are now dead, replaced by a race of intelligent, talking monkeys.

Obviously inspired by **Planet Of The Apes** (1968), this is actually a movie gleaned from various half-hour episodes of a Japanese television series (1971-1974) called **Army Of Apes**. As one might expect, the motion picture is little more than a series of loosely related action-oriented vignettes dealing with conflicts between the primates. A Western company, helmed by **William Cooper Jr** and **Sandy Frank**, put the feature project together in 1987 and dubbed it into English, anglicizing the names to Johnny, Caroline and Aunt Katherine instead of their more obvious Asian names.

The original Japanese director, **Atsuo Okunaka**, carved a career from kid-oriented Nippon TV shows. He's best known for the long running **Strictly Judo** (Judo Ichyokusen), a **Karate Kid** knockoff that thrilled audiences throughout the 80s.

TIME OF MADNESS (1967)
[Satsujinkyojidai]
director: **Kihachi Okamoto**
Tatsuya Nakadai • **Reiko Dan**
Hideo Sunazuka • **Hideyo Amamoto**
**½

Director **Okamoto** abandons his *chambara* roots [**Samurai** (1965)] for a tongue-in-cheek SciFi black comedy. It's the story of the JPCC (Japan's Population Control Council), a top secret organization dedicated to the extermination of unnecessary people. **Tatsuya Nakadai** is a dedicated agent who eliminates a parade of hapless characters who are "better off dead" (*i.e.*, **Misako Tominaga**, a woman with an artificial eye; a cripple played by **Seishiro Hisano**; fat woman **Satoko Fukai**; plus other society misfits like a man who thinks he's a dog, another who can't stop winking, and still another who laughs uncontrollably).

Five years later British director **Michael Campus** made a similar (albeit less mean-spirited) film **ZPG: Zero Population Growth** (1972) with **Oliver Reed**. Filmmaker **Okamoto** returned to his samurai roots with such notable entries as **Red Lion** (1969) and **Zatoichi Meets Yojimbo** (1965). However he remade this film as **Blue Christmas** (1978), with some interesting SciFi variations {see separate listing}. Okamoto died in 1979.

TIME SLIP (1981)
[Sengoku Jieitai]
director: **Kosei Saito**
Shinichi (Sonny) Chiba • **Isao Natsuki**
Miyuki Ono • **Tsunehiko Watase**
**½

What a great idea! Too bad it's executed so sluggishly. During military maneuvers, a battalion [40 men, a few tanks and a helicopter] slips through a crack in time and the soldiers suddenly find themselves face to face with 16th

Sonny Chiba (left) with Isao Natsuki in *Time Slip*

century samurai warriors. Squad leader Lieutenant Ia (played by **Sonny Chiba**, who also choreographs the impressive battle scenes) is, at first, amused by the extraordinary situation. But he soon becomes lethargic when it appears he will never return to contemporary Japan.

However, Ia concocts a dangerous plan. Believing that if he does something which would alter the course of history (*i.e*, militarily taking over the country), he and his men will be jetted into the future like so much unwanted garbage. What the leader hasn't taken into consideration is history has a way of rewriting itself.

The original Japanese version of this film is more stately, with a haunting soundtrack and a running time of 145 minutes. The international English language print adds cheesy westernized rock ballads is missing 35 minutes of footage.

TO DIE IN THE COUNTRY
see **PASTORAL**

TOKAIDO ROAD
MONSTERS (1969)
[Tokaido Obake Dochu]
translation: **Journey With
Monsters On Tokaido Road**

director: Kimiyoshi Yasuda
Kojiro Hongo • Masami Kojomon
Pepe Hozumi • Kitayo Ima
Yosuke Shimada • Rokko Toura
*½

Here's a major disappointment from director **Yashuda** on the heels of his successful **Hundred Monsters** (1968). It must have looked good on paper: *Daiei*'s top horror director, special effects by **Yoshiyiki Kuroda**, a unique cast including famous bad-guy samurai **Rokko Toura** and husband-n-wife comedy team **Kitayo Ima** and **Yosuke Shimada** in co-starring roles, plus obvious **Gamera** [kids in peril] similarities.

A little girl (**Masami Kojomon**) travels notorious Tokaido Road (known as "Monster Alley" to the locals) when she goes off to find her long-lost father. Most all the adults in the cast try to rob her or hurt her in some way (with the lone exception of **Kojiro Hongo** who eventually befriends her). She also teams up with an orphan boy (**Pepe Hozumi**) for the latter part of her journey. Together, aided by a bunch of humdrum monsters, they defeat all the bad guys.

Kimiyoshi Yasuda returned to the more familiar *adult* horror genre for **Horror Of An Ugly Woman** in 1970.

TOKYO BAY FIREBALL (1975)
[Tokyo-wan Enjo]
director: Katsumune Ishida
Tetsuro Tanba • Yutaka Mizutani
Midori Kanazawa • Kei Sato
**

Big stars, big action, big snickers. Purposely bad special effects, followed by a load of *unintentionally* awful ones. A ludicrous script — unforgivably terrible — but based on a taut bestselling action novel by **Mitsuji Tanaka**. Worshiped by *bad movie fans* as one of the best of the worst (second place to **Lake Of Illusion**, of course).

This one is similar to *Richard Lester*'s **Juggernaunt** (which, coincidentally, was made the same year, 1974). It tells the story of a mammoth oil-tanker seajacked by a gang of environmental terrorists. Their list of demands includes the destruction and dismantling of an oil-refinery in Kagoshima. If the government doesn't immediately blow up the refinery, the terrorists are prepared to detonate the tanker and turn Tokyo into a "fireball." **Tetsuro Tanba** (repeating the same Prime Minister role from **Submersion Of Japan**) and his political cronies hire an FX crew from a movie studio to create a simulated oil-refinery explosion. The *staged* blast is then aired on television, as proof to the terrorists that their demand has been met. However, the special effects are so bad, and so obvious, the bad guys don't believe it for a second. They retaliate with *threats* of keeping their promise, but all the guerrillas are captured before they can explode the big one.

TOKYO BLACKOUT (1987)
[Shuto Shoshitsu]
translation: **Vanishing Capital City**
director: Toshio Masuda
Tsunehiko Watase • Yuko Natori
Shinji Yamashita • Shuji Ohtaki
*½

At 115 minutes, this film is epic in scope. But it's wacky in concept; rudimentary in execution. A decade has passed since director **Masuda** tried to convert the world with **Last Days Of Planet Earth** (1974) and now he's is back in the saddle with more doomsday baloney.

This time, a mysterious cloud has engulfed Tokyo and 20 million people are suddenly isolated from the rest of the world. Telephone lines, as well as all other instruments of communication, are inoperative. It all has to do with cosmic energy and a "disturbance in the soul of animals."

A TV newswoman (**Yuko Natori** who fared much better a couple years later with **Nobuhiko Ohbayashi**'s **Summer with Ghosts** [1989]) and her scientist boyfriend (**Tsunehiko Watase**) want to correct the environmental crisis, but no one will listen to their solution. Instead, the American ambassador blames the disaster on the Soviets who happen to be conducting nuclear tests in the China

Yuko Natori in *Tokyo Blackout*

Shinya Tsukamoto (left) and Kaori Fujii in *Tokyo Fist*

Sea. A full-fledged World War seems inevitable, until our two heroes defuse the cloud barrier by rescuing a trapped dog from the eye of the disturbance.

Utter nonsense from SciFi writer **Sakyo Komatsu** (director of **Sayonara Jupiter** [1985]) who should've known better. And director **Masuda** who obviously doesn't.

TOKYO CRISIS WARS
see **LIVING DEAD IN TOKYO BAY**

TOKYO FIST (1995)
[Kokyo Fisuto]
director: Shinya Tsukamoto
Shinya Tsukamoto • Kaori Fujii
Koji Tsukamoto • Naoto Takenaka
***½

This is director **Tsukamoto**'s best film to date. That's quite a statement in the afterglow of his notorious debut **Tetsuo** (1990). But this movie is more accessible, better written, and designed to deliver its ghastly message without delving into unrealistic netherworlds.

Similar to **Tetsuo** (1990) and **Hiruko** (1991), the film is preoccupied with the concept of "power through metamorphoses." This time, the central charac-

ter, Tsuda (played by director **Tsukamoto** himself) transforms from a passive salaryman into an iron-pumping, kung fu intensive "killing machine" when he looses his girlfriend to Takuji, a long-lost-chum-turned-professional-boxer. Takuji changes too. He becomes a cowering fool when faced with the unleashed violence wielded by the body piercing girlfriend, Hizuru. The three face off in a climactic blood-splashing gorefest, the likes of which are unparalleled in cult cinema.

When **Tokyo Fist** was released theatrically in Japan, it shared the bill with another **Shinya Tsukamoto** feature, **Adventures Of The Electric Rod Man** {see separate listing}.

TOKYO MAGIC WORLD WAR
see **TARO! MAGIC WORLD**

TORIKO
see **VICTIM**

TOWER STORY (1995)
[Tenshu Monogatari]
director: Tamasaburo Bando
Tamasaburo Bando • Kai Shishido
Rie Miyazawa • Shogo Shimada
**½

Hisashi Igawa investigates a murder in *Trap*

Male actress **Bando** directs and stars. A big budget *kaidan eiga*, based on novel by Japan's #1 fantasy writer *Kyoka Izumi*.

Princess Tomi (veteran **Tamasaburo Bando**) is a ghost living on top of Himeji castle tower. She and her considerably younger sister (**Rie Miyazawa**) rule the kingdom in a benevolent fashion. The people are cautiously respectful, and no one crosses the two women. In fact, no one even tries to get close to them. That is, until a young samurai scales the wall to give praise to Princess Tomi. She falls in love with the young stud and won't allow him to leave. Eventually the warrior convinces her that he must return to his lord. She honors her lover with a memento, a magic helmet which has been in the Himeji Castle for generations. However, when he returns to his lord, everyone believes he stole the artifact. A warrant is issued for his arrest. He's disillusioned by the mistrust in his family. Rather than stand trial as a thief, he returns to the tower and the arms of Princess Tomi. However the authorities are on his tail. The princess conjures up a dragon, which turns things into a bloody battle. Both she and the samurai are stabbed in the eyes, but magic reverses the injuries. Everyone lives happily ever after.

A major release, supported by a ton of advertising money. **Bando**, despite his age, proves that he can still hold his own as one of Japan's most respected actors (actresses?), the long-time transvestite king of the Kabuki theater. But more than one Japanese critic has complained over the shallow plot and over **Rie Miyazawa**'s non-performance. Exactly what is she doing in this picture? The starlet hasn't done well since her attempted suicide after breaking up with a sumo wrestler boyfriend in 1993. But, with specific regards to this film, it's difficult to understand why the young samurai would fall in love with Princess Tomi — a woman easily 30 years his superior — when he could have had Ms **Miyazawa**. This movie does nothing to further her career.

TRAP (1962)
[Otoshiana]
director: Hiroshi Teshigahara
Hisashi Igawa • Kazuo Miyahara
Kanichi Ohmiya • Kunie Tanaka
**½

Another *Kobo Abe* novel transferred to the screen by director **Teshigahara** {also see his **Face Of Another** [1966] and **Woman In The Dunes** [1964]). And, as typical of the **Teshigahara/ Abe** adaptions, there's more going on than what meets the eye. The rudimentary plot deals with a search for a murderer after a man is killed on a train. Behind this who-dun-it facade is a clever political satire — unmitigatedly leaning to the left — about labor unions and capitalism. But that's not all, it's also a ghost story.

The locale is a desolate coal mining town during the depression of post-war Japan. An anarchical miner is killed when thrown off a train. Is the murderer the rightwing company boss or the labor union activist? A banker or a grocery store owner? The proceedings are narrated by a ghost who's frustrated, along with the audience, by his inability to decipher the clues and figure out who killer is.

Director **Teshigahara** freely admits that many of his techniques and much of his cinematography was inspired by a

TVO

Polish movie **Cien (Shadow)** [1956]. Unfortunately, by today's standards, both films are dated.

TRAVELER TO THE UNKNOWN
see **PSYCHIC**

TROPICAL MYSTERY
see **YOUTH REPUBLIC**

TVO (1991)
[TVO]
director: Tatsuya Ohta
Miho Tsumiki • Atsushi Okuno
Shiro Sano • Yukako Hayase

A girl, Satsuki (**Miho Tsumiki**, from *Whisper Of A Nymph* [1987] and **Toshiharu Ikeda**'s *Misty* [1991]) uses her ESP powers to investigate the mysterious disappearance (death?) of her sister. She befriends a nightclub singer (**Atsushi Okuno**) who used to be her sister's boyfriend, and manages to also get romantically involved with him. Eventually, after many twists and turns inside the seedy Tokyo "after-hours" world, Satsuki manages to learn the truth about her sister's multiple personalities and the accompanying fits of violence and rage — and how it all relates back to her. Was there a sister at all?

A very atmospheric melodrama with effective moments of *noir* within the decadent smoky-glass setting. Aside from the purposely confusing denouement (and limited budget), this is the movie that *Looking For Mr Goodbar* (1977) wanted to be.

TWILIGHT (1994)
[Twilight]
director: Tengai Amano
Daiko Ishimaru • Eiko Tamura
**

In this silent film, a boy (**Daiko Ishimaru**) refuses to accept his death. He leaves the casket and wanders aim-

lessly though his past, present and future. His meandering seems to be spontaneous, but he's actually being guided to his place in the afterlife. The boy finally bids goodbye to death itself and melts into nothingness.

Director **Amano** is the founder of a Tokyo stage theatre called *Shonen Ohjakan*. His movie is poetic and nostalgic. But definitely not scary. It was co-billed with **Evening Calm Battle Line** for theatrical release {see separate listing}.

TWO (1991)
[Futari]
director: Nobuhiko *Obi* Ohbayashi
Hikari Ishida • Tomoko Nakajima
**

Another of Obi's *Onomichi* tales {movies shot in his home town, *e.g.*, **House**, **New Student**, **Girl Who Traveled Beyond The Time Barrier**, *et al*} dipping into the supernatural grabbag. High school coed Chizuko (**Tomoko Nakajima**) is both beautiful and smart. By comparison, her sister Mika (**Hikari Ishida**) is mousy and clumsy. But they are very close. So, Miki is especially traumatized when her sister dies in a freak accident. At first the family ignores her insistence that Chizuko's ghost "has come from the beyond to protect her." Yet, sure enough, whenever Miki finds herself in trouble, her sister's ghost jumps to the rescue.

Ulee

Although a bit more tasteless than his earlier more commercial films, this is standard *Obi* fare. It's a small, human interest drama embedded in the trappings of a horror story. Unfortunately, this one isn't as literate as the director's *Summer With Ghosts* (1989). Obi also made *Drifting Classroom* later in 1991.

ULLIE (1996)
[Ullie]
director: Yuji Sakamoto
Ichinari Ishida • Maki Sakai
**½

Masayuki (**Ichinari Ishida**) is on Summer Break. He's a typical young guy, hangin' out, doing nothing. But then, one day, he meets a mysterious girl, Nanami (**Maki Sakai**). She's hauling a refrigerator — which she calls Ullie — and she's helped by an Iranian friend named Amir. What's inside the icebox? It's the dead body of Nanami's ex-boyfriend, of course. Masayuki doesn't let something little like murder interfere with his infatuation for the girl. He's in lust with the girl and joins them in the unusual trek which develops into an extended journey. A refrigerator named Ullie? *Ullie's Cold?*

ULTRA Q: THE MOVIE (1990)
[Urutora Q Za Muubi: Hoshi No Densetsu]
translation: Ultra Q: Legend of the Stars
director: Akio Jissoji
Toshio Shiba • Keiko Oginome
*½

Ultra Q is a popular, long-running Japanese TV program, similar to America's *Twilight Zone* or, more accurately, *Outer Limits* (for disconcerning viewers who recognize the difference). In addition to the various monsters and SciFi adventures, the television series is best known for spawning the **Ultraman** character during the late '60s {see separate review}. Unfortunately, *Ultra Q: The Movie* has none

Ultra Q: The Movie

of the small screen charm. It suffers immeasurably from a terminal case of self-importance, bloated by a ridiculously pedantic script. Director **Akio Jissoji** is more concerned with answering impossible questions about the "beginning and end of life on Earth" than he is in entertaining his audience. Certainly, a big mistake, in light of the **Ultra Q** reputation, similar to *Robert Wise*'s **Star Trek: The Movie** fiasco in 1979.

This overly-long, talky SciFi film follows the exploits of three environmental scientists who discover an alternate dimension and a resulting time crack. After 101 minutes of technical discussions, scenic South Sea Island photography, and native cult shenanigans, a monster shows up and starts wrecking havoc. Actually, this creature is Godzilla with a few cosmetic alterations, including long antler-like horns. His screen-time is exactly four minutes. Was it really worth the wait?

ULTRAMAN series (1966-1991)
[Urotoraman] 6 Theatrical Episodes

Ultraman was introduced as a reoccurring character on the *Ultra Q* television series in 1966 {see **Ultra Q** review for additional information}. Once a month, this superhero would battle rubber monsters and generally keep the world safe

from peril. The initial episode was intended as a parody of America's *Superman* but the character's popularity gave birth to a sequel. And eventually to a monthly slot.

The producers of **Ultra Q** were hesitant about Ultraman's status within the respected SciFi production. He was okay as a one-shot *joke*. But this goofball crime-fighter had changed the complexion of the series. He was cancelled the following year.

However, it's hard to keep a good man down. Ultraman was back in 1972, this time with his own series, **The Return Of Ultraman**. Over the years, cast members changed and Ultraman gradually grew into Ultra Seven. A new series was developed in 1991 to celebrate Ultraman's 25th anniversary, a Japanese/Australian co-production called **Ultraman G** (incidentally, the *"G"* is for *Great*).

Ultraman is essentially a *television* phenomenon, but the big screen was not spared. A movie, culled from TV episodes, was released in 1967. As expected, the story is very episodic, but it does explain how Agent Hayata (**Shoji Kobayashi**) became Ultraman in the first place.

The second Ultraman movie was released in 1979. It consists of scenes from five episodes in the **Return Of Ultraman** series (1972); a third film was also distributed during the same year under the title **Monster's Great Duel**. This was compiled from segments of

the original *Ultraman* (1967)

The Ultra Family *(12 Ultrafamily Members vs 10 Monsters)*

the 1973 TV series, plus it also features new footage called *12 Ultrafamily Members vs 10 Monsters*.

The story behind **Ultra 6 Brothers Vs The Monster Army** is anybody's guess. It appears to be shot with a Japanese crew in Indonesia using an all Indonesian cast. The production standards are abysmal.

Although they claim to be Japanese coproductions, the two **Ultraman G** films have completely Australian casts and a director to match. He's **Andrew Prowse**, the man responsible for the 1989 Filipino horror movie, **Demonstone**. The two installments here are pretty cheesy. **Dore Kraus** plays Jack Shindo, the member of UMA (Universal Military Association) who becomes Ultraman G.

Three short films (***Revive! Ultraman***, 23 minutes; ***Ultraman Company*** [animated], 30 minutes, ***Ultraman Zeasu***, 51 minutes) are meshed into one feature, **Ultraman Z** (1996) to celebrate the 30 year anniversary of the Ultraman character. A new Ultraman steps forward, this time wearing a red mask, but his goal is the same: defend the world. Katsuhito Asahi (**Masaharu Sekiguchi**) is a gas station attendant working secretly for the *Universal Military Association*. He challenges a money-eating monster, Kottenpoppe, sent from Benzen Planet to destroy the Earth's economy. The whole thing is as silly as it sounds.

At one time, **Joji Kaga** was considered a top-notch actor, but he fumbles badly as the wicked king of Benzen

who resorts to snatching children to fulfill his dream of world domination. He plays the part with a restrained hamminess, neither fish nor fowl, which limits his overall effectiveness. Perhaps the most significant aspect of this episode is it introduces the first female Ultraman (Ultrawoman?) when **Yuka Takaoka** transforms into the legendary crimefighter after brushing her teeth with the superhero's toothbrush. Another step forward for women's lib in Japan.

Here is a listing of the Ultraman films:

▶ **Ultraman** (1967)
[Urutoraman]
director: Hajime Tsuburaya
Shoji Kobayashi • Susumu Kurobe
Hiroko Sakurai • Toshi Furuya

▶ **Return Of Ultraman** (1979)
[Urutoraman]
director: Akio Jissoji
Shoji Kobayashi • Susumu Kurobe
Hiroko Sakurai • Ikichi Ishii

▶ **Ultraman:**
 Monster's Great Duel (1979)
[Urutoraman: Kaiju Daikessen]
director: Tokuko Anakura
Shoji Kobayashi • Susumu Kurobe
Hiroko Sakurai • Sandaiyu Dokumamushi

▶ **Ultra 6 Brothers vs**
 Monster Army (1982)
[Urutora 6 Kyodai vs Kaiju Gundan]
director: Shohei Tojo
Ko Kaeoduendee • Anan Pricha
Yoo Maeksuwan • Pawana Chanachit

Ultraman Z (1996)

▶ **Ultraman G: Monster**
 Termination Project (1990)
[Urutoraman G:
 Kaiju Gekimetsu Sakusen]
director: Andrew Prowse
Dore Kraus • Gia Carides
Ralph Cotterill • Lloyd Morris

▶ **Ultraman G: Alien Invasion** (1990)
[Urutoraman G:
 Godesu No Gyakushu]
director: Andrew Prowse
Dore Kraus • Gian Carides

▶ **Ultraman Z** (1996)
[Urutoraman Zeasu]
director: Shinya Nakajima
Masaharu Sekiguchi • Yuka Takaoka
Yoshitake Kinashi • Joji Kaga

UNDER THE
CHERRY BLOSSOMS (1975)
[Sakura No Mori No Mankai No Shita]
director: **Masahiro Shinoda**
Shima Iwashita • Hiroko Isayama
 and **Tomisaburo Wakayama**

Generally, **Double Suicide** (1969) is considered **Masahiro Shinoda**'s masterpiece. But for sheer *artistic* bloodletting, for an adult horror film of epic proportions, this film is unbeatable. **Shinoda**'s preoccupation with the erotic and the sadistic comes together in this amazingly effective ghost story, complete with a suitably eccentric cast. Three very dissimilar performers make the screen crackle with energy, *Baby Cart*'s **Tomisaburo Wakayama**, former pink starlet **Hiroka Isayama** (see **Delicate Skillful Fingers** and **Ichijo's Wet Lust** [both 1972]), and the director's beautiful, talented wife **Shima Iwashita** (*Double Suicide*).

In the 12th Century, mountain man Hiroyuki (**Tomisaburo Wakayama**) realizes something very unusual is happening in the cherry grove. People who travel through it are going insane. Then one day, Hiroyuki watches as a group

Under The Cherry Blossoms

of travelers emerge, apparently unaffected. Upon a closer look, the man notices a beautiful noblewoman, Eko (**Shima Iwashita**), in the troupe. He is overcome with passion. After killing the woman's husband, Hiroyuki whisks her away to his home in the woods. Once they arrive, Eko demands that he kill everyone living there, except a servant (**Hiroko Isayama**). He does so.

Their life is idyllic; the three of them live in erotic bliss. Hiroyuki goes out daily, killing and robbing travelers, so Eko can continue to live like a princess. Eventually, she convinces Hiroyuki to move them to town. In the village, he continues his daily slaughter, bringing her money and the severed heads of the victims. She stores the money away and plays games with the heads.

The woodsman grows tired of city life and dreams of returning to the mountains. Finally she agrees. They journey home through the cherry grove and Hiroyuki becomes terrified when he sees her transform into an ugly witch before his very eyes. He goes insane and murders Eko.

Kazuo UMEZU'S
 TERROR ZONE (1993)
 [Umezu Kazuo Terror]
 aka **HORROR!**
director: Hikari Hayakawa
Ayako Sugiyama • Yumiko Takahashi
**½

Here's a film based on two short stories written by **Kazuo Umezu**, affectionately called the Japanese *Stephen King*. Both entries, although completely different in style and pacing, are directed by the same man, **Hikari Hayakawa**. According to Japan's *Flash* magazine, **Hayakawa** made the first part (**Return To Darkness**) as a student film while attending Tokyo University. Writer **Umezu** was so impressed that he hired the young director and personally financed the second story, *Stolen Heart*.

In tale **#1**, Junko is a young woman from Tokyo, betrothed to a country gentleman. She leaves the big city to join him in a desolate village, but she finds a houseful of ghosts instead. However, there's a line of dialogue in the second story that describes the premise for both entries: "A beautiful

Stolen Heart: Umezu's Terror Zone

girl always has a dark side." Apparently this is true. And the ghosts get more than they bargained for.

The second story is the slicker of the two, with a large budget for gory special effects. It deals with two schoolgirl chums who swear complete devotion to one another, even agreeing to a "heart donation" should the other need it. Of course, as it turns out, one of them does need it. Her friend isn't particularly willing to give up the vital organ.

But— a promise is a promise.

Right?

UNDERWATER BATTLE BOAT
see **ATRAGON**

VAMPIRE BRIDE (1960)
[Hanayome Kyuketsuma]
director: Kyotaro Namiki
Junko Ikeuchi • Yasuko Mita
☐ *pick your own rating*

When pretty **Junko Ikeuchi** burst on the movie scene in the late '50s, she was generally perceived as "a fresh young beauty star." Her future looked bright and promising. That is, until she announced her wedding plans. *Shintoho* boss **Mitsugu Ookura** {see listing for **Military Cop And The Dismembered Beauty** (1957) for background information on this controversial CEO} warned the starlet about getting married, claiming that it would destroy her career. But Ms **Ikeuchi** threw caution to the wind, and tied the knot anyway. As it turned out, her business executive husband was demanding, overly protective and wildly jealous; the young couple was often seen in public squabbles and violent outbursts. Within a year, they were divorced.

None of the studios would touch Ms **Ikeuchi**; the producers were convinced that she had lost both her popularity and her bankability. The girl, desperate for work, crawled back to big boss

ad mat for *Vampire Bride*

Ookura. He agreed to hire her for a *special* project. Along with studio director **Kyotaro Namiki**, he wrote **Vampire Bride** for the girl. Many insiders claim his intention was to shame her for not listening to his advice, but some film historians insist he was simply trying to make a quick buck by capitalizing on her now tainted reputation. Years later, after regaining popularity (she finally made her comeback in 1965 with *Shiro Toyoda*'s lyrical **Ghost Story Of Yotsuya**), **Junko Ikeuchi** wrote in her autobiography: "How much I hated **Mr Ookura** and his shadow, **Mr Namiki**, for the terrible things they made me do." She also said: "My marriage was a *private* humiliation, but **Vampire Bride** was a *public* humiliation."

The story is about a young woman, Junko (obviously played by Junko **Ikeuchi**) living in sin with a poor man. They are hopelessly in debt. To make a few dollars, she enters a beauty pageant and wins. During a fit of anger, a rival contestant shoves a spotlight at Junko,

badly scarring her face. Her miserable life is further ruined when the same girl snatches her boyfriend. And then, on top of everything else, Junko's mother kills herself. In the suicide note, mom tells the girl to "go visit grandmother, she will help add order to your life."

Grandma is a witch, who promises to fix Junko's face and make her pretty again. But the mumbo-jumbo only makes the girl worse, she emerges more hideous-looking than ever before. Junko commits suicide. Grandmother conjures up a spell which revives the dead girl's body. But she has returned to life with an unusual side-effect. Junko transforms into a bat whenever she gets angry. Now, this isn't necessarily a bad thing for Junko, but it's definitely a bad news for her enemies. She goes after them with a vengeance.

In contrast to the mean-spirited, depressing atmosphere of the film, the FX are absolutely awful. Bat-Junko looks more life a cheap stuffed animal than a deadly predator. It's all very reminiscent of the chicken-man costume worn by **Steve Hawkes** in *Brad Gintner*'s **Blood Freak**. "Stylistically this movie reminds me of *Izo Hashimoto*'s **Bloody Fragments On A White Wall** (1989). They're both cheap and ugly films," says **TDC Fujiki** in his Nippon book **Bad Taste Japanese Movie Theater**.

VAMPIRE MAN
 see **FEMALE VAMPIRE**

VARAN
 THE UNBELIEVABLE (1958)
 (USA release 1961)
 [Daikaiju Baran]
 translation: **Great Supermonster Baran**
director: Ishiro Honda
JAPANESE CAST:
Kozo Nomura • **Ayumi Sonoda**
 and **Fumito Matsuo**

Varan The Unbelievable

AMERICAN CAST:
Myron Healey • **Tsuruko Kobayashi**
 and **Clifford Kawada**
**½

Introducing *Toho*'s third monster (preceded by Rodan and Godzilla). But what is it? Obviously, here's a creature patterned after Godzilla, but it looks more like a prehistoric squirrel than something from the reptile family. Like his predecessors, Varan also destroys Tokyo. Apparently, he's enraged over some experiments conducted by the U.S. Navy in the Pacific Ocean.

Some reference books claim this is the first *kaiju eiga* to use an Anglo in the starring role, but this is blatantly incorrect information. In similar fashion to the previous rubber monster movies (*i.e.*, **Raymond Burr** in **Godzilla**), the footage featuring "American" performers were inserted into the USA release. TV actor **Myron Healey** (*Doc Holiday* in ABC's **Wyatt Earp** [1955-61]) plays

a Navy scientist married to pretty **Tsuruko Kobayashi**. For the American version, 22 minutes of original Japanese footage was replaced with the Healey segments (shot by producer *Jerry Baerwitz*). **Myron Healey**, **Kozue Saito**, and **Rikako Murakami** are only seen in the American edit.

The name of the monster was changed in the dubbing from *Baran* to *Varan*.

VENUS FLY TRAP
see **DEVIL GARDEN**

VICIOUS DOCTOR (1967)
[Akutokui]
director: Seiichi Fukuda
Machiko Sakyo • Yuichi Minato
Akio Kanbara • Naomi Tani
*½

Saeko (**Machiko Sakyo**), a female doctor, is raped and sexually assaulted by a man who is secretly enamored with her. She is disgusted by the rape, but she allows the man (**Yuichi Minato**) to continue his sexual gymnastics night after night. In her demented state, she hopes to become pregnant and teach the rapist a lesson. When the woman learns that she has indeed conceived, Saeko forces the man to watch while she mutilates her genitalia, causing a massive hemorrhage and miscarriage. During the entire self-inflicted torture, Saeko mutters lunacy about hating all men and how this act will show them the depth of her "black vengeance."

No matter how vivid and grotesque her final act may be, any logical message is lost on the authors of this book.

VICTIM (1995)
[Toriko]
director: Masahide Kuwabara
Naomi Morinaga • Shihori Nagasaka
Daisuke Nagakura • Tadao Iwamoto
*½

A brutal sex-maniac is slaughtering women. He picks a girl at random, breaks into her house and rapes her. At the moment of ejaculation, he butchers the girl. This freak's identity is kept a secret from both the police and the audience as he wears a gas-mask during the assault and his voice is altered with an *osmo*-box [an image of a Darth Vader sex pervert is unintentionally brought to mind].

A psychotherapist named Yoko (**Naomi Morinaga**, not looking old enough to be a trainee let alone a therapist) becomes his next victim; however, this time the psycho rapes the girl without killing her. He leaves quietly after explaining that he's fallen in love with her. Yoko believes that this sick puppy might be one of her patients and she contacts the police. As it turns out, the investigating detective falls in love with Yoko and they become bed partners. Meanwhile, the serial killer continues to slice and dice his way across Tokyo. Eventually Yoko learns that her detective-lover is secretly the killer. He leaves town (presumably to participate in an unnecessary sequel) while forlorn Yoko stares out the window into the rainy night.

Time and money was invested in the graphically exploitive rape scenes. But the rest of the movie is terrible. Visually it's a disaster, filled with haphazard camerawork and clumsy editing. The naive script gives new meaning to words like "ludicrous" and "cliched;" it's little more than a wrap-around for the violent assaults. In addition, **Naomi Morinaga**'s performance is lethargic to the point of comatose. Only *pinku eiga* starlet **Shihori Nagasaka** {see **Erotic Seduction: Flesh Bondage** [1987], **Woman In The Box 2** [1986], *et al*, in *Japanese Cinema The Sex Films*} brings any semblance of acting to the project.

VIDEO GIRL AI (1991)
[Denei-shoujo Ai]
director: Ryu Kaneda
Kaori Sakagami • Ken Ohsawa
**½

Based on a 15 volume manga by **Kazuhara Keisho** (and a resulting 13 episode animated series), this is a live action version starring perky **Kaori Sakagami** as the video love goddess. In the story, a teen boy, Youta (**Ken Ohsawa**), is hopelessly in love with his best friend's girl. He can't bring himself to make a play for her; poor Youta even becomes a nervous wreck when he tries to say that he enjoys her company. While walking home after a particularly dismal evening with his friends, he spots a new video store, **Paradise**. Youta rents a "video date" tape and takes it to his place for an evening of safe sex. But he suddenly gets more than he bargained for when video girl Ai (incidentally, *Ai* is a Japanese word for *love*) jumps through the TV into his room.

The movie, which could have easily drifted into **Porky's** territory, plays it surprisingly prudent. The plot focuses on Youta's puerile relationship with the brazenly sexy Video Girl and with the problems he faces after his *true love* Moemi decides that she'd rather be with him instead of his best friend.

A similar plot surfaced in **Aya Sugimoto**'s **Good Luck Venus** (1993) {see separate review}.

Video Girl Ai

Matsuyama Twins in *Village Of Dreams*

VILLAGE OF DREAMS (1996)
(E No Naka No Boku No Mura)
translation: My Village In The Picture
director: Yoichi Azuma
Mieko Harada • Kyozo Nagatsuka
Keigo and Shogo Matsuyama

When two brothers get together, their reunion turns to discussions of "the way it used to be in the old days" near the village in their country home. But their nostalgic ramblings take a horrific flair when they recall the time they were "chased by the ugly witch." Truth or reality? A child's memory is dotted with moments of supernatural thrills which are often forgotten in adulthood. Director **Azuma** concentrates on recreating the most idyllic setting and then peppering it with ghosts, witches and goblins. The story is based on an autobiographical essay written by **Seizo Tajima**, a famous illustrator for children books. In the movie, Tajima visits his long-lost twin brother, a writer, to discuss the possibility of collaborating on a book. Soon, the two men drift into the fanciful discussions of their childhood. The majority of the film deals with the taut-n-tender story-within-a-story shared by the two brothers; the youthful Tajima twins are played by **Keigo** and **Shogo Matsuyama**. Their mother is **Mieko Harada** who won the Nippon Academy Award for Best Actress Award in 1997 for this role.

VIOLATED ANGELS (1967)
[Okasareta Hakui]
director: Koji Wakamatsu
Juro Kara • Michiko Sakamoto
**½

Often, **Koji Wakamatsu** is regarded as the king of the Japanese underground. His movies — usually dealing with historically taboo subjects — have single-handedly legitimized the entire *pink movie* S&M industry in Japan. By today's standards, his early films seem tediously slow. But **Wakamatsu**'s concept of approaching prohibited themes in a low-keyed artistic manner, challenged and beat government censors time and time again.

Supposedly, he shot this film in less than a week, inspired by a news story of **Richard Speck** slaughtering a houseful of nurses in Chicago. For his film, director **Wakamatsu** mixes footage of student demonstrations, campus unrest, the Viet Nam war and naked models with the story of a troubled man invited into a nurse dormitory for some sexual games. He watches two lesbians make love. Then he promptly pulls out a gun and shoots them both. For the rest of the film, the other nurses cry and plead and beg for him to spare their lives. But he doesn't.

At the end, the movie switches from black-and-white to color for the blood-splattering scenes. Then back to black-and-white for shots of cops arriving on the scene, followed by heavy-handed photos of (American) police brutality, while the credits roll.

This is not a masterpiece. But it is a significant film which, based on the box office success, defined a new level of tolerance within mainstream Nippon cinema. There was no stopping Japan's Theater of Cruelty now. However, **Wakamatsu**'s next film, **Sexual Play** (1968), would be a diversion from the excessive violence.

VIRGIN OF THE 99th SWORD (1959)
[Kyuju-kyuhonme No Kimusume]
translation: **Blood Sword of 99th Virgin**
director: Morihei Magatani
Yoko Mihara • Bunta Namiji
**½

This film is generally recognized as one of the first (if not the most notorious) to introduce S&M themes into the contemporary entertainment medium. The plot is little more than an excuse to capture and torture a bevy of beautiful girls.

Deep in the rural mountains, there's a community of traditionalists who sacrifice virgins, usually unsuspecting vacationers, to their god. Each girl is crucified, flogged and stabbed with sacred swords. The movie concentrates on victim 99, the final sacrifice in a long line of offerings. She and her college friends are kidnapped by the cult, but rescued in the nick of time by her father, a local constable.

VIRUS (1980)
[Fukkatsu No Hi]
translation: **Day Of Redemption**
director: Kinji Fukasaku
Massao Kusakari • Olivia Hussey
Shinichi (Sonny) Chiba • Bo Svenson
Glenn Ford • Chuck Connors
Robert Vaughn • Henry Silva
George Kennedy • Isao Natsuki
***½

The most expensive, the most extravagant film in Japan's cinematic history is also one of the most ambitious, marred only by unnecessary sentimentality, irritating coincidences, and some amazingly hammy performances by a unique collection of American B-players. But Director **Fukasaku** has created a disturbing doomsday parable of frustration and terror in the near future.

An East German scientist has developed *MM88*, described as "a Franken-

Masao Kusakari encounters a shocking reminder of the *Virus*

stein monster masquerading as a virus." All vertebrate lifeforms on Earth are susceptible to this *mimic virus* which attaches its to any existing disease, copies it, and accelerates its growth a hundredfold. The result is instantaneous death. The film opens with the virus accidentally unleashed on an unsuspecting world, slowly creeping across the European Nations, into Asia, Japan and the Americas, leaving mountains of dead in its path. This is the birth of a new Black Plague. The USA military machine, under the maniacal control of General Garland (**Henry Silva**), brings out the nuclear weapons and prepares for an attack against Russia thinking they are responsible for the bacteriological warfare. However everyone in Washington, including Garland, dies from the virus before the rockets can be activated.

Meanwhile, an international community of 858 men and eight women are living plague-free in Antarctica while the rest of the human race is dying off. Seemingly, the virus is incapable of penetrating the below-zero temperatures. These survivors have a different problem. Their instruments indicate an intense earthquake is certain to hit in upper state New York. The tremors will be strong enough to activate the ARS (Automatic Reconnaissance System) in Washington, causing the *ready* rockets to engage in a nuclear strike against Russia. This will result in an automatic doomsday reaction from the Soviets. Unfortunately, one of the USSR nuclear weapons is aimed for that very base in Antarctica. The community agrees to "draw straws" to see who goes on a suicide mission into contaminated Washington to immobilize the ARS.

Kinji Fukasaku's message is clear. And on the off-chance someone in the audience may be brain-dead, a character pounds the desk and cries: "How long are we to be haunted by our past!" Unequivocally, the answer is *forever*. Because the earthquake does hit, nuclear weapons are discharged, and the movie ends with complete annihilation (not counting the artificial denouement).

Even though much of the film is incredible to look at, many Western critics sited the lengthy 112 minute running time as "overlong" and "rambling," but the original Japanese version runs even longer, at 156 minutes.

Shortly after the release of this film, **Olivia Hussey** married Japanese pop singer **Akira Fuse**.

▶ **WALKER IN THE ATTIC** (1976)
[Edogawa Rampo Ryoki-Kan:
Yaneura No Sanpo Sha]
translation: **Edogawa Rampo's Psycho
Killer Showcase: Walker In The Attic**

director: Noboru Tanaka
Junko Miyashita • Renji Ishibashi
***½

❖

Remake:
▶ **WALKER IN THE ATTIC** (1994)
[Edogawa Rampo Monogatari:
Yaneura No Sanpo Sha]
translation: **Edogawa Rampo Theater:
Walker In The Attic**
director: Akio Jissoji
Masumi Miyazaki • Hiroshi Mikami

Based on a story by Japan's #1 thriller novelist **Edogawa Rampo** (a Japanization for Edgar Allan Poe, *read his name out loud*), **Nikkatsu Studios** presented this film in their popular **Psycho Killer Showcase** under the **Edogawa Rampo** banner. It's the story of a man (**Renji Ishibashi**) living in an exclusive boarding house who sneaks around peeping on the other residences late at night. He especially likes to watch Lady Minako (**Junko Miyashita**) as she has sex with various partners, including a horny chauffeur. At one point, the peeper watches Minako as she masturbates in her leather easychair. He imagines what it would feel like to be inside that chair.[1] The prowler's obsession eventually drives him crazy and he kills Lady Minako's husband by dripping poison into his mouth through the hole in the ceiling. **Rampo** regular, Detective Kogoro Akechi, investigates

Walker In The Attic (1976)

Walker In The Attic (1994)

the creepy case and discovers even more twists and turns.

The movie was initially promoted as another *Roman Porno* (Soft-core *Romantic Pornography*). But critics quickly agreed the film had excelled far beyond its modest *Pinku Eiga* roots. Director **Noboru Tanaka** finally received notoriety from Japan's mainstream press (although some "hip" critics had recognized his talents as far back as **Secret Chronicles: She Beast Market** in 1974). Respected journalists lavished praise on the film; the conservative *Peer Cinema Club Annual* called it "a perfect marriage of decadence and art." With this film, hot on the heels of his previous **Sada Abe Story** {see review in *Japanese Cinema: Essential Handbook*}, **Tanaka** became the new king of *Nikkatsu*.

Eighteen years later, director **Akio Jissoji** remade the controversial thriller, this time with **Masumi Miyazaki** (Japanese action star from **XX: Beautiful Weapon** [1993]) as Lady Minako. Two different versions were made: the official R-rated, *Eirin* approved, theatrical edit; and an international *adult* version featuring extensive full-frontal nudity. Although diametrically against the existing obscenity

laws, the company premiered the *adult* version at the *1993 Tokyo Fantastic Film Festival*. The motion picture was shown without incident, an indication that government censorship [fogging] was near an end. A few months later, the Japanese ban on *pubic hair* in printed matter (magazines, books, newspapers, etc.) was lifted. However, in order to receive the Eirin "code of approval" films and videos, as of this writing, must be fogged.

[1]Interestingly this idea was lifted from yet another Rampo story called **Human Chair**. It became the subject matter for its own film in 1997. {See separate listing under *Human Chair*}

WAR IN SPACE (1977)
[Wakusei Daisenso]
translation: **Planet Wars Space Story**
director: Jun Fukuda
Kensaku Morita • Yuko Asano
Ryo Ikebe • William Ross
*½

This **Jun Fukuda** film is generally dismissed as a grab-the-bucks-and-run clone of **Star Wars** (earlier in 1977). It does use similar, although cheaper, special effects and the characters are indeed close to those of **George Lucas**. But the plot, as thin as it may be, does cover new ground. Just not very well.

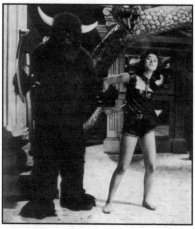

Yuko Asano captured in *War In Space*

Ishiro Honda's *War Of The Gargantuas*: Sanda vs Gaira

The Earth is attacked by aggressive aliens in 1980 and the first interplanetary war begins. A secret Earth organization, hoping to conquer the extraterrestrials and gain control of the world at the same time, dispatch a battleship rocket into space for the ultimate battle.

William Ross is an unsung hero of Nippon/American co-projects; besides this film, he's the neglected veteran of **Last Dinosaur** (1977), **Message From Space** (1978) and **Green Slime** (1968).

WAR OF
THE GARGANTUAS (1966)
[Furankenshutain No Kaiju,
 Sanda Tai Gaira]
translation: **Frankenstein's Monster:**
 Sanda Vs Gaira
director: **Ishiro Honda**
Russ Tamlyn • Kumi Mizuno
Kenji Sahara • Kipp Hamilton

American Cult actor **Russ Tamlyn** steps in where **Nick Adams** stumbled out, in this colorful sequel to **Frankenstein Conquers the World** (1965). This time, **Tamlyn** is a visiting scientist; pretty **Kumi Mizuno** is still the assistant. Of course, the giant 100+ foot "Sanda *Frankenstein*" is back, too. But there's trouble in paradise when an identical twin named Sailah (identical, except for green fur and a hateful disposition) shows up. Sailah [called Gaira in the Japanese version] is a clone, generated from his *brother's* severed hand, but he's inherently evil while Sanda is good.

The film's US distributor, **American-International**, decided against promoting this one as a sequel to their previous release. So, any references to **Frankenstein Conquers the World** were removed from the print, including all mentions of Sanda losing his hand and

the "rejuvenation birth" of his sibling. The creatures become known as the **Gargantuas**, accidental freaks of nature.

This film also features American B-actor **Kipp Hamilton** who starred in US blockbusters **Harlow** (1965) and **The Unforgiven** (1960). *War Of The Gargantuas* is his swan song.

WAR OF THE INSECTS
see **GREAT INSECT WAR**

WARNING FROM SPACE
see **COSMC MAN**
　　　APPEARS IN TOKYO

▶ **WATCHDOGS FROM HELL:**
　　RED EYEGLASSES (1987)
[Jigoku No Banken: Akai Megane]
director: **Mamoru Oshii**
Shigeru Chiba • **Machiko Washio**
**½

❖

▶ **WATCHDOGS FROM HELL:**
　　KERUBERSU (1988)
[Jigoku No Banken: Kerubersu]
aka **THE LAST ROBOCOP**
director: **Mamoru Oshii**
Shigeru Chiba • **Yoshikatsu Fujiki**
Takashi Matsuyama • **Sue Chin**

Here's a project written and directed by animation wizard **Mamoru Oshii**,

Watchdogs From Hell

based on his gekiga, *Watchdogs From Hell*. The unusual combination of "art photography" with exploitive genre characteristics is initially irksome but soon becomes an engaging aspect of the production. Often the script is insufferably pedantic, only to explode in charismatic wit moments later. In short, these two films are demanding on the viewer. But, ultimately, they're worth the extra effort.

The first film explores the world of the *Watchdogs*, a secret syndicate funded by a powerful financial conglomerate, Keruberosu. They are sent on a mercenary mission to thwart a political uprising which could have serious repercussions on Tokyo itself.

#2 begins as Zenchi (**Shigeru Chiba**) is ordered to find his former leader, Honyi (**Yoshikatsu Fujika**), a renegade who abandoned his unit and escaped to China. Zenchi takes the mission with some reluctance, not knowing if he has the will to murder the man once he finds him. After about an hour of philosophizing, reminiscent of the infamous **Sheen / Brando** talk-opus in *Apocalypse Now* (1979), the Keruberosu organization ends all discussions with a supercharged robo-terminator.

WATER TRAVELER:
　SAMURAI KIDS (1993)
[Mizu No Tabibito: Samurai Kids]
director: **Nobuhiko** *Obi* **Ohbayashi**
Tsutomu Yamazaki • **Ryo Yoshida**
*½

Somewhere in the early '90s, filmmaker **Obi** lost his way. After a decade of trendsetting fantasies (including such classics as **Stranger In Her Eyes** [1977], **House** [1982], **The New Student** [1982], **Summer with Ghosts** [1989], *et al*), Obi faltered badly with **Drifting Classroom** (1991) and now again with this film. His strength was always in his ability to create likable,

everyman-type characters. These personalities were the inertia that propelled the movies. But this time, Obi is so preoccupied with computer graphics and simplistic knee-jerk philosophies that he neglects his flesh-n-blood creations. The characters are so shallow they fail to garner empathy from the audience. They are merely walking mouthpieces.

A *Tom Thumb* samurai, the victim of a time-slip, arrives in modern Tokyo. He's washed ashore inside a wooden soup bowl. A timid boy rescues the miniature warrior and the two become best friends. Together they face and try to solve the social problems plaguing industrialize Japan (*i.e.,* environmental pollution and overcrowded living conditions, to name but two in a long litany). The film is a masterpiece of special effects, trick photography and computer animation, but it's irritatingly weak as a movie. Too bad.

WEATHER GIRL (1993)
[Otenki Onesan]
aka **WEATHER REPORT GIRL**
director: Tomoaki Hosoyama
Kei Mizutani ● Takashi Sumida
Yasuyo Shiratori ● Hideyo Amamoto

Keiko Nakadai (**Kei Mizutani**) looks into the bathroom mirror and mutters, "Now it's my turn." Seconds later, she's on television, Tokyo's JTV network, substituting for weather girl Michiko. Keiko makes the best of her few seconds in the spotlight as she brazenly exposes her panties to the jaded viewing public. Weather girl Keiko is an overnight sensation — the hit of Tokyo — quickly replacing poor Michiko for good. In fact, when the original weather girl returns from vacation to find her position filled, she tries to get Keiko fired. But the plan backfires. Instead, as a punishment, she's relegated to hosting a new show, *Hello*

Kei Mizutani is the original *Weather Girl*

Perverts. At the same time, Keiko continues to gain in popularity as she turns the weather program into a voyeur's delight. Even though she has the unmitigated support of the station owner (**Hideyo Amamoto**), Keiko has made some heavy enemies — namely the CEO's daughter Shimamori (**Yasuyo Shiratori**), a Paris educated snob who has her own designs on the weather show. Eventually, Shimamori concocts a plan which publically humiliates Keiko, forcing her into hiding. Shimamori takes control of the TV station and the weather program.

Meanwhile, heroine Keiko befriends long-time admirer Yamagishi (**Takashi Sumida**) and convinces him to escort her to the countryside where she hopes to "harness the supernatural force of the weather." Exactly how does she plan on doing that? Through the sting of the sacred Sky/Heaven whip, of course. Yamagishi proceeds to lash and pummel her delectable body until the lightning strikes, thunder cracks, and Keiko transforms into a Weather Witch. She

then returns to JTV and challenges Shimamori — on nationwide television — in a death-battle for the Weather Queen throne.

There is probably no other movie which so dramatically illustrates the enormous cultural differences between Japanese and American sensibilities. **Weather Girl** is a brilliant film, worthy of all the praise it received from some very tough critics, constantly flirting with bad taste while managing to stay fresh and innocent— much like Keiko herself.

Weather Girl is also one of the major Japanese success stories of the '90s. It's based on a popular adult manga (and subsequent animated video series), financed by **Bandai Home Video**. From the beginning the company treated this film as "a stepchild," little more than a "necessary evil." With minor fanfare, **Bandai** released the movie directly to video in early 1995. However, over the year, it managed to secure an underground reputation, especially with the college crowd. The studio — seemingly oblivious to the grassroots support for the film — approached director **Hosoyama** for a sequel in late '95. But this time they wanted him to *push the envelope*, to "concentrate less on black humor and more on sex." Apparently, **Bandai** had mistakenly gauged the film's audience as the *pinku eiga* market.

After reading the new script, **Kei Mizutani** refused to continue in the role of the Weather Girl. She was replaced by **Misa Aika**, a similar-looking but vastly inferior actress {see **Splatter**, also 1995}. After Mizutani bailed out, there was no pretense about continuing the facade. The company hired new cast members including pink-film starlet **Kiyomi Ito**.

Director **Hosoyama** did what he was hired to do. He delivered a sexier

Weather Girl, with a lot more nudity and soft-core gyrations, but considerably light on story {see review following this essay}. The *sequel* was called **Weather Girl R** (in Japan *"R"* means *"Restricted"* identical to the American MPAA rating system; by adding *R* to the title, the production company was obvious about their "more sex" message). The new film did not please the growing legions of *Weather Girl* fans. In fact, they were becoming more vocal about their support for the original movie. Meanwhile, the first motion picture was chosen as the winner of both the Oslo and Stockholm Film Festivals in early '96. **Bandai**, finally convinced they had misread the public, decided to take **Weather Girl #1** more seriously. In an unprecedented move, they pulled the video from the retail stores and formed a distribution deal with **Boxoffice**. The film opened theatrically in Japan on August 16, 1996. Shockingly, it became one of the biggest hits of the year (*i.e.*, #26 on **Kinema Jumpo**'s **40 Best Movies Of 1996**) and was included on many critics' Top 10 lists (*i.e.*, **Tokitoshi Shioda** rated it #6 on his personal *Best Of '96*).

The success of the theatrical *Weather Girl* caused **Toei** to purchase the rights from **Bandai** and they created a brand new weekly television series which premiered on **Asahi TV Network** in January 1997. Those individual episodes then became available on video cassette by the end of the year. Ironically, the Weather *Girl* came full circle.

Information on the movie *sequel*:

▶ **WEATHER GIRL R** (1996)
[Otenki Onesan R]
director: Tomoaki Hosoyama
Misa Aika • **Ryoko Kato**
Saori Taira • **Kiyomi Ito**
**

This time the story is moved from Tokyo to a Hot Springs resort village where there are two television stations are vying for the audience, the conservative Higashiya Network and TV Trendy. After the stuffy Higashiya CEO dies from a heart attack, his high-school daughter, Keiko Nakadai (**Misa Aika**), takes over. She hires herself for the weather show and builds viewership by flashing her panties. Across the street, TV Trendy, has a vicious woman president (**Ryoko Kato**) who isn't amused by the new "scandalous programming" from her competition. This escalates into a big TV war when she hires a former porn star (**Kiyomi Ito**) to do the weather at her station.

WEREWOLF (1990)
[Oazuke]
director: **Takuma Uchida**
Yukiko Sakurai ● **Yayoi Niijima**
Manabu Nakao ● **Taro Kawano**
****½**

Two best friends (**Yukiko Sakurai** and **Yayoi Niijima**) have supernatural powers. Their extrasensory abilities draw them to a struggling soul named Oazuke (**Manabu Nakao**), a gentle boy who was infected with a werewolf serum by a mad scientist (**Taro Kawano**). The girls fall in love with the wolfman but their infatuation is cut short when the scientist hunts him down and kills him. Yukikio and Yayoi seek revenge.

Even though this debut film by **Takuma Uchida** was billed as a black comedy, it's taken very seriously by the fans. The movie won top awards at 1991's *Tokyo Horror Seminar* for the unique transformation sequences and special effects.

The director is the son of director **Tomu Uchida**, best remembered for his *Miyamoto Musashi* samurai series (1961-65).

WHALE GOD (1962)
[Kujira-gami]
director: **Tokuzo Tanaka**
Kojiro Hongo ● **Shintaro Katsu**
Shiho Fujimura ● **Kyoko Enami**

Here's a big budget film based on a novel by **Kouichiro Uno** which won the coveted *Akutagawa Award* for excellence in literature. Interestingly, this is the same **Kouichiro Uno** whose name became synonymous with "adult sex books" in the '70s and '80s, the man responsible for scripting such *Nikkatsu* films as *Nurse's Journal*, *Up and Wet*, and *Stripper Of Izu*.

This is a fantasy actioner about a schooner and its weary crew's search for a giant legendary white whale. Obviously, as the critics quickly pointed out, it owes more than a passing nod to *Melville*'s **Moby Dick**.

WHAT HAPPENS AFTER DEATH?
see **TANBA'S GREAT
SPIRIT WORLD**

WHEEL OF IRON (1972)
[Kanawa]
aka **THE IRON RING**
director: **Kaneto Shindo**
Nobuko Otowa ● **Hideo Kanze**
Meg Flower ● **Taiji Tonoyama**

Wheel Of Iron

Here's a ghost story inspired by the 11th century tale, *Kanawa*, part of the *Noh* folk stories. But, ultimately, it's a lesser film for director **Shindo** who was responsible for two of the genre's most respected movies **Kuroneko** (1968) and **Onibaba** (1964). Aside from the historic wrap-around footage, there's nothing very interesting going on here. The story is simplistic to a fault.

When a shifty husband betrays his wife, the jolt releases her soul. She becomes a "living ghost," and follows her husband and his young lover, plaguing them with bad luck and, ultimately, a death curse. This particular version of the tale is retold in a modern setting with a wronged wife taking vengeance against her two-timing husband.

WHEN EMBRYO
 GOES POACHING (1966)
 [Taiji Ga Mitsuryo Suru Toki]
 aka **EMBRYO**
 aka **EMBRYO HUNTS IN SECRET**
director: Koji Wakamatsu
Hatsuo Yamane • Miharu Shima
****½**

After making twenty movies for **Nikkatsu**,[1] director **Wakamatsu** quit over their handling of his political *hot potato* **Skeleton In The Closet** in 1965. He formed his own company and this was the first release.

Obviously, with this project, director **Koji Wakamatsu** is treading in murky waters. Many critics say he purposely pushed the storyline to the extreme in hopes of antagonizing the government to move against him, thus creating free publicity for his production. But **Eirin** and **Nippon Film Federation** had already lost an obscenity case against **Tetsuji Takechi** for **Black Snow** earlier in the year and they were beginning to adopt a hands-off policy towards censorship and legislation of morality.

Regardless, **Wakamatsu**'s film remains a disturbing portrayal of a sado-sexual relationship, borderlining on horror.

A man (**Hatsuo Yamane**) wants to have normal relationships with women but he is tormented by an uncontrollable fixation on sadism. No matter how hard he tries, he can't control the dark passion. And his girlfriend becomes a victim in his game.

Most of the film takes place within two rooms as the man tortures his partner with whips, razors, and various other devices. He occasionally suffers from flashbacks dealing with other misogynist sessions and even a vivid memory of his father beating his mother (Japanese people believe most everything is inherited directly from one's parents, including ideas and philosophies {see **Star Of Dave: Beauty Hunting** in *Japanese Cinema: The Sex Films*}).

In a reoccurring **Wakamtsu** theme (*i.e.,* **Violated Angels**, *et al*) the woman finally frees herself and stabs her capturer. He finds happiness and comfort in death.

[1]The *Nikkatsu* of the '60s, under the iron-fist rule of **Kyusaku Hori**, was a much more conservative production company than the free-spirited *pinku eiga* studio of the '70s.

WHISPER OF A NYMPH (1987)
 [Seirei No Sasayaki]
director: Yoshiharu Ueoka
Miho Tsumiki • Han Bun-Jak

There's a mansion hidden deep in the snowy forest, shrouded by the frozen wilderness. This is actually an asylum for mentally retarded patients, long forgotten by their wealthy relatives. One day, from the *outside world* comes a girl named Miho (**Miho Tsumiko**). She brings happiness to the inmates, by showing them attention and taking an interest in their stagnant lives. Is she real or illusion? Nymph or nymphet?

Seemingly, Ms **Tsumiki** is a beauty with limited acting ability. She fared adequately in this movie because little was expected of her. Tsumiki satisfactorily interacts with the more colorful supporting players, but **Yoshiharu Ueoka**'s lackluster direction doesn't manage to create any sense of mystery for her character. On the other hand, four years later, filmmaker **Toshiharu Ikeda** would capitalize on **Tsumiki**'s withdrawn personality, tailoring it for a key role in his **Misty** (1991) {see separate review}.

WHO AM I?! (1969)
[Kiki Kaikai Ore Wa Dareda?!]
director: Takashi Tsuboishima
Tani Kei • Hideko Yoshida
**½

Here's one of those *Twilight Zone* concepts that makes no sense but still works on a basic entertainment level. Some critics have also interpreted the film as a psychological essay "in the spirit of *Kafka*."

An office worker Taro Suzuki (**Tani Kei**, a Japanese comedian who took his name from *Danny Kaye*) becomes utterly confused when another Taro Suzuki shows up at work and takes over his desk. No one seems bothered that the imposter looks nothing like the original guy. Instead, everybody accepts the new Suzuki as the *only* Suzuki. This obviously leads to a severe identity crisis for the agitated *everyman*. So Taro drags himself home to his wife and family. But, by the time he gets there, the other Taro is already making himself comfortable at the kitchen table. Even when the poor loser visits his parents, he finds a picture of the imposter hanging on the wall.

WINDS OF GOD (1995)
[Winds Of God]
director: Yoko Narahashi

Masahiro Imai • Shota Yamaguchi
**½

Tashiro and Kinta (**Masahiro Imai and Shota Yamaguchi**) are a standup comedy team. Even though they give the appearance of *rising stars*, times are not good. In fact, these two barely have enough money for food.

One night, after getting paid for a performance, they jump on their 50cc scooters and head for an evening on the town. But they plow straight into a traffic accident. Seriously injured, the two comics are rescued and taken to a nearby hospital.

However, much to their surprise, the hospital isn't what it seems. Apparently the accident jolted them into a time slip (a popular theme in '90s Japanese cinema from **Drifting Classroom** [1991] to **Full Moon: Mr Moonlight** [1991], **Memory Of The Future** [1992] to **Koya Mountains** [1993], **Adventures Of Electric Rod Man** [1995] to **Water Traveler** [1993], *et al*). The hospital is actually a warsite clinic situated squarely in the middle of World War 2. Tashiro and Kinta are no longer themselves. Their souls are now living in the bodies of two *dead* air force pilots. The new spirits bring the two patriots back to life.

So this comedy team is now stuck inside the bodies of two militaristic kamikaze pilots, ready to leave on a new suicide mission. Tashiro and Kinta try all types of hairbrained schemes to get out of the 1940s and back to the safety of the '90s. But they fail. Eventually the big day arrives. It's time for them to man their planes and take off. In an unexpected downbeat ending, Tashiro snaps out of his coma, finding himself in the safety of a modern Tokyo hospital room. But his partner doesn't follow. Kinta dies in his sleep. Seemingly, he went on the heroic kamikaze mission.

The film is a seasoned blend of humor and tension, nicely supported by an exceptional *Paul Winter* score. The anti-war stance is expected, reeking of safe filmmaking. But the plot does take some unexpected twists and the charisma between **Imai** and **Yamaguchi** is so infective that the heavy-handed political sentimentality is forgivable.

Yoko Narahashi is one of a handful of female directors in Japan.

WINK OF AN ANGEL:
NIKKO MONKEY UNIT (1995)
aka **GOD TALKS TO A MONKEY**
[Tenshi No Wink: Nikko Saru Gundan]
director: Katsuya Kida
Nobuhide Takagi • Minayo Watanabe
Tetsuro Tanba • Mayumi Ogawa
*

Somebody should've killed this one before it was ever born. The fact that it was produced — with an sizable budget,

Kimika Yoshino is a good witch in *Wizard Of Darkness*

yet — is proof that Hollywood does not have a lock on stupidity.

A monkey named Ryota is a member of the Nikko Troupe, a traveling primate circus act. One night, God appears to Ryota in an attempt to clear up a problem. "There was a mistake during your birth," God explains to the monkey, "you were accidentally born with a human soul." Conversely, of course, somewhere in the world is a little boy (now ten years old) with an ape's soul. Ryota is given the assignment of finding the mismatched spirit and helping God make a grand cosmetic switch.

Assuredly, none of it makes any sense in the first place, so there's no reason to wonder why God has to enroll the aid of a monkey in this escapade, nor why the monkey is so anxious to help. The plot, as hairbrained as it may be, serves little purpose other than catapulting Ryota into a series of adventures and mishaps.

WIZARD
 see **MAD MONK**

▶ **WIZARD OF DARKNESS** (1995)
[Eko Eko Azaraku]
director: Shimako Sato
Kimika Yoshino • Miho Kanno
Natsumi Takahashi • Mio Takaki

Based on a manga by **Shinichi Koga**. And directed by **Shimako Sato**, one of the few Japanese female directors in the business {also see the previous entry **Winds Of God** by female **Yoko Narahashi**}.

The new girl at school is secretly a *good witch* investigating the murder of her brother. She finds evidence of a black magic ceremony in the school's basement and has a premonition of something terrible about to happen. Meanwhile, one of the teachers is conducting a lesbian love affair with a stu-

Wizard Of Darkness 2

dent. After giving a reading assignment to her class, she sneaks out for some nookie. No sooner than they get down and dirty, all hell breaks loose. A girl winds up dead in a toilet stall. Another is decapitated. Then a boy freaks out and slices up two classmates before killing himself. The heroine tries to calm the students down, but a few more excessively gory deaths undermine her attempts. Eventually, she and her nemesis are the only ones left in a battle of good and evil.

The first 45 minutes are rather slow, spiced up by the gratuitous lesbian sex scenes. But the last half-hour is so kinetic, so pumped-up that it doesn't seem to be part of the same movie. Even the quirky metaphysical ending manages to be oddly hip.

The success of the film begot
a sequel the following year:

▶ **WIZARD OF DARKNESS 2** *aka*
 BIRTH OF THE WIZARD (1995)
[Eko Eko Azaraku 2]
director: Shimako Sato
Kimika Yoshino • Hideyo Amamoto
Chieko Shiratori • Noritsune Yomo

Actress **Yimika Yoshino** and director **Sato** are back for the sequel (and it's also written **Shinichi Koga**). At the end of the 19th century, the Saiga Family of benevolent warlocks are exterminated by a black witch named

Kiria. Today, in the historic ruins, Kiria's mummy is excavated. Her evil spirit possesses a dead body and she goes looking to kill Misa Kuroi, the heroine from #1 who has successfully learned the secrets of white magic.

Similar to the first one, the film ends with another spectacular death battle. But this time the Good Witch is joined by a vengeful ghost, a descendent of the Kaira family. Obviously, after an exhaustive bout, the good guys win.

WOMAN IN THE DUNES (1964)
[Suna No Onna]
director: Hiroshi Teshigahara
Eiji Okada • Kyoko Kishida
Koji Mitsui • Hiroko Ito
***½

The rudimentary storyline is simplicity personified. An entomologist is captured by nondescript villagers and forced into a deep pit near the sand dunes. At the bottom of the shaft lives a woman who takes care of the man's needs, satisfying him with food, shelter and sex. The scientist is forced to live in the pit forever and the woman becomes his entire world.

This film was a huge underground hit in the West during the turbulent '60s. America's disenchanted youths saw it as a counter-culture allegory. The film was often cited as a parable of 20th Century meaningless, a condemnation of sociological (*i.e.*, governmental)

Kyoko Kishida is the *Woman In The Dunes*

control. But many critics have since remarked that this interpretation is merely another example of trying to put a round peg into a square hole.

In Japan, where people are more familiar with the themes of writer **Kobo Abe**, it was accepted as yet another variation on man's search for identity. That is, an existential philosophy seen in other **Teshigahara / Abe** collaborations: man's search for a "reason to continue" despite the numbing redundancy of day by day life.

Regardless, the ambiguity of the film coupled with generous helpings of sex, limited dialogue, and stylish cinematography gave this film a distinct commercial advantage in the West. Director **Hiroshi Teshigahara** and novelist **Kobo Abe** collaborated on a number of films (also see **Face Of Another** [1966]), but *Woman In The Dunes* is the only one to see boxoffice success in the United States.

The WOMAN WHO NEEDED SEX (1995)
[Shitakute Shitakute Tamaranai Onna]
translation: I Need Sex, I Need Sex: Lustful Woman
director: Isao Okishima
Misa Jono • Shoichi Kurata
*½

A bitter-sweet story of a young woman who drifts to a small hot-springs town in the remote Japanese mountains. Meanwhile, Tokyo University student Youchi (**Shoichi Kurata**) has come home for summer vacation. He is intrigued by all the gossip surrounding this mysterious new resident. She is rumored to be, not only beautiful, but also terrific in bed. A newspaper reporter even treks from Tokyo to do an story on her.

The woman is really a *living* ghost, the restless soul of a notorious movie

starlet — now an old woman — who has returned to the city in search of a lost lover. After people discover her true identity, her hospitalized body in Tokyo gives up the ghost and she dies.

There's not much of a movie here. Some of the hot-springs cinematography is nice and **Misa Jono** is exceptionally erotic, but plotwise— this is a germ of an idea with nowhere to go. As the film meanders about, it only manages to become sillier and sillier. The idea that a big city journalist would even bother to investigate a mysterious woman in a resort town is ludicrous.

WOODS ARE WET:
WOMAN HELL (1973)
[Onna Jigoku: Mori Wa Nureta]
director: Tatsumi Kumashiro
Hiroko Isayama • Rie Nakagawa
Hatsuo Yamane • Yuri Yamashina

Loosely based on a portion of *Justine* penned in 1791 by the Marquis DeSade *(Donatien Alphonse Francois de Sade)*, director **Kumashiro** changes his setting to the contemporary Japanese country-side and the *heroine*'s name from Justine to Sachiko. However, the flavor of the production remains faithful to that of the original work.

Yoko (**Rie Nakagawa**) and Ryuno-suke (**Hatsuo Yamane**), a couple living luxuriously in the desolate Japanese mountains, offer to share their palatial home with a runaway city-girl, Sachiko (**Hikoko Isayama**). Mistress Yoko convinces the waif that she's hungry for companionship, that life is "hideously lonely" and she needs someone with whom she can "share womanly ideas." After Sachiko agrees to stay, the girl finds some scary things are happening in this resort home. For instance, the mysterious hosts are killing the other guests in a frenzy of sadistic sex games. Once Sachiko realizes her own life is in

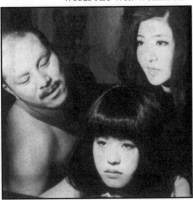

Woods Are Wet: Woman Hell

danger, she wants to get out. Ryun-osuke gives her an ultimatum. If she truly wants to leave, then she has to offer herself to one of the new male guests and convince him to take her away. The brutish man gladly rapes her, but then ignores her plea for escape. He's killed for his ignorance.

Poor Sachiko is tortured, both mentally and physically, throughout the length of the extremely decadent film. This may celebrate a demented form of **Darwinism**, but **Kumashiro**'s message is obvious. It's inspired by the perverse philosophies of DeSade himself, *"Good conduct well chastised."*

Tatsumi Kumashiro became known as the *King Of Nikkatsu*, the most consistently successful director in Japan's cinematic history. "If I can shoot what I like without the pressure of how it will turn out, I am motivated," he said in 1972 while accepting awards from **Kinema Junpo** [Cinema Bi-monthly] for best director/best scriptwriter. But **Kumashiro** was constantly irritated over the "archaic Japanese code of censorship" (*i.e.*, the custom of *fogging* or *blacking out* genitalia). In this movie, as a protest, **Kumashiro** created exaggerated optical black boxes which covered much more than the pubic hair region. While the anti-censorship senti-

Hiroki Tanaka inside the *World Apartment Horror*

ment is appreciated, the tactic is more an annoyance than an effective grievance. The film suffers because of it.

WORLD APARTMENT
HORROR (1990)
[Warudo Apaatomento Hora]
director: Katsuhiro Otomo
Hiroki Tanaka • Yuji Nakamura
Mohammed Abdul Sahib • Jazz Cutz
***½

Katsuhiro Otomo, who found international notoriety as the creator of the animation masterpiece **Akira** (1988), leaves his illustrations behind. This time, he paints with a camera and achieves the same goal through purposely broad performances, especially featuring a memorable one from actor **Hiroki Tanaka**.

It's a genuinely funny *horror* film, with the humor flowing naturally from both a shrewd script and well-defined multi dimensional characters. Ita is a young gangster doing odds jobs for the Yakuza. One day, big boss Kokubu gives him a special assignment: a house cleaning. It seems the mob owns a valuable plot of land and a developer wants to build a highrise on it. But there's a problem: a small two-story apartment is

already already on the land. And it's filled with foreigners who don't want to move. In Japan, the law forbids any company from tearing down a building if people are living inside. So— Ita has one week to get them to move out. "Without killing anyone," the boss adds, "We can't afford the attention."

This may not sound like the makings for a horror story, but Ita quickly finds himself in wrapped up in a bizarre mystery with black magic and a strange Filipino blood curse. Plus he also meets a collection of incredibly strange tenants living in the World Apartment.

X FROM OUTER SPACE (1967)
[Uchu Daikaiju Guilala]
translation: **Giant Space Monster Guilala**
director: Kazui Nihonmatsu
Eiji Okada • Toshiya Wazaki
Peggy Neal • Itoko Harada
Franz Gruber • Toshinari Kazusaki
*½

The best thing, the kindest thing, that can be said about this first (and last) *kaiju eiga* attempt from **Shochiku Studios** is it's not made for children. Thus, it's not supposed to be funny.

But unfortunately, this tale of space-gunk which attaches itself to a rocket

during an interplanetary flight is unintentionally funny. This creature, named Guilala, devours the energy from every weapon used against it, doubling in size with each attack. Eventually, the monster is defeated with an anti-energy substance called Guilalalium (was there really a scriptwriter for this?), shrunk down to miniature size and shot back into space.

This film followed *Shochiku*'s **Great Insect War** disaster from the previous year {see separate entry}. Once again, this time, the company was uniformly chastised for dropping a bomb; critics and fans were merciless in their attack against the studio for this bargain basement attempt. Shochiku responded by pulling the plug on their horror film division. **Peggy Neal** and **Franz Gruber** also starred together in *Toei*'s underwater thrill show, **Terror Beneath The Sea** (1966); Ms Neal continued making motion pictures in Japan with little success (*e.g.*, **Krazy Kats Free-For-All** [Kureizi Ogon Sakusen] in '67; **Agent X-2: Operation Underwater** a year later) before retiring from the silver screen.

▶ **XX: BEAUTIFUL WEAPON** (1993)
[XX: Utsukushiki Kyoki]
director: (Gaira) Kazuo Komizu
Masumi Miyazaki • Kunio Murai
**½

❖

▶ **XX: BEAUTIFUL VICTIM** (1995)
[XX: Utsukushiki Hyoteki]
director: Naosuke Kurosawa
Yoko Natsuki • Shiho
Kojiro Kusanagi • Toru Minegishi

❖

▶ **XX: BEAUTIFUL PREY** (1996)
[XX: Utsukushiki Emono]
director: Toshiharu Ikeda
Kei Marimura • Makiko Watanabe

▶ **XX: BEAUTIFUL KILLING MACHINE** (1996)
[XX: Utukushiki Kinou]
director: Takahito Hara
Rei Natsume • Kenichi Endo
*½

❖

▶ **XX: BEAUTIFUL BEAST** (1997)
[XX: Utsukushiki Gakuen]
director: Toshiharu Ikeda
Kaori Shimamura • Takeshi Yamato
 and Yuko Katagiri
**½

Here's a continuing series of films based on the popular "XX" books of novelist **Arimasa Oosawa**, collections of short stories featuring deadly or forceful women. These movies are not *sequels* in the truest series, rather they are conceptually similar. Both highlight women in pivotal, customarily male roles.

#1 is directed by cult filmmaker **Kazuo Komizu** {this time **not** using his familiar *Gaira* pseudonym, see **Living Dead In Tokyo Bay** for background information} and it's based on the story *Woman At The Dead End* [Yuki-

Kaori Shimamura in *XX: Beautiful Beast*

domari No Onna]. Yoshi Zawa is a very thorough assassination-broker. Sometimes, if the case is particularly delicate, he covers his ass by assigning his Secret Agent XX to "fix" the hit-man who pulled the job. Sakagami (**Toru Minegishi**) is one of Yoshi's pro-fessional killers who figures out the double-cross, learning the identity of the female lethal weapon (played by **Masumi Miyazaki**, quite a departure from her *Be-Bop High School* days). But Sakagami can't help falling in love with this beauty, and that's a fatal mis-take.

The second one is a better looking movie, perhaps due to a larger bank-roll, or maybe **Naosuke Kurosawa** is simply a more competent filmmaker {after all, he made **Banned: Woman's Secret Pictures** (1983) look like a multi-million dollar film with a very limited budget}. Regardless, this is a mean-spirited story about a serial killer pick-ing on girls who lead a *double life*, (*e.g.*, office girl by day, hooker by night). **Yoko Natsuki** plays a tough-as-nails forensic doctor. She becomes the object of the maniac's twisted sense of humor when she starts receiving cryptic

Masumi Miyazaki is *XX: The Beautiful Weapon* (1993)

messages sealed inside condoms found deep in the victims' throats. The whole thing ends with a bitter observation: "These types of killings will increase in today's Japan, influenced by foreign lifestyles." There was an *unofficial* sequel to this installment, by the same director, released in 1996 called **Another XX: Red Murderer** {see separate listing}.

#3, *Beautiful Prey*, is easily the best of the series, with cult filmmaker **Ikeda** riding the helm, once again demonstrating why he's the best thriller director in Japan today {see **Evil Dead Trap** for overview}. This is a tense psychological shocker set against the perverse backdrop of aberrant S&M behavior. A female masochistic commits a series of grisly murders to experience the ultimate *sexual* thrill of losing a loved one. The investigating detectives suddenly find themselves victims in the brutal cat-n-mouse game.

This episode stars real-life jazz singer **Kei Marimura**, as the manipulating killer, and **Makiko Watanabe** is her unwitting victim. **Toshiharu Ikeda**'s direction is superb, featuring some of the best cinematography the genre has to offer. Especially remarkable is the camera work at the film's conclusion, a 13 minute segment, starting outside on the beach, then following the characters into the house, room by room, up the stairway and out onto the balcony. All the necessary closeups are on cue, perfectly matching the crucial dialogue. But, amazingly, the entire segment is all one fluid, single-take. No edits. This extravagant type of cinematography hasn't graced a contemporary horror film since **Dario Argento**'s famous *around-the-house-and-over-the-roof* trick in **Tenebrae** {*aka* **Unsane**} (1982).

The next installment, *Beautiful Killing Machine*, is a major disappoint-

Kei Marimura & Makiko Watanabe deadly lovers in *XX: Beautiful Prey*

ment especially after such a strong antecedent. But director **Takahito Hara** is out of his element here, nowhere as accomplished as **Toshiharu Ikeda**, and -- if that weren't enough — his leading performers, **Rei Natsume** and **Kenichi Endo**, lack the charisma to pull off this cumbersome love/hate story of a female bodyguard and a hired assassin. It serves only as a poor-man's version of the first entry, *Beautiful Weapon*.

Not surprisingly, **Toshiharu Ikeda** is back as the director for the next entry, *Beautiful Beast*. And with his return, the series is on track once again. However, this film is still not as good as *Beautiful Prey*. Ikeda manages to bring his virtuosity to the proceedings, but the project has all the markings of a work-for-hire. Even though the director's flair is plentiful (*i.e.*, the stark closeups, the crystal-blue hues, the pop-jazz "chrome-n-glass" soundtrack, the sudden eruptions of violence, *et al*), his intricately constructed plotline is missing. Quite routinely, this is the story of a Chinese hitwoman, Black Orchid (**Kaori Shimamura**), who avenges the

the giant hydra from Takao Ohgawara's *Yamato Takeru*

brutalized death of her sister at the hands of a Japanese yakuza gang. Some ultra-cool girl-n-gun action, a few steamy sex scenes, bit little else.

Not considered part of the series:

XX: RED MURDERER (1996)
[Another XX: Akai Satsujinsha]
translation:
ANOTHER XX: RED MURDERER
director: Naosuke Kurosawa
Yoko Natsuki • Etsuko Nishio
**½

Here's an unofficial sequel to **XX: Beautiful Victim**, made by the same director with the same star. **Yoko Natsuki** is back as an obdurate forensic doctor investigating the twisted pattern of a psycho-killer rapist. And once again she becomes the object of his obsession. This entry differs from the actual *XX series* by emphasizing thrills rather than the psychological conflicts behind the thrills. But, as usual, director **Naosuke Kurosawa** tempers the horrific elements with his superb cine-matography. Unfortunately the story isn't unique enough to rise above its vicious tone.

YAMATO TAKERU (1994)
[Takeru Yamato]
director: Takao Ohgawara
Masahiro Takashima • Akaji Maro
Yasuko Sawaguchi • Saburo Shinoda

Similar to the *gods-vs-mortals* fantasy films produced during Europe's cine-matic heyday (*i.e.*, **Pietro Francisci**'s **Hercules** [1959] plus countless sequels and spinoffs) this one tells the story of two twin brothers, Osamumko and Takeru, born of the royal family in the land of Yamato. But twins are con-sidered a bad omen, an indication of political turmoil, so, the emperor orders baby Takeru to be thrown off a cliff to his death. In midair, the infant is res-cued by a golden Phoenix. Takeru is taken to his aunt in another providence where he is raised in her protective cus-tody.

Meanwhile, the emperor's evil advisor has beckoned the aid of the Dark Forces to help him gain control of the throne. A series of tragedies brings Takeru back to Yamato where he becomes "the soldier of the gods" in a struggle against the evil deities, including a handsome galactic warrior who is able to transform into a giant hydra (a creature very similar to *Toho*'s Ghidorah, not surprising considering that director **Ohgawara** was responsible for the best films of the *Godzilla* revival series, **Destroyer** [1995], **Mothra** [1992] and **Mechagodzilla** [1993]).

Good special effects, mixing stop motion animation (comparable to the *Sinbad* work of **Ray Harryhausen**) with the latest innovations in computer graphic morphing, make this mythological Japanese tale come alive. But director **Ohgawara**'s approach is purposely more deliberate than his Hong Kong peers (*i.e.*, **Ronny Yu** [Bride With White Hair] or *Ching Siu Tung* [Chinese Ghost Story]); he prefers a slower more elegant odyssey.

YATSUHAKA VILLAGE
see **KINDAICHI** series

YEAR 200X: SHO (1992)
[200X-nen: Sho]
director: **Yutaka Akiyama**
Shingo Kazami • **Rie Takemoto**
**

In the relatively near future, a black hole explodes near Planet X1 in the Hakucho Galaxy. Miniscule particles are spewed throughout the universe and attach themselves to the embryos of pregnant women on the Earth. As a result, all newborn babies are mutants. Initially they appear normal. But soon these children are maturing at an accelerated speed, and appear to have an unhealthy instinct for survival at the expense of everything else around

them. Bluntly, these kids are cannibals. It's discovered that the bloodthirsty brats can be cured with heavy doses of Mesotron. In the real plot, a young couple played by **Shingo Kazami**, the government exterminator from *Hunting Ash* [1992], and **Rie Takemoto** take their *infected* boy Sho to a rural mountain village where it's rumored that Mesotron is thick in the air and family life is normal. From the director of **Keko Mask**. Maybe it's supposed to be funny.

Year 200X: Sho

YOG: MONSTER FROM SPACE (1970)
[Kessen Nankai No Daikaiju]
director: **Ishiro Honda**
Akira Kubo • **Atsuko Takahashi**
Yoshio Tsuchiya • **Kenji Sahara**
**

Yet another variation of the old *space-gunk-attaching-itself-to-a-rocket* story. This time, an alien substance is brought back and contaminates an island where a group of people have been shipwrecked (shades of **Honda**'s **Attack of the Mushroom People** [1963]). As a result, the survivors fight a constant barrage of giant mutated sea creatures (squids, crabs, and in an obvious jab at **Gamera**, turtles).

After this movie, **Ishiro Honda** switched to television production {including the **Mirrorman** series}. He returned to the big screen one more time for *Toho Studios* with **Terror of**

Ishiro Honda's *Yog: Monster From Space*

Mechagodzilla (1975). In 1976, he formed a movie company with his friend **Akira Kurosawa**. The two made films together, including **Kagemusha** (1980), **Ran** (1985) and **Kurosawa's Dreams** (1990). Honda died in 1994.

YOUTH REPUBLIC:
 TROPICAL MYSTERY (1984)
 [Tropical Mystery: Seishun Kyowakoku]
director: **Koyu Ohara**
Narumi Yasuda ● **Takayuki Takemoto**

Koyu Ohara, infamous director of such films as **True Story Of A Woman Condemned To Hell** (1975), **Pink Tush Girl** (1978) and **I Like It From Behind** (1981), left the *pinku eiga* genre with the restructuring of *Nikkatsu Studios* in the early '80s. He took his creativity to the more lucrative youth audience, making a film version of the popular counter-culture novel **Seishun Kyowakoku** *[Youth Republic]* by *Jiro Akagawa*.

In this fantasy, there's a Pacific island called The Youth Republic. It's a virtual paradise for the "under 30 generation," a completely self-sufficient island community governed totally by young people, dedicated to the ideals of freedom, art and celebration (not unlike San Francisco's hippy districts of the late '60s). But everything is not what it seems. Deep in the shadows, beneath the sparkling banter, is a wicked dictator with his own sinister game plan.

Starlet **Yasuda**, besides acting in this film, also sings the title song. Both the song and movie were major hits in Japan.

YUKIONNA
 see **GHOST STORY OF**
 SNOW GIRL

YUMEJI (1991)
 [Yumeji]
director: **Seijun Suzuki**
Kenji Sawada ● Tamasaburo Bando

Michiyo Ohkusu • Kazuhiko Hasegawa

This film is often considered as the third in director **Suzuki**'s *Mirage* trilogy (preceded by the award-winning **Zigeunerweisen** [1980] and **Mirage Theater** [1981]). It's a liberal adaption of the real-life story of artist Yumeji Takehisa who specialized in painting female nudes. He also had, if **Suzuki**'s tale is true, a terrible habit of becoming sexually obsessed with them. Besides getting romantically involved with countless models, Yumeji is haunted by a *Mr Hyde* who contacts him "from the other side" while he's sleeping.

▶ **ZEIRAM** (1992)
 [Zieram]
director: Keita Amamiya
Yuko Moriyama • Yukihiro Hotaru

Yuko Moriyama in *Zeiram*

▶ **ZEIRAM 2**
 [Zieram Zoku]
director: Keita Amamiya
Yuko Moriyama • Kunihiko Ida
**½

State-of-the-arts FX, spirited direction by **Kamen Rider**'s **Keita Amamiya**, and a deadly serious performance from **Yuko Moriyama** put these movies in a class by themselves, regardless of the obvious comparisons with **Star Wars**, **Alien** and the like. This is SciFi for the comic book enthusiast (in fact, **Zeiram** is based on an adult *gekiga*) where the story flows more like a video game than a **Frank Herbert** novel.

A chic female bounty hunter sets a trap for an evil alien called Zeiram. She is aided by two inept power company agents (the unfortunate weak link in the film) and a high-tech computer named Bob. It's worth taking a look for **Yuko Moriyama**'s costuming alone
.

ZIGEUNERWEISEN[1] (1980)
 (Like The Gypies)
 [Tsuigoineru Waizen]
director: Seijun Suzuki
Yoshio Harada • Michiyo Ohkusu
Toshiya Fujita • Naoko Otani

[1]The title is a famous classical Hungarian rhapsody composed by the Spanish violinist **Pablo De Sarasate** (*Sarasate*) (1844-1908). His haunting "gypsy" music serves as soundtrack for this film.

After his ten year hiatus **and** a disastrous *comeback* film, **Story Of Grief And Sorrow** (1977), **Seijun Suzuki** found it impossible to get a studio interested in his projects (similar to the **Orson Welles** tragedy). He finally secured a deal with **Cinema Purasetto**, an independent "traveling" film-festival organization known for "setting up a tent and showing unusual cult films" in cities all over Japan. But even a carnival side-show distributor is better than no distributor at all.

This time, some of Japan's biggest stars supported **Suzuki**'s renaissance, many of them donating their talents to his film. **Toshiya Fujita**'s participation is particularly significant. He's a famous *Nikkatsu* studio director, a twenty-five year company man, who had originally started his career at the studio in 1955 *with* **Suzuki**. Despite the unfortunate circumstances surrounding "*Nikkatsu*, **Suzuki** and the **Branded To Kill** fiasco" {Sukuzi was fired from Nikkatsu in 1967 after "creating movies nobody understands;" he became a recluse, not returning to filmmaking for ten years}, **Toshiya Fujita** publicly paid homage to **Suzuki** by co-starring in this film.

Here, **Seijun Suzuki** comes very close to making a horror film as he intertwines a collection of reality and dream motifs by using terror symbolism reminiscent of *Ingmar Bergman*'s work in **Persona** (1966) and **Hour Of The Wolf** (1968). Four people, each suffering from their own paranoia are bound together by a peripheral but very real mystery which could have devastating— even fatal— results. They must learn to trust one another as they explore the dark underbelly of each other's fantasies.

Seijun Suzuki's *Zigeunerwisen*

This one is certainly **Suzuki**'s most ambitious film. Not all of it works, but even the ostentatious segments are fascinating to watch. It's also his longest movie, clocking in at 145 minutes. And, perhaps because of the *Cinema Purasetto* novelty (*i.e.*, the fact that the film wasn't shown in the normal theaters), it was instantly perceived as "something special" or "something unusual." It was an unqualified hit. As a result, **Cinema Purasetto** made a distribution deal. The film was pulled "off tour" and released to the theaters.

It won the Japanese Academy Award for Best Picture of the Year. **Seijun Suzuki** also won for Best Director. He immediately began work on his next film, **Mirage Theater**.

ZIPANG (Japan) (1990)
director: Kaizo Hayashi
Masahiro Takashima • Narumi Yasuda
Mikijiro Hira • Haruko Wanibuchi
*****½**

A creative idea, loosely based on the writings of *Marco Polo*. In a report to his Italian sponsor, enthusiastic Marco described Japan as *the golden country of Zipang*. He said the streets were paved with gems and buildings were made from gold. He also claimed that the country was overrun with strange human-like beasts and vicious blood-thirsty warriors, making it unsafe for civilized man.

This movie assumes all that is **true** and recreates a new *history* for Japan. Much of the film is highly entertaining, especially the outrageous fight sequences, like a samurai movie gone mad. Director **Hayashi** is a wizard at recreating famous moments from Japanese *chambara* films, and then exaggerating these scenes into astonishing parodies. Plus well-known characters like Zatoichi and Itto Igami show up at the most unexpected moments.

The story itself deals with a master swordfighting rogue who helps mutant creatures rally against a deadly female gunslinger as she attempts to take over the town.

Kaizo Hayashi is obviously influenced by the Hong Kong action films. This is one of the first Japanese ventures to successfully capture the same kinetic style. The director would try again in 1994 with **Worst Time Of My Life**.

Masahiro Takashima in *Zipang*

Apendix A:
Japanese/English Titles

The following is a list of the original Japanese titles, coupled with their English equivalent, for all of the motion pictures itemized in "The Film" section of this book. In some cases, where there is no Iternational moniker, the English title is a direct translation from the Japanese. For additional information or clarification, refer to "The Film" section.

ORIGINAL JAPANESE TITLE	ENGLISH LANGUAGE TITLE
Abunai Hanashi: Mugen Monogatari	Dangerous Tales: Three Dream Stories
Acri	Acri
Agi Kijin No Ikari	Agi: Fury Of The Evil God
Akudama Junen	Ten Years Of Evil
Akuma Karano Kunsho	Medal From The Devil
Akuma No Niwa	Devil Garden
Akuryo Kaidan: Norowareta Bijotachi	Ghost Story Of Evil Spirits
Akutokui	Vicious Doctor
Ama No Bakemono Yashiki	Haunted Mansion Of Ama
Ammonite No Sasayaki	I Heard The Whisper Of The Ammonite
Angel: Boku No Uta Wa Kimi No Uta	Angel: My Song Is Your Song
Aru Mittsu: Shikimu	Some Stories Of Adultery
Bakuretsu Toshi	Burst City
Batoru Garu	Living Dead In Tokyo Bay
Battle Heater: Kotatsu	Battle Heater
Bijo No Harawata	Entrails Of A Beautiful Woman
Bijo To Ekitai Ningen	H-Man
Biyaku No Wana	Love Potion Trap
Borei Gakkyu	Haunted Classroom
Borei Kaibyo Yashiki	Ghost Monster Cat Mansion
Botandoro 1990	Brides From Hell 1990
Boyoku No Shikibutton	Bed Of Violent Desires
Burusera-shop Of Horrors	Burusera Shop Of Horrors
Byaku Fujin No Youren	Mysterious Love Of Lady White
Byoinzaka No Kubikukuri No ie	Death House On Hospital Hill
Chi O Suu Bara	Blood Thirsty Rose
Chi O Suu Me	Blood Thirsty Eyes
Chi O Suu Ningyo	Blood Thirsty Doll

Chi To Ekusutasi	Blood And Ecstacy
Chigireta Ai No Satsujin	Evil Dead Trap 3: Broken Love Killer
Chikyu Boeigun	Mysterians
Chonoryokusha Michi Eno Tabibito	Psychic: Traveler To The Unknown
Choryoku Sentai: O-ranger	O Rangers: Super Power Unit
Chokouso Hantingu	Hunting ASH
Choshoujo Reiko	Supergirl Reiko
Chushingura Gaiden Yotsuya Kaidan	Ghost Story Of Yotsuya: Chushingura
Dai Hado Enjerusu	Die Hard Angels
Daijobu, My Friend	Don't Worry, My Friend
Daikaiju Baran	Varan The Unbelievable
Daikaiju Gamera	Gamera
Daikansho Kamen	Great Sentimental Mask
Daikyoju Gappa	Monster From Prehistoric Planet
Daimajin	Majin
Denchu Kozo No Boken	Adventures Of The Electric Rod Boy
Denei-shoujo Ai	Video Girl Ai
Denen Ni Shisu	Pastoral: To Die In The Country
Densetsu No Gogo=Itsukamita Dracula	Emotion: Dracula Legendary Afternoon
Denso Ningen	Secret Of The Telegian
Desu Pawuda	Death Powder
Doa	Door
Dogura Magura	Dogura Magura
E No Naka No Boku No Mura	Village Of Dreams
Eko Eko Azaraku	Wizard Of Darkness
Enjeru Dasuto	Angel Dust
Esupai	ESP Spy
Fukashigi Monogatari	Miraculous Stories
Fukkatsu No Hi	Virus
FurankenshutainNo Kaiju Sanda Tai Gaira	War Of The Gargantuas
Furankenshutain Tai Baragon	Frankenstein Conquers The World
Fushigina Baby	Miraculous Baby
Futari	Two
Futari No Iida	Eda
Gaki Damashii	Tastiest Flesh
Gakko Ga Abunai!	School Is In Danger!
Gakko No Kaidan	Elementary School Ghost Story
Gakko No Y-dan	School Ghost Story Lampoon
Gamera Tai Barugon	Gamera Vs Barugon
Gamera Tai Dai Akuju	Gamera Vs Guiron
Gamera Tai Dai Akuju Jaiga	Gamera Vs Monster X
Gamera Tai Gaos	Gamera Vs Gaos
Gamera Tai Shinkai Kaiju Jigura	Gamera Vs Zigra
Gamera Tai Uchu Kaiji Bairasu	Gamera Vs Viras
Ganheddo	Gunhed
Ganma Sango Uchu Daisakusen	Green Slime
Gasu Ningen Daiichigo	Human Vapor
Gekko Kamen	Moonbeam Mask

Gojira	Godzilla
Gojira Ebira Mosura: Nankai No Daiketto	Godzilla Vs Sea Monster
Gojira No Gyakushu	Godzilla Counterattacks
Gojira No Musuko	Son Of Godzilla
Gojira Tai Biorante	Godzilla Vs Biolante
Gojira Tai Desutoroiya	Godzilla Vs The Destroyer
Gojira Tai Gaigan	Godzilla Vs Gigan
Gojira Tai Hedora	Godzilla Vs Smog Monster
Gojira Tai Kingu Gidora	Godzilla Vs King Ghidorah
Gojira Tai Megaro	Godzilla Vs Megalon
Gojira Tai Mekagojira	Godzilla Vs Cosmic Monster
Gojira Tai Mekagojira (1993)	Godzilla Vs Mechagodzilla
Gojira Tai Supeisugojira	Godzilla Vs Space Godzilla
Gojira Tai Mosura	Godzilla Vs Queen Mothra
Gokumonto	Island Of Horrors
Goumon Kifujin	Female Inquisitor
Gyaku Funsha Kazoku	Crazy Family
Happy End No Monogatari	Happy Ending Story
Himiko	Himiko
Hikarigoke	Luminous Moss
Hiroku Kaibyoden	Haunted Castle
Hakui No Amazonesu	Amazons In White
Hanayome Kyuketsuma	Vampire Bride
Hebigami maden	Snake God's Temple
Hebimusume To Hakuhatsuki	Snake Girl and Silver Haired Witch
Hiruko Yokai Hanta	Hiruko
Hitomi No Naka No Houmonshi	Stranger In Her Eyes
Hokuto No Ken	Fist Of The North Star
Honoto Ni Atta Kowai Hanashi	Scary True Stories
Hoshi O Tsugumono	Man Who Inherited A Star
Hoshizora No Mukou No Kuni	Adventure In The Parallel World
Hyoryu Kyoshitsu	Drifting Classroom
Ido Zero Daisakusen	Latitude Zero
Ie [Hausu]	House
Iga Ninpou Cho	Black Magic Wars
Ijintachi Tono Natsu	Summer With Ghosts
Ijo Na Hanno: Monzetsu	Abnormal Reaction: Ecstacy
Ikenie	Sacrifice
Imouto To Aburaage	My Sister And Tried Tofu
Inju Gakuen	Sex Beast On Campus
Inju Kyoushi	Sex Beast Teacher
Inugami-ke No Ichizoku	Inugami Family
Izakaya Yurei	Ghost In A Tavern
Jain	Snake Lust
Jigoku	Hell
Jigoku No Banken	Watchdogs From Hell
Jigoku No Keibiin	Security Guard From Hell
Jigoku-do Reikai Tsushin	Spiritual Report: Hell Occult Shop

Jigokuhen	Hell Screen
Jiku Senshi Miki	Time-Fighter Miki
Jintai-mokei No Yuru	Night Of The Anatomical Doll
Jinzoningen Hakaida	Humanoid Hakaida
Jotai Johatsu	Female Bodies Are Disappearing
Joyoku No Kurozuisen	Narcissus Of Lust
Joyurei	Ghost Of An Actress
Jujin Yukiotoko	Half-Human
Juko: Bee Fighters	Hard Helmets: Bee Fighters
Kagero-za	Mirage Theater
Kaibyo	Ghost Cat
Kaibyo Arima Goten	Ghost Cat Of Arima Palace
Kaibyo Karakuri Tenjo	Ghost Cat: False Ceiling
Kaibyo Noroi No Kabe	Ghost Cat: Cursed Wall
Kaibyo Noroi Numa	Ghost Cat In Haunted Swamp
Kaibyo Okazaki Sodo	Ghost Cat Disturbance In Okazzaki
Kaibyo Otama-ga-ike	Ghost Cat of Otama Pond
Kaibyo Yonaki Numa	Ghost Cat From Night-Crying Swamp
Kaidan	Kwaidan (Ghost Story)
Kaidan Ama Yurei	Ghost Of The Girl Diver
Kaidan Bancho Sarayashiki	Ghost Story Of Broken Dishes
Kaidan Barabara Yurei	Ghost Story Of Barabara Phantom
Kaidan Botandoro	Bride From Hell
Kaidan Chibusa Enoki	Ghost Story Of The Breast Elm
Kaidan Chidori-Ga-Fuchi	Ghost Story Of Chidori-Ga-Fuchi
Kaidan Dochu	Lady Was A Ghost
Kaidan Hebi-onna	Ghost Story of Snake Woman
Kaidan Hitotsume Jizou	Ghost Story of One-Eyed God
Kaidan Honjo Nanafushigi	Ghost Wanderer At Honjo
Kaidan: Ikiteiru Koheiji	Horror: Koheiji Is Alive
Kaidan Kagami-ga-fuchi	Ghost Story Of Kagami Swamp
Kaidan Kakuidori	Ghost Story Of Bird
Kaidan Kasane-ga-fuchi	Ghost Story of Kasane Swamp
Kaidan Kasane-ga-fuchi (1970)	Horror Of An Ugly Woman
Kaidan Katame No Otoko	Ghost Story Of One-Eyed Man
Kaidan Nobori Ryu	Blind Woman's Curse
Kaidan Oiwa No Borei	Ghost Story Of Curse Of Oiwa
Kaidan Onibi No Numa	Ghost Story: Swamp Of Corpse Candle
Kaidan Otoshiana	Ghost Story Of The Pit
Kaidan Saga-yashiki	Horror Of Saga Mansion
Kaidan Semushi Otoko	Ghost Of The Hunchback
Kaidan Yonaki-dourou	Ghost Story Of Night-Crying Lantern
Kaidan Zankoku Monogatari	Cruel Ghost Legend
Kaidan Yukijoro	Ghost Story Of The Snow Girl
Kaiju Daisenso	Monster Zero
Kaiju Soshingeki	Destroy All Monsters
Kairakusatsujin: Onna Sousakan	Murder For Pleasure: Female Detective
Kairyu Daikessen	Magic Serpent

Kaitei Daisenso	Terror Beneath The Sea
Kaitei Gunkan	Atragon
Kamen Raida	Kamen Rider
Kamitsukitai	My Soul Is Slashed
Kanawa	Wheel Of Iron
Kaori Ohnuki SM Se7en	SM Se7en
Kekko Kamen	Keko Mask
Kenpei To Barabara Shibijin	Military Cop and Dismembered Beauty
Kenpei To Yurei	Military Cop And The Ghost
Kessen Nankai No Daikaiju	Yog: Monster From Space
Ki No Ue No Sougyo	Fish On A Tree
Kigeki: Kaidan Ryoko	Horror Transfer
Kike Wadatsumi No Koe: Last Friends	Listen To The Voice Of The Sea
Kiki Kaikai Ore Wa Dareda?!	Who Am I?!
Kimi To Itsumademo	Forever With You
King Kong No Gyakushu	King Kong Escapes
King Kong Tai Gojira	King Kong Vs Godzilla
Kirai...Janaiyo	I Hate You... Not
Konchu Dai Senso	Great Insect War
Konto 55-go: Uchu Daiboken	Konto 55: Space Adventure
Kosupure Senshi Cutie Knight	Cutie Knight In Costume
Kowagaru Hitobito	Scared People
Koya Choken-bou Oboegaki	Koya Mountains: Choken Memorandum
Kuchisake Onna	Split Mouth Woman
Kujira-gami	Whale God
Kumo-otoko	Spider Man
Kumonosujo	Throne Of Blood
Kunoichi Ninpo: Kannon Biraki	In Bed With The Enemy
Kunoichi Ninpou-cho	Female Ninja: Magic Chronicles
Kunoichi Senshi Ninja	Female Neo Ninjas
Kurisumasu Mokushi-roku	Apocalypse Christmas
Kurobara No Yakata	Black Rose
Kurotokage	Black Lizard
Kuruizaki Sanda Rodo	Crazy Thunder Road
Kusa-meikyu	Grass Labyrinth
Kyofu Kikei Ningen	Horror Of A Malformed Man
Kyofu: Manster	Manster
Kyofu Shinbun	Horror Newspaper
Kyoryu, Kaicho No Densetsu	Legend Of A Dinosaur and Giant Bird
Kyouju Luger PO8	Cursed Luger P08
Kyuju-Kyu Honme No Kimusume	Virgin Of The 99th Sword
Kyuketsu Dokurosen	Living Skeleton
Kyuketsuga	Bloodsucking Moth
Kyuketsuki Gokemidoro	Goke: Bodysnatcher From Hell
Maboroshi No Mizuumi	Lake Of Illusions
Maboroshi Panti	Legendary Panty Mask
Maju Toshi	Beast City
Makai Tensho	Darkside Reborn

Mandara	Mandara
Mangetsu: Mr Moonlight	Full Moon: Mr Moonlight
Mangetsu No Kuchizuke	Kisses From The Moon
Maniac: Aidoru Yukai	Maniac: Captured Starlet
Mantango	Attack Of The Mushroom People
Maria No Ibukuro	Maria's Stomach
Masho No Natsu: Yotsuya Kaidan Yori	Ghost Story Of Yotsuya
Megami Ga Kureta Natsu	Good Luck Venus
Megyaku	Splatter
Meikyu	Labyrinth
Mekagojira No Gyakushu	Terror Of Mechagodzilla
Mesupai	Miss Spy
Mikadroid	Robokill Beneath Disco Club Layla
Minagoroshi No Reika	Requiem For A Massacre
Minna Yatteruka?	Getting Any Lately?
Mirai Ninja: Kinin Gaiden	Renegade Robo Ninja & Princess Saki
Mirai No Omoide: Last Christmas	Memory Of The Future: Last Christmas
Mizu No Naka No Hachigatsu	August In The Water
Mizu No Tabibito: Samurai Kids	Water Traveler: Samurai Kids
Moju	Blind Beast
Mosura	Mothra
Mosura Tai Gojira	Godzilla Vs The Thing
Muma	Dream Devil
Namakubi Jochi Jiken	Freshly Severed Head
Nihon Boko Ankokushi Bogyakuma	Dark Story Of A Japanese Rapist
Nihon Chinbotsu	Submersion Of Japan
Nihon Seihanzaishi: Torima	Japanese Sex Crime: Concurrence
Nihon Tanjo	Birth Of Japan
Nihon Yokai-den: Satori	Japanese Goblin Story: Satori
Ningen Isu	Human Chair
Ningyo Densetsu	Mermaid Legend
Non-chan Kumo Ni Noru	Non-chan: Riding On The Clouds
Nosutoradamusu No Daiyogen	Last Days Of Planet Earth
Nosutoradamusu: Senritsu No Keiji	NostradamusL Fearful Predictions
Numa Nite	Bottom Of The Swamp
Oedipus No Yaiba	Blade Of Oedipus
Ohinaru Gakusei	Ambitious Student
Okasareta Hakui	Violated Angeles
Onmitsu Hicho: Maboroshi-jo	Samurai Spy: Castle Of Illusions
Onna Batoru Koppu	Lady Battle Cop
Onna Jigoku: Mori Wa Nureta	Woods Are Wet: Woman Hell
Onna Kyuketsuki	Female Vampire
Onna Tomurai-shi, Beni-Kujaku	Red Peacock, Female Undertaker
Ooru Naito Rongu	All Night Long
Oru Kaiju Daishingeki!	Godzilla's Revenge
Oshie To Tabisuru Otoko	Man With Embossed Tapestry
Otenki Onesan	Weather Girl
Otoshiana	Trap

Ougon Batto	Golden Bat
Oazuke	Werewolf
Persian Blue No Shozo	Portrait Of Persian Blue
Piramiddo No Kanata	Beyond The Great Pyramid
Rasuto Furankenshutain	Last Frankenstein
Rex: Kyoryu Monogatari	Rex: A Dinosaur Story
Rose: Satsuriku No Mehyo	Rose: Carnage Of The Panther
Sakura No Mori No Mankai No Shita	Under The Cherry Blossoms
Samayoeru Nouzui	Roaming Tortured Brain
Sandai Kaiju Chikyu Saidai No Kessen	Ghidrah The Three Headed Monster
Saraba Hakobune	Goodbye Ark
Saru No Gundan	Time Of The Apes
Sasou Onna	Female Seductress
Satomi Hakken-den	Legend Of The Eight Samurai
Satsujin Ga Ippai	Lots Of Killing
Satsujinkyojidai	Time Of Madness
Sei No Kaidan	Ghost Story Of Sex
Seibo Kannon Daibosatsu	Sacred Mother Kannon
Seigida! Mikatada! Zeninshugo!	Justice Fighting: Everyone In Place!
Seihanzai	Sex Crimes
Seirei No Sasayaki	Whispers Of A Nymph
Sekai Daisenso	Last War
Sengoku Jieitai	Time Slip
Senrei	Baptism
Shiberia Chotokkyu	Siberian Super Express
Shigatsu Kaidan	April Horror
Shinpan Yotsuya Kaidan	Ghost Of Yotsuya
Shinrei	Spirit
Shiroi Kabe No Kekkon	Bloody Fragments On A White Wall
Shiryo No Wana	Evil Dead Trap
Shitakute Shitakute: Tamaranai Onna	The Woman Who Needed Sex
Shizonuki	Missing Heart
Shojo No Harawata	Entrails Of A Virgin
Shonen Tantei-dan	Boy's Detective Team
Shura	Bloodshed
Shuranosuke Zanma-ken	Sacred Sword Of Shuranosuke
Shuto Shoshitsu	Tokyo Blackout
Sora No Daikaiju Radon	Rodan
Suiito Homu	Sweet Home
Suna No Onna	Woman In The Dunes
Taiji Ga Mitsuryo Suru Toki	When Embryo Goes Poaching
Taketori Monogatari	Story Of The Bamboo Hunter
Tanba Tetsuro No Daireikai	Tanba's Great Spirit World
Tanin No Kao	Face Of Another
Taro! Tokyo Makai Taisen	Taro! Tokyo Magic World War
Teito Monogatari	Capitol Story
Teito Monogatari Gaiden	Capitol Story: Secret Report
Teito Taisen	Capitol Great War

Tenamonya Yurei Dochu	Samurai Comedy: Ghost Journey
Tenkawa Densetsu Satsujin Jiken	Noh Mask Murders
Tenkosei	New Student
Tenshi No Wakemae	Angel's Share
Tenshu Monogatari	Tower Story
Tobuyume O Shibaraku Minai	I Never Had A Flying Dream
Tokaido Obake Dochu	Tokaido Road Monsters
Tokaido Yotsuya Kaidan	Ghost Story Of Yotsuya
Toki O Kakeru Shoujo	Girl Who Traveled Beyond Time
Tokyo Fist (Kokyo Fisuto)	Tokyo Fist
Tokyo-wan Enjo	Tokyo Bay Fireball
Tomei Kaijin	Invisible Man
Tomei-kenshi	Invisible Swordsman
Tomei-ningen	Invisible Man
Tomei-ningen To Hae-otoko	Invisible Man Vs The Fly Man
Tomeiningen Erohakase	Invisible Man: Dr Eros
Toire No Hanako-san	Hanako In The Restroom
Toriko	Victim
Toumei-tengu	Invisible Monster
Tsuru	Crane
200X-nen: Sho	Year 200X: Sho
Uchu Dai Kaiju: Dogora	Dogora The Space Monster
Ucha Daikaiju Guilala	X From Outer Space
Uchu Daisenso	Battle In Outer Space
Uchu Kaiju Gamera	Space Monster Gamera
Uchu Kaisoku-sen	Invasion Of The Neptune Men
Uchu Kamotsusen: Remunanto 6	Space Cargo: Remunanto 6
Uchu Kara No Messeji	Message From Space
Uchujin Tokyo Ni Arawaru	Cosmic Man Appears In Tokyo
Umezu Kazuo Terror!	Umezu's Terror Zone
Umi To Dokuyaku	Sea And Poison
Uratsukidoji: Hakui Jogoku-hen	Exorister
Urutora Q: Hoshi No Densetsu	Ultra Q: Legend Of The Stars
Ushimitsu No Mura	Cursed Village
Utahime Makai O Yuku	Diva In The Netherworld
Warudo Apaatomento Hora	World Apartment Horror
Wakusei Daisenso	War In Space
Watashi No Karada O Kaeshite	Give Me Back My Body
Yabu No Naka	In The Thicket
Yabu No Naka No Kuroneko	Kuroneko (Black Cat)
Yamada Babaa Ni Hanataba O	Bouquet For Spinster Yamada
Yami Ni Hikaru Me	Fear For the Mummy
Yaneura No Sanpo Sha	Walker In The Attic
Yashaga Ike	Demon Pond
Yatsuhaka-mura	Eight Tombstone Village
Yokai Daisenso	Big Monster War
Yokai Hyaku Monogatari	Hundred Monsters
Yoru No Tadare	Night Decay

Yosei Gorasu	Gorath
Yotsuya Kaidan	Ghost Story Of Yotsuya
Yotsuya Kaidan: Oiwa No Borei	Ghost Story Of Yotsuya: Oiwa Curse
Youba	Evil Woman
Youjo Densetsu	Computer-Age Ghost
Youjo Densetsu: Siren	Sorceress Legend: Siren
Youkai Tengoku: Ghost Hero	Monster Heaven: Ghost hero
Yousou	Mad Monk
Yudono Sanroku Noroimura	Cursed Village In Yudono Mountain
Yunagi-sensen 8-Gatsu-go	Evening Calm Battle Line: August
Yusei Oji	Prince of Space
Za Ginipiggu	Guinea Pig

Apendix B: Personnel
Directors

The following filmographies cover all directors mentions in the credits of "The Films" section of this book. For each individual, all his films in the Horror, Fantasy or Science Fiction genre are listed. For more information about the film, refer to "The Films" section.

ADACHI, NOBUO: Invisible Man Appears
AINODA, SATORU: Moonbeam Mask (Gekko Kamen)
AKASAKA, NAGAYOSHI: Return Of Supergiant (Transformation Of The Devil,
 Kingdom Of Poisonous Moths)
AKIYAMA, YUTAKA: Keko Mask: The Birth, Keko Mask, Keko Mask In Love,
 Year 200X (Sho)
AMAMIYA, KEITA: Humanoid Hakaida, Kamen Rider Z, Kamen Rider J,
 Renegade Robo Ninja and Princess Saki, Zieram, Zieram 2
AMANO, TENGAI: Twilight
ANAKURA, TOKUKO: Ultraman (Monster's Great Duel)
ARAI, RYOHEI: Horror Of Saga Mansion, Ghost Cat Of Arima Palace
AWAYA, YUMIKO: Nostradamus Fearful Prediction
AZUMA, YOICHI: Japanese Goblin Story (Satori), Village Of Dreams
BANDO, TAMASABURO: Tower Story
BANNO, YOSHIMITSU: Godzilla Vs The Smog Monster
BREAKSTON, GEORGE: Manster
CRANE, KENNETH: Devil Garden, Half Human, Manster
DEME, MASANOBU: Listen To The Voice Of The Sea God (Last Friends)
EJIKI, HAJIME: Guinea Pig (series)
FORD, TERENCE see SATO, HAJIME
FUJIWARA, KEI: Organ
FUKASAKU, KINJI: Black Lizard, Black Rose, Darkside Reborn,
 Ghost Story of Yotsuya (Chushingura Version), Green Slime,
 Legend Of The Eight Samurai (1984), message From Space, Virus
FUKAZAWA, KIYOSUMI: Time Of The Apes
FUKUDA, JUN: ESP Spy, Godzilla Vs The Cosmic Monster, Godzilla Vs Gigan,
 Godzilla Vs Megalon, Godzilla Vs Sea Monster, Konto 55,
 Secret Of The Telegian, Son Of Godzilla, War In Space

FUKUDA, KINNOSUKE: Ghost Cat, Ghost Story Of The One Eyed God
FUKUDA, SEIICHI: Female Bodies Are Disappearing, Vicious Doctor
FUKUI, SHOZIN: Pinnochio 964, Rubber's Lover
GAIRA see KOMIZU, KAZUO
GOTO, HIDEJI: Beast City 2, Don Matsugoro's Great Adventure
HAGIBA, SADAAKI: Roaming Tortured Brain
HAGIWARA, RYO: Samurai Spy
HARADA, MASATO: Gunhed
HARADA, YUICHI: Tanba's Great Spirit World
HARAGUCHI, SATOO: Robokill Beneath Disco Club Layla
HASE, KAZUO: Cruel Ghost Legend
HASHIMOTO, IZO: Bloody Fragments On A White Wall,
 Capitol Story (Secret Report), Evil Dead Trap 2
HASHIMOTO, SHINOBU: Lake Of Illusions
HASIMOTO, KOJI: Godzilla 1985, Sayonara Jupiter
HATTORI, MITSUNORI: Amazons In White, Hunting Ash, Sex Beast Teacher,
 Sex Beast Teacher 2, Sex Beast Teacher 4, Tanba's Great Spirit World 3
HAYAKAWA, HIKARI: Agi (Fury Of The Evil God), Umezu's Terror Zone
HAYASHI, KAIZO: Zipang
HINO, HIDESHI: Guinea Pig (series)
HIRAYAMA, HIDEYUKI: Elementary School Ghost Story,
 Elementary School Ghost Story 2, Maria's Stomach
HIROKI, RYUICHI: Captured For Sex 2, Dream Devil, Forever With You
HISAZUMI, MASAYUKI: Guinea Pig 8 (He Never Dies)
HONDA, ISHIRO: Attack Of The Mushroom People, Atragon,
 Battle In Outer Space, Destroy All Monsters, Dogora The Space Monster,
 Frankenstein Conquers The World, Ghidrah The Three Headed Monster,
 Godzilla, Godzilla Vs The Thing, Godzilla's Revenge, Gorath, H-Man,
 Half-Human, Human Vapor, King Kong Escapes, King Kong Vs Godzilla,
 Latitude Zero, Monster Zero, Mothra, Mysterians, Rodan,
 Terror Of Mechagodzilla, Varan The Unbelievable,
 War Of The Gargantuas, Yog Monster From Space
HOSOYAMA, TOMOAKI: Weather Girl, Weather Girl R
ICHIKAWA, KON: Crane, Inugami Family, Devil's Bouncing Ball Song (1977),
 Island Of Horrors, Queen Bee (1978), Death House On Hospital Hill,
 Eight Tombstone Village, Noh Mask Murders, Story Of Bamboo Hunter
ICHINOSE, TAKASHIGE: Capitol Great War
IIDA, JOJI: Battle Heater
IIJIMA, TOSHIHIRO: Daigoro Vs Goriasu
IKEDA, TOSHIHARU: Cursed Village In Yudono Mountain, Evil Dead Trap,
 Evil Dead Trap 3 (Broken Love Killer), Mermaid Legend, Misty,
 XX Beautiful Prey, XX Beautiful Beast
IMAI, TADASHI: Evil Woman
IMAI, TAKEO: Good Luck Venus
IMAZEKI, AKIYOSHI: Green Requiem, Miraculous Stories
INAGAKI, HIROSHI: Birth Of Japan
INAGAWA, JUNJI: Spirit
INOUE, SHINSUKE: Beast City, Raped In Heaven

INOUE, UMEJI: Black Lizard

ISHIDA, AKIRA: Tanba's Great Spirit World 2

ISHIDA, KATSUMUNE: Tokyo Bay Fireball

ISHII, TATSUYA: Acri, Kappa

ISHII, TERUO: Blind Woman's Curse, Horror Of A Malformed Man, Supergiant

ISHII, TERUYOSHI: Horror Newspaper, Split Mouth Woman, Taro

ISHII, TOSHIHIRO (SOGO): Angel Dust, August In The Water, Burst City,
 Crazy Family, Crazy Thunder Road, Labyrinth Of Dreams

ISHIKAWA, HITOSHI: Blood And Ecstacy, Captured For Sex 2

ISHIKAWA, ATSUSHI: Fish On A Tree

ISHIKAWA, YOSHIHIRO: Ghost Cat Of Otame Pond,
 Ghost Cat In The Haunted Swamp

ISHIYAMA, AKINOBU: Terra Soldier (Cyboy)

ISOMURA, KAZUMICHI: Bride From Hell 1990

ITO, DAISUKE: Ghost Story Of Yotsuya

ITO, KAORU: Miraculous Stories

IWASAKI, TOMOHIKO: Philip

IWAI, SHUNJI: Swallowtail Butterfly

IZUMIYA, SHIGERU: Death Powder

IZUTSU, KAZUYUKI: Dangerous Tales

JINNO, FUTOSHI: Rose

JISSOJI, AKIO: Capitol Story, Mandala, Return Of Ultraman,
 Ultra Q The Movie, Walker In The Attic (1994)

KADOKAWA, HARUKI: Rex A Dinosaur Story

KANEDA, OSAMU: Hard Helmets

KANEDA, RYU: Kisses From The Moon, Video Girl Ai

KANEKO, SHUSUKE: Gamera Guardian Of The Universe, Gamera 2
 My Soul Is Slashed

KASAI, MASAHIRO: Female Neo Ninjas

KATO, BIN: Ghost Cat Disturbance In Okazaki,
 Ghost Story of The Swamp Of The Corpse Candle,
 Suzunosuke Akado (series), Monster In The Moonlight,
 Devil In New Moon Tower

KATO, TAI: Ghost Story Of Yotsuya (Curse Of Oiwa), Requiem For A Massacre

KATANO, GORO: Ghost Wanderer At Honjo, Ghost Story of The Breast Elm,
 Ghost Of The Girl Diver

KAWAMURA, TAKESHI: Last Frankenstein

KAWASAKI, MINORU: Miss Spy

KAWASHIMA, TORU: The Checkers In Raccoon Fever,
 Man With The Embossed Tapestry

KIDA, KATSUYA: Wink Of An Angel

KIMIZUKA, TAKUMI: Ruby Fruit

KIMURA, MAKOTO: SM Se7en

KINOSHITA, KEISUKE: Ghost Story Of Yotsuya

KINUGASA, TEINOSUKE: Mad Monk

KITANO, BEAT TAKESHI: Getting Any Lately?

KOBAYASHI, KANAME: Sex Beast On Campus

KOBAYASHI, MASAKI: Kwaidan

KOBAYASHI, TSUNEO: Ghost Story Of One Eyed Man, Invisible Man,
 Mitsukubi Tower, Moonbeam Mask (Gekko Kamen), Boys Detective Team
KOBAYASHI, YOSHIAKI: O Ranger
KODAMA, TAKASHI: Female Seductress
KOIKE, TAKASHI: Ambitious Student
KOISHI, EIICHI: Ghost Story Of Chidori-ga-fuchi Swamp
KOMATSU, SAKYO: Sayonara Jupiter
KONO, HUICHI: Ghost Story Of Broken Dishes At Bancho
KOZUKI, HIDEYUKI: Give Me Back My Body
KOKUSHO, HIROHISA: Nighty Night
KOMINE, TAKAO: Revenge With Pao
KOMIZU, KAZUO (GAIRA): Female Inquisitor, Entrails Of A Beautiful Woman,
 Entrails Of A Virgin, Living Dead In Toyko Bay,
 Man Who Inherited A Star, XX Beautiful Weapon
KOMORI, MAKU: Snake Lust, Ten Years Of Evil
KONAKA, KAZUYA: Adventure In The Parallel World, April Horror,
 Black Jack (series), Defender, Lady Poison, Teddy Bear From Outer Space
KONUMA, MASARU: Murder For Pleasure
KOTANI, TOM see KOTANI, TSUGUNOBU
KOTANI, TSUGUNOBU (TOM): Last Dinosaur
KOUZU, MITSUO: Invisible Monster
KUDO, EIICHI: Snake God's Temple
KUMAGAI, KOKI: Great Sentimental Mask
KUMAI, KEI: Luminous Moss, Sea And Poison
KUMASHIRO, TATSUMI: Hell, Woods Are Wet (Woman Hell)
KURAMOTO, KAZUHITO (KAORU): Guinea Pig (Android Of Notre Dame),
 Sex Beast On Campus 2, Sex Beast On Campus 3
KURATA, JUNJI: Legend Of The Dinosaur And Giant Bird
KURATA, FUMITO: Non-Chan (Riding On The Clouds)
KURODA, YOSHIYUKI: Big Monster War, Invisible Swordsman
KUROSAWA, AKIRA: Ran, Throne Of Blood
KUROSAWA, KIYOSHI: Dangerous Tales, Door 3, Security Guard From Hell,
 Sweet Home
KUROSAWA, NAOSUKE: XX Beautiful Victim, XX Red Murderer
KUSUDA, YASUYUKI: Patio
KUWABARA, MASAHIDE: Victim
MAGATANI, MORIHEI: Haunted Mansion Of Ama, Virgin Of The 99th Sword
MAKOTO, WADA: Scared People
MANDA, KUNITOSHI: Space Cargo
MATSUDA, SADAJI: Devil Comes Down And Blows His Flute,
 Gokumon Island, Queen Bee (1952), Yatsuhaka Village
MASUDA, TOSHIO: Last Days Of Planet Earth, Tokyo Blackout
MASUMURA, YASUZO: Blind Beast
MATSUBAYASHI, SHUE: Last War, Samurai Comedy (Ghost Journey)
MATSUMOTO, TOSHIO: Bloodshed, Dogura Magura,
 Funeral Procession Of Roses
MATSUMURA, KATSUYA: All Night Long 1, All Night Long 2 (Atrocity),
 All Night Long 3 (Atrocities)

MATSUNO, HIROSHI: Living Skeleton
MATSUOKA, JOJI: Hanako In The Restroom
MATSUYAMA, HITOSHI: Time-Fighter Miki
MATSUYAMA, ZENZO: Eda
MAYUZUMI, RINTARO: Rampo
MINAMOTO, YUNOSUKI: Labyrinth
MISUMI, KENJI: Ghost Cat (Cursed Wall), Ghost Of Yotsuya,
 Majin (Return Of Majin)
MITSUISHI, FUJIO: School Ghost Story Lampoon
MITSUWA, AKIRA: Supergiant (Appearance Of The Space Phantom)
MIYAGAWA, TAKAYUKI: In Bed With The Enemy
MIYAKE, MASAYUKI: Spirit
MIYASAKA, TAKESHI: Burusera Shop Of Horrors
MIZUNO, HARUO: Siberian Super Express
MIZUTANI, TOSHIYUKI: Human Chair
MORI, ISSEI (KAZUO): Chimera With Three Eyes,
 Ghost Story Of The Bird That Ate Mosquitoes,
 Ghost Story Of Yotsuya (Oiwa), Majin Strikes Again
MORI, KAZUO see MORI, ESSEI
MORITA, YOSHIMITSU: Memory Of The Future (Last Christmas)
MORITANI, SHIRO: Submersion Of Japan
MOURI, MASAKI: Ghost Story Of Kagumi Swamp, Ghost Story Of Yutsuya
MURAHASHI, AKIO: Cab
MURANO, TETSUTARO: Koya Mountains (Chuken Memorandum)
MURATA, SHINOBU: Sacrifice
MURAYAMA, MITSUO: Invisible Man Vs The Fly Man, Medal From the Devil
NAGAMINE, TAKAFUMI: Diva In The Netherworld, Hellywood,
 Legendary Panty Mask
NAGAISHI, TAKAO: Rapeman (series)
NAKAGAWA, NOBUO: Female Vampire, Ghost Monster Cat Mansion,
 Ghost Story Of Kasane Swamp, Ghost Story Of The Snake Woman,
 Ghost Story Of Yotsuya, Hell (1960), Horror (Koheiji Is Alive),
 Military Cop And The Ghost
NAKAJIMA, KOUICHI: Beyond The Great Pyramid
NAKAJIMA, SADAO: Renegade Robo Ninja And Princess Saki
NAKAJIMA, SHINYA: Ultraman Z
NAKAMURA, GENJI: Captured For Sex 2, Lots Of Killing, Sadistic Song
NAKANO, TAKAO: Exorsister (series)
NAKATA, HIDEO: Ghost Of An Actress
NAKATA, SHINICHIRO: Don Matsugoro's Life, Miraculous Stories
NAMIKI, KYOTARO: Military Cop And The Dismember Beauty, Vampire Bride
NARAHASHI, YOKO: Winds Of God
NARUSHIMA, TOICHIRO: Blade Of Oedipus
NASU, HIROYUKI: Spiritual Report (Occult Shop From Hell)
NEMOTO, MASAYOSHI: Miraculous Baby
NINAGAWA, YUKIO: Ghost Story Of Yotsuya (Haunted Summer)
NIHONMATSU, YOSHIMIZU: Great Insect War, X From Outer Space
NISHIHARA, GIICHI: Abnormal Reaction Ecstacy, Ghost Story Of Sex

NOGUCHI, HARUYASU: Monster From Prehistoric Planet
NOMURA, YOSHITARO: Yatsuhaka Village
OCHIAI, MASAYUKI: Parasite Eve
ODA, MOTOYOSHI: Godzilla Counterattacks, Invisible Man
OGAWA, KINYA: Freshly Severed Head, Ghost Story Of The Barabara Phantom
OGURA, SATORU: Guinea Pig (series)
OHARA, KOYU: Youth Republic
OHBAYSHI, NOBUHIKO "OBI": Drifting Classroom, Emotion,
 Girl Who Traveled Beyond The Time Barrier, House,
 Adventures Of Kosuke Kindaichi, Pearl Sprite, New Student,
 Stranger In Her Eyes, Summer With Ghosts, Two, Water Traveler
OHGAWARA, TAKAO: Godzilla Vs Destroyer, Godzilla Vs Mechagodzilla,
 Godzilla Vs (Queen) Mothra, Supergirl Reiko,Yamato Takeru
OHI, TOSHIO: Bouquet For Spinster Yamada
OHMORI, KAZUKI: Full Moon, Godzilla Vs Biolante,
 Godzilla Vs King Ghidorah
OHSAWA, KEN: Happy Ending Story
OHTA, KOJI: Invasion Of The Neptune Men
OHTA, TATSUYA: TVO
OKAMOTO, AKIHISA: Lady Battle Cop
OKAMOTO, KIHACHI: Blue Christmas, East Meets West, Time Of Madness
OKISHIMA, ISAO: Woman Who Needed Sex
OKUNAKA, ATSUO: Time Of The Apes
OKUYAMA, KAZUYOSHI: Rampo
OMORI, KAZUKI see OHMORI, KAZUKI
OSHII, MAMORU: Watchdogs From Hell, Watchdogs From Hell 2
OTOMO, KATSUHIRO: World Apartment Horror
OZAWA, SHIGEHIRO: Mitsukubi Tower
PROWSE, ANDREW: Ultraman G (Monster Termination Project),
 Ultraman G (Alien Invasion)
SAISHU, KYOJI: Lavish Wonder
SAITO, KOSEI: Time Slip
SAKAIYA, MIYUKI: Bite It Right
SAKAMOTO, JUNJI: Biriken
SAKAMOTO, YUJI: Ullie
SARAFIAN, RICHARD: Crisis 2050
SASAKI, HIROHISA: Passionate Wasteland, School Is In Danger!
SASAKI, MASATO: Donor
SATO, HAJIME (FORD, TERENCE): Agent X-2 (Operation Underwater),
 Ghost Of The Hunchback, Goke (Bodysnatcher From Hell),
 Golden Bat, Terror Beneath The Sea
SATO, JUNYA: Psychic Traveler
SATO, MITSUMASA: Black Magic Wars,
 Devil Comes Down And Blows The Flute (1979)
SATO, SHIMAKO: Wizard of Darkness, Wizard Of Darkness 2
SATO, TOSHIYASU: In The Thicket, Night Of The Anatomical Doll, Splatter
SAWADA, ARTHUR MITSUGA: Die Hard Angels, Zombie Annihilation
SAWADA, YUKIHIRO: Moonbeam Mask (Gekko Kamen) (1991)

SAWASHIMA, TADASHI: Lady Was A Ghost
SEGAWA, MASAHARU: Horror Transfer, Justice (Fighting The Good Fight)
SEKI, KOJI: Invisible Man (Dr Eros), Love Potion Trap
SHIMA, KOJI: Cosmic Man Appears In Tokyo, Ghost Story Of The Pit
SHIMAZU, SHOICHI: Moon Mask Rider (Gekko Kamen) (series)
SHIMIZU, ATSUSHI: Target Campus
SHIMIZU, KOJI: Sex Beast Teacher
SHINDO, KANETO: Kuroneko, Onibaba, Wheel Of Iron
SHINODA, MASAHIRO: Demon Pond, Himiko, Island Of Evil Spirits,
 Under The Cherry Blossoms
SHIRAI, MASAKAZU: Darkside Reborn (1996), Darkside Reborn (Path To Hell)
SUGAWA, EIZO: I Never Had A Flying Dream
SUKIDA, MASAYOSHI: Tastiest Flesh
SUZUKI, JUKICHI: Buruba
SUZUKI, OHJI: Evening Calm Battle Line
SUZUKI, SEIJUN: Mirage Theater, Yumeji, Zigeunerweisen
TADA, HIROAKI: Super Coming
TAGA, HIDENORI, Portrait Of Persian Blue
TAKABAYASHI, YOICHI: Honjin Murder Case
TAKAHASHI, AKIRA: Manster
TAKAHASHI, GEN: Missing Heart
TAKAHASHI, IWAO: Sorceress Legend (Siren)
TAKAHASHI, TOMOAKI: Dangerous Tales, Door, Door 2
TAKIGAWA, CHISUI: Ring
TAMURA, MASAKURA: Fear For The Mummy
TANAKA, HIDEO: Sukeban Deka, Sukeban Deka 2, Sukeban Deka 3
TANAKA, NOBORU: Computer-Age Ghost, Cursed Village,
 Walker In The Attic (1976)
TANAKA, SHIGEO: Gamera Vs Barugon
TANAKA, TOKUZO: Ghost Story Of Snow Girl, Haunted Castle, Whale God
TANBA, TETSURO: Tanba's Great Spirit World
TANNO, YUJI: Season For Tears
TASAKA, KATSUHIKO: Ghost Cat From Night-Crying Swamp,
 Ghost Story Of Night-Crying Lantern
TESHIGAHARA, HIROSHI: Face of Another, Trap, Woman In The Dunes
TENGAN, DAISUKE: My Sister And Fried Tofu
TERAYAMA, SHUJI: Goodbye Ark, Grass Labyrinth, Pastoral
TEZUKA, MAKOTO: Bottom of The Swamp, Monster Heaven
TOCHIHARA, HIROAKI: Happy Ending Story
TOJI, SHOHEI: O Rangers (Super Power Unit Vs Kaku Rangers),
 Ultra 6 Brothers, Vs Monster Army
TOYODA, SHIRO: Ghost Story Of Yotsuya, Hell Screen,
 Mysterious Love Of Lady White
TSUBOISHIMA, TAKASHI: Who Am I?!
TSUBURAYA, HAJIME: Ultraman
TSUJI, TOSHINARI: Angel's Share
TSUKAMOTO, SHINYA: Adventures Of The Electric Rod Boy, Hiruko, Tetsuo,
 Tetsuo 2 (Body Hammer), Tokyo Fist

TSURUTA, NORIO: Ghost Classroom, Ghost Story Of Evil Spirits,
New Scary True Stories, Scary True Stories (Night One),
Scary True Stories (Night Two)

TSUSHIMA, MASARU: Female Ninja: Magic Chronicles (series), Red Peacock,
Sacred Sword Of Shuranosuke

UCHIDA, EIICHI: I Hate You…Not

UCHIDA, TAKUMA: Werewolf

UCHIDE, KOUKICHI: Legend Of The Eight Samurai (1959)

UEOKA, YOSHIHARU: Whisper Of A Nymph

WADA, TAKUYA: Dragon Blue

WAKABAYASHI, EIJIRO: Prince Of Space

WAKAMATSU, EIJIRO: Moonbeam Mask (Gekko Kamen) (series)

WAKAMATSU, KOJI: Dark Story Of A Japanese Rapist, Narcissus Of Lust,
Sacred Mother Kannon, Sex Crimes, Violated Angels,
When Embryo Goes Poaching

WATANABE, KUNIO: Secret Of Inugami Family, Devil Is Dancing,
Devil's Bouncing Ball Song (1961)

WATANABE, TAKAAKI: Alice's Sanctuary

WATANABE, TAKESHI: Cursed Luger P08

WATANABE, TAKAYOSHI: Angel (My song Is Your Song),
Ghost In The Tavern, Ghost In the Tavern 2

WATANABE, YUZURU: Bed Of Violent Desires

WAXMAN, KEONI: Apocalypse Christmas

YAMADA, ISAO: I Heard The Whisper Of The Ammonite

YAMAKAWA, NAOTO: Miraculous Stories

YAMAMOTO, HIROYUKI: Spider Man

YAMAMOTO, MICHIO: Blood Thirsty Doll, Blood Thirsty Eyes,
Blood Thirsty Rose

YAMAMOTO, SATSUO: Bride From Hell (1968)

YAMAMOTO, SHINYA: Night Decay, Some Stories Of Adultery

YAMASHITA, KENSHO: Godzilla Vs Space Godzilla, Nineteen

YAMASHITA, OSAMU: Japanese Sex Crime

YAMAUCHI, TETSUYA: Magic Serpent

YAMAZAKI, MIKIO: Pu

YASUDA, KIMIYOSHI: Ghost Story Of Kasane Swamp (1960),
Horror of An Ugly Woman, Hundred Monsters, Majin,
Tokaido Road Monsters, Beating The Devil Mask Gang, Hicho Style,
Majin With One Leg

YOSHIDA, KAZUYUKI: Maniac R, Maniac (Captured Starlet)

YOSHIHARA, KENICHI: Baptism

YOUEDA, YONEDA: Mothra (1996)

YUASA, NORIAKI: Cutie Knight in Costume 1, Cutie Knight In Costume 2,
Gamera, Gamera Vs The Gaos, Gamera Vs Viras, Gamera Vs Guiron,
Gamera Vs Monster X, Gamera Vs Zigra, Space Monster Gamera

YUMIZURI, SUSUMU: Phantom With Twenty Faces (Boys Detective Team)

Apendix C: Personnel
Performers

The following filmographies cover all performers mentioned in the credits of "The Films" section of this book. For each individual, all their films in the Horror, Science Fiction or Fantasy genre are listed. For more information about the film, refer to "The Films" section.

ABE, HIROSHI: Cursed Luger P08
ABE, NAOYUKI: Gamera Vs The Gaos
ADACHI, YUMI: Rex (A Dinosaur Story)
ADAMS, NICK: Frankenstein Conquers The World, Monster Zero
AI, KYOKO: Destroy All Monsters
AI, MICHIKO: Ghost Cat of Arima Palace
AI, TOMOKO: Terror Of Mechagodzilla
AIDA, MASASHI: O Rangers, Super Power Unit Vs Kaku Rangers
AIKA, MISA: Splatter, Weather Girl R
AIZAWA, JUNE: Scary True Stories 2, Scary True Stories 3
AKASAKA, AKIRA: Miraculous Baby
AKASHI, USHIO: Samurai Spy
AKAZA, MIYOKO: Bride From Hell
AKECHI, JUZABURO: Ghost Of The Girl Diver, Ghost Wanderer At Honjo
AKIKAWA, RISA: Baptism
AKIKAWA, REIKO: Ghost Story Of Barabara Phantom, Invisible Man (Dr Eros)
AKIMOTO, NAOMI: Die Hard Angels, Zombie Annihilation
AKIYOSHI, KUMIKO: Summer With Ghosts
AMACHI, SHIGERU: Female Vampire, Ghost Story Of Yotsuya (1959), Ghost Wanderer Of Honjo, Hell, Military Cop And Dismembered Beauty, Military Cop And The Ghost
AMAMI, YUKI: Apocalypse Christmas
AMAMIYA, RYO: Door 3
AMAMOTO, EIMEI (HIDEYO): Female Neo Ninjas, My Soul Is Slashed, Time Of Madness, Weather Girl, Wizard Of The Darkness 2
AMAMOTO, HIDEYO see AMAMOTO, EIMEI
AMANO, TERUKO: Abnormal Reaction: Ecstacy
AMIHAMA, NAOKO: Bloody Fragments On A White Wall

ANKRUM, MORRIS: Half-Human
ANZAI, KYOKO: Battle In Outer Space
AOI, MITSUKO: Horror Of A Malformed Man
AOYAMA, CHIKAKO: Bride From Hell 1990, Door 2
AOYAMA, KAZUYA: Godzilla Vs Cosmic Monster
AOYAMA, YOSHIHIKO: Big Monster War, Ghost Story Of Yotsuya (1969),
 Majin (Majin Monster Of Terror)
AOKI, SHINSUKE: August In The Water
ARAKI, KEISUKE: Guinea Pig 8
ARATAMA, MICHIYO: Kwaidan
ARIMORI, YUMI: Adventure In The Parallel World
ARIMURA, TSUGUMI: Ruby Fruit
ARIZONO, YOSHIKI: Night Of The Anatomical Doll
ASAHI, SARA: Monster Heaven
ASAKA, YUI: Sukeban Deka, Sukeban Deka 2, Sukeban Deka 3
ASAMIYA, JUNKO: Burusera Shop Of Horrors, Sex Beast On Campus
ASANO, AIKO: Drifting Classroom
ASANO, KEIKO: Female Inquisitor
ASANO, TADANOBU: Acri
ASANO, YUKO: Eight Tombstone Village (Kindaichi series), War In Space
ASANUMA, JUNKO: Scary True Stories
ASHIKAWA, YOSHIMI: Nostradamus Fearful Prediction
ASO, MAMIKO: Blood And Ecstacy
ASO, MARIKO: Ambitious Student
ATSUMI, MARI: Gamera Vs Viras
ATSUTA, YOKO: Invisible Swordsman
AYUKAWA, HIROSHI: Military Cop And The Dismembered Beauty
AZUMA, CHIYONOSUKE: Ghost Story Of Broken Dishes At Bancho
AZUSA, EIKO: Medal From The Devil
AZUSA, MARI: Abnormal Reaction: Ecstacy
BACHITA, SCOTT: East Meets West
BAISHO, CHIEKO: Requiem For A Massacre
BAISHO, MITSUKO: Crazy Family
BAKKE, BRENDA: Gunhed
BANDO, TAMASABURO: Demon Pond, Tower Story, Yumeji
BANDO, YOSHITARO: Horror Of Saga Mansion,
 Ghost Cat Disturbance In Okazaki
BANRI, MASAYO: Haunted Mansion Of Ama
BARAGRAY, JOHN: Gamera
BESSHO, TETSUYA: Crisis 2050, Godzilla Vs Queen Mothra
BOONE, RICHARD: Last Dinosaur
BOYLE, PETER: Crisis 2050
BRENNAN, PEGGY LEE: Message From Space
BURR, RAYMOND: Godzilla, Godzilla 1985
CARIDES, GIAN: Ultraman G
CARRADINE, JOHN: Half-Human
CARR, JAY: East Meets West
CASNOFF, PHILLIP: Message From Space

CHAPMAN: Super Coming
CHARA: Swallowtail Butterfly
CHECKERS: The Checkers In Raccoon Fever
CHIAKI, MINORU: Throne Of Blood
CHIBA, SHIGERU: Watchdogs From Hell, Watchdogs From Hell 2
CHIBA, SHINICHI (SONNY): Black Magic Wars, Darkside Reborn, Golden Bat,
 Invasion Of The Neptune Men, Legend Of The Eight Samurai (1984),
 Message From Space, Terror Beneath The Sea, Time Slip, Virus
CHIHARA, SHINOBU: Ghost Story Of One Eyed God
CHIN, SUE: Watchdogs From Hell 2
CONNORS, CHUCK: Virus
CONWAY, HAROLD: Battle In Outer Space
COTTERILL, RALPH: Ultraman G
COTTON, JOSEPH: Latitude Zero
CRAIG, JAMES: Devil Garden
CURTIS, MICKEY: Beast City, Beast City 2, Gunhed, Swallowtail Butterfly
CUTZ, JAZZ: World Apartment Horror
DAIMON, MASAAKI: Godzilla Vs Cosmic Monster
DAN, REIKO: Time Of Madness
DANGELY, DIANE: Sayonara Jupiter
DANIELS, GARY: Fist Of The North Star
DANKAN: Getting Any Lately?
DATE, SABURO: Horror Of An Ugly Woman
DATE, SEIZABURO: Ghost Cat Of Otama Pond,
 Horror Of An Ugly Woman (Ghost Story Of Kaggami Swamp)
DEKKER, ALBERT: Gamera
DOKUMAMUSHI, SANDAIYU: Ultraman (series)
DOMON, HIROSHI: Kamen Rider Z
DONAHUE, TROY: Drifting Classroom
DONLEVY, BRIAN: Gamera
DRIFTERS: Justice
DYNELEY, PETER: Manster
EBARA, SHINJIRO: Invasion Of The Neptune Men
ECHIGO, MITSUYOSHI: School Ghost Story Lampoon
EGUCHI, YOSUKE: Acri
EMI, SANAE: Blood Thirsty Eyes
EMI, SHUNTARO: Ghost Story Of Yotsuya (1959)
EMOTO, AKIRA: Battle Heater, Last Frankenstein, Maria's Stomach
ENAMI, KYOKO: Gamera Vs Barugon, Medal From The Devil, Whale God
ENDO, MASA: All Night Long 2
ENDO, KEIICHI: North 45, XX Beautiful Killing Machine
ENDO, YUMIKO: Checkers In Raccoon Fever
ENOKI, MIDORI: Female Bodies Are Disappearing
ENOKI, TAKAAKI: Noh Mask Murders
EVE: Guinea Pig 8
EZAWA, MOEKO: Getting Any Lately?
FINDLAY, DIANE: Gamera
FLOWER, MEG: Wheel Of Iron

FONDA, PETER: Don't Worry My Friend
FORD, GLENN: Virus
FUJI, TATSUYA: Acri, Kappa
FUJII, AKITO: Missing Heart
FUJII, KAORI: Tokyo Fist,
FUJIKI, YU: King Kong Vs Godzilla
FUJIKI, YUKIKO: Mad Monk
FUJIKI, YOSHIKATSU: Watchdogs From Hell 2
FUJIMA, FUMIHIKO: Horror (Koheiji Is Alive)
FIJIMAKI, JUN: Hundred Monsters, Majin
FUJIMORA: YUKO: Amazons In White
FUJIMOTO, AYANO: I Hate You...Not
FUJIMOTO, SENAKO: Female Neo Ninjas
FUJIMURA, SHIHO: Ghost Story Of Snow Girl, Majin (Return Of Majin),
 Whale God
FUJIOKA, HIROSHI: ESP Spy, Submersion Of Japan
FUJISAWA, MAYA: Mothra (1996)
FUJISHIMA, NORIBUMI: World War 3 Breaks Out
FUJISHIRO, MINAKO: Sukeban Deka
FUJITA, KEIKO: Snake God's Temple
FUJITA, MAKOTO: Samurai Comedy
FUJITA, MIDORI: Blood Thirsty Eyes
FUJITA, SUSUMU: Spider Man
FUJITA, TETSUYA: I Heard The Whisper Of The Ammonite
FUJITA, TOSHIYA: Zigeunerweisen
FUJITANI, AYAKO: Gamera Guardian Of The Universe
FUJITANI, KANAKO: Legendary Panty Mask, School Ghost Story Lampoon,
 SM Se7en
FUJIWARA, HIDEKI: Taro!
FUJIWARA, KEI: Adventures of the Electric Rod Boy, Organ, Tetsuo
FUJIWARA, KIYOSE: Diva In The Netherworld
FUJIWARA, REIKO: Ghost Story of Night-Crying Lantern
FUJIYAMA, KOJI: Gamera Vs Barugon
FUJIYAMA, YOKO: Atragon, Dogora The Space Monster
FUKIGOSHI, MITSURU: Time-Fighting Miki, Gamera 2
FUMIAKE, MACH: Space Monster Gamera
FUNAKOSHI, EIJI: Blind Beast, Gamera, Gamera Vs Guiron,
 Ghost Story Of The Bird That Ate Mosquitoes, Ghost Story Of The Pit
FUNAKOSHI, KEISUKE: Kappa
FUROUYA, MASATO: Blade Of Oedipus, Cursed Village, Island Of Evil Spirits
FURUSATO, YAYOI: World War 3 Breaks Out
FURUYA, IKKO: Adventures Of Kosuke Kindaichi,
 Pearl Sprite (Kindaichi series)
FURUYA, TOSHI: ultraman (series)
FUSHIMI, SENTARO: Legend Of The Eight Samurai (1959)
FUTAMI, KAZUKI: Mothra (1996)
GODA, KAZUHIKO: Entrails Of A Beautiful Woman, Entrails Of A Virgin
GOMI, RYUTARO: Majin

GOTO, YUMI: Forever With You, Scary True Stories
GRUBER, FRANZ: Terror Beneath The Sea, X From Outer Space
GUNJI, MASATO: Sex Beast On Campus
HADA, MICHIKO: Rampo
HAGIMOTO, KINICHI: Konto 55
HAGINO, TAKASHI: Give Me Back My Body
HAGIO, NAOMI: Entrails Of A Virgin
HAGIWARA, KENICHI: Ghost In A Tavern, Ghost Story Of Yotsuya (1981),
 Eight Tombstone Village
HAGIWARA, NAOMI: Split Mouth Woman
HAGIWARA, NAGARE: Sukeban Deka, Sukeban Deka 2, Sukeban Deka 3
HAMA, MIE: King Kong Escapes, King Kong Vs Godzilla
HAMA, YUKO: Gamera Vs Guiron
HAMADA, MITSUO: Season For Tears
HAMADA, YUKO: Medal From The Devil, Snake Girl And Silver Haired Witch
HAMAGUCHI, YOSHIHIRO: Buruba, Invisible Man Vs Fly Man
HAMAMURA, JUN: Man With The Embossed Tapestry
HAMILTON, KIPP: War Of The Gargantuas
HAN BUN-JAK: Maria's Stomach, Whisper Of A Nymph
HANAI, SUZUMI: Legendary Panty Mask
HANI, MIO: Hellywood
HARA, SETSUKO: Birth Of Japan, Man With Three Fingers,
 Non-Chan (Riding On The Clouds)
HARA, KYOKO: Pinnochio 964
HARADA, CHISE: Full Moon
HARADA, ITOKO: X From Outer Space
HARADA, KIWAKO: Godzilla Vs King Ghidorah
HARADA, MIEKO: Capitol Story, Hell (1979), Psychic (Traveler To Unknown),
 Ran, Scared People, Village Of Dreams
HARADA, RYUJI: Kappa
HARADA, TOMOYO: Girl Who Traveled Beyond Time
HARADA, YOSHIO: Last Frankenstein, Mirage Theater, Ring, Zigeunerweisen
HARAGUCHI, YORIKO: Robokill Beneath Disco Club Layla
HARAGUCHI, YUKO: Eda
HARUKAWA, MASUMI: Ghost Of The Hunchback, Pastoral
HASEGAWA, KAZUHIKO: Ghost of Yotsuya. Yumeji
HASEGAWA, KIMIHIKO: Organ
HASEGAWA, MACHIKO: Ghost Story Of Snow Girl
HASHIMOTO, KYOKO: Great Sentimental Mask
HASHIO, YUKO: Buruba
HASHIZUME, JUN: Godzilla Vs Space Godzilla
HATSUSE, KAORU: Apocalypse Christmas
HAYAKAWA, AKIKO: Miraculous Stories
HAYAMA, REIKO: Female Ninja Magic Chronicles, Sadistic Song
HAYAMA, YOKO: Ghost Of The Hunchback
HAYAMI, RYO: Dragon Blue
HAYASE, KEIKO: Living Dead In Tokyo Bay
HAYASE, YUKAKO: TVO

HAYASHI, MIKI: Dark Story Of A Japanese Rapist,
 Ghost Story Of The Barabara Phantom, Night Decay
HAYASHI, NARITOSHI: Akado Suzunosuke
HAYASHI, TAKASHI: Evening Calm Battle Line
HAYASHI, YASUFUMI: Drifting Classroom, Godzilla Vs The Destroyer
HAYASHI, YUMIKA: Exorsister 2
HAZUKI, REINA: Hard Helmets
HAZUKI, RIONA: Parasite Eve
HAYASHIDA, AKIHIKO: Tanba's Great Spirit World
HEALEY, MYRON: Varan The Unbelievable
HESTON, CHARLTON: Crisis 2050
HIDA, RIE: Beast City
HIDAKA, SAYO: Sex Beast On Campus, Sex Beast On Campus 2,
 Sex Beast On Campus 3
HIGASHIYAMA, NORIYUKI: Nineteen
HIIRO, TOMOE: Horror Transfer
HIJIKATA, TATSUMI: Himiko
HIKARU, IPPEI: School Is In Danger
HINO, TOSHIHIKO: Guinea Pig 2
HINOTORI, KOZUE: Freshly Severed Head
HIRA, MIKIJIRO: Capitol Story, Face Of Another, Rampo, Zipang
HIRATA, AKIHIKO: Godzilla, Godzilla Vs Cosmic Monster, Gorath, H-Man,
 Mysterians, Rodan, Secret Of The Telegian, Son of Godzilla,
 Terror Of Mechagodzilla
HIRO, SHINKO: Super Coming
HIROSE, MASATAKA: Murder For Pleasure
HIROTA, REONA: Don't Worry My Friend, North 45, Organ
HISHIMI, YURIKO: Godzilla Vs Gigan
HITOMI, REIKO: Great Insect War
HOLMAN, CATHY: Great Insect War
HONDA, HIROTARO: Rose, Spiritual Report (Occult Shop From Hell)
HONDA, YASUAKI: Humanoid Hakaida
HONGO, KOJIRO: Bride From Hell, Gamera Vs Barugon, Gamera Vs The Gaos,
 Gamera Vs Viras, Haunted Castle, Majin (Return Of Majin),
 Tokaido Road Monsters, Whale God
HORAGUCHI, YORIKO: Man Who Inherited A Star
HORI, MEGUMI: In Bed With the Enemy
HORII, SHINJI: Majin Strikes Again
HORTON, ROBERT: Green Slime
HOSEI, MAI: Humanoid Hakaida
HOSHI, YUKO: Die Hard Angels
HOSHI, TERUMI: Supergiant (series)
HOSHI, YURIKO: Ghidrah The Three Headed Monster, Godzilla Vs The Thing
HOSOKAWA, TOSHI: Ghost Monster Cat Mansion
HOSOKAWA, TOSHIYUKI: I Never Had A Flying Dream
HOTARU, YUKIHIRO: Zieram, Zieram 2
HOZUMI, PEPE: Tokaido Road Monsters
HUI, ANDY: Swallowtail Butterfly

HUSSEY, OLIVIA: Virus
HYLTON, JANE: Manster
IBU, MASATO: Monster Heaven
ICHIKAWA, HIROSHI: Godzilla Vs Gigan
ICHIKAWA, RAIZO: Mad Monk
ICHIRYUSAI, TEISUI: Split Mouth Woman
IDA, KUNIHIKO: Zieram, Zieram 2
IGAWA, HISASHI: Trap
IHARA, TSUYOSHI: Gamera Guardian Of The Universe
IIZUKA,MASAHIDE: Majin Strikes Again
IIJIMA, NAOKO: Zombie Annihilation
IKEBE, RYO: Battle In Outer Space, Gorath, Bloodsucking Moth, Mysterious
Love Of Lady White, War In Space
IKEGAMI, KIMIKO: House
IKENAMI, SHINO: Cursed Village, Evil Dead Trap 2
IKEUCHI, JUNKO: Female Vampire, Ghost Story Of Yotsuya (1965),
 Spacegiant (series), Vampire Bride
IMA, KITAYO: Tokaido Road Monsters
IMAFUKU, MASAO: Bloodshed
INAGAWA, JUNJI: Spirit
IMAI, MASAHIRO: Female Seductress, Winds Of God
IMAMURA, RIE: Baptism, Sacred Sword Of Shuranosuke
IMAMURA, TOSHIKAZU: My Sister And Fried Tofu
INANO, KAZUKO: Ghost Story Of Yotsuya (1969)
INOUE, ANRI: Exorsister 2
INOUE, TAKAYUKI: Hanako In The Restroom
INUKAI, TAKICHI: Death Powder
INUZUKA, HIROSHI: Daigoro Vs Goriasu
IPPONGI, BAN: Exorsister, Exorsister 2, Exorsister 3, Exorsister 4
IRIE, TAKAKO: Ghost Cat Disturbance In Okazaki,
 Ghost Cat From Night Crying Swamp, Ghost Cat Of Arima Palace,
 Horror Of Saga Mansion
ISAYAMA, HIROKO: Under The Cherry Blossoms, Woods Are Wet
ISHIBASHI, KEI: Ghost Classroom
ISHIBASHI, RENJI: Angel's Share, Dangerous Tales,
 Ghost Story Of Yotsuya (1981), Ghost Story Of Yotsuya (Chushingura),
 Hell, Sacred Mother Kannon, Tetsuo, Walker In The Attic
ISHIBASHI, SHOJI: Horror (Koheiji Is Alive)
ISHIBASHI, TAMOTSU: Gamera 2, Roaming Tortured Brain
ISHIDA, AYUMI: Submersion Of Japan
ISHIDA, ERI: I Never Had A Flying Dream
ISHIDA, HIKARI: My Soul Is Slashed, Two
ISHIDA, ICHINARI: Ullie
ISHIGURO, KEN: Don Matsugoro's Great Adventure
ISHIHARA, YURI: Exorsister 3
ISHIHAMA, AKIRA: Ghost Story Of Snow Girl
ISHII, IKICHI: Return Of Ultraman
ISHIMARU, DAIKO: Twilight

ISHIMURA, HIROKO: I Heard The Whisper Of The Ammonite
ISHINO, YOKO: Godzilla Vs The Destroyer
ISHIYAMA, RITSU: Horror Of An Ugly Woman
ISHIZAKA, KOJI: Inugami Family, Devil's Bouncing Ball Song,
 Island Of Horrors, Queen Bee, Death House On Hospital Hill (Kindaichi)
ISHIZAKI, JINICHI: Emotion
ISOKA, HITOMI: Japanese Sex Crime Concurrence
ITAMI, JUZO: Grass Labyrinth, Sweet Home
ITO, AYUMI: Swallowtail Butterfly
ITO, DAVID: Memory Of The Future
ITO, HIROKO: Woman In The Dunes
ITO, KIYOMI: I Hate You...Not, Weather Girl R
ITO, KAZUE: Sukeban Deka 3
ITO, TAKESHI: I Hate You...Not, Missing Heart
ITO, YUNOSUKE: Invisible Man
ITO SISTERS (THE PEANUTS): Destroy All Monsters,
 Ghidrah The Three Headed Monster, Mothra, Godzilla Vs The Thing
IURA, HIDETOMO: Terra Soldier (Cyboy)
IWAMATSU, RYO: Ambitious Student
IWAMI, YUKIYOSHI: Philip
IWAMOTO, TADAO: Victim
IWASHITA, SHIMA: Himiko, Island Of Evil Spirits, Under The Cherry Blossoms
IZUMI, MOTOYA: Memory Of The Future
IZUMI, SHIGEAKI: Maniac R, Maniac (Captured Starlet)
IZUMI, YUKI: Female Bodies Are Disappearing
IZUMIDA, YOSHI: Freshly Severed Head
IZUMIYA, SHIGERU: Burst City, Death Powder
JAECKEL, RICHARD: Green Slime, Latitude Zero
JESSER, ROLF: Great Insect War
JINBO, MIKI: House
JINNAI, TAKANORI: Burst City, Cab, Kappa
JO, KENZABURO: Ghost Story Of Swamp of Corpse Candle
JO, MAMI: Sex Beast On Campus 2, Sex Beast On Campus 3
JONO, MISA: Give Me Back My Body, Woman Who Needed Sex
KADOMATSU, KANORI: All Night Long 2, All Night Long 3, Labyrinth,
 Sex Beast Teacher
KADOTA, EISUKE: All Night Long
KAGA, JOJI: Ultraman Z
KAGA, MARIKO: Mirage Theater
KAGA, NAOMI: Japanese Sex Crime Concurrence
KAGA, TAKESHI: Island Of Evil Spirits
KAGAWA, KYOKO: Birth Of Japan, Mothra
KAGAWA, TERUYUKI: Black Jack
KAGAWA, YUKIE (LILIE): Ghost Story Of The Snake Woman,
 Invisible Man (Dr Eros)
KAGEYAMA, TAMIO: Guinea Pig 5
KAJI, MASAAKI: Time Of The Apes
KAJI, MEIKO: Blind Woman's Curse

KAMEI, MITSUYO: Haunted Castle
KANA, AKIKO: Darkside Reborn
KANAI, SHIGERU: Hard Helmets
KANAOKA, NOBU: Tetsuo, Tetsuo 2
KANAZAWA, AKANE: Cutie Knight In Costume 2
KANAZAWA, MIDORI: Tokyo Bay Fireball
KANBARA, AKIO: Vicious Doctor
KANBAYASHI, SHIGENORI: Bottom Of The Swamp
KANDA, MASAKI: Roaming Tortured Brain
KANDA, TAKASHI: Hundred Monsters
KANDA, YUJI: Adventure In The Parallel World
KANGETSU, ARISA: Supergirl Reiko
KANNO, MIHO: Wizard Of Darkness
KANEHAKO, SOUJI: Captured For Sex 2
KANEKO, NOBUO: Living Skeleton, Magic Serpent
KANIE, KEIZO: Sacred Mother Kannon
KANZE, HIDEO: Wheel Of Iron
KARA, JURO: Bloodshed, Last Frankenstein, Violated Angels
KARITA, TOYOMI: Cosmic Man Appears In Tokyo
KARNS, ROBERT: Half-Human
KASAHARA, KENJI: Half Human
KASAHARA, REIKO: Gamera Vs The Gaos, Horror Of An Ugly Woman
KASE, TAISHU: Patio
KASHIMA, NOBUHIRO: Gamera Vs Guiron
KASHIWABARA, YOSHIE: School Is In Danger
KATASE, RINO: Siberian Super Express
KATAGIRI, KAHORU: Exorsister
KATAGIRI, YUKO: XX BEautiful Beast
KATAHIRA, NAGISA: Stranger In Her Eyes
KATAOKA, CHIEZO: (Kindaichi:) Man With Three Fingers, Gokumon Island,
 Yatsuhaka Village, Devil Comes Down And Blows The Flute,
 Secret Of The Inugami Family, Mitsukubi Tower
KATAOKA, TSURUTARO: Summer With Ghosts
KATO, GO: Demon Pond
KATO, MASAYA: Capitol Great War
KATO, RYOKO: Weather Girl
KATO, TAIJU: Entrails Of A Virgin
KATORI, MIYUKI: Legendary Panty Mask
KATORI, TAMAKI: Abnormal Reaction: Ecstacy,
KATSU, SHINTARO: Capitol Story, Ghost Cat: Cursed Wall,
 Ghost Cat From Night-Crying Swamp, Whale God
KATSUMA, NORIKO: Supergiant series
KATSUNO, HIROSHI: Blue Christmas
KATSURA, NAMI: Love Potion Trap
KATSURA, SHIJAKU: Dogura Magura
KATSURAGI, ASAMI: Amazons In White, Keko Mask In Love, Sadistic Song
KATSURAGI, FUMI: Evil Dead Trap
KAWADA, CLIFFORD: Varan The Unbelievable

KAWAGUCHI, SAE: Cruel Ghost Legend
KAWAI, CHIHARU: Teddy Bear From Outer Space
KAWAI, HANBEI: Renegade Robo Ninja & Princess Saki
KAWAI, NODOKA: Amazons In White
KAWAI, PAPPARA: Battle Heater
KAWAI, YU: Maniac (Captured Starlet)
KAWAJI, TAMIO: Monster From Prehistoric Planet
KAWAMURA, YUKI: Requiem For A Massacre
KAWANO, TARO: Werewolf
KAWANO, YUKA: Hanako In The Restroom
KAWASAKI, AKANE: Big Monster War, Haunted Castle
KAWASAKI, KEIZO: Cosmic man Appears In Tokyo
KAWASE, HIROYUKI: Godzilla Vs Megalon, Godzilla Vs Smog Monster
KAWAZU, SEIZABURO: Ghost Story Of The Snake Woman, Invisible Man
KAWAZU, YUSUKE: Cruel Ghost Legend, Gamera Vs Zigra, Great Insect War
KAZAMA, HITOMI: Female Inquisitor
KAZAMA, MORIO: Summer with Ghosts
KAZAMI, SHINGO: Hunting Ash, Year 200X
KAZUSAKI, TOSHINARI: X From Outer Space
KEATS, STEVEN: Last Dinosaur
KEI, TOMOKO: Samurai Comedy
KEI, TANI: Who Am I?!
KEITH, MICHAEL: King Kong Vs Godzilla
KENNEDY, GEORGE: Virus
KERA: Living Dead In Tokyo Bay, Super Coming
KIKI, KIRIN: New Student
KIKUCHI, MOMOKO: Patio, Terra Soldier (Cyboy)
KIKUCHI, TAKANORI: Donor, Female Ninja #5 (Secret Of Jaraiya),
 Siberian Super Express
KIM, SUJIN: Tetsuo 2
KIMURA, ISAO: Black Lizard
KINAMI, KIYOSHI: Bed Of Violent Desires
KINASHI, YOSHITAKE: Ultraman Z
KINUGASA, KEIKO: In Bed With The Enemy
KIRIHARA, MIKA: Splatter
KIRITACHI, HARUMI: Gamera
KISHI, KEIKO: Noh Mask Murders
KISHIBE, ITTOKU: East Meets West
KISHIDA, KYOKO: Crane, Face Of Another, Hell, Woman In The Dunes
KISHIDA, SHIN: Blood Thirsty Eyes. Blood Thirsty Rose, Mandala
KISHIMOTO, YUJI: Humanoid Hakaida
KITABAYASHI, TANIE: Majin Strikes Again
KITAGAWA, CHIZURU: Invisible Man Appears, Gokumon Island, Queen Bee
KITAGAWA, YUJI: All Night Long 3
KITAHARA, RINA: Female Ninja Magic Chronicles 6
KITAHARA, YOSHIRO (YOSHIO): Gamera, Invisible Man Vs Fly Man,
 Snake Girl And Silver Haired Witch
KITAJIMA, MAI: Female Seductress

KITAJIMA, MAYA: Horror Of An Ugly Woman
KITAKAMI, YATARO: Ghost Story Of Kasane Swamp
KITAMURA, JUSIN (JUN): Emotion, Invisible Man (Dr Eros)
KITANO, BEAT TAKESHI: Getting Any Lately?, Man Who Inherited A Star
KITAZAWA, NORIKO: Ghost Cat Of Otama Pond, Ghost Monster Cat Mansion,
 Ghost Story Of Kagami Swamp, Ghost Story Of Kasane Swamp,
 Ghost Story Of Yotsuya
KITaZUME, YUKI: Lady Battle Cop
KIYOKAWA, AYU: Female Inquisitor
KIZUKI, SAEKO: Entrails Of A Virgin, Female Inquisitor
KO, HIDEO: Goke
KOBAYASHI, HITOMI: Evil Dead Trap
KOBAYASHI, KAORU: Scared People
KOBAYASHI, KATSUHIKO: Ghost Story Of Night-Crying Lantern
KOBAYASHI, KATSUYA: Crazy Family
KOBAYASHI, KEIJU: Godzilla 1985
KOBAYASHI, MEGUMI: Mothra (1996)
KOBAYASHI, NAOMI: Haunted Castle
KOBAYASHI, SHOJI: Ultraman (series)
KOBAYASHI, SATOMI: Godzilla Vs Queen Mothra, New Student
KOBAYASHI, TOSHIJI: Crazy Thunder Road
KOBAYASHI, TSURUKO: Varan The Unbelievable
KOBAYASHI, YUKIKO: Blood Thirsty Doll, Destroy All Monsters
KOBORI, AKIO: Rodan
KOCHI, MOMOKO: Godzilla, Half Human
KODAKA, EMI: Godzilla Vs The Destroyer, Godzilla Vs Mechagodzilla,
 Godzilla Vs Queen Mothra, Godzilla Vs Space Godzilla
KOIKE, ASAO: Horror Of A Malformed Man
KOIZUMI, HIROSHI: Attack Of The Mushroom People, Atragon,
 Dogora The Space Monster, Ghidrah The Three Headed Monster,
 Godzilla Counterattacks, Mothra
KOIZUMI, HIROSHI: Godzilla Vs The Thing
KOJIMA, YAEKO: Space Monster Gamera
KOJOMON, MASAMI: Tokaido Road Monsters
KOMATSU, MIYUKI: Female Ninja Magic Chronicles 3
KOMINE, REINA: August In The Water
KOMIYA, MITSUE: Moonbeam Mask (Gekko Kamen series)
KOMIYAMA, SAEKO: Zombie Annihilation
KON, YOKO: Season For Tears
KONDO, MIEKO: Invisible Monster
KONDO, RIE: Evil Dead Trap 2, Keko Mask
KOSAKAI, SHINOBU: Scary True Stories 3
KOZUKA, SAORI: Sorceress Legend (Siren)
KOZUKI, JUNKO: Freshly Severed Head
KOZUKI, MIYA: Sex Crimes
KRAUS, DORE: Ultraman G
KUBO, AKIRA: Attack Of The Mushroom People, Destroy All Monsters,
 Monster Zero, Son Of Godzilla, Yog Monster From Space

KUBO, KEIKO: Philip
KUBO, NAOKO: Military Cop And The Ghost
KUDO, MASAKI: Hiruko
KUDO, SHIZUKA: Memory Of The Future
KUDO, YUKI: Crazy Family
KUJI, ASAMI: Bloodsucking Moth
KUMAGAI, MAMI: Scared People
KUNIMURA, HAYATO: Human Chair
KUNO, MAKIKO: Security Guard From Hell
KURATA, TETSUO: Female Ninja Magic Chronicles 6
KURATA, SHOICHI: Woman Who Needed Sex
KURITA, YOKO: Diva In The Netherworld
KUROBE, SUSUMU: Ultraman (series)
KURONUMA, HIROMI: North 45
KUROSAWA, TOSHIO: Blood Thirsty Rose, Last Days Of Planet Earth
KUSAKA, TAKESHI: Noh mask Murders
KUSAKARI, MASAO (MASSAO): Black Jack 2, Black Jack 3, ESP Spy, Himiko,
 Monster Heaven, North 45, Teddy Bear From Outer Space, Virus
KUSAMURA, REIKO: Fish On A Tree
KUSANAGI, KOJIRO: XX Beautiful Victim
KUSUNOKI, YUKO: Ghost Of The Hunchback
KYO, MACHIKO: Black Lizard, Evil Woman
KYOMOTO, MASAKI: Blade Of Oedipus, Sacred Sword of Shuranosuke,
 Sukeban Deka 2
LEYES, LANDY: Gunhed
LONDON, JASON: Apocalypse Christmas
MACHIDA, KEIKO: Emotion
MAEDA, BEVERLY: Son Of Godzilla
MAEDA, GIN: Don Matsugoro's Life
MAHINDA, EDWIN: Beyond The Great Pyramid
MAKI, CAROUSEL: Konto 55
MAKI, FUYUKICHI: Renegade Robo Ninja & Princess Saki
MAKI, TOKICHI: Legend Of The Dinosaur And Giant Bird
MAKO, MICHIYO: Some Stories Of Adultery
MARIMURA, KEI: XX Beautiful Prey
MARINO, HASE: Female Ninja Magic Chronicles 3
MARO, AKAJI: Yamato Takeru
MARUYAMA, AKIHIRO: Black Lizard, Black Rose
MASAOKA, KUNIO: O Rangers, Super Power Unit Vs Kaku Rangers
MASAYAMA, KENICHIRO: Ghost Story Of The Barabara Phantom
MASON, RICHARD: East Meets West
MASUOKA, TORU: Agi
MATHESON, TIM: Crisis 2050
MATSUBARA, ROKURO: Fear Of The Mummy
MATSUDA, EIKO: Sacred Mother Kannon
MATSUDA, CHIYURI: Sex Beast Teacher 4
MATSUDA, YOJI: Dogura Magura
MATSUDA, YUSAKU: Mirage Theater

MATSUI, KAZUYO: Tastiest Flesh
MATSUI, YASUKO (YACHIE): Bed Of Violent Desires,
 Snake Girl And Silver Haired Witch
MATSUKA, AIKO: Captured For Sex 2
MATSUKATA, HIROKI: Magic Serpent
MATSUMOTO, KAPPEI: Invasion Of The Neptune Men
MATSUO, FUMITO: Varan The Unbelievable
MATSUO, KAYO: Blood Thirsty Doll
MATSUOKA, KIKKO: Black Rose, Living Skeleton
MATSUOKA, SHUNSUKE: In The Thicket
MATSURA, YASUSHI: Abnormal Reaction: Ecstacy
MATSUSHIRO, YUTAKA: Security Guard From Hell
MATSUYAMA, KEIGO: Village Of Dreams
MATSUYAMA, SHOGO: Village Of Dreams
MATSUZAKA, KEIKO: Ghost In A Tavern 2
MATSUZAKA, YUKARI: Nighty Night
MATSUZAKA, TAKASHI: Watchdogs From Hell 2
MAYA, TAKESHI: Hard Helmets, Labyrinth
MAYUMI, TOMOKO: Door 3, Dream Devil, Lady Poison
McEVOY, ANN MARIE: Beyond The Great Pyramid
MIDORI, MAKO: Blind Beast, Japanese Goblin Story
MIFUNE, TOSHIRO: Birth Of Japan, Throne Of Blood,
 Story of The Bamboo Hunter
MIHARA, YOKO: Female Vampire, Haunted Mansion Of Ama,
 Military Cop And The Ghost, Virgin Of The 99th Sword
MIHARA, YUKO: End To Miyazu
MIHASHI, TAKASHI: Sadistic Song
MIHASHI, TATSUYA: Human Vapor
MIHO, JUN: Black Magic Wars
MIKAGE, KYOKO: Ghost Cat In Haunted Swamp, Ghost Story of Yotsuya (1969)
MIKAMI, HIROSHI: Grass Labyrinth, Parasite Eve, Swallowtail Butterfly,
 Walker In The Attic
MIKI, NORIHEI: Horror Transfer
MIKIMOTO, SHINSUKE: Ghost Of The Girl Diver
MIKUNI, RENTARO: Evil Woman, Himiko, Inugami Family, Kwaidan,
 Luminous Moss
MIKUTEI, RANYAKU: Pinnochio 964
MILLER, LINDA: King Kong Escapes
MINAKAZE, YOKO: Blood Thirsty Doll
MINAMI, KAHO: Angel Dust, Angel's Share, Capitol Great War, Ruby Fruit
MINAMI, SHINSUKE: Daigoro Vs Goriasu
MINAMINO, YOKO: Sukeban Deka
MINATO, YUICHI: Some Stories Of Adultery, Vicious Doctor
MINE, HIROKO: Moonbeam Mask (Gekko Kamen series)
MINEGAMI, TATSUKO: Invasion Of The Neptune Men
MINEGISHI, TORU: XX Beautiful Victim
MISHIMA, YUKIO: Black Lizard
MISORA, HIBARI: Ghost Story Of Broken Dishes At Bancho

MITA, YASUKO: Vampire Bride
MITA, YOSHIKO: Drifting Classroom, World War 3 Breaks Out
MITAMURA, KUNIHIKO: Godzilla Vs Biolante
MITSUI, KOJI: Woman In The Dunes
MIURA, AYANE: Beast City, Ring
MIURA, TOMOKAZU: Psychic, Sayonara Jupiter
MIURA, YOICHI: Taro!
MIYA, KAORU: Love Potion Trap, Ten Years Of Evil
MIYAKE, YUJI: Ghost In A Tavern
MIYAHARA, KAZUO: Trap
MIYAMOTO, HARUE: Bottom Of The Swamp
MIYAMOTO, NOBUKO: Sweet Home
MIYATA, FUMIKO: Hell
MIYAUCHI, HIROSHI: Darkside Reborn (1996), Darkside Reborn: Path To Hell
MIYASHITA, JUNKO: Horror (Koheiji Is Alive), Walker In The Attic
MIYAZAKI, MASUMI: Walker In The Attic (1994), XX Beautiful Weapon
MIYAZAWA, JURI: Ghost Classroom
MIYAZAWA, RIE: Tower Story
MIZKOU: Die Hard Angels, Zombie Annihilation
MIZUHARA, YUKI: Honjin Murder Case (Kindaichi)
MIZUKI, RIKA: Snake Lust
MIZUNO, KUMI: Frankenstein Conquers The World, Godzilla Vs Sea Monster,
 War of The Gargantuas
MIZUNO, MIKI: Gamera 2
MIZUSHIMA, KAORI: Monster Heaven
MIZUTANI, KEI: Weather Girl
MIZUTANI, MANAMI: Amazons In White
MIZUTANI, RIKA: Sex Beast Teacher 2, Sex Beast Teacher 3
MIZUTANI, YUTAKA: Tokyo Fireball
MOCHIZUKI, MARIKO: Blood Thirsty Rose
MOCHIZUKI, RUMI: Ghost Story Of Evil Spirits
MOCHIZUKI, YUTA: Beast City, Kamen Rider J
MOMOYAMA, TARO: Akado Suzunosuke
MORI, AKIKO: Mandala
MORI, MITSU: Emotion
MORIGUCHI, MAI: Scary True Stories
MORIMOTO, YOSHIE: Happy Ending Story
MORINAGA, NAOMI: Sorceress Legend (Siren), Victim
MORIO, YUMI: Miraculous Stories
MORISAKI, MEGUMI: Female Seductress
MORISHIGE, HISAYA: Sayonara Jupiter
MORISHITA, SUMINA: Cutie Knight In Costume 2
MORITA, KENSAKU: Horror Transfer, Renegade Robo Ninja, War In Space
MORIYAMA, YUKO: Darkside Reborn (1996), Darkside Reborn: Path To Hell,
 Zieram, Zieram 2
MOROBOSHI, KAZUMI: Miraculous Baby
MORRIS, LLOYD: Ultraman G
MORROW, VIC: Message From Space

MOTOKI, MASAHIRO: Rampo
MOURI, KIKUE: Horror Of Saga Mansion
MUKAI, AKI: Die Hard Angels
MUKAI, KUNIO: XX Beautiful Weapon
MUKAI, MARI: Narcissus Of Lust
MURAI, TARO: Majin (Return Of Majin)
MURAKAMI, RIKAKO: Death Powder
MURATA, HIDEO: Terror Beneath The Sea
MURATA, KAZUMI: Target Campus
MUROI, SHIGERU: Ghost In A Tavern, Miraculous Stories
MUROTA, HIDEO: Dangerous Tales, Island Of Evil Spirits
MURPHY, CHRIS: Gamera Vs Guiron
MURPHY, KATHERINE: Gamera Vs Monster X
MUTO, KEIJI: Dragon Blue
MUTO, SHUSAKU: Night Decay
NAGAKURA, DAISUKE: Victim
NAGAOKA, JOJI: Bed Of Violent Desires
NAGASAKA, SHIHORI: Victim
NAGASHIMA, EIKO: Cursed Village In Yudono Mountain
NAGASHIMA, TOSHIYUKI: Cursed Village In Yudono Mountain, Gamera 2
 Misty
NAGATO, HIROYUKI: Sukeban Deka, Sukeban Deka 2, Sukeban Deka 3
NAGATSUKA, KYOZO: Tastiest Flesh, Village Of Dreams
NAGISA, MAYUMI: Ghost Story Of The Pit
NAITO, TAKETOSHI: Ghost Story Of Snow Girl
NAITO, YOKO: Hell Screen
NAKA, MACHIKO: Godzilla's Revenge
NAKA, SACHIKO: Nighty Night
NAKADA, YASUKO: Ghost Story Of Yotsuya
NAKADAI, TATSUYA: Blue Christmas, East Meets West, Face Of Another,
 Ghost Story Of Yotsuya (1965), Hell Screen, Ran, Time Of Madness
NAKAGAWA, ANNA: Godzilla Vs King Ghidorah
NAKAGAWA, ERIKO: Evil Dead Trap
NAKAGAWA, RIE: Woods Are Wet (Woman Hell)
NAKAHARA, SANAE: Ghost Story Of One Eyed Man, Requiem For A Massacre
NAKAHARA, HITOMI: Tanba's Great Spirit World (series)
NAKAI, KIICHI: Story Of The Bamboo Hunter
NAKAJIMA, HIROMI: Cursed Luger P08, North 45
NAKAJIMA, MICHIYO: Female Ninjas (Secret Of Jaraiya)
NAKAJIMA, TOMOKO: April Horror, Two
NAKAJIMA, SHOKO: Evil Dead Trap 2
NAKAMURA, AZUSA: Lady Battle Cop
NAKAMURA, GANJIRO: Ghost Story Of Kasane Swamp,
 Ghost Story Of Night-Crying Lantern
NAKAMURA, KAZUO: Bloodshed
NAKAMURA, KICHIEMON: Kuroneko
NAKAMURA, KINNOSUKE: Ghost Story Of Chidori-ga-fuchi Swamp,
 Hell Screen, Lady Was A Ghost

NAKAMURA, KUMI: Agi
NAKAMURA, NOBUO: Half-Human
NAKAMURA, REIKO: Bloody Fragments On A White Wall
NAKAMURA, SATOSHI: Manster
NAKAMURA, TADAO: Secret Of The Telegian, Terror Of Mechagodzilla
NAKAMURA, TETSU: Last Dinosaur
NAKAMURA, TORU: Listen To The Voice Of The Sea God
NAKAMURA, TORAHIKO: Hell
NAKAMURA, YUJI: Guinea Pig 5, World Apartment Horror
KAKAMURA, YUMI: Sukeban Deka 2, Sukeban Deka 3
NAKAMURA, YUTAKA: Invisible Monster
NAKANO, REI: Keko Mask
NAKANO, SUN PLAZA: Battle Heater
NAKAO, AKIRA: Black Magic Wars, Blood Thirsty Doll,
	Godzilla Vs Space Godzilla, Honjin Murder Case (Kindaichi series)
NAKAO, MANABU: Werewolf
NAKATA, YASUKO: Ghost Story Of The Bird That Ate Mosquitoes,
	Ghost Story Of Kasane Swamp
KAKATA, MAYU: Sex Beast Teacher 2
NAKAYA, NOBORU: Kwaidan
NAKAYAMA, HIROKO: Horror Newspaper
NAKAYAMA, JIN: Adventures Of Kosuke Kindaichi (Kindaichi series)
NAKAYAMA, SHINOBU: Donor, Gamera Guardian Of The Universe
NAKAYAMA, SHOJI: Military Cop And The Dismembered Beauty,
	Military Cop And The Ghost
NAKAYAMA, TAKAMASA: Spiritual Report
NAKAZAWA, AKIYASU: Door 3
NAMIJI, BUNTA: Virgin Of The 99th Sword
NAMISHIMA, SUSUMU: Boy's Detective Team, Invisible Man
NANBARA, KOJI: Demon Pond
NANBU, SHOZO: Cosmic Man Appears In Tokyo
NANIWA, CHIEKO: Horror Of Saga Mansion
NANJO, KOJI: Crazy Thunder Road
NANJO, REIKO: Lake Of Illusions
NARITA, MIKIO: Black Magic Wars, Darkside Reborn, Ghost Story Of The Pit,
	Sea And Poison
NARUSE, KEIKO: Love Potion Trap
NASA, KENJIN: Organ
NATORI, YUKO: Koya Mountains Choken Memorandum, Summer With Ghosts,
	Tokyo Blackout
NATSUKI, AKIRA: Gamera Vs Barugon
NATSUKI, ISAO: Time Slip, Virus
NATSUKI, MARI: Death Powder
NATSUKI, YOKO: XX Beautiful Victim, XX Red Murderer
NATSUKI, YOSUKE: Dogora The Space Monster,
	Ghidrah The Three Headed Monster
NATSUME, MASAKO: Ghost Story Of Yotsuya (1981)
NATSUME, REI: XX Beautiful Killing Machine

NAWA, HIROSHI: Ghost Cat In Haunted Swamp,
 Ghost Story Of Night-Crying Lantern
NEAL, PEGGY: Terror Beneath The Sea, X From Outer Space
NEGISHI, AKEMI: Ghost Story Of The Snake Woman
NEZU, JINPACHI: Ran
NGUYEN, DOLL: Gunhed
NIIJIMA, YAYOI: Werewolf
NINOMIYA, HIDEKI: Majin Strikes Again
NISHIDA, HIKARU: Bouquet For Spinster Yamada
NISHIDA, KAORU: Exorsister 4
NISHIDA, NAOMI: Elementary School Ghost Story 2
NISHIDA, TOSHIYUKI: Devil Comes Down And Blows The Flute (1979)
NISHIKAWA, TADASHI: Fish On A Tree
NISHIKIORI, KAZUKIYO: Nineteen
NISHIMURA, AKIRA: Ghost Of The Hunchback, Ghost Story Of One Eyed Man,
 Living Skeleton
NISHIMURA, KAZUHIKO: Capitol Story: Secret Report
NISHIMURA, TOMOMI: Hunting Ash, Don Matsugoro's Life
NISHINA, MARI: Beast City 2
NISHIO, ETSUKO: XX Red Murderer
NITAKA, KEIKO: Grass Labyrinth
NODA, HIDEKI: Crane
NOGAMI, MASAYOSHI: Narcissus Of Lust
NOGAWA, YUMIKO: Samurai Comedy
NOKKO: Keko Mask, Sweet Home
NOMOTO, MIHO: Beast City 2, Female Ninja Magic Chronicles 6
NOMURA, HIRONOBU: Elementary School Ghost Story,
 Elementary Ghost Story 2
NOMURA, KOZO: Varan The Unbelievable
NOMURA, YUKA: Kamen Rider J
NUMATA: YOICHI: Hell
OBASHI, KENJI: Horror Newspaper
ODA, KUMIKO: House
ODA, JOJI: Prince of Space
ODA, YUJI: Angel: My Song Is Your Song,
ODAKA, MEGUMI: Godzilla Vs King Ghidorah
OGASAWARA, ARISA: Scary True Stories 2
OGATA, KEN: Darkside Reborn, My Soul Is Slashed
OGATA, NAOTO: Listen To The Voice Of The Sea God
OGAWA, ATSUKO: My Sister And Fried Tofu
OGAWA, MAYUMI: Goodbye Ark, Eight Tombstone Village, Wink Of An Angel
OGAWA, TOMOKO: Magic Serpent
OGINOME, KEIKO: Ghost Story Of Yotsuya (Chushingura), Ultra Q The Movie
OGURA, ICHIRO: Tastiest Flesh
OHIKI, MASAMITSU: Crazy Thunder Road
OHIZUMI, AKIRA: Keko Mask, Keko Mask In Love
OHKAWA, KEIKO: Lady Was A Ghost
OHKI, MINORU: Black Lizard, Horror of A Malformed Man

OHKUSU, MICHIYO: Mirage Theater, Yumeji, Zigeunerweisen
OHMIYA, KANICHI: Trap
OHNISHI, YUKA: Female Neo Ninjas, Female Ninja Magic Chronicles 6,
 Sukeban Deka 2, Sukeban Deka 3
OHNUKI, KAORI: SM Se7en
OHSAWA, ITSUMI: Murder For Pleasure
OHSAWA, KEN: Supergirl Reiko, Video Girl Ai
OHSAWA, SAYAKA: Godzilla Vs The Destroyer
OHSHIMA, AKEMI: Female Neo Ninjas
OHTA, YUMI: Spirit
OHTAKI, SHUJI: Tokyo Blackout
OHTAKE, KAZUE: Give Me Back My Body
OHTAKE, RYUTA: Spiritual Report
OHTAKE, SHINOBU: Rex (A Dinosaur Story)
OHTSUKI, KENZI: Living Dead In Tokyo Bay
OHIDE, SHUN: Hell Screen
OKA, JOJI: Queen Bee (Kindaichi series), Spider Man
OKADA, EIJI: Blue Christmas, Boy's Detective Team, Face Of Another,
 Ghidrah The Three Headed Monster, Sea And Poison,
 Woman In The Dunes, X From Outer Space
OKADA, MARIKO: Ghost Story Of Yotsuya
OKADA, MASUMI: Living Skeleton, Sea And Poison
OKADA, YUJI: Monster From Prehistoric Planet
OKAMORI, AKIRA: Hunting Ash
OKAMOTO, JIRO: Humanoid Hakaida
OKAMOTO, REI: Noh Mask Murders
OKAWA, MIKIKO: Dark Story Of A Japanese Rapist
OKAWA, OSAMU: Big Monster War
OKAYASU, YUMIKO: Tanba's Great Spirit World (series)
OKAZAKI, JIRO: In Bed With the Enemy
OKI, NAOMI: Computer-Age Ghost
OKITA, HIROYUKI: Rapeman (series)
OKUMURA, KIMINOBU: Angel's Share
OKUNO, ATSUSHI: TVO
OMAE, HITOSHI: Time Of The Apes
OMI, TOSHINORI: New Student
OMURA, FUMITAKE: Moonbeam Mask (Gekko Kamen series)
OMURA, KON: Gamera VS Monster X
ONN-CHAN: Pinnochio 964
ONO, MIYUKI: Evil Dead Trap, Sayonara Jupiter,
 Taro! Tokyo Magic World War, Time Slip
ONO, SHINICHI: North 45
ONODERA, AKIRA: Gamera Guardian Of The Universe
OSHIMA, YOKO: Legendary Panty Mask
OSHIBE, RENA: I Heard The Whisper Of The Ammonite
OSUGI, REN: Lady Poison
OTABE, AYA: Last Frankenstein
OTANI, NAOKO: Pearl Sprite (Kindaichi series), Zigeunerweisen

OTOMA, RYUTARO: Magic Serpent, Samurai Spy
OTOWA, NOBUKO: Kuroneko, Last War, Onibaba, Wheel Of Iron
OTSUKA, MICHIKO: Bride From Hell
OTSUKI, RAIKO: Japanese Sex Crime Concurrence
OZARA, MAYUMI: Ghost Story Of Yotsuya (1965)
OZAWA, EITARO: Black Rose
OZAWA, KAZUYOSHI: Sacrifice
OZAWA, MEGUMI: Entrails Of A Beautiful Woman
OZAWA, MIKI: Cab
OZAWA, NATSUKI: Nineteen
OZAWA, SHIGEHIRO: Mitsukubi Tower
PALANCE, JACK: Crisis 2050
PALUZZI, LUCIANA: Green Slime
PETER: Funeral Procession Of Roses, Guinea Pig 5, Guinea Pig 6
PETTY, LORI: Apocalypse Christmas,
REASON, RHODES: King Kong Escapes
RICHTER, ELISE: Battle In Outer Space
ROME, ANGELICA: East Meets West
ROMERO, CESAR: Latitude Zero
ROSS, WILLIAM: Green Slime, Last Dinosaur, War In Space
RYU, DAISUKE: Black Jack, Black Jack 2, Black Jack 3,
 Koya Mountains Choken Memorandum, Lake Of Illusions
SAEGUSA, MIO: Miss Spy
SAEKI, KENZO: I Heard The Whisper Of The Ammonite
SAEKI, HIDEO: Narcissus Of Lust
SAEKI, HINAKO: Target Campus
SAGARA, HARUKO: Maria's Stomach, Sukeban Deka
SAHARA, KENJI: Attack Of The Mushroom People, Atragon,
 Godzilla's Revenge, H-Man, King Kong Vs Godzilla, Mysterians,
 Rodan, War Of The Gargantuas, Yog Monster From Space
SAHIB, MOHAMMED ABDUL: World Apartment Horror
SAI, YOUICHI: North 45
SAIKI, SHIGERU: Guinea Pig 4
SAITO, HIROKO: Time Of The Apes
SAITO, KOJI: Computer-Age Ghost
SAITO, TOMOKO: Devil Comes Down And Blows The Flute (1979), Hellywood
SAITO, YOSUKE: Tastiest Flesh
SAKAGAMI, JIRO: Konto 55
SAKAGAMI, KAORI: In The Thicket, Video Girl Ai
SAKAGAMI, SHINOBU: Green Requiem
SAKAGAMI, YATSUSHI: Gamera Vs Zigra
SAKAI, ENAMI: Alice's Sanctuary,
SAKAI, FRANKIE: Horror Transfer, Last War, Mothra
SAKAI, KAZUKI: Alice's Sanctuary
SAKAI, MAKI: Ullie
SAKAI, OSAMU: Invisible Swordsman
SAKAI, SACHIO: Godzilla's Revenge
SAKAKI, YUKO: Sacrifice

SAKAKIBARA, RUMI: Justice
SAKAMOTO, KAZUE: Dark Story Of A Japanese Rapist
SAKAMOTO, MICHIKO see SAKYO, MICHIKO
SAKITA, MEGUMI: Female Ninja Magic Chronicles 4
SAKURABA, ATSUKO: Miss Spy
SAKURAGI, RUI: Zombie Annihilation
SAKURAI, HIROKO: Mandala, Ultraman (series)
SAKURAI, YUKIKO: Werewolf
SAKURAMACHI, HIROKO: Cruel Ghost Legend, Ghost Story Of Oiwa
SAKYO, MICHIKO: Female Bodies Are Disappearing, Snake Lust,
 Vicious Doctor, Violated Angels
SANADA, HIROYUKI (HENRY): Black Magic Wars, Darkside Reborn,
 East Meets West, Legend Of The Eight Samurai (1984), Scared People
SANJO, MAKO: Fear Of The Mummy, Ghost Story Of The Pit
SANJO, MIKI: Invisible Man
SANO, KEI: Captured For Sex 2
SANO, SHIRO: Bloody Fragments On A White Wall, Dangerous Tales,
 Defender, Evil Dead Trap 2, Evil Dead Trap 3, Lady Battle Cop,
 Scared People, TVO
SASAKI, KATSUHIKO: Godzilla Vs Megalon, Terror Of Mechagodzilla
SATO, HIROYUKI: Miraculous Baby, North 45
SATA, KEIKO: Human Vapor
SATO, KOICHI: Ghost Story of Yotsuya (Chushingura), Pu
SATO, KEI: Ghost Story Of Yotsuya (1969), Kuroneko, Onibaba, Tokyo Fireball
SATO, MAKOTO: Blind Woman's Curse
SATO, MASAHIRO: Guinea Pig 8
SATO, MIEKO: House
SATO, MITSURU: New Student, Requiem For A Massacre
SATO, REIKO: Haunted Mansion Of Ama
SATO, TOMOMI: Goke
SATOMI, KOJI: Love Potion Trap, Ten Years Of Evil
SATOMI, KOTARO: Ghost Cat In Haunted Swamp,
 Legend Of The Eight Samurai (1959)
SATSUKI, FUJIE: Ghost Cat Of Otama Pond,
 Military Cop And The Dismembered Beauty
SAWADA, KENJI: Darkside Reborn, Hiruko, Yumeji
SAWAGUCHI, YASUKO: Godzilla 1985, Story Of The Bamboo Hunter,
 Yamato Takeru
SAWAI, KEIKO: Monster Zero
SCHOFIELD, ANNABEL: Crisis 2050
SCHWARZENEGGER, ARNOLD (voice only): North 45
SEKIGUCHI, MASAHARU: Ultraman Z
SEKINE, KEIKO see TAKAHASHI, KEIKO
SEKIYA, MASUMI: Last Dinosaur
SENBA, NARIAKI: Adventures of the Electric Rod Boy
SENDA, KOREYA: Battle In Outer Space, H-Man
SEO, AKIRA: Sex Beast Teacher
SERIZAWA, NAOMI: Good Luck Venus

SHIBA, TOSHIO: Ultra Q The Movie
SHIBATA, SHOHEI: Kamen Rider Z
SHIBATA, YOSHIHIRO: Miraculous Stories
SHIHO: XX Beautiful Victim
SHIINA, AKIYO: Miraculous Stories
SHIMA, MIHARU: When Embryo Goes Poaching
SHIMADA, KYUSAKU: Capitol Story, Capitol Great War
SHIMADA, SARA: Cutie Knight In Costume
SHIMADA, SHOGO: Tower Story
SHIMADA, YOKO: Inugami Family
SHIMADA, YOSUKE: Tokaido Road Monsters
SHIMAMURA, KAORI: Rose, XX Beautiful Beast
SHIMASAKI, RINO: Captured For Sex 2
SHIMIZU, HITOMI: Darkside Reborn (Path To Hell)
SHIMIZU, KENTARO: Mermaid Story
SHIMIZU, KOJI: Mandala
SHIMIZU, MISA: Human Chair, Memory Of The Future
SHIMIZU, SETSU: Ghost Story Of The Barabara Phantom
SHIMURA, TAKASHI: Bride From Hell, Frankenstein Conquers The World,
 Ghidrah The Three Headed Monster, Godzilla, Gorath, Throne Of Blood
SHINAGAWA, RYUJI: Invisible Man Vs Fly Man, Mysterians
SHINDO, EISAKU: Miraculous Stories
SHINDO, EMI: Great Insect War
SHINODA, SABURO: Godzilla Vs The Destroyer, Yamato Takeru
SHINOHARA, AYU: Sex Beast Teacher
SHIOMI, ETSUKO (SUE): Legend Of The Eight Samurai (1984),
 Message From Space
SHIOYA, SHUN: Roaming Tortured Brain
SHIRAISHI, HITOMI: Night Of The Anatomical Doll
SHIRAISHI, KUMI: Beast City
SHIRAKAWA, KAZUKO: Capitol Story Secret Report
SHIRAKAWA, YUMI: Gorath, H-Man, Last War, Mysterians, Rodan,
 Secret Of The Telegian
SHIRAKI, MINORU: Samurai Comedy
SHIRASHIMA, YASUYO: Female Ninja Magic Chronicles
SHIRATO, MARI: Mermaid Legend
SHIRATORI, CHIEKO: Wizard Of Darkness 2
SHIRATORI, YASUYO: Ghost Of An Actress, Weather Girl,
SHISHIDO, KAI: Tower Story
SHISHIDO, JO: Stranger In Her Eyes
SHISHIDO, MASARU: O Rangers, Special Power Unit Vs Kaku Rangers
SHO, MAI: Good Luck Venus
SILVA, HENRY: Virus
SOMA, CHIEKO: Ghost Story Of Yotsuya, Yatsuhaka Village
SONODA, AYUMI: Varan The Unbelievable
SONOI, KEISUKE: Great Insect War
STANFORD, LEONARD: Battle In Outer Space
SUGA, KENTARO: Pastoral

SUGANO, MIHO: Defender
SUGAWARA, BUNTA: Crane, Haunted Mansion Of Ama
SUGIMOTO, AYA: Donor, Good Luck Venus
SUGIMOTO, TETTA: Biriken, Bride From Hell 1990, Luminous Moss
SUGIYAMA, AYAKO: Umezu's Terror Zone
SUMIDA, TAKASHI: Weather Girl
SUMIDA, YUKI: Female Ninja Magic Chronicles 2
SUMII, SHIMON: Female Neo Ninjas
SUNAZUKA, HIDEO: Godzilla Vs Sea Monster, Time Of Madness
SUZUKI, CUTEI: Living Dead In Tokyo Bay
SUZUKI, HAGE: Pinnochio 964
SUZUKI, KYOKA: Ghost In A Tavern 2
SUZUKI, MIHO: Beast City 2
SUZUKI, NAO: Missing Heart
SUZUKI, RYOSUKE: All Night Long
SUZUKI, SAWA: Capitol Story Secret Report,
SUZUKI, SEIJUN: Fish On A Tree
SUZUKI, SUMIKO: Ghost Cat (False Ceiling)
SVENSON, BO: Virus
SWOPE, TRACY: Beyond The Great Pyramid
TACHI, HIROSHI: Ghost In A Tavern 2
TACHIBANA, KAKO: Invisible Man (Dr Eros)
TACHIBANA, MAKI: In Bed With The Enemy
TACHIBANA, RISA: Don Matsugoro's Great Adventure
TAGUCHI, TOMOROH: Adventures of the Electric Rod Boy, All Night Long 3,
 Angel's Share, Darkside Reborn (1996), Darkside Reborn: Path To Hell,
 Defender, Dragon Blue, Dream Devil, Forever With You,
 I Hate You...Not, North 45, Pu, Ring, Sadistic Son, Super Coming,
 Swallowtail Butterfly, Teddy Bear From Outer Space, Tetsuo, Tetsuo 2
TAICHI, KIWAKO: Kuroneko
TAIRA, SAORI: Beast City, Red Peacock, Weather Girl R
TAJIMA, HONAMI: Black Jack 2, Black Jack 3
TAJIMA, REIKO: Godzilla Vs Cosmic Monster
TAKADA, MINORU: Battle In Outer Space
TAKADA, MIWA: Hundred Monsters, Majin
TAKAGI, NOBUHIDE: Wink Of An Angel
TAKAGI, YOKO: Blind Woman's Curse
TAKAHARA, RIE: Kisses From The Moon
TAKAHASHI, ATSUKO: Yog Monster From Space
TAKAHASHI, KAORI: Lots Of Killing, Portrait Of Persian Blue
TAKAHASHI, KATSUNORI: Ring
TAKAHASHI, KAZUYA: Eight Tombstone Village (Kindaichi series)
TAKAHASHI, KEIKO: Door, Ghost Story Of Yotsuya (1981)
TAKAHASHI, KOJI: Tanba's Great Spirit World
TAKAHASHI, MASAYA: Goke
TAKAHASHI, MAYUMI: Snake Girl And Silver Haired Witch
TAKAHASHI, MEGUMI: Sex Beast On Campus
TAKAHASHI, NATSUMI: Wizard of Darkness

TAKAHASHI, NORIKO: Konto 55
TAKAHASHI, OSAHIDE: Blood Thirsty Eyes
TAKAHASHI, YUMIKO: Umezu's Terror Zone
TAKAKI, MIO: Guinea Pig 2, Hunting Ash, Wizard Of Darkness
TAKAKURA, KEN: Devil's bouncing Ball Song (Kindaichi series)
TAKAKUWA, TSUTOMU: Gamera Vs Monster X
TAKAMINE, MIEKO: Inugami Family
TAKANO, HIROYUKI: Pastoral
TAKAOKA, SAKI: Ghost Story of Yotsuya (Chushingura)
TAKAOKA, YUKA: Ultraman Z
TAKARADA, AKIRA: Godzilla, Godzilla Vs Sea Monster,
 Godzilla Vs (Queen) Mothra, Godzilla Vs The Thing, Half-Human,
 King Kong Escapes, Last War, Latitude Zero, Monster Zero
TAKASHIMA, MASAHIRO: Gunhed, Yamato Takeru, Zipang
TAKASHIMA, REIKO: Roaming Tortured Brain, Ruby Fruit
TAKASHIMA, TADAO: Atragon, Frankenstein Conquers The World,
 King Kong Vs Godzilla, Son Of Godzilla]
TAKATSUKA, TORU: Gamera Vs Viras
TAKAYANAGI, RYOICHI: Girl Who Traveled Behind Time
TAKAZAWA, JUNKO: Honjin Murder Case (Kindaichi series)
TAKECHI, TOYOKO: Manster
TAKEDA, YUZO: Blood And Ecstacy
TAKEMOTO, RIE: Year 200X
TAKEMOTO, TAKAYUKI: Topical Mystery (Youth Republic)
TAKENAKA, NAOTO: Dangerous Tales, East Meets West, Guinea Pig 5,
 Hanako In The Restroom, Hiruko, Rampo, Taro! Tokyo Magic World War,
 Tokyo Fist, Terra Soldier (Cyboy)
TAKESHIMA, MASAHIRO: Godzilla Vs Mechagodzilla
TAKESHITA, KEIKO: Blue Christmas
TAKIDA, YUSUKE: Submersion Of Japan
TAKIGAWA, YUMI: Lots Of Killing
TAKUMA, SHIN: Godzilla 1985, Eight Tombstone Village (Kindaichi series)
TAMAOKI, KOJI: Portrait Of Persian Blue
TAMIYA, JIRO: Medal From The Devil
TAMLYN, RUSS: War Of The Gargantuas
TAMURA, EIKO: Twilight
TAMURA, HIROSHI: Guinea Pig 3, Guinea Pig 6
TAMURA, MASAKAZU: Black Rose, Cruel Ghost Legend
TAMURA, RYO: Mandala
TAMURA, SHOKO: Space Cargo
TAMURA, TAKAHIRO: Honjin Murder Case (Kindaichi series)
TANAKA, HIROKI: World Apartment Horror
TANAKA, HIROKO: Dragon Blue
TANAKA, KEN: Godzilla 1985
TANAKA, KUMIKO: Bottom Of The Swamp
TANAKA, KUNIE: Blood Thirsty Rose, Adventures Of Kosuke Kindaichi
 (Kindaichi series), Hell, Luminous Moss, Man Who Inherited A Star, Trap
TANAKA, MINAKO: Door 3

TANAKA, SUZUNOSUKE: Spiritual Report
TANAKA, YOSHIKO: Godzilla Vs Biolante
TANBA, MATASABURO: Ghost Story of Swamp Of Corpse Candle
TANBA, TETSURO: Capitol Great War, Female Neo Ninjas,
 Ghost Story Of Kasane Swamp, Kwaidan, Last Days of Planet Earth,
 Message From Space, Submersion Of Japan,
 Tetsuro Tanba's Great Spirit World (series: Great Spirit World),
 Tokyo Fireball, Wink Of An Angel
TANBA, YOSHITAKA: Tanba's Great Spirit World (series)
TANI, NAOMI: Bed Of Violent Desires, Ten Years Of Evil, Vicious Doctor
TANIGUCHI, WAKI: Exorsister
TATSUMI, NORIKO: Inflatable Sex Doll Of The Wastelands, Ten Years Of Evil
TATSUMI, TAKURO: Godzilla Vs The Destroyer
TAZAKI, JUN: Atragon, Destroy All Monsters
TERA, JUGO: Angel's Share
TERADA, EMI: Scary True Stories 2
TERAO, SATOSHI: Ran
TERAWAKI, YASUFUMI: Kisses From The Moon
THOMPSON, JAMES B: Gunhed
THORSON, RUSSELL: Half-Human
TOGAWA, JUN: Ruby Fruit
TOKITO, SABURO: Full Moon
TOKUDA, EIJI: Luminous Moss
TOKUDA, HOKI: Blind Woman's Curse
TOKUNAGA, REIKO: Time Of The Apes
TOMINAGA, MINA: Teddy bear From Outer Space
TOMITA, YASUKO: Battle Heater
TOMODA, YURIKO: Female Seductress
TONOYAMA, TAIJI: Sacred Mother Kannon, Wheel Of Iron
TORII, KAHORI: Green Requiem
TOSHISHIGE, TSUYOSHI: Guinea Pig 4
TOURA, ROKKO (sometimes MUTSUHIRO): Haunted Castle,
 Tokaido Road Monsters
TOYAMA, MASUMI: Elementary School Ghost Story
TOYOHARA, KOSUKE: Godzilla Vs King Ghidorah
TOYOKAWA, ETSUSHI: Eight Tombstone Village
TSUBOUCHI, MIKIKO: Gamera Vs Zigra, Hundred Monsters
TSUCHIYA, DAISUKE: Hard Helmets
TSUCHIYA, SAORI: Miraculous Stories
TSUCHIYA, YOSHIO: Attack Of The Mushroom People, Destroy All Monsters,
 Funeral Procession Of Roses, Human Vapor, Yog Monster From Space
TSUGAWA, MASAHIKO: Ghost In A Tavern 2
TSUJI, KARIN: Exorsister 4
TSUKAMOTO, KOHJI: Tokyo Fist
TSUKASA, YOKO: Birth Of Japan
TSUKUMO, HAJIME: Keko Mask, Keko Mask In Love
TSUKAMOTO, SHINYA: Adventures of the Electric Rod Boy, Tetsuo 2,
 Tokyo Fist

TSUKIGATA, RYUNOSUKE: Ghost Cat (False Ceiling), Invisible Man Appears
TSUMIKI, MIHO: Misty, Whisper Of A Nymph, TVO
TSUNA, MISATO: Tanba's Great Spirit World
TSURUMI, JOJI: Invisible Man Vs Fly Man
TSURUOKA, HACHIRO: Female Bodies Are Disappearing,
 Freshly Severed Head
TSURUTA, KOJI: Secret Of The Telegian
TSUTSUI, YASUTAKA: Scared People
TSUTSUMI, DAIJIRO: Door
TSUTSUMI, TARO: Goodluck Venus
UCHIDA, ASAO: Majin (Return Of Majin)
UCHIDA, RYOHEI: Ghost Cat In Haunted Swamp
UCHIDA, TOMOO: Big Monster War
UEDA, KICHIJIRO: Gamera Vs The Gaos
UEHARA, KEN: Atragon
UEKI, HITOSHI: Crazy Family
UEKUSA, KATSUHIDE: Nineteen
UENO, MAKIKO: Female Ninja Magic Chronicles 4
UENO, MEGUMI: Hiruko
UENOYAMA, KOICHI: Haunted Castle
UEYA, KENICHI: Eda
UMEKI, MIYOSHI: Devil Garden
UMEZU, SAKAE: Rapeman (series)
UMEMIYA, TATSUO: Boy's Detective Team, Prince of Space,
 World War 3 Breaks Out
UMEWAKA, SHOJI: Akado Suzunosuke,
UNO, JUKICHI: Onibaba
URAJI, YOKO: Ghost Cat in Cursed Wall, Ghost Story Of Kasane Swamp (1960)
URIU, RYOSUKE: Sex Crimes
USAMI, JUNYA: Black Lizard, Moonbeam Mask (Gekko Kamen series)
UTSUI, KEN: Gamera Vs Zigra, Supergiant series
VAN ARK, JOAN: Last Dinosaur
VARIS, KELLY: Gamera Vs Monster X
VAUGHN, ROBERT: Virus
WADA, KEINOSUKE: Female Vampire
WADA, KOJI: Monster From Prehistoric Planet
WADA, TAKASHI: Ghost Story Of Kasane Swamp
WAKABAYASHI, AKIKO: Dogora The Space Monster
WAKAMATSU, TAKESHI: Angel Dust, Grass Labyrinth
WAKAMIZU, YOSHIKO: Ghost Story Of Chidori-ga-fuchi Swamp
WAKAO, AYAKO: Story Of The Bamboo Hunter
WAKASUGI, EIJI: Boy's Detective Team
WAKASUGI, KATSUKO: Ghost Story Of Kasane Swamp,
 Ghost Story Of Yotsuya (1959)
WAKASUGI, KEINOSUKE: Snake God's Temple
WAKAYAMA, SETSUKO: Godzilla Counterattacks
WAKAYAMA, TOMISABURO: ESP Spy, Ghost Story Of One Eyed God,
 Ghost Story Of Yotsuya, Ghost Story of Oiwa, Devil's Bouncing Ball Song

(Kindaichi series), Tanba's Great Spirit World 2,
Under The Cherry Blossoms
WAKUI, EMI: Angel: Your Song Is My Song
WAKUI, SHINO: Nighty Night
WANIBUCHI, HARUKO: Devil Comes Down And Blows The Flute,
 Non-Chan (Riding On The Clouds), North 45, Zipang
WASHIO, ISAKO: Fist Of The North Star, Man With the Embossed Tapestry
WASHIO, MACHIKO: Watchdogs From Hell
WATANABE, HIROYUKI: Darkside Reborn (1996),
 Darkside Reborn: Path To Hell
WATANABE, KEN: Sea And Poison
WATANABE, MAKIKO: XX Beautiful Prey
WATANABE, MINAYO: Wink Of An Angel
WATANABE, NORIKO: Black Magic Wars
WATANABE, TORU: Godzilla Vs Sea Monster
WATASE, TSUNEHIKO: Legend Of Dinosaur And Giant Bird, Time Slip,
 Tokyo Blackout
WAZAKI, TOSHIYA: X From Outer Space
WHITMAN, GEORGE: Battle In Outer Space
WIDOM, BUD: Green Slime
YABE, MIHO: Cutie Knight In Costume
YABUKI, MARINA: Sex Beast Teacher 4
YACHIGUSA, KAORU: Human Vapor, Pastoral
YAEGAKI, MICHIKO: Gamera Vs Viras
YAGI, JAMES: Devil Garden, King Kong Vs Godzilla
YAKUSHIMURU, HIROKO: Legend Of The Eight Samurai (1984)
YAMADA, ISUZU: Throne Of Blood
YAMADA, KUNIKO: Bouquet For Spinster Yamada
YAMADA, TATSUO: Crazy Thunder Road
YAMADA, TOSHIKO: Scary True Stories 3
YAMAGATA, ISAO: Cosmic man Appears In Tokyo
YAMAGUCHI, KENJI: Female Ninja Magic Chronicles 2
YAMAGUCHI, KOUJI: Miraculous Stories
YAMAGUCHI, SAYAKA: Mothra (1996)
YAMAGUCHI, SHOTA: Winds Of God
YAMAGUCHI, TOMOKO: Biriken, Ghost In A Tavern
YAMAGUCHI, TOSHIKO: Mysterious Love Of Lady White
YAMAKAWA, WATARU: Golden Bat
YAMAMOTO, SHOHEI: Japanese Sex Crime Concurrence
YAMAMOTO, YOKO: Monster From Prehistoric Planet
YAMAMURA, SO: Last Days Of Planet Earth
YAMANAKA, HITOMI: Scary True Stories 3
YAMANAKA, JO: Door 2
YAMANE, HATSUO: Capitol Story Secret Report, Japanese Goblin Story,
 When Embryo Goes Poaching, Woods Are Wet (Woman Hell)
YAMANE, RYUSHI: Nostradamus Fearful Prediction
YAMASHINA, YURI: Woods Are Wet (Woman Hell)
YAMASHIRO, SHINGO: Ghost Story Of The Snake Woman, Sweet Home

YAMASHITA, JUNICHIRO (JUN): Gamera, Miraculous Baby
YAMASHITA, KISUKE: Lady Battle Cop
YAMASHITA, OSAMU: Dark Story Of A Japanese Rapist
YAMASHITA, SHINJI: Tokyo Blackout
YAMATANI, HATSUO: Sex Crimes
YAMATO, TAKESHI: Space Cargo, XX Beautiful Beast
YAMAUCHI, AKIRA: Godzilla Vs Smog Monster
YAMAZAKI, TSUTOMU: Demon Pond, Goodbye Ark,
 Eight Tombstone Village, Water Traveler
YANAGI, YUREI: Ghost Of An Actress
YANAGIBA, TOSHIRO: April Horror, Defender
YASUDA, NARUMI: My Soul Is Slashed, Zipang, Tropical Mystery
YAZAKI, TOMONORI: Godzilla's Revenge
YOKOSUKA, FUMI: Red Peacock
YOKOYAMA, AKIO: Getting Any Lately?
YOKOYAMA, CHISA: Time-Fighting Miki
YOKOYAMA, MEGUMI: Evil Dead Trap 3,
 Renegade Robo Ninja & Princess Saki
TOMO, NORITSUNE: Wizard Of Darkness 2
YONEHARA, MISATO: Super Coming
YONEYAMA, TAKAKO: Nighty Night
YONEZAWA, GYU: Great Sentimental Mask
YOSHIDA, HIDEKO: Who Am I?!
YOSHIDA, RYO: Water Traveler
YOSHIDA, TERUO: Goke, Horror Of A Malformed Man
YOSHIDA, YUKI: Robokill Beneath Disco Club Layla
YOSHIKAWA, TOWAKO: Godzilla Vs Space Godzilla
YOSHIMOTO, TAKAMI: Fish On A Tree
YOSHIMURA, JITSUKO: Man Who Inherited A Star, Onibaba
YOSHINAGA, SAYURI: Crane
YOSHIOKA, MAYUMI: Keko Mask In Love
YOSHINO, KIMIKA: Acri, Ghost Story Of Evil Spirits, Wizard of Darkness,
 Wizard Of Darkness 2
YOSHIZAWA, AKEI: Sukeban Deka
YOSHIZAWA, KEN: Sex Crimes
YUGAO, KIRARA: Guinea Pig 3, Guinea Pig 6
YUMI, KAORU: ESP Spy, Last Days Of Planet Earth